Home Front

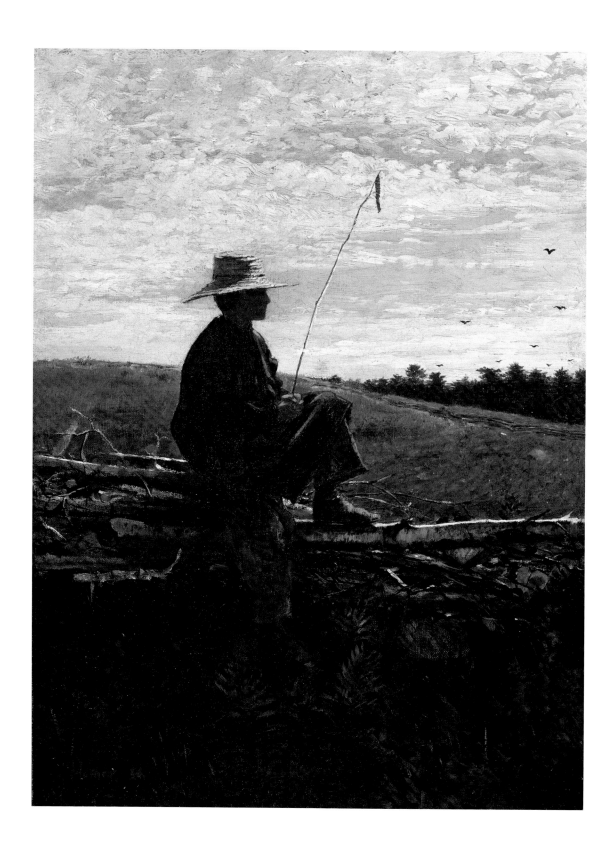

PETER JOHN BROWNLEE

SARAH BURNS

DIANE DILLON

DANIEL GREENE

SCOTT MANNING STEVENS

With a Foreword by Adam Goodheart

Home Front

Daily Life in the Civil War North

The University of Chicago Press

CHICAGO AND LONDON

This book is published on the occasion of the exhibition *Home Front: Daily Life in the Civil War North*, co-organized by the Newberry Library and the Terra Foundation for American Art, on view at the Newberry Library from September 27, 2013, through March 24, 2014. The exhibition is made possible through support from the Terra Foundation for American Art.

The University of Chicago Press, Chicago 60637
The University of Chicago Press, Ltd., London
© 2013 by The University of Chicago
All rights reserved. Published 2013.
Printed in Canada

22 21 20 19 18 17 16 15 14 13 1 2 3 4 5

ISBN-13: 978-0-226-06185-6 (cloth)
ISBN-13: 978-0-226-06574-8 (e-book)

Generous support for this book's publication provided by the Terra Foundation for American Art.

Library of Congress Cataloging-in-Publication Data

Home front : daily life in the Civil War North / Peter John Brownlee, Sarah Burns, Diane Dillon, Daniel Greene, Scott Manning Stevens ; with a foreword by Adam Goodheart.
 pages : illustrations ; cm
 Published to accompany an exhibition prepared by Terra Foundation for American Art in Chicago and Newberry Library, held at the Newberry Library from September 2013 to March 2014.
 Includes bibliographical references and index.
 ISBN 978-0-226-06185-6 (cloth : alkaline paper)
 ISBN 978-0-226-06574-8 (e-book) 1. Art, American—Northeastern States—19th century—Exhibitions.
2. Painting, American—Northeastern States—19th century—Exhibitions. 3. United States—History—Civil War, 1861–1865—Art and the war—Exhibitions.
4. Art, American—Northeastern States—19th century.
5. Painting, American—Northeastern States—19th century. 6. United States—History—Civil War, 1861–1865—Art and the war. I. Brownlee, Peter John, author. II. Burns, Sarah, author. III. Dillon, Diane, 1958–, author. IV. Greene, Daniel, 1973–, author. V. Stevens, Scott Manning, author. VI. Goodheart, Adam, writer of added commentary. VII. Terra Foundation for American Art, sponsoring body. VIII. Newberry Library, host institution.
 N6510.H57 2013
 704.9'499737—dc23
 2013000532

♾ This paper meets the requirements of ANSI/NISO Z39.48-1992 (Permanence of Paper).

Contents

Figures

Director's Foreword

This book and the exhibition it accompanies offer readers and visitors a new vista on an era whose sesquicentennial we are marking. Here for the first time we have an interdisciplinary examination of visual culture in the home fronts of the North during the American Civil War. The home front remains even now an understudied but key part of the Civil War's story, with unanswered questions about topics ranging from household economics and consumption to the relative absence of younger men. Pictorial materials shed revealing light on such matters, of course, as they do on the visual culture that both produced and was changed by them. Here, however, those objects are brought into intimate contact with other kinds of contemporary materials, many of them textual, which enlarge what we can know about the pictorial objects and lead to new dialogues among and between them.

None of this would have been possible without a fruitful collaboration between the Terra Foundation for American Art and the Newberry Library, two very different institutions bound by their shared interest in the humanities and the arts.

The Newberry has been fortunate to have such a fine partner as the Terra, with its deep commitment to fostering appreciation of American art, as well as its exceptional collection of paintings, prints, and other art objects. Over some years we have had generous financial support from the foundation for several projects. Its president, Elizabeth Glassman, has shown sustained interest in what our two institutions might do together on behalf of the greater Chicago community and beyond. This entire project would not have been possible without a very substantial grant from the foundation and the creative, scholarly insight of Terra associate curator Peter John Brownlee, who cocurated the exhibition with Newberry vice president for research and academic programs Daniel Greene.

A longstanding Newberry habit of collaborating with former Newberry Fellows is also in evidence here. Sarah Burns, professor emerita of fine arts at Indiana University, who held the Terra Foundation Fellowship in Art History at the Newberry in 2008–9, was the ideal contributor for this volume.

This project reflects the work of a wide array of Newberry staff, in research and academic programs, library services (especially conservation services and digital imaging services), public programs, and facilities. So we can truly say that it was an institution-wide effort. The materials highlighted in this book and the exhibi-

tion are drawn from Newberry collection strengths in American history and culture, American Indian and indigenous studies, Chicago and the Midwest, and maps, travel, and exploration. They include books and manuscripts in abundance but also magazines, newspapers, sheet music, maps, and ephemera. We are delighted that such materials can be brought into close conjunction with the Terra Foundation's paintings.

The exhibition on view at the Newberry from September 2013 to March 2014 is the largest initiative in Chicago to commemorate the Civil War's 150th anniversary. That public programs, a scholarly symposium, and professional development programs for Chicago-area teachers accompany the exhibition show how far a successful institutional partnership can reach. This book stands as permanent testimony to that partnership, and makes a notable contribution to scholarship by helping us understand how the Civil War transformed people's thinking, living, and seeing.

David Spadafora
President and Librarian
Newberry Library

Director's Foreword

More than 150 years after the Civil War began, its transformative power and lasting implications continue to reverberate in the cultural imagination. Through its unique focus on the art and visual culture of daily life on the Northern home front, this exhibition makes important contributions to our ongoing assessment of this seminal moment in American history.

Partnership and collaboration are central to how we study and exhibit works in the collection of the Terra Foundation for American Art, and our partnership with the Newberry Library in organizing this exhibition has been one of lively intellectual dialogue and collegial exchange. The exhibition has provided a wonderful opportunity to showcase the foundation's rich holdings of paintings from the Civil War period, contextualized by popular materials drawn from the Newberry's collections of maps, illustrated books and magazines, sheet music covers, and other ephemera. The exhibition and its catalog bring together the perspectives of an interdisciplinary team of specialists of art history, cultural history, and literature to advance scholarship on this crucial era in American history. We are particularly grateful to the book's contributors for their valuable new research and writing on paintings in the Terra collection. Moreover, by focusing on the experience of war from a distance, the catalog and exhibition point to the Civil War's broader national and international contexts, which reflect the foundation's mission to place the historical art of the United States on a global stage. This partnership also demonstrates another facet of the foundation's mission: in addition to the exhibition and catalog, a series of scholarly and public programs, including a symposium and workshops for area teachers, amplifies the exhibition's themes and extends the reach of the material to multiple audiences in multiple ways, in Chicago and beyond.

The exhibition and the sesquicentennial of the Civil War it commemorates also provide an opportunity to showcase the significant holdings of war-related material in Chicago archives and collections. For example, *The Civil War in Art: Teaching and Learning through Chicago Collections,* a new web-based resource featuring nearly 130 works of art from seven of the city's cultural organizations, connects students and teachers to the issues, events, and people of the era (http://www.civilwarinart.org). Organizations contributing art and content to this unique

online resource include the Art Institute of Chicago, Chicago History Museum, Chicago Park District, Chicago Public Library, DuSable Museum of African American History, Newberry Library, and the Terra Foundation for American Art. Jennifer Siegenthaler, Terra Foundation education program officer, orchestrated the project with assistance from Eleanore Neumann, former programs and communications associate, and Sara Jatcko, grants and collections intern. Historian Margaret Storey and art historian Mark Pohlad, both faculty members at DePaul University, served as consultants and writers.

At the Terra Foundation, thanks go to Elizabeth Kennedy, former curator of collection, who several years ago initiated this project in conversation with staff at the Newberry, and to the rest of the Terra staff who have supported the project. Special thanks are reserved for exhibition curators Daniel Greene, vice president for research and academic programs at the Newberry, and Peter John Brownlee, associate curator at the Terra Foundation, who have organized an excellent exhibition and a rich and multifaceted catalog.

We also wish to extend our thanks and appreciation to David Spadafora, president and librarian, and the entire staff of the Newberry for hosting this exhibition, and for their ongoing contribution to the cultural and intellectual life of Chicago. This book is a lasting testament to our pleasant and productive exchange.

Elizabeth Glassman
President and Chief Executive Officer
Terra Foundation for American Art

Foreword: Picturing War

ADAM GOODHEART

On April 20, 1861, thousands of Americans opened a sheet of newsprint and saw a national catastrophe unfold before their very eyes. Less than a week earlier, the small federal garrison holding Fort Sumter, in Charleston Harbor, had surrendered to a much larger Confederate force after a thirty-four-hour bombardment. Now, the latest issue of *Frank Leslie's Illustrated Newspaper* featured a gigantic, quadruple-folded woodcut illustration—measuring nearly two feet by three feet— that put subscribers in the middle of the action (fig. 1.).[1] In the engraving, artillery shells tore fiery streaks across the sky. Roiling smoke and flames poured from the stone citadel as if from an erupting volcano. Near the center of the image, the Stars and Stripes still waved proudly amid the onslaught. But readers of earlier newspaper reports would have known that it was destined to topple, its staff shattered by a rebel shell.[2]

That image in *Leslie's* was intended as reportage, not art; in a caption, the editors presented it as a piece of visual journalism, a picture "taken by our Special Artist" in the thick of the battle, not long before the Union troops' surrender.[3] Yet it still represented a profound innovation in the history of seeing.

The Civil War has often been referred to as the "second American revolution"— a moment that transformed American politics, culture, and experience in a myriad of ways.[4] Back at the beginning of America's first revolution, in April 1775, it had taken weeks or even months for the shots at Lexington to reverberate across the far-flung colonies and the mother country. Americans and Britons received the news by word of mouth or in the form of slow-arriving press dispatches, drably written and set in dreary columns of small print (fig. 2). The first American visual depictions of the battle—a set of amateurish copperplate engravings by a New Haven printer named Amos Doolittle—did not appear until December, and then only in an edition of a few hundred copies at most.[5]

By 1861, however, Americans did not simply read the news—they *saw* the news. Barely a decade earlier, the first issue of an American illustrated weekly had been published in Boston.[6] By the eve of the Civil War, numerous pictorial papers— most notably *Leslie's*, *Harper's Weekly*, and the *New York Illustrated News*—churned forth copies by the hundreds of thousands on their high-speed steam-powered presses.[7] (British papers, especially the *Illustrated London News*, also employed

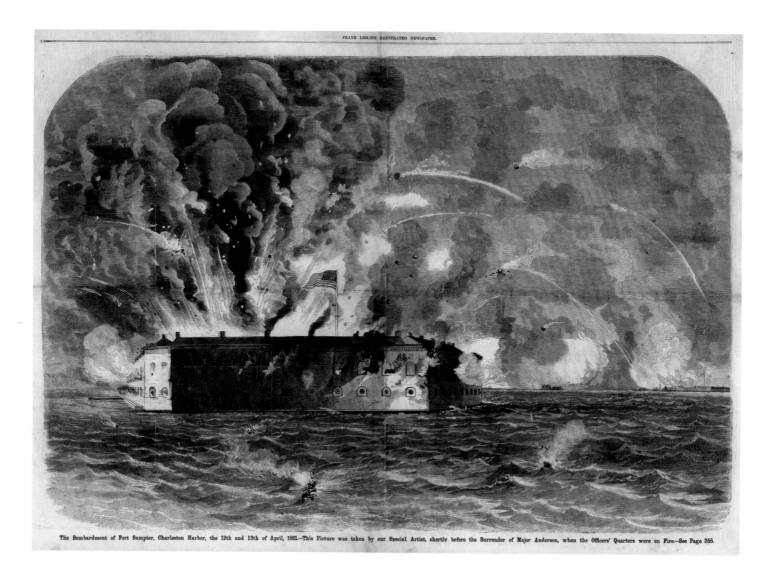

The Bombardment of Fort Sumpter, Charleston Harbor, the 12th and 13th of April, 1861.—This Picture was taken by our Special Artist, shortly before the Surrender of Major Anderson, when the Officers' Quarters were on Fire.—See Page 355.

FIG. 1.

"The Bombardment of Fort Sumpter [*sic*], Charleston Harbor, the 12th and 13th of April, 1861," *Frank Leslie's Illustrated Newspaper*, April 27, 1861. Magazine illustration, 33 × 22 in. Collection of Adam Goodheart.

American correspondents and circulated in the United States.) The pages of these periodicals were chockablock with large-scale, meticulously detailed depictions of militia parades and congressional debates; baseball games and cotillions; senators and society belles. Photography had brought a new standard of realism to visual culture, and although printing technology did not yet allow its accurate reproduction, editors were wont to boast in captions that a woodcut image was "taken from a photograph." Like daily newspapers (which were still largely devoid of illustrations), the pictorial weeklies competed for scoops, hurrying to press with the first public glimpses of an event or personage.[8] Artists' sketches were rushed to the publishing houses on trains and steamboats, telegraph lines carried descriptions of far-away events, and teams of draftsmen and engravers hastily melded these into pictures that just as quickly poured forth into the hands of readers throughout the Union.[9]

The result was that the 1861 attack on Fort Sumter marked the first time in history that citizens of the entire country could experience a great national trauma in unison: vividly and almost simultaneously. Today, we might think of it as Amer-

The PARTICULARS of what passed on the 19th of April, 1775, between a DETACHMENT of the KING's TROOPS in the PROVINCE of MASSACHUSETT's BAY, and several PARTIES of REBEL PROVINCIALS, as published, by Authority, in the LONDON GAZETTE.

General Gage having received intelligence of a large quantity of military stores being collected at Concord, for the avowed purpose of supplying a body of troops to act in opposition to his Majesty's Government, detached, on the 18th of April at night, the Grenadiers of his army, and the light infantry, under the command of Lieutenant Colonel Smith, of the 10th regiment, and Major Pitcairne of the Marines, with orders to destroy the said stores; and the next morning eight companies of the 4th, the same number of the 23d, and 49th, and some Marines, marched under the command of Lord Percy to support the other detachment.

Lieutenant Colonel Smith finding, after he had advanced some miles on his march, that the country had been alarmed by the firing of guns and ringing of bells, dispatched six companies of light infantry, in order to secure two bridges on different roads beyond Concord, who, upon their arrival at Lexington, found a body of the country people drawn up under arms on a green close to the road; and upon the King's troops marching up to them, in order to enquire the reason of their being so assembled, they went off in great confusion, and several guns were fired upon the King's troops from behind a stone wall, and also from the Meeting-house and other houses, by which one man was wounded, and Major Pitcairne's horse shot in two places. In consequence of this attack by the rebels, the troops returned the fire, and killed several of them; after which the detachment marched on to Concord, without any thing further happening, where they effected the purpose for which they were sent, having knocked off the trunnions of three pieces of iron ordnance, burnt some new gun carriages, and a great number of carriage wheels, and thrown into the river a considerable quantity of flour, gun-powder, musket balls, and other articles. Whilst this service was performing, great numbers of the rebels assembled in many parts, and a considerable body of them attacked the light infantry posted at one of the bridges; on which an action ensued, and some few were killed and wounded.

On the return of the troops from Concord, they were very much annoyed, and had several men killed and wounded, by the rebels firing from behind walls, ditches, trees, and other ambushes; but the Brigade, under the command of Lord Percy, having joined them at Lexington, with two pieces of cannon, the rebels were for a while dispersed; but as soon as the troops resumed their march, they began again to fire upon them from behind stone walls and houses, and kept up in that manner a scattering fire during the whole of their march of 15 miles, by which means several were killed

June, 1775.

and wounded; and such was the cruelty and barbarity of the rebels, that they scalped and cut off the ears of some of the wounded men who fell into their hands.

It is not known what number of the rebels were killed and wounded; but it is supposed that their loss was very considerable.

General Gage says, That too much praise cannot be given to Lord Percy, for his remarkable activity during the whole day, and that Lieutenant Colonel Smith and Major Pitcairne did every thing that men could do, as did all the Officers in general; and that the men behaved with their usual intrepidity.

Return of the Commission, Non-Commission Officers, Drummers, Rank and File, killed and wounded, prisoners and missing, on the 19th of April, 1775.

4th, or King's own regiment. Lieutenant Knight, killed. Lieutenant Gould, wounded and prisoner. Three Serjeants, one Drummer, wounded. Seven rank and file killed, 21 wounded, eight missing.

5th regiment. Lieutenant Thomas Baker, Lieutenant William Cox, Lieutenant Thomas Hawkshaw, wounded. Five rank and file killed, 13 wounded, one missing.

10th regiment. Lieutenant Colonel Francis Smith, Captain Lawrence Parsons, Lieutenant Wald. Kelly, Ensign Jeremiah Lester, wounded. One rank and file killed, 13 wounded, one missing.

18th regiment. One rank and file killed, four wounded, and one missing.

23d regiment. Lieutenant Colonel Bery Bernard wounded. Four rank and file killed, 26 wounded, six missing.

38th regiment. Lieutenant William Sutherland wounded. One Serjeant wounded. Four rank and file killed, eleven wounded.

43d regiment. Lieutenant Hull wounded and prisoner. Four rank and file killed, five wounded, two missing.

47th regiment. Lieut. Donald M'Cleod, Ensign Henry Baldwin, wounded. One Serjeant wounded. Five rank and file killed, 21 wounded.

52d regiment. One Serjeant missing. Three rank and file killed, two wounded.

59th regiment. Three rank and file killed, three wounded.

Marines, Capt. Souter, second Lieutenant M'Donald, wounded. Second Lieut. Isaac Potter, missing. One Serjeant killed, two wounded, one missing. One Drummer killed, 25 rank and file killed, 36 wounded, five missing.

T O T A L.

One Lieutenant killed. Two Lieutenant Colonels wounded. Two Captains wounded. Nine Lieutenants wounded. One Lieutenant missing.

U u Two

FIG. 2.

"The Particulars of What Passed on the 19th of April, 1775, between a Detachment of the King's Troops in the Province of Massachusett's Bay, and Several Parties of Rebel Provincials, as Published, by Authority, in the London Gazette," *Westminster Magazine*, June 1775, p. 329. Magazine article, 5 × 8 1/4 in. Collection of Adam Goodheart.

ica's—and indeed the world's—first Pearl Harbor moment, its first 9/11 moment. Taking a second look at that foldout woodcut from *Leslie's*, a twenty-first-century eye can find uncanny similarities to images of the World Trade Center emblazoned across the front pages of morning newspapers on September 12, 2001.

The shocking impact of visual and verbal news reports from Charleston—what Walter Benjamin in the twentieth century, speaking of the cinematic experience, would call "the sight of immediate reality"[10]—galvanized the North into united action, stoking military ardor and erasing political differences in a way totally unanticipated by the Confederate leaders who had ordered the attack. (Perhaps not coincidentally, antebellum Southerners had received little exposure to the illustrated weeklies, which were published in New York and Boston and reviled as

abolitionist propaganda below the Mason-Dixon Line.)[11] Thanks in large part to the rapid diffusion of words and images that new technologies afforded, the Confederacy's tactical victory at Sumter soon turned into a strategic disaster.

Throughout the war the pictorial press, consistently pro-Union, would continue both to inform and enflame the Northern public. In 1862, no less than Secretary of War Edwin Stanton thanked *Harper's Weekly* for its role in the war effort.[12] Indeed, although the photographs of Mathew Brady's studio and others have received the lion's share of attention in latter-day assessments of the war's visual culture, they played a merely supporting role at the time: without any technological means of reproducing them in large quantities, they were seen by few people beyond those who could visit Brady's showroom on Broadway. Despite the much-quoted 1862 *New York Times* article crediting Brady with having "brought bodies and laid them in our dooryards and along the streets," it was actually *Harper's, Leslie's,* and their ilk that laid the sights of war on Northern doorsteps and breakfast tables.[13]

Beginning in the very first days of the conflict, frontline soldiers were recruited to feed the public appetite for images of war. The same issue of *Leslie's* that contained the Sumter foldout also carried a front-page "Important Notice!" from the editor himself, offering to "pay liberally" any officer from either army who could supply "sketches of important events and striking incidents which may occur during the impending struggle."[14] In fact, even before the first shots were fired at Charleston, at least two of the nine Union officers inside Sumter were making sketches of the fort and selling them to *Harper's* for the handsome sum of twenty-five dollars apiece.[15]

So too, America's professional artists flocked to the colors—in more than one sense. Sanford Gifford, John Ferguson Weir, and others enlisted in the Union army in the first weeks of the war. At the beginning of May 1861, an illustrious assemblage of New York painters—including Eastman Johnson, John Frederick Kensett, Louis Lang, Asher Durand, and John William Casilear—gathered at Kensett and Lang's studio "to devise the best means of promoting the present patriotic movement in support of the government and the Union." Each resolved to begin by donating at least one painting to be sold in benefit of a new "Artists' Patriotic Fund."[16] Other painters, including Frederic Church, created visual propaganda on behalf of the war effort.[17] And some American artists joined the ranks of war correspondents streaming south toward the front lines—most notably the young Winslow Homer of *Harper's,* who had been contributing drawings to the illustrated weeklies since he was a teenager. His Civil War experiences would soon turn Homer into a painter, as well as inspire new ideas about race, American identity, and the nature of human experience that would remain essential to his work throughout his long and varied career.[18]

Images of war appeared not just on magazine pages and painters' canvases but also in a vast array of other formats, including lithographs and steel engravings, stereographs and magic lantern slides, decorative stationery and sheet music covers, parade banners and illuminated window displays, as well as high-tech visual

entertainments with a variety of fanciful names: *cyclorama, pantechnoptomon, automapictableau.* It is true that despite their creators' insistent claims of hyper-realism, most of these portrayals—and many in the illustrated weeklies—mixed large doses of fantasy into their reportage. "Those who draw their conceptions of the appearance of rebel soldiery from pictures in *Harper's Weekly,* would hardly recognize one on sight," one frontline newspaper correspondent complained.[19] Of course this did not lessen the powerful influence that such depictions exercised on the public imagination. Moreover, the sheer quantity of images was at least as significant as their quality. Many Americans—indeed, most people middle-aged and older—could remember a time when their only intermittent experiences with representational art came in the form of occasional crude book illustrations, family portraits, tavern signs, and the like. Now, even rural dwellers were subjected to what must have seemed a visual barrage.

Notably, this wartime explosion of imagery was largely a Union phenomenon.[20] The Northern states began the war with a disproportionate share of the nation's art academies, galleries, and publishing houses—not to mention with a culture less burdened by censorship and more concerned with enlightening and entertaining a large middle class.[21] In 1862, a Richmond publisher launched a Confederate version of *Harper's* and *Leslie's* called the *Southern Illustrated News,* whose early issues bore the masthead motto "Not a luxury, but a necessity." But the magazine never remotely rivaled its Northern counterparts, its illustrations consisting of clumsily executed cartoons and portraits of Confederate generals.[22]

Yet in the North, at least, the "second American revolution" was also a visual revolution. In the pictorial arts, as in other arenas, the Civil War was a moment when the medieval often seemed to brush up against the modern. Just as soldiers on the battlefield were fighting one another with swords while at the same time ducking shells fired by high-powered artillery pieces, similar odd juxtapositions were happening in the visual culture. Photo reportage as stark as anything from World War II existed alongside baroquely allegorical engravings that seemed to have been lifted straight out of sixteenth-century German printmaking.[23]

The result was a visual culture in which old symbols and tropes were constantly being redefined. Not only were Americans seeing new sights, they were also seeing old sights made new. Familiar referents like cotton bales, log fences, and baskets of autumn fruit could suddenly assume whole new wartime meanings—as readers of this volume will see.

Nowhere was this truer than in depictions of African Americans. Existing stereotypes began to be undermined almost from the moment the war began. In June 1861, *Leslie's*—which had traditionally evinced less of an antislavery leaning than *Harper's*—published a two-page spread of woodcuts showing escaped slaves fleeing toward the Union lines in Virginia. Far from portraying the fugitives as comical buffoons—the usual depiction of African Americans in the antebellum popular press—the engravers made them dignified and even valiant, with black men, women, and children boldly crossing a creek under a full moon before being welcomed by Northern soldiers into the safety of a Union fort.[24]

Such widely circulated images contributed to a rapid change in Northern whites' attitude toward African Americans. Instead of being seen as ignorant and childlike—or, perhaps worse yet, as the pernicious cause of the war—slaves and freed people could now be heroes. Yet the old stereotypes still persisted, sometimes even within the same visual frame as the more positive images. (See, for instance, fig. 18, "Morning Mustering of the Contraband," in the chapter entitled "The Fabric of War: Cotton, Commodities, and Contrabands" in this book.) Even in Homer's wartime prints and paintings, he vacillated between clownish stereotypes and more dignified portrayals. It was not until the war's end that he became a consistently sympathetic observer of the African American experience, and one who would create some of the most eloquent and nuanced statements about race in the canon of American art.[25]

"The Civil War . . . disturbed many things, but strange to say, it had less effect upon art than upon many things with more stable foundations," the Hudson River school painter Worthington Whittredge reflected some four decades later.[26] Perhaps this too was true in its way, at least for the New York academic circle to which Whittredge belonged. Unlike with both twentieth-century world wars, no major new schools of painting emerged from the crucible of the conflict.

And except for the work of a few painters like Homer (who remained on the fringe of the New York establishment), literal depictions of the war were uncommon in high art between 1861 and 1865, although many references can be found encoded in the familiar genres of landscape and historical painting.[27] It was only in the postbellum years that America's artistic elite began gradually to take stock of the war's meaning and legacy in a more explicit fashion. This may partly have had to do with the exigencies of the art market. An 1863 editorial in the *New York Herald* deplored the fact that "our most munificent patrons of art" showed no interest in purchasing paintings about the war.[28] The following year, two of Homer's scenes of camp life in the Army of the Potomac were admitted to the spring exhibition at the National Academy of Design but failed to sell; the artist's brother Charles secretly purchased them as an act of fraternal charity.[29]

Rather, the immediate changes wrought by the Civil War are to be found mostly in the broader, more democratic visual culture that is the subject of this book. Sheet music covers and cartoons, magazine woodcuts and popular lithographs, all reflected and simultaneously shaped the American public's rapidly shifting ideas about the war—and, in a larger sense, their evolving attitudes on race, community, family, and national identity.

"The present is a year productive of strange and surprising events," a newspaper editorialist wrote on July 4, 1861. "It is one prolific of revolution and abounding in great and startling novelties. . . . We are entering, to say the least, upon a new and important epoch in the history of the world."[30] Those strange events and startling novelties would only multiply during the four arduous years ahead. And today, when we look at Civil War images across the gulf of a century and a half, it is clear that those war years would prove to be an era not just of revolution, but also of revelation: the passing of timeworn realities and the intimation of things to come.

SARAH BURNS AND DANIEL GREENE

The Home at War, the War at Home

*The Visual Culture of
the Northern Home Front*

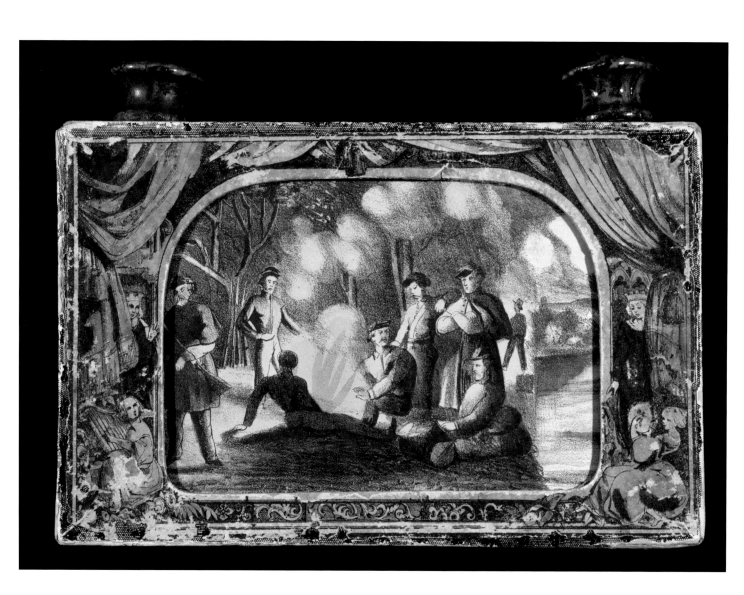

Not long after the end of the Civil War, game manufacturer Milton Bradley issued the Myriopticon, a miniature toy panorama that unrolled the history of the "Rebellion" in some twenty-two colorful pictures copied from illustrations that had appeared in *Harper's Weekly* magazine during wartime. The design of the foot-square cardboard box mimicked a proscenium stage draped in patriotic bunting. It came with play tickets, a mock advertising poster, and a script for the narrator, to be read aloud as he or she turned the cranks that scrolled from scene to scene. The instruction booklet recommended that the show take place in a darkened room with a candle to provide dramatic backlighting for the scenes as they glided by.

One young enthusiast wrote to tell Bradley that neighbors flocked to his house to enjoy multiple repeat performances of the show. The child wanted Bradley to sell more of the devices, so "as to make it less crowded in our parlor." So vividly authentic were the tableaux that an older brother who had been in the war "says it is just as your game represents it to be." The Myriopticon embodied the very theater of war itself, scaled down to a manageable size, commodified, and packaged as parlor entertainment. It stood witness to the ways in which the far-off conflict had infiltrated and changed daily life—even after it was over. It is difficult to imagine a more evocative representation of the war at home.[1]

Designed to replay the war over and over again, the Myriopticon enshrined and preserved its remembrance, which has lived on to this day. One hundred and fifty years after it began, the Civil War still occupies a prominent place in the national collective memory. Our cultural productions tend first to portray the war as a battle over the future of slavery, or to focus on Lincoln's determination to save the Union, or on brother fighting against brother. Battles and battlefields occupy us as well. Bull Run, Antietam, and Gettysburg all conjure up images of desolate landscapes strewn with war dead. Both North and South experienced unprecedented suffering. Forces for both sides described the war as a "harvest of death." Yet many depictions have neglected the war's influence on home fronts across the divided nation. Battlefields were not the only landscapes altered by the war. Soldiers were not the only ones who suffered. Countless individuals, whether near to the battle lines or far from them, saw their daily lives altered by the war.

While scholars in American history and literature have studied many different aspects of the Northern home front, art historians and museum curators have, with few exceptions, focused largely on the theater of war itself, as represented in media ranging from painting to photography and mass-circulated wood engravings in popular magazines.[2] Thus, powerful images such as Timothy O'Sullivan's *Harvest of Death*—a raw, grisly, and shocking photograph of corpses strewn about the Gettysburg battlefield—have become canonical and authoritative, as have paintings such as Winslow Homer's 1866 *Prisoners from the Front,* a now classic representation of Union triumph and Confederate defeat.

FIG. 3.
The Myriopticon:
A Historical Panorama; The
Rebellion, Springfield, MA:
Milton Bradley & Co., ca.
1866–70. Artifact, 5 5/8 ×
8 7/16 × 2 7/16 in. Newberry
Vault Case oversize
E468.7.M96 1890.

The fact that such images have acquired iconic status speaks to a nagging problem that has provoked debate since the 1860s. Writing in the latter days of the war, New York critic Clarence Cook puzzled over the fact that the war had exerted such a "very remote and trifling influence" on American art. Only a widely scattered few had pictured aspects of the conflict, but the "chief body" of American artists had "gone on painting landscapes and genre pieces and portraits as if the old peace had never been interrupted." Cook had no ready answer to this conundrum. In our own era, art historians have attributed that seeming escapism or elision to a "crisis" that boiled over when mechanized modern warfare starkly defied the capacity of traditional history painting to represent it: high ideals, theatrical posing, and noble self-sacrifice no longer seemed to fit the picture. While many artists whom Cook failed to credit did paint the leaders and battles of the war, only the pitiless stare of the photograph or Winslow Homer's deadpan gaze seemed capable of confronting the antiheroic realities of a brutal conflict with what now strike us as truly modern eyes.[3]

By contrast, *Home Front: Daily Life in the Civil War North* reveals another side of the war. This volume, companion to the exhibition mounted jointly by the Newberry Library and the Terra Foundation for American Art, is the first to comprehensively examine the visual culture of Civil War–era home fronts in the North. It asks whether those artists on the home front—those who, as Cook saw it, simply went on as before—sought only to avoid the awful truth by burying their heads in the sand of landscapes far removed from battle, or if they yearned only to take nostalgic refuge in scenes of ordinary American life that seemed to escape war's disruption. Avoidance of the war may have been the mode of some. But the war left its mark on many others, whose consciousness of the prolonged crisis impelled them to rethink and reshape conventional pictorial categories in ways that subtly or not-so-subtly referenced the war's haunting presence on home fronts rural and urban, far-flung and close by, domestic and institutional. Just as the war intertwined with political and economic networks, it did so with those of fine art and visual culture more generally of the Northern home front. Thus, paintings and other depictions that at first glance appear to have little or nothing to do with the war reveal on further inspection telltale traces of its shadow. Others allude to it outright but in the process betray tensions and ambiguities that hint at the war's heavy social and historical toll.

The essays collected here closely examine the mid-nineteenth-century American paintings that form the core of the exhibition. However, we also go much further, embedding these works in a dynamic visual context that illuminates, amplifies, and complicates their meanings and connotations. Frederic Church's 1861 painting *Our Banner in the Sky*, for example, is an allegorical landscape in which a smoldering red sunrise morphs into a dramatic vision of the American flag, waving in tatters over a dark and desolate wilderness. The trunk of a leafless tree serves as flagstaff; directly above it, an eagle soars. Spurred by the Confederate bombardment of Fort Sumter in April 1861 that had torn the Union flag to shreds,

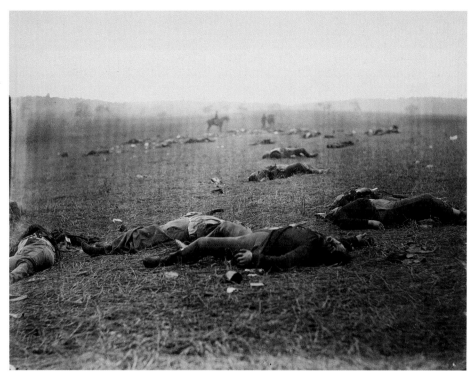

The Home at War,
the War at Home

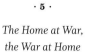

FIG. 4.
Timothy O'Sullivan, printed
by Alexander Gardner, *A
Harvest of Death, Gettysburg,
Pennsylvania, July 1863*, 1863.
Albumen print, 6 11/16
× 8 11/16 in. (17.3 × 22.4
cm). Gift of Mrs. Everett
Kovler, 1967.330.36, The
Art Institute of Chicago.
Photography © The Art
Institute of Chicago.

FIG. 5.
Winslow Homer (1836–
1910), *Prisoners from the
Front*, 1866. Oil on canvas, 24
× 38 in. (61 × 96.5 cm). Gift
of Mrs. Frank B. Porter, 1922,
22.207, The Metropolitan
Museum of Art, New York,
NY, U.S.A. Image copyright
© The Metropolitan
Museum of Art. Image
source: Art Resource, NY.

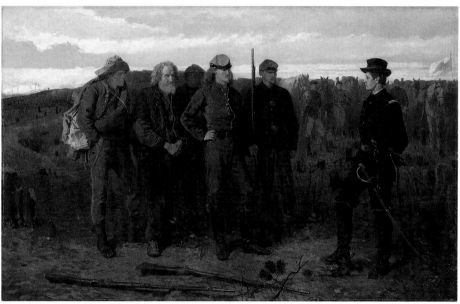

Church painted *Our Banner in the Sky* to stir patriotic fervor at the moment of na-
tional rupture, the dawn of war. Scholars have singled out this work as a classic il-
lustration of the ways in which Hudson River school painters used nature as vehi-
cle to communicate political, national, social, and religious messages in symbolic
terms. Not surprisingly, Church's work also has figured in discussions of Ameri-
can painters' attempts to address the crisis of the war in oblique and emblematic
language.[4]

One critically important visual matrix for *Our Banner in the Sky* has largely escaped attention, however. The New York branch of the publishing firm Goupil & Co. bought the copyright and produced a lithograph after Church's painting. Although few copies now survive, Goupil's recorded profit of $1,500 as of August 18, 1861—just four months after combat began—suggests that the print was extremely popular. Church's visionary imagery did not stand alone: viewers would have perceived it as a single coordinate in a visual landscape then so thoroughly blanketed by the patriotic image of the flag that it amounted to an epidemic of "flag mania."[5] Indeed, Goupil's rival, Sarony, Major, and Knapp, quickly issued *Our Heaven-Born Banner* after a painting by one William Bauly, who flagrantly parroted Church's flag and sky imagery, only replacing the bare tree with a Zouave sentry standing at attention with bayoneted rifle aloft; under the colors of the blazing firmament lies the stricken fort. Appended beneath the print were the first lines of Joseph Rodman Drake's "The American Flag," which declaimed the identical vision in stirring lines of verse:

When Freedom from her mountain height
Unfurled her standard to the air,
She tore the azure robe of night
And set the stars of glory there.
She mingled with its gorgeous dyes
The milky baldrick of the skies,
And striped its pure celestial white
With streakings of the morning light.[6]

In poetry and printmaking alike, conflating elevated landscape art with patriotic passion brought the war into many a Northern parlor.

The phenomenon extended well beyond the world of prints. Flag propaganda, often showing a soldier brandishing the banner in triumph, proliferated in newspapers, magazines, and broadsides as well—the message always one of hope and ultimate triumph even during the darkest days of the war. More ubiquitous still was the icon of the Union flag that adorned scores, perhaps hundreds, of sheet music covers with titles such as *Unfurl the Glorious Banner* or *The Bonnie Flag with the Stripes and Stars*. To reckon with *Our Banner in the Sky* in such a context—as opposed, say, to that of a landscape-painting exhibition, or a book on Civil War–era painting more generally—is to gain a different, richer understanding of its relevance, its immediacy, and its enormous appeal for the contemporary home-front audience in the North.

FIG. 7.
Sarony, Major & Knapp, lithographers (from painting by William Bauly), *Our Heaven-Born Banner*, 1861. Lithograph on wove paper, 9 15/16 × 12 23/32 in. (25.2 × 32.3 cm). Courtesy of Prints and Photographs Division, Library of Congress, LC-USZC4-12417.

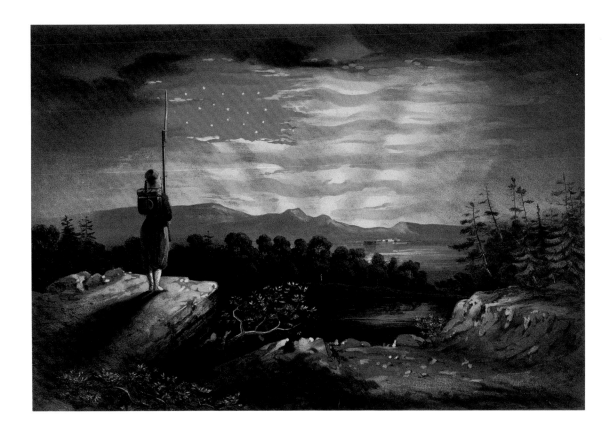

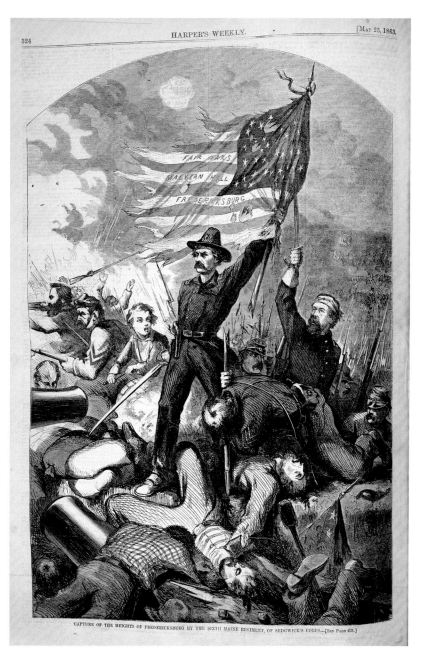

CAPTURE OF THE HEIGHTS OF FREDERICKSBURG BY THE SIXTH MAINE REGIMENT, OF SEDGWICK'S CORPS.—[SEE PAGE 633.]

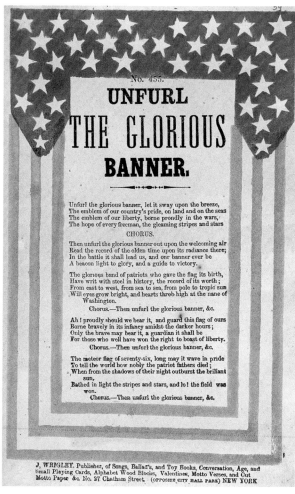

FIG. 8.
"Capture of the Heights of Fredericksburg by the Sixth Maine Regiment, of Sedgwick's Corps," *Harper's Weekly,* May 23, 1863, 16 × 10 1/2 in. Newberry folio A5.392 v. 7.

FIG. 9.
Unfurl the Glorious Banner, ca. 1861–65. Broadside, 8 1/2 × 5 1/2 in. Newberry Case Y274.17. No. 54.

As with Church's painting, the conjunction of both elite and popular home-front artifacts shapes both this book and the exhibition upon which it is based. Throughout, we juxtapose war-era paintings from the collection of the Terra Foundation with a wealth of material drawn from the Newberry Library's collection, including popular prints, illustrated newspapers, photographs, maps, magazines, sheet music, fashion plates, letters, diaries, advertisements, and other ephemera. This approach not only enriches our interpretation of the individual objects, but it also generates a fresh understanding of the ways in which the war per se—largely unseen here—so profoundly affected and infiltrated the lives of all who lived through it. With these pictorial and textual constellations, the essays take view-

ers behind the scenes, into the backstage of the war's theater and its aftermath. Together, they offer a vivid portrayal of the ways in which ordinary Northerners dealt with crisis and calamity, and—ultimately—strove for healing and renewal.

Given that thousands of books and scores of exhibitions have focused on the Civil War, the published visual record is correspondingly vast. Yet by and large, painting and popular visual culture remain segregated in different registers. For example, *Mine Eyes Have Seen the Glory: The Civil War in Art*, the magisterial 1993 survey by Harold Holzer and Mark E. Neely Jr., concentrates almost exclusively on paintings that represent every aspect of the war: generals, heroes, battles, domestic life, North and South. In *The Union Image: Popular Prints of the Civil War North* (2000), those same authors survey mass-market images—as the title alone makes

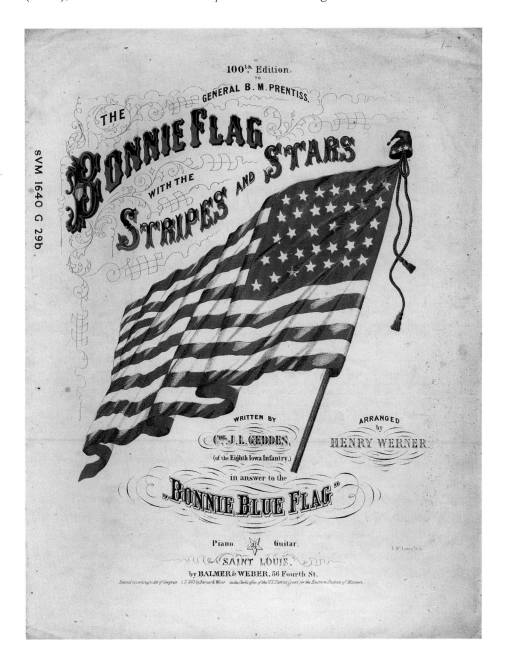

FIG. 10.
James Lorraine Geddes, *The Bonnie Flag with the Stripes and Stars*, Saint Louis: Balmer and Weber, 1863. Sheet music, 14 × 11 in. Newberry sheet music VM1640.G29b.

manifest. On that end of the visual spectrum as well is Alice Fahs's groundbreak-ing *The Imagined Civil War: Popular Literature North and South, 1861–1865* (2001), which reproduces an array of popular prints, illustrations, and cartoons, and re-minds readers that wartime visual culture did not evade but engaged with the realities of war. Fahs does not interpret these prints, illustrations, and cartoons as aesthetic objects in their own right, however, nor does she discuss contemporary paintings. Civil War photography also occupies its own niche as a specialized sub-field in the literature, from Alan Trachtenberg's now-classic "Albums of War: On Reading Civil War Photographs," originally published in *Representations* (1985), to William C. Davis's *The Civil War in Photographs* (2002).

This highly interdisciplinary book stands alone in assembling an array of ma-terials on pictorial aspects of the Civil War rarely if ever studied or interpreted in dialogue with each other. Seen together, they open a new window onto a world far removed from the horror of war and yet intimately bound to it. We explore the Northern Civil War home front through a number of lenses to ask, for example, how did the war influence household economies and management? What was its impact on production and consumption at home? How did those on the home front contribute to the war effort—or keep the war at bay? How did the absence of young men from the home or the presence of wounded veterans in public alter daily life? How did the war disrupt life on fronts remote from the centers of cul-tural production? Why were Indians on the frontier pushed out of nation's con-sciousness during the war years? What did wartime and immediate postwar de-pictions of landscapes communicate about the nation's past, present, and future? And finally—and most fundamentally—to what extent *did* the war transform the ways in which people lived, thought, and worked?

Art historian Peter John Brownlee's contribution traces the implications of wartime cotton trade in the artworks and other visual materials that came to represent it. Opening his essay with Samuel Colman's *Ships Unloading, New York* (fig. 11), Brownlee examines the complex visual culture that depicted cotton, slaves, and contraband to reference the radical social, political, and economic transformations at the heart of the conflict between North and South. Literary scholar Scott Stevens's essay studies traumatic events on the frontier, the Civil War's forgotten backcountry, where American Indians struggled to protect and defend their own home front, increasingly a place of lawlessness and danger in the face of land-hungry settlers. Using a rich array of illustrations, paintings, and photographs—including Eugene Benson's *Indian Attack* (fig. 26)—Stevens traces the course the Dakota War and the New Mexico Campaign to reveal their disas-trous consequences for Indian peoples. In recounting and analyzing that violent and tragic history, Stevens restores the Indian Wars to their rightful place in na-tional memory of the period from 1861 to 1865.

On another front, historian Daniel Greene writes on Chicago's deep connec-tions to the war, focusing on the flow of war-related goods, information, and relief through the city. In particular, he examines the work of the US Sanitary Commis-sion in Chicago, highlighting the gendered dimensions of war relief and detailing

the crucial roles played by such figures as E. W. Blatchford, Mary Livermore, and Jane Hoge, whose tireless travels from home front to battlefront and back underscore the physical and emotional bonds that linked those far-distant zones of action. Art historian Sarah Burns also considers the gendered dimensions of the home front during war in her analysis of Lilly Martin Spencer's *The Home of the Red, White, and Blue* (fig. 58), which celebrates but at the same time questions the agency of women in stitching together the tattered nation, symbolized by an American flag that lies in two pieces on the ground. Weaving Spencer's work into a constellation of related images, Burns discusses how visual culture responded to and represented women and their children—their lives, their work, their traumas, their activism, their patriotism—during and after the momentous war. Finally, art historian Diane Dillon explores the complex meanings of autumnal imagery on the Northern home front during the final years of the conflict and its immediate aftermath. Dillon considers a group of paintings—landscape and still life—that at first glance appear unrelated to the war. Her essay demonstrates that, despite appearances to the contrary, these works incorporate layers of public and private meaning that yoke them to the war and illuminate, once again, the war's capacity to twist and subtly alter even the most idyllic of genres.

Overall, the individual essays piece together a many-faceted mosaic that shifts between the broad view and the intimate glimpse, revisiting the massacre on the frontier as well as the middle-class Northern sewing circle, home-front relief efforts, and Union camps—another sort of home front behind the battle lines. Integrating art, history, and literature, as well as little known sources both visual and textual, this collaborative effort provides a platform for fresh thinking and revelatory narratives of the trials and traumas that defined and transformed the lives of ordinary Americans during those momentous years.

PETER JOHN BROWNLEE

The Fabric of War

Cotton, Commodities, and Contrabands

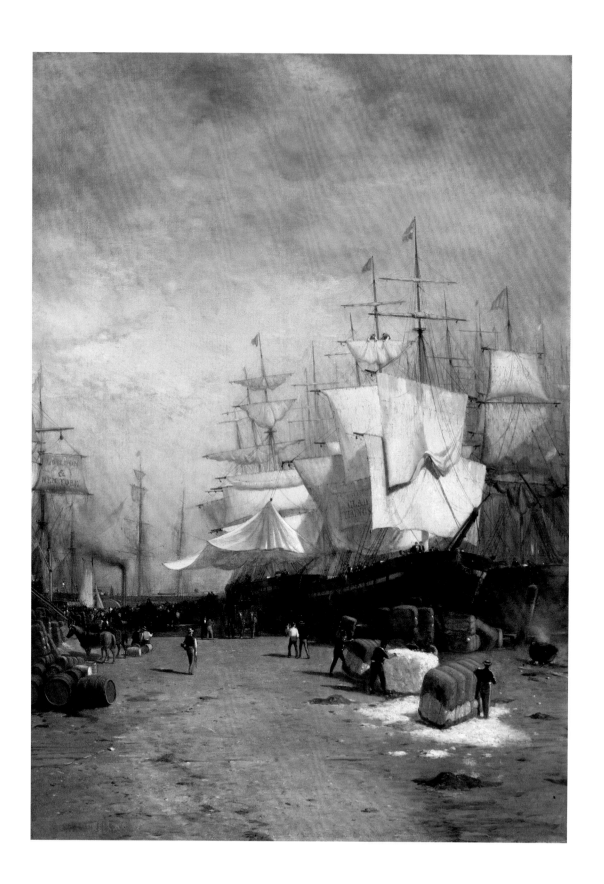

Cotton bales—one opened, two still wrapped—occupy the immediate foreground of Samuel Colman Jr.'s painting *Ships Unloading, New York.* The bleached whiteness of the billowing sails above makes light of the hulking, rectangular bales below and draws the viewer's gaze back to the wheelhouse and smokestack of the steamboat in the distance at left. From a single stack, dark exhaust wafts gently out of the frame. Colman demonstrated a penchant for painting ships during the mid to late 1860s, particularly depictions of vessels on the Hudson River and in the New York docks. With special focus on their rigging and the perspectival rendering of their hulls situated in the water, Colman's maritime pictures are precise documents, imbued with detail and invested with an active sense of their subjects' mobility. This portrait of the packet-boat *Glad Tidings,* nestled into one slip of a busy port, quietly discloses the vessel's participation in cotton's global trade. The intricate rigging of the ships repeats the grid pattern formed by the ropes containing the still-enclosed bales. It also alludes to and approximates the graphs and grids that filled nineteenth-century newspapers, pamphlets, periodicals, and maps charting the trade's elaborate network of ships, cargoes of cotton, and, of course, slaves. Indeed, throughout the 1850s and 1860s, these interrelated commodities were visually constituted through this dense web of interconnected signs and signifiers.

Built in New York in 1856, the ship was owned by William Nelson and Sons until 1867 and by William Nelson Jr. from 1868 to 1874. Colman may have been commissioned to paint the ship on the occasion of its passing from father to son in or around 1868. These may be the two figures stationed prominently upon the forecastle, in line with the opened bale. Early in its career, the *Glad Tidings* sailed between its home port and New Orleans for the Holmes Line. The ship's most important cargo on its return voyages would have been cotton, the mainstay of the South's slave economy and New York's most important export. On the left edge of the composition a banner suspended from the yard of an unseen vessel reads "London and New York," a reminder that through the port of New York the American South supplied the vast majority of raw cotton for the English textile industry.[1]

Filled with activity, yet calm in feeling, *Ships Unloading* is a study in contrasts. Facing away, as if looking back toward the two figures peering over the ship's prow, an agent idly leans against the foremost bale. A black worker, along with two white counterparts, tends to a second bale that has spilled open, while a single white worker wrestles with a third. Other bales clustered in the shadow below the ship's protruding bow await handling. By the time Colman painted this image, the *Glad Tidings* was not just any commercial vessel, but one long involved in the trade of "free labor" cotton, an agricultural model and economic practice best associated with Edward Atkinson, a cotton manufacturer and abolitionist-leaning free labor advocate from Boston. Throughout the war years, Atkinson advocated this approach to the crop's cultivation and harvest, a system he articulated most fully in his 1861 pamphlet *Cheap Cotton by Free Labor: By a Cotton Manufacturer.* In

FIG. 11.
Samuel Colman, *Ships Unloading, New York,* 1868. Oil on canvas mounted on board, 41 5/16 × 29 15/16 in. (105.0 × 76.0 cm). Terra Foundation for American Art, Chicago, Daniel J. Terra Collection, 1984.4.

it, Atkinson vigorously dismantled the widely held belief that cotton could only be raised in "sufficient quantity by the compulsory labor of the colored race."[2] Though cotton was already being profitably cultivated by free laborers in parts of Tennessee and Texas, in certain cotton-growing areas of the South captured and occupied by Union forces during the war—coastal South Carolina and areas of Mississippi and Louisiana among them—that compulsory labor was replaced by the "free" labor of fugitive slaves, first classified as "contrabands" of war in 1861 by Major General Benjamin Butler, commander of Union forces at Fortress Monroe in Hampton, Virginia.[3] Though resistance to this new form of "compulsory" labor was common, contrabands served as informants, servants, laborers, and eventually, soldiers. The redeployment of contraband laborers, Atkinson argued, would "crush rebellion at home by the most positive measures."[4] Indeed, their participation was instrumental in gradually exhausting the Confederacy's ability to prosecute the war. What Colman's painting does not picture but cannot help but to reference is the employment of free labor cotton as war tactic and the transformative, though complicated, reclassification of the labor force employed in its production. Though the painting also looks forward to the ascendancy of steam over sail, it frames a narrative in reverse, detailing how the cultivation and harvest of cotton, thought possible only with enslaved labor, was reengineered by free labor advocates and Union forces to defeat the Confederacy by co-opting the economic strength of both its labor power and its most valuable cash crop.

The interwoven story of contrabands and "free labor" cotton, central to the maritime career of the *Glad Tidings* and hinted at in Colman's placement of the black figure who handles the open bale, is confronted more directly in "Principle vs. Interest," an engraving published in the upstart and short-lived satirical magazine *Vanity Fair* in April 1861, the month the war began.[5] This image was drawn by Henry Louis Stephens—an illustrator and caricaturist who also contributed images to *Frank Leslie's* and *Harper's*—and carved in wood by the partners Albert Bobbett and Edward Hooper, English immigrants active in New York in the 1850s and 1860s. England's John Bull casts a sidelong glance at the seated Confederate president turned cotton broker, Jefferson Davis. With his back turned away from the dark figure emerging from the bale, it is clear that England's abolitionist "principles" will not preclude it from acting on its commercial "interests." "My colored brother," he says, "don't be irrepressible—the unhappy condition to which the oppressor has reduced you, enlists my warmest sympathy—but, then, really, one cannot know friends in trade." The contorted figure of the black man is emphasized in the contrast between his dark skin, inscribed through a dense thumbprint of engraved tints, and the whiteness of the bale, conveyed through the blank sheet of the page only interrupted here and there by lines strategically deployed to define its volumetric form. In an ironic twist, the very same commodity that served as the basis for this slave's bondage has provided the means for his liberation.

Though the cartoon takes aim at England's thorny relationship with Southern cotton, it also alludes to the story of Tom Wilson, a fugitive slave who escaped the South by concealing himself in similar fashion.[6] On the move, simultaneously a

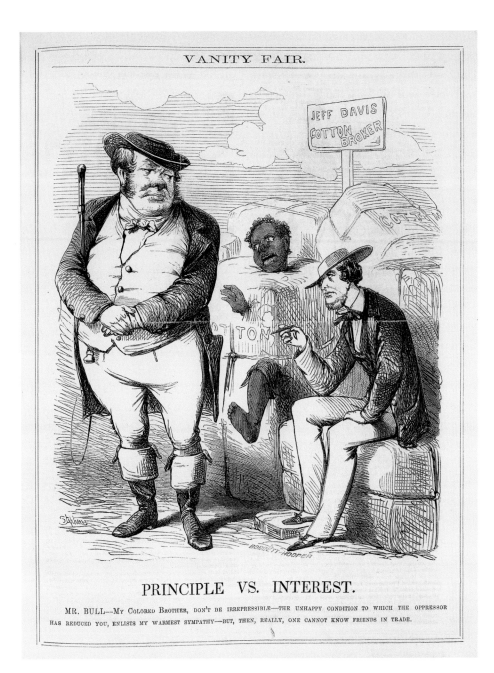

FIG. 12.
Albert Bobbett, Edward
Hooper, and Louis H.
Stephens, "Principle vs.
Interest," *Vanity Fair*, April 13,
1861. Magazine illustration,
11 1/2 × 8 7/8 in. Newberry
folio A5.93 v. 3.

stowaway in hiding, a commodity in transit, and a contraband of war, the cartoon's
Tom Wilson figure, like the black wage worker in *Ships Unloading*, symbolizes the
place of slave labor at or near the core of every bale. The fates of slaves and cotton, of course, had been long intertwined. But their relations assumed a new cast
as the status of each was radically reassigned by Union efforts to subdue the rebellion. For slaves turned contraband laborers who harvested cotton on captured
plantations across the South, the cultivation of the crop that once served as the
basis for their bondage became a means for their liberation and marked a point of
entry into the mixed race, wage system of free labor on display in the expansive
foreground of Colman's *Ships Unloading*.

These developments were documented with incredible alacrity and in great profusion in the wood engraved illustrations of popular periodicals such as *Frank Leslie's Illustrated Newspaper* and *Harper's*, magazines that evolved with the progress of the war itself. Built on the rapid transmission of often sensational or sensationalized news, *Leslie's* found its footing with its coverage of John Brown's Harper's Ferry raid in 1859. With a circulation nearing two hundred thousand in 1860 and a staff of editors, artists, engravers, and writers numbering over one hundred, the weekly fed its audience's insatiable desire for illustrated reportage. While its editorial outlook trended Union in its politics, *Leslie's* covered all aspects of the war, from the distant battlefield to the altered cultural landscape back home.[7] The illustrated weeklies in which these engravings appeared provided many readers in the North with their only point of access to slaves and cotton in its raw or baled state. Such illustrations traced for their audiences the slave's trajectory from bondage to freedom, and the transformation of cotton, once the Confederacy's unassailable strength, into a strategic weapon turned against it. This redefinition essentially inverted the prewar cotton economy, as the Union seized planters' profits from the cotton trade and converted the commodity of their slave labor into a pro-Union force deployed against the Confederacy. The success of experiments in free labor cotton and the raising of black troops, first in the Sea Islands of South Carolina and later elsewhere, were pivotal developments in the larger strategic and cultural shift from a war to maintain the Union to a war to end slavery. These actions, along with the Confiscation Act of 1861, the Emancipation Proclamation of 1863, and the various forms of resistance exercised by slaves themselves, redefined the status of enslaved African Americans and reconfigured the cotton economy with implications for local, national, and global markets.

Beyond the probing, topical subject matter of such illustrations, the graphic techniques utilized in creating them, particularly those employed to delineate dark skin and light cotton, tended to emphasize rather than elide the intensely schematic ways in which these and other forms were commonly rendered. Actually, the depiction of "white" cotton and "black" bodies enacts one of the most fundamental principles and manual operations of wood engraving, which is based on the manipulation of tonal relationships ranging between the white of the page and the black of the ink. In his *Treatise on Wood Engraving* (1839), John Jackson stressed the importance of every line in delineating forms:

> The proper use of lines of various kinds as applied to the execution of woodcuts is a most important consideration to the engraver, as upon their proper application all indications of form, texture, and conventional colour entirely depend. Lines are not to be introduced merely as such,—to display the mechanical skill of the engraver; they ought to be the signs of an artistic meaning, and be judged of accordingly as they serve to express it with feeling and correctness.[8]

In practice, engravers intentionally applied lines, tints, and shades as "signs of artistic meaning" to give their subjects "form, texture, and conventional colour."

Along with giving two-dimensional definition to representations of a three-dimensional world, these techniques structured and determined the visual articulation of the ever-fluid categories of "black" and "white," which prior to the war often served as shorthand for slave and free. Within the context of the upheavals wrought by the Civil War, these marks on the page structurally index the transitional status of cotton and contrabands transformed by the Union's three-pronged strategy to seize slaves as contrabands of war, cultivate cotton from captured plantations, and implement an effective blockade of Southern ports.[9]

The ability of the engraver's use of lines to convey information with "feeling and correctness"—the density of baled cotton, say, or the depth of a figure's dark complexion—assumed new meaning as the war dragged on. Embraced by the popular press to convey old and new forms of information both textually and visually, such techniques were also adapted as the constituent parts of thematic or statistical maps, a revolutionary new mode of cartography that emerged in France in the 1840s and in the United States in the following decade. Capitalizing on the availability of raw data collected by the US Census Bureau and the Coast Survey, thematic maps evolved rapidly to convey ever-increasing amounts of complex information in easily understandable terms. In the process, the indexical character of lines, tints, shading, and shadow became paramount in popular cartoons and statistical maps alike.[10]

Although slave labor had been a component of American agriculture since the colonial era, the rise of cotton in the American economy had been swift. It took just half a century following the advent of Eli Whitney's famed cotton gin for this highly prized crop to become "king." By its peak in 1860, "King Cotton" dominated world markets. The Cotton Belt that sourced this highly valuable cash crop stretched east to west from the Carolinas to West Texas, and north and south along the Mississippi River, as is illustrated in the vibrantly colored *Norman's Chart of the Lower Mississippi*. Drawn by Marie Adrien Persac and published by B. M. Norman in 1858, this exquisite and mammoth-sized statistical map was engraved, printed, and mounted by J. M. Colton & Co. of New York, a firm that would produce important maps during the Civil War. Measuring nearly six feet long, it employs the cartographic techniques of thematic mapping that emerged in the decade leading up to the war to deliver increasingly complex combinations of information regarding population density, agricultural output, and climatic conditions. In brightly color coded bands, this thematic map demarcates cotton and sugar plantations along the ribbon of river stretching from Natchez, Mississippi, to New Orleans, some of the most fertile land in the South, made even more productive and valued by easy access to river transportation. Framed by an ornamental border of interweaving vines and blooming flowers, the map includes an elaborate legend that demarcates cotton plantations in blue and pink and sugar plantations in yellow and green as well as nearby creeks and bayous, rivers, lakes, canals, and railroads.

Four carefully elaborated vignettes delineate key points along the river's winding route in decidedly more conventional terms to anchor the map's complicated color coding. In two entirely different registers the map depicts the places of

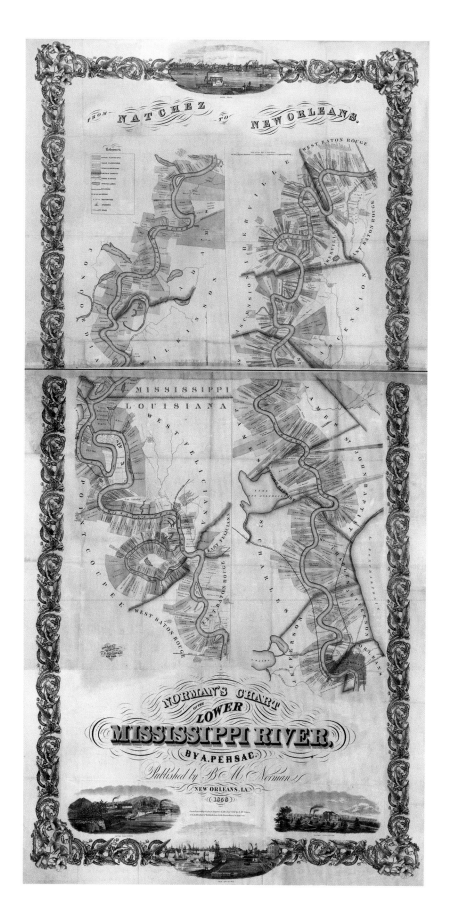

FIG. 13.
Marie Adrien Persac,
Norman's Chart of the Lower Mississippi River, 1858.
Map, 64 13/16 × 26 7/16 in.
The Arthur Holzheimer
Collection.

cotton cultivation and the various modes of its processing and distribution. However, aside from the density of colors signaling volume of output, both registers largely omit references to the labor responsible for moving the crop from field to port. At top center, the first vignette pictures the stretch of Baton Rouge's famed riverfront between the "Pentagon Barracks" of the fort and arsenal at left to the Old State House at right. A sugar plantation anchors the composition at bottom right and is flanked by a cotton plantation at bottom left. Between them sits the port at New Orleans, the receptacle for their yield and the centralized point of dissemination to global markets. A few figures, clearly coded as white, saunter or ride in carriages along the otherwise empty quay. Cotton bales ready for shipment, each comprising four hundred pounds of ginned or processed cotton, are pictured here and in the plantation scene. The instruments for the production of these bales are referenced in the manufactory-like structures and substantial landings seen on the plantation's riverfront. Here, a few diminutive yet darker figures maneuver bales toward the riverside for loading. Easily lost among the map's many details, these miniscule figures are the only representation in *Norman's Chart* of the scores of slaves who harvested, hauled, and processed the crop. Their growing numbers throughout the decade leading up to the start of the Civil War, documented in census records, lend the grand chart, which approximates the height of a productive field hand, its absent cause.[11]

In each census during the antebellum period, slaves made up at least 45 percent of Louisiana's total population, and more than 60 percent of the population outside of New Orleans. Slave concentrations were highest along the Mississippi River, with the majority of the state's slave population concentrated in parishes and plantations nearest its waterways.[12] While not home to a large slave population, New Orleans did contain the South's largest interstate slave market, where slaves from the Upper South were sold to the cotton fields of the Deep South. Thus it served as a clearinghouse for the dissemination of both cotton and slave labor in great profusion. Indeed, between 1840 and 1860 Louisiana's annual cotton crop rose from about 375,000 bales to nearly 800,000 bales, a statistic represented in the darkly shaded areas of this and other statistical maps of the period. In 1860 Louisiana produced nearly one-sixth of all cotton grown in the United States and almost one-third of all cotton exported from the United States, most of which went

FIG. 14.
Marie Adrien Persac,
*Norman's Chart of the Lower
Mississippi River*, 1858.
Map, 64 13/16 × 26 7/16 in.
The Arthur Holzheimer
Collection. Detail.

to Britain and France via ports in New York or the Caribbean. The dependence of these two industrialized nations on Southern cotton was driven by their industrial efforts to keep pace with demand for its manifold products.

The textile industry centered in the United States in the New England mills of Lowell, Massachusetts, and in the industrialized cities of Manchester and Lancashire in England transformed ginned cotton into threads and fabrics that supplied an ever-expanding global market. In an article published in 1850, H. C. Carey called cotton "the weed of the world," and estimated its average consumption in the United States alone at "not less than thirteen," or "most probably fifteen pounds per head."[13] Between 1826 and 1860, 70 percent of cotton textiles made in the United States were produced in the mills of New England. Although American-made fabrics tended to be simpler in design than those manufactured in British factories, US factories tended to use higher quality cotton, on average, than their counterparts across the Atlantic. Exportation of American-made plain cotton cloth began in the 1820s and peaked in the early 1850s but only represented 10 percent of the nation's output of cotton fabric. As Britain began to import more of its cotton from the American South—up to 88 percent of its total import by 1860—British output far exceeded that of the United States, exporting nearly two-thirds of its yield annually.[14] Thus demand for Southern cotton, along with the corresponding price of slaves necessary for its cultivation, peaked just as hostilities erupted between the Union and the Southern states that seceded following the election of Abraham Lincoln. The dominance of Southern cotton in the global marketplace bolstered the Confederacy's resolve on the assurance that England and France, the South's primary markets, would intervene on its behalf.[15]

The international reach of Southern cotton was in part due to the wide array of its applications and its general utility for consumers. The fiber, in its refined state, had a range of uses, from quilt batting to postsurgical medical bandaging to the wadding cloth used inside of firearms. "Combining the luster of silk with the strength of linen," one advertisement ran, spool cotton was used to make "superior" sewing thread.[16] Cotton was also used in carpet chain and in the production of rugs and lamp wicks. Cheap, lower-grade cotton fabrics were often utilized for inexpensive clothing while lighter-weight fabrics made from finer cotton were used for summer clothing or men's shirting. Undergarments, children's clothing, bedcovers, quilt fabric, and sewing threads were all comprised of the fiber. Even the canvas sails of the ships that conveyed the commodity across the Atlantic and beyond were woven from cotton threads, which replaced linen in the early nineteenth century due to its lightness and easy availability.

As the war progressed, cotton found a number of new uses even more directly involved in its prosecution. In patriotic support of the Union soldiers now deployed, Northern women gathered to stitch havelock head coverings from pieces of cotton fabric. However impractical they proved in the field, these patches of cloth were intended to extend the protective relief of home, symbolized by this domestic product, to the exposed heads and necks of Union troops in faraway theaters (see fig. 62). In the South, cotton was deployed as a protective fortifi-

Peter John Brownlee

cation of much greater density. The *Maine Farmer* reported in August 1863 that the Confederate-occupied Fort Sumter was completely clad with bales of cotton, "bound round with sheet iron, which the rebels say render it impregnable to shot and shell, but this remains to be seen."[17] Cotton bales also were applied to insulate the hulls of steam and sail vessels against enemy fire. These vessels, known as "cotton-clads," were typically used as ramming devices in river warfare. Though its absorptive properties helped Confederate hulls bear the brunt of assaults levied by Union guns, cotton was extremely flammable, and thus subject to combustion. But its "combustibility" derived not only from its propensity to burn. Capital and labor intensive, the cotton trade was precariously erected on shaky economic foundations. As the prices of cotton and slaves peaked around 1860, so too did this powerful commodity's volatility.

While cartoons published in *Vanity Fair* and elsewhere probed sensitive topics related to the racial politics of the trade in slaves and cotton, other individuals worked to document and analyze the cotton economy at closer range. During the 1850s, Frederick Law Olmsted, who in the next decade would achieve prominence as designer of Manhattan's Central Park and Brooklyn's Prospect Park, traveled throughout the Southern states to document living and working conditions in an effort to measure the productivity of agricultural slave labor. Commissioned by Henry Raymond, editor for the *New-York Daily Times* (later the *New York Times*), Olmsted's journey would take him through Virginia, the Carolinas, and across the Cotton Belt to Texas. He published his findings in a series of three volumes subsequently condensed into *Journeys and Explorations in the Cotton Kingdom*, which appeared in 1861. With the aim of convincing Great Britain and other would-be allies of the Confederacy that slavery was not worth fighting for, Olmsted described various aspects of the landscape of cotton cultivation in extensive detail, noting in particular the South's decrepit infrastructure, which ran counter to its boastful claims of economic stability and global power.[18]

Behind the rhetoric of proponents like South Carolina Senator James Hammond, who trumpeted cotton's unassailability in his famed "King Cotton" speech of 1858, lay a differently reality. Decades of minimal investment in much beyond land and slaves for cotton cultivation had left the South in poor shape, and not at all prepared for war. Olmsted wrote:

> Coming directly from my farm in New York to Eastern Virginia, I was satisfied, after a few weeks' observation, that the [sic] most of the people lived very poorly; that the proportion of men improving their condition was much less than in any Northern community; and that the natural resources of the land were strangely unused, or were used with poor economy.[19]

This same condition was decried by James Dunwoody Brownson DeBow, the publisher and statistician best known for his influential magazine *DeBow's Review*. DeBow, who served as the head of the US Census from 1853 to 1857, charted King Cotton's rise during the 1850s. But he pointed to a crescendo that spelled doom for

a Southern economy based solely on cotton production. Counter to a vocal majority of Southern planters and brokers, DeBow championed diversifying the Southern economy as a measure against Northern economic power and influence in the region. He warned, "Whenever cotton rises to ten cents, labor, i.e. the price of slaves, becomes too dear to increase production rapidly."[20] King Cotton was built on the labor of slaves, and the profit to be made from its cultivation depended on the fluctuating price of their labor. As the price of cotton rose steadily through the 1850s, so too did the labor cost, thus negating or at least diminishing the profit margin that rising prices fetched.

Early in his text, Olmsted underscored the essential valuation of a slave's labor in language that emphasizes his tendency toward classification and quantification:

> I soon perceived that labor was much more readily classified and measured with reference to its quality than at the North. The limit of measure I found to be the ordinary day's work of a "prime field-hand," and a prime field-hand, I found universally understood to mean, not a man who would split two cords of wood, or cradle two acres of grain in a day, but a man for whom a "trader" would give a thousand dollars, or more, to take on South, for sale to a cotton planter . . . he was viewed, for the time, from the trader's point of view, or, as if the question were— What is he worth for cotton?[21]

In exact ratios, slave owners calculated the amount of cotton that one slave might pick in an "ordinary day's" work. Atkinson estimated the standard value for a field hand at one hundred dollars for each cent per pound of the price of cotton, while the price each for other slaves on a plantation was typically one-half the field hand's value.[22] But against this value, Atkinson calculated the costs of buying and caring for a slave. Atkinson, himself a successful manufacturer in the cotton trade, was guided as much by his instincts for business as he was by free labor politics. In his article "Is Cotton Our King?," Atkinson estimated the cost of purchasing one hundred slaves, including men, women, and children, at $500 each, thus equaling $50,000. Maintaining those one hundred slaves per year, including interest; allowance for life insurance; an overseer's wages, houses, and provisions; doctors' fees, hospitals, and medicine; renewal and repairs of Negro quarters; clothing and food at one dollar per week for each slave amounted to roughly $12,700. Atkinson extended this point further, and more graphically, in a statistical map he produced a few years later, *The Cotton Kingdom*.

Along with mapping the productivity and climatic conditions of various cotton rich regions of the Southern states, the texts and tables bordering the map itself document concentrations of slaves per square mile, the output of their labor, and the output of their free labor counterparts. Wandering lines, solid and broken, mark growing regions and climatic zones as they disperse viewers' gazes over the map's entire surface. Squat stacks of horizontally incised lines punctuate the meandering lines, denoting the output volume of various regions in relation to the number of slaves. With the outbreak of Civil War, the cotton system's checks

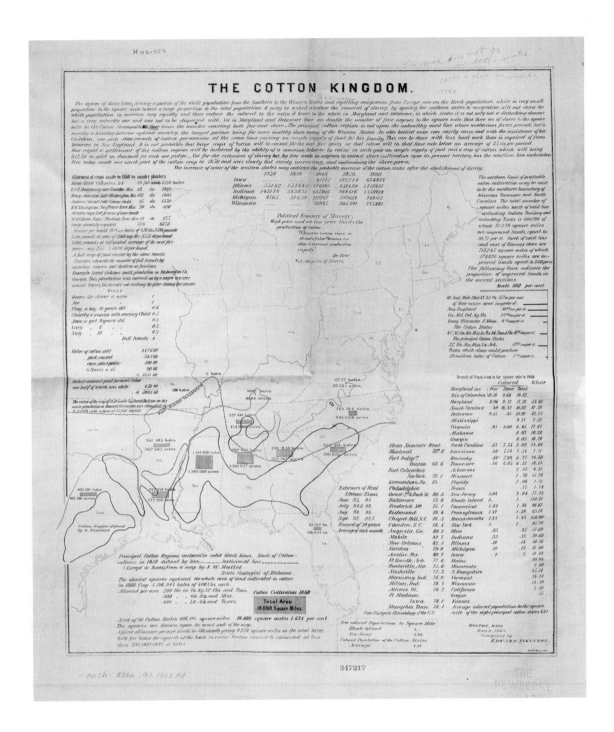

and balances that Atkinson's map analyzes began to collapse more rapidly as the South's capacity to distribute its cash crop was diminished and the economic relation between slave and free labor was irrecoverably altered by war.

On April 27, 1861, President Lincoln issued a proclamation establishing a blockade of the ports of the states of South Carolina, Georgia, Florida, Alabama, Louisiana, Mississippi, and Texas. Monitoring the Gulf and Atlantic coasts, the blockade was intended to prevent the passage of trade, goods, supplies, and arms to and from the Confederacy. The stranglehold the blockade would eventually exercise

FIG. 15.
Edward Atkinson, *The Cotton Kingdom*, Boston, March 1863. Map, 21 1/4 × 17 1/2 in. Newberry H42.052.

on Southern ports is captured in *Scott's Great Snake* published by J. B. Elliott of Cincinnati in 1861. With its tail wrapped tightly around the Union flag marking Washington, DC, the serpent, an analogue for General Winfield Scott's so-called Anaconda Plan, sought to constrict and starve the South. Even as early as 1861, South Carolina is identified with contrabands, while within the borders of Louisiana, stick figures stand beside cotton bales that they "can't ship now." The serpentine form of Scott's anaconda recalls the river's twisting route depicted in *Norman's Chart* and echoes the wandering lines of Atkinson's map. It is striking to note that within four years of the publication of *Norman's Chart*, Union forces occupied both Baton Rouge and New Orleans, and the flow of cotton down the Mississippi River was either heavily constricted or cut off altogether. As the combined result of the blockade and the absence of overseers and slaves to harvest staple crops, cotton production dropped drastically as the war dragged on: while four and a half million bales were grown in 1861, only one and a half million bales were produced the following year. By 1863 that number was again cut in half, with the overall trade reduced to a mere three hundred thousand bales during 1864.

In spite of the extensive smuggling efforts of Confederate blockade-runners and privateers during the war, the blockade disrupted most aspects of Southern trade, which brought about shortages of food, consumer goods, and the weapons and ammunition needed to prosecute the war.[23] As Olmsted and others lamented, the investment in slaves and land for the cultivation of cotton had shortchanged investments in infrastructure and the means for mass production. It also precluded the cultivation of much needed crops such as wheat, grain, and corn

that would sustain the Confederacy now cut off from its suppliers. This affected the South's capacity to provide for its own material needs and necessitated its dependence on trade for basic subsistence. This situation was exacerbated as slave owners and overseers departed to join the Confederate ranks and as slaves themselves fled in substantial numbers. Clearly, the Union had struck a decisive economic blow at the heart of the Southern home front.

The plight of the so-called Infant Confederacy, the combined result of cash crop agriculture, shortsighted economic policies, and the effects of the Union blockade and slave resistance, is graphically imagined in a cartoon published in *Yankee Notions* in March 1862. Here a rotund yet menacing slave "mammy" attends to an emaciated baby lying on a cotton bale. Swathed in a blanket labeled "Confederacy," the frail infant holds an empty spoon, or perhaps the handle of an unused bullwhip, its symbolic power and strength sapped by the absence of white control and the unsustainability of a home economy dependent on the importation of foodstuffs and manufactured goods. With no one to watch the kitchen,

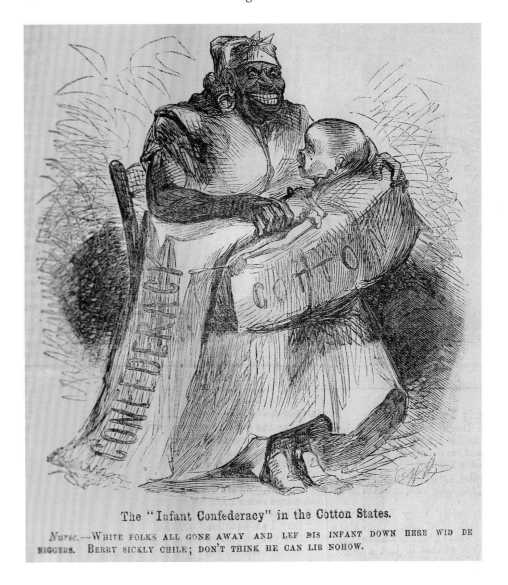

The " Infant Confederacy" in the Cotton States.

Nurse.—White folks all gone away and lef dis infant down here wid de niggers. Berry sickly chile; don't think he can lib nohow.

this slave, rendered in brutishly masculine terms, appears quite healthy while the baby wastes away on a bale of cotton. The nurse's knowing grin suggests that the Confederacy cannot properly nourish its "berry sickly chile" without her help. In the absence of oversight, however, it seems more likely that she will opt instead to steal away amid the chaos of the war, hinted at by the prominence of her walking shoes jutting out from below her dress and in the fission-like scribbles that activate the far left and right of the plate. Hemmed in by the Federal blockade, the feeble, "infant" Confederacy was relatively easy to contain, its single-crop mentality easy to bottle up. However, suddenly "uncontained" in the absence of masters and overseers, the peculiar institution was upended when slaves began to simply walk away from their bondage.

With the South's men increasingly drawn into the fight and away from their homes, farms, and plantations, and with King Cotton significantly weakened, the US government began to move in on the Confederacy's last great resource: its enslaved peoples. In fact, emancipation commenced with the firing on Fort Sumter. As slave owners and overseers went off to fight, slaves across the South, particularly in those areas animated by the military buildup of Unions and Confederates, sensed and tested the already loosened restraints on their bondage. In the absence of oversight, slaves increasingly exercised resistance to their overseers and began fleeing plantations and farms in growing numbers. The structures of power that for so long had held the slavery system in place disintegrated as the Confederacy turned its attention to waging war. As African Americans near active theaters of war fled to seek the protection of Union troops they were reclassified by a system already accustomed to thinking of them as commodities.

The first use of the term "contraband" occurred in the famed deliberations of Benjamin Butler at Fortress Monroe in Hampton, Virginia.[24] Far removed from the Cotton Belt, it was a place where slaves, often bound for cotton-growing regions in the Deep South, had their highest export value. The first three slaves to seek asylum within the Union-held fort were hands on a nearby farm. As Butler soon discovered, they had been tasked with building Confederate fortifications. Often male slaves were impressed into the service of the rebellion, while their wives and children were sent south, away from the frontlines. In Butler's words, "as a military question it would seem to be a measure of necessity to deprive their masters of their services."[25] But as he and others in similar positions would soon find out, there were many questions raised by their presence behind Union lines. Soon, hundreds then thousands of slaves left their homes to join the encampments growing within and without the fort. Such Union strongholds became immediate targets; in fact, anywhere Union troops were stationed in any significant numbers, slaves fled bondage to seek their protection. In Cairo, Illinois, in eastern portions of Kansas and Arkansas, in areas along the Mississippi River, in Washington, DC, and elsewhere, contrabands clustered and assumed new status as the confiscated "property" of the enemy. These growing populations were either mobile, if their liberators were on the march, or sedentary if their liberators were encamped or ensconced within fortifications, captured or otherwise.

In these liminal spaces between slavery and freedom, contrabands performed a number of important roles that helped national leaders see the possibility of manumission and even eventual citizenship for freedmen. These developments also encouraged discussion of colonization and other "solutions" to the problem of freed people.[26] But as is well told, the evolution of Lincoln's thinking on the questions of slavery and emancipation was quite gradual. A bitingly satirical article published in the June 1863 issue of the *Old Guard* titled "Lincoln's Negro Scale" took aim at the evolution of Lincoln's policy toward slavery and the status of African Americans.

> No one can say that the Negro is not a progressive race in Mr. Lincoln's mind. He styled them:
>
> In 1859, "negroes;"
> In 1860, "colored men;"
> In 1861, "intelligent contrabands;"
> In 1862, "free Americans of African descent."
>
> Next they will be "my beloved brethren," and, and notwithstanding all this, the Negroes and Abolitionists are guilty of the ingratitude of putting Lincoln's nose out of joint, by expressing their preference for Fred. Douglass for the next President.[27]

Charting a full spectrum of racial and political identities, this lampoon of Lincoln's evolving thought reflects the equally rapid transformation of the status, activity, and agency of African Americans collected and commandeered as contrabands. Indeed, Union forces quickly capitalized on this ready labor force eager to strengthen its tenuous hold on an uncertain freedom.

Initially, the Union employed contrabands in a manner similar to that of their former owners. "The older make capital servants, hospital help, and laborers," wrote *The Independent* reporting on developments at Fortress Monroe in August 1861. "So far from being idle," the reporter continued, "the Sergeant who is detailed as their superintendent says that 'fifty of them will do more work in a day than a hundred of the white men he used to have.'"[28] Fifty or so are depicted in this illustration from *Frank Leslie's* as they march out from the fort for a day's work under the watchful eyes of the mounted Union officers who serve as their overseers. As suggested by the implements they proudly carry, contrabands provided the menial labor for digging ditches and latrines, and for burying the dead. The disorderly progress of this motley assortment is further conveyed through their bowed legs, slovenly postures, and ragtag outfits. Absent are the straight, uniform lines of the tightly knit columns of marching soldiers seen in other images with which this cartoon would have been juxtaposed in the popular press. But the railway path along which they march, bordered by cannon on one side and mounted officers on the other, speaks to the vigorous channeling of their efforts. The train tracks

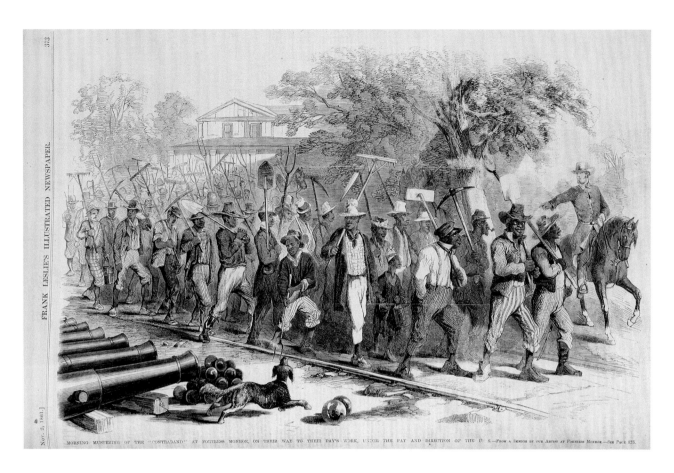

MORNING MUSTERING OF THE "CONTRABAND" AT FORTRESS MONROE, ON THEIR WAY TO THEIR DAY'S WORK, UNDER THE PAY AND DIRECTION OF THE U. S.—FROM A SKETCH BY OUR ARTIST AT FORTRESS MONROE.—SEE PAGE 375.

FIG. 18.

"Morning Mustering of the Contraband," *Frank Leslie's Illustrated Newspaper,* November 2, 1861. Magazine illustration, 16 × 10 1/2 in. Newberry oversize A5.34 v. 12.

that serve as their guide and the bank of cannon pointed directly at them serve as reminders that contrabands also were employed in bridge and railroad construction, as well as that of fortifications and gun batteries. Armed only with shovels, rakes, and hoes, these laborers freed Union soldiers to carry the fight to their foes. The tactical value of their deployment expanded and enhanced the Union's capacity to wage war while it denied the Confederacy and its slave owners the profit of their former slaves' labor.[29]

But Butler himself was one of the first on record to acknowledge the greater strategic importance of contrabands and acted quickly to co-opt it. Labeled "intelligent contrabands" in the Northern press, these fugitives provided valuable information about enemy activities nearby. Along with intimate knowledge of their masters' whereabouts, habits, and warlike activities, intelligent contrabands were familiar with the surrounding geography. They knew local waterways, trails, and roads; they knew the locations of rebel encampments, gun batteries, and fortifications. They had seen firsthand the movements of Confederate troops and had expended their labor in building Confederate fortifications, hauling their weapons and their supplies, or constructing gun batteries. Though occasionally praised in the press for their acumen and assistance to the Union cause, intelligent contrabands were often lampooned in racist anecdotes and images, as if the combination of the terms "intelligent" and "contraband" was unavoidably oxymoronic. As news of the contraband situation made its way north, unfounded fears spread—

particularly among those less inclined to take a favorable view of the liberation of slaves—that ragged and rootless contrabands would soon follow.

Stalking along the street, and hunched over from the long hike north, the "Highly Intelligent Contraband," depicted in the August 26, 1862, issue of *Vanity Fair* chases the shadow of Horace Greeley, publisher of the *New York Tribune* and an outspoken abolitionist. With a walking stick to guide and prop up his crouching figure and his little bundle of possessions tied to the end of a stick, the contraband is rendered with the hooded eyelids and protruding lips characteristic of period depictions of black figures. His skin is articulated in a densely curving tangle

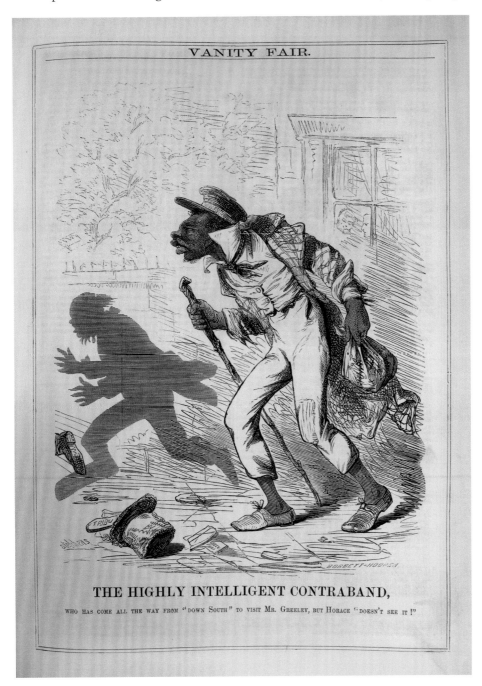

THE HIGHLY INTELLIGENT CONTRABAND,

WHO HAS COME ALL THE WAY FROM "DOWN SOUTH" TO VISIT MR. GREELEY, BUT HORACE "DOESN'T SEE IT!"

FIG. 19.
Albert Bobbett, Edward Hooper, and Louis H. Stephens, "The Highly Intelligent Contraband," *Vanity Fair*, April 26, 1862. Magazine illustration, 11 1/2 × 8 7/8 in. Newberry folio A5.93 v. 5.

of tints intended to allow the maximum saturation of printer's ink. This feature is repeated in the fleeting image of Greeley's shadow, though here the tints are horizontally applied rather than curved to reflect the rapidity of the publisher's quickened escape. In this engraving, however, both abolitionist sympathizer and recently freed slave are delineated in the print medium as "black." Often such fears of northern migration were unfounded, as the majority of contrabands remained in or near theaters of war, which also happened to be closer to their former homes and families left behind. In such locations, their usefulness remained at a premium.[30]

In an effort to strengthen the fledgling blockade of the Confederate coastline of Georgia and the Carolinas, the Union mounted an amphibious attack on Port Royal, South Carolina, in November of 1861. With seventeen warships carrying twelve thousand infantry, six hundred marines, and supplies, steam-powered boats led the attack on several forts and batteries to establish an outpost midway between Savannah, Georgia, and Charleston, South Carolina, for the newly established South Atlantic Blockading Squadron. Like countless other battles, the attack at Port Royal was depicted dramatically by the illustrated weeklies.[31] After a few hours of resistance from the two forts at the mouth of the harbor, the rebels fled. The town of Beaufort was deserted by its white inhabitants who had "retired for some miles into the interior."[32] Quickly abandoned by owners and defending rebel troops, this region was rich with the long-staple cotton plantations and slaves documented in the densely shaded portions of thematic maps. The region remained occupied by Union forces throughout the war.

Just as the Confederate attack on Fort Sumter began to unhinge the framework of the slave system, the capture of Port Royal, South Carolina, put the lock on the Southern coast, enabling it to become a beachhead for emancipation efforts there and elsewhere throughout the South. The ten thousand slaves left behind by their owners and other refugees who flocked to the area became part of the abolitionist experiment in freedmen's education. All men capable of work were employed as boatmen, carpenters, and other laborers at rates of pay varying from five to eight dollars per month, in addition to their rations, while women served as laundresses and cooks.[33] As might be expected, wages for contraband workers were low; they occasionally went unpaid. Reprinting a notice from the *Boston Globe* and retitling it "More Dirty Work," the *Liberator* explained, "The contrabands are getting organized into gangs in view of the opening of the spring's work, and under the direction of government agents will soon commence cultivating cotton, corn, sweet potatoes, &c."[34] Of course, liberated slaves also took up arms in South Carolina, forming some of the first all-black regiments mustered under the Union banner. Commandeered by Thomas Wentworth Higginson, one of the Secret Six who had supported John Brown's ill-fated raid on Harper's Ferry, the First South Carolina Colored Regiment conducted raids up the waterways and inlets of the South Carolina coast. With nothing less than "home and household and liberty to fight for," as Higginson recounted, black regiments demonstrated courage and bravery as they increased in number and became more directly involved in fighting as the

war progressed.[35] Another reason for occupying this stretch of the South Carolina coastline, though not immediately apparent to the Union early in the campaign, was its rich deposits of cotton.

> The expedition which … successfully captured Port Royal with its islands and deep, safe waters, was a blow in the vital part of the Slave Kingdom. In that part of South Carolina, *the dark map of Slavery has its deepest shade.* Of the 38,000 inhabitants of the Beaufort District, over 32,000 are Slaves.... Many of them are now in the employ of the Union forces. Orders, it is stated, have also been sent out from Washington to Gen. Sherman, to take possession of all the crops at Port Royal—cotton, corn, rice &c.—on military account, and to ship the cotton, and other such crops as are not wanted for the army, to New-York, to be sold there for the account of the Government. Gen. Sherman is also directed to use the Slaves to gather and secure the crops, and to erect his defenses.[36]

Though contrabands often did not make it as far north as New York, the yield of their labor, particularly harvested cotton, made it into the warehouses and ships of eager buyers there and to markets beyond.

All phases of the cultivation, preparation, and shipment of cotton with the "free" labor of contrabands under the direction of Northern agents is the subject of the complex constellation of illustrative vignettes titled "Our Cotton Campaign in South Carolina," published in *Frank Leslie's* in February 1862. Exposing viewers to cotton cultivation at ground level, here the "dark map" of slavery is complicated by the engravers' treatment of a spectrum ranging between the lightness of cotton being picked, hoed, and handled, and the darkness of black contrabands engaged in a variety of these and other tasks. A single-column article placed on a subsequent page explained the pictures and recounted the firsthand experiences of their "special artist":

> I went on board the steamer Mayflower, Captain Phillips, and visited the following plantations where the cotton was being picked, ginned, and bagged for transportation to New York, after being discharged from out of the Mayflower into a Government steamer. The plantations I first visited were Mr. Pope's, Dr. Jennings's, Frogmore's, and Drayton's. I here witnessed the *modus operandi....* The Mayflower alone collected approximately $150,000 worth of cotton.[37]

Depicting all stages of cotton's production from planting to loading for shipment, the illustration shows black figures laboring over cotton in its various forms, while white overseers look on and direct their activities. In several of the vignettes, African American contrabands are the only ones who actually handle the crop, as they plant, hoe, pick, whip, mote, and load the confiscated yield of area plantations. These figures, though technically now "freed," still bear the hunched profile characteristic of the runaway slave advertisement with which readers North and South would have been intimately familiar. In an indirect way, this feature of the

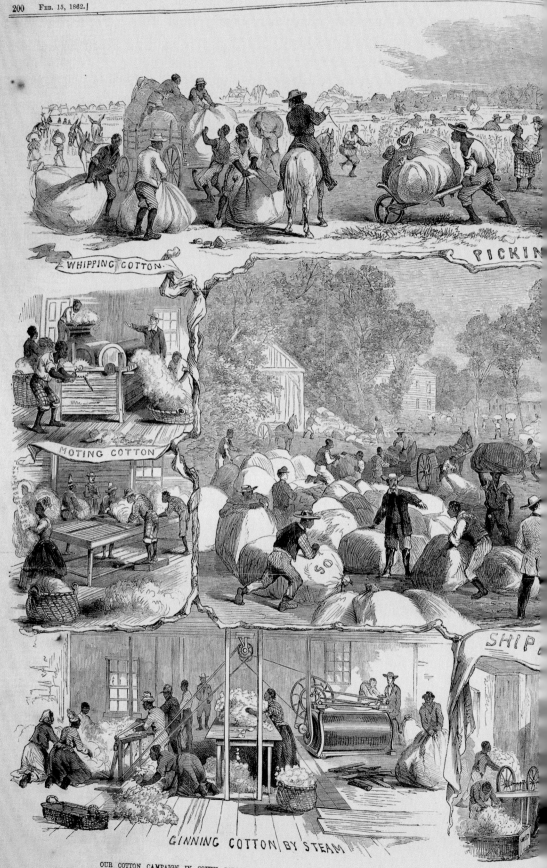

WHIPPING COTTON.

PICKIN

MOTING COTTON

SHIP

GINNING COTTON BY STEAM

OUR COTTON CAMPAIGN IN SOUTH CAROLINA—GATHERING, PACKING AND SHIPPING THE COTTON CROPS OF THE SEA ISLA

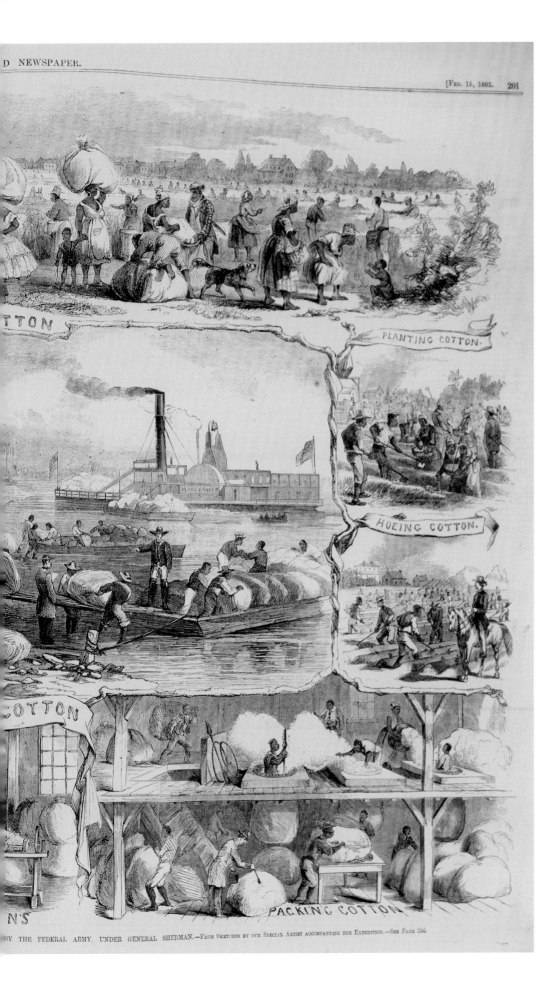

PLANTING COTTON.

HOEING COTTON.

PACKING COTTON.

FIG. 20.
"Our Cotton Campaign
in South Carolina," *Frank
Leslie's Illustrated Newspaper,*
February 15, 1862. 16 × 22 in.
Newberry oversize A5.34 v. 13.

engraving underscores the "compulsory" nature of their purportedly "free" labor by grounding their representation in prewar visual codes. But the constellation engraving also alludes to a new spectrum of possibilities raised in the engraving's deft handling of the tonal relationships between Union overseers and cotton on one hand and the contrabands handling and moving it about on the other.

Though somewhat varied in skin tone, figures of contrabands throughout the constellation are delineated with the characteristically dense grids of tints necessary to register volumetric form in areas of darker hue. The networks of incised lines utilized in dark-skinned figures or areas of deep shadow were critical to the medium's ability to convey a convincing, two-dimensional image. These passages stand in stark contrast to the relatively "underworked" areas of the composition occupied by depictions of the contrabands' white counterparts and the commodity that has brought them all together. Indeed, cotton's amorphous, billowy form has a tendency in two dimensions to resemble a cloud, a puff of smoke, or a pile of laundry.[38] Recognition of this undifferentiated white mass required that it be tended to by dark-skinned workers or depicted in piles, bags, or bales. But across the illustration's spectrum of lightness and darkness, those forms rendered in "grayscale," those tints that govern viewers' perception of the middle range of tones, take on new meaning in pictures of slaves-turned-contrabands laboring in a moment of marked transition. Akin to the engraver's delineation of the ephemeral exhaust escaping from the steamboat's stacks, for instance, the gray areas of certain figures bespeaks their intermediary status between slave and free as their fates were cast adrift by the winds of war. Nevertheless, while the landscape had changed, methods for the representation of people of color, like solutions for what to do with these newly freed individuals, evolved more gradually.

The Port Royal experiment demonstrated the utility as well as the complexities of free labor cotton as it raised even more vexing questions regarding the status and future of the contrabands. Accounts in the *Friend* and *Christian Advocate* corroborated the successes of the harvest, documented the activities intended to care for and educate the contrabands, and speculated on their futures. Questions of what to do with the women and children, for instance, were part of an ongoing redefinition of the idea of "home" for thousands of men, women, and children newly freed. Clustered in and around Union encampments and forts, contraband camps were spaces betwixt cotton field and battlefield, between slavery and freedom. These were spaces of new possibilities and challenges.

Living conditions in the camps varied from adequate to dismal, as contrabands flocked to makeshift shelters or followed the marches of Union troops. Representatives of the US Sanitary Commission, one of the main charitable organizations supporting the Union, monitored the conditions in selected contraband camps throughout the conflict. Edward Atkinson himself was commissioned to inspect conditions at Port Royal in 1864. In an "Appeal for Clothing for the Refugees," published the day after Christmas, 1861, one writer lamented the deplorable conditions at another camp:

There is a deficiency of proper quarters for sheltering so many, and an entire want of blankets. There is no hospital room, and no proper provision or medical attendance … Some families of six to eight persons are living in a house twelve feet by six, made by joining two gun-houses together. Others live crowded in old tents; others in diminutive shanties, made by hastily knocking a few boards together, while the number of men, women, and children crammed into the old building at the corner of the road leading from the fort to Hampton is beyond computation; they seem to ooze out at all its crevices.

But along with a deficit of shelter and other makeshift enclosures, the shortage of clothing for women and children was even more dire and underscored the value of items often made from cotton fabrics:

In the matter of clothing there is great destitution among the women and children. Government has, to a certain extent, supplied the men whom it employs with coat, trousers, shoes, and hat; there is still a lack of clothing however, among them, and no provision is made for underclothing, there would be advantage could it be supplied from other sources. Government has furnished no clothing for women or children. Small amounts have come in from private contributions, but they are wholly insufficient.[39]

Though conditions in the camps in some ways exceeded the quality of life under slavery, treatment of contrabands, as might be expected, was uneven at best. But in several areas, contrabands remained on the move, whether by force or by choice, marching along with Union troops in whichever direction they might be going.

The Emancipation Proclamation of 1863 significantly expanded the quantity of these newly freed, newly mobile people, while further underscoring their uncertain, transitory status. The bewildering sense of betwixt and between is playfully captured in the cartoon "The New Place," published in *Vanity Fair* on December 27, 1862. In this and other images documenting the plight of contrabands, clothing and other material possessions are utilized as outward indicators of the changes these figures experienced. In the cartoon, an African American sports a liberty cap and a rumpled suit with a stick and little bundle perched over his right shoulder. Slightly outdated and ill fitted, the figure's costume, a near exact replica of that worn by the "intelligent contraband" seen earlier, signifies this figure's "new place" between subservient dependence and independent self-reliance. The Democratic leaning *Vanity Fair* framed the contraband's liminal space on the eve of the Emancipation Proclamation with the question "Yah! Yah! Dis Chile's on de move to his new situmavation. Wonder what sort of pusson new Mass's gwine to be!" as if slavery would be continued under the new regime, if only under a different name. The assurance with which the black figure in "The New Place" struts as he exits one doorway to enter the next belies his doubts about his new master, and for the viewer, the complexity of "what to do with the contrabands," as was so frequently

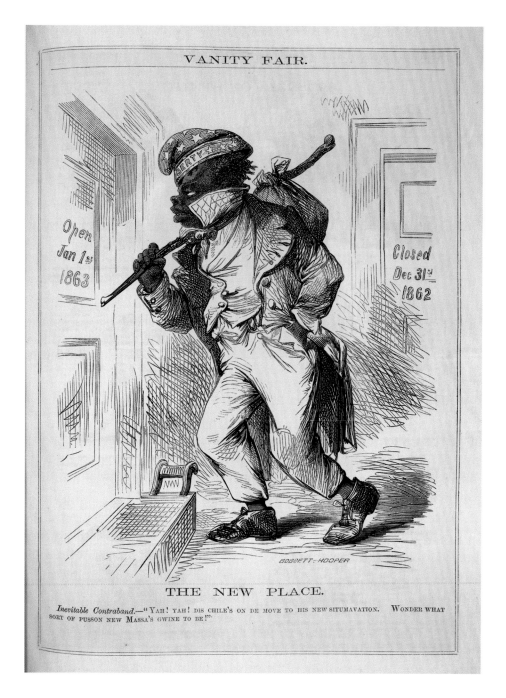

FIG. 21.
Albert Bobbett and Edward
Hooper, "The New Place,"
Vanity Fair, December 27,
1862. Magazine illustration,
11 1/2 × 8 7/8 in. Newberry
folio A5.93 v. 6.

asked in the periodical press. The skeptical, even pessimistic "Song of the Contraband," also printed in *Vanity Fair*, describes freedmen in the harsh terrain of betwixt and between. Without a home, the contraband is "pushed and spurned by the busy throng" of Broadway:

> I don't know whar dis darkey
> At last is gwine to rest;
> Dey've stole him from Georg'a,

Dey've driv him from de West;
De Norf refuse to hab him,
An' ebery oder pince—
goly! But dis darkey's
A Lord-forsaken case!

Now who will take dis darkey
Afore he's 'pletely froze
An' gib him for his labor
De hoe-cake an' de clothes?
Dar's Massa Wendell Phillips,
What preaches 'bout de sin
Ob slabery, I wonder
Ef *he* would take me in?[40]

But the transition, though joyous for many, was much graver in reality. In this engraving after a drawing by war correspondent Alfred Waud, an English-born illustrator, painter, and photographer who immigrated to the United States in 1858, the ragged covering of the wagon echoes the fugitives' tattered clothes. As he described the scene, "There is something very touching in seeing these poor people coming into camp—giving up all the little ties that cluster about home."[41]

FIG. 22.
A. R. Waud, "Contrabands Coming into Camp in Consequence of the Proclamation," *Harper's Weekly*, January 31, 1863. Magazine illustration, 16 × 10 1/2 in. Newberry folio A5.392 v. 7.

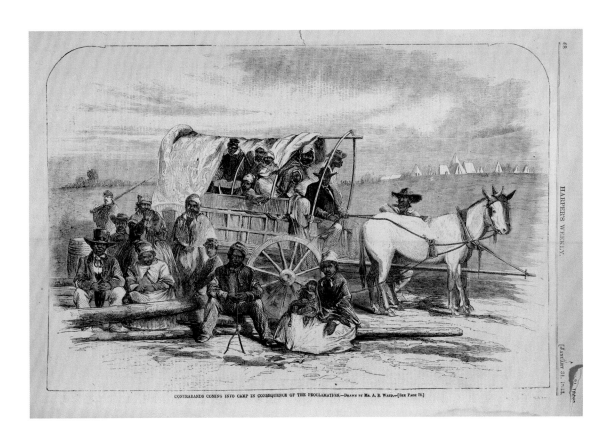

CONTRABANDS COMING INTO CAMP IN CONSEQUENCE OF THE PROCLAMATION.—Drawn by Mr. A. R. Waud.—[See Page 76.]

Though destitute and lacking material possessions, they arrive now as freed men and women, not as contrabands. In taking to this ramshackle wagon, they are barely covered in a "carpet" whose raggedness contrasts with the tautly upright tents of the Union encampment in the distance. Pictured in their mobile home, and anchored momentarily in place by the stalwart and stiff Union soldier standing sentry at far left, these particular contrabands have abandoned their more fixed residences on nearby plantations or farms to make new homes outside the boundaries of Confederate control. Waud's image was much reproduced and circulated widely throughout the war and after. It graphically captured the transitory, the fugitive, the brooding sense of an uncertain outcome echoed by Thomas Wentworth Higginson in concluding his narrative: "Whether this vast and dusky mass should prove the weakness of the nation or its strength, must depend in great measure, upon our efforts."[42]

That individuals emerging from this "dusky mass" would eventually prove the strength of the Union, and later the nation, finds evidence in this before-and-after illustration based on photographs made by T. B. Bishop of an "escaped slave" turned Union soldier. Here, the hunched figure of the fugitive is transformed by the leavening power of the Union uniform and rifle. This slave had fled from Montgomery, Alabama, to Chattanooga "for the express purpose of enlisting in the army of the Union." The slave, now standing tall as soldier, was, as this author wrote, "endowed for the first time with his birth-right of freedom, and allowed the privilege dearer to him than any other—that of fighting for the nation which is hereafter pledged to protect him and his."[43] Along with the change from seated to standing position, the contraband's new status is conveyed most vividly through his change in costume from the rags of downtrodden fugitive slave to the regimental outfit of the Union soldier.

As the war progressed, the prospect of slavery's demise grew more certain while the fate of the American cotton trade was thrown into further doubt. With the labor force once thought necessary for the cultivation of cotton now dispersed and redeployed, questions concerning the future of the cotton economy circulated widely as the war ended in early 1865. In December of that year, months after the surrender at Appomattox, a brief article in the *Friends' Review* signaled one result, reporting:

> Two vessels recently arrived in Mersey [Liverpool] direct from New Orleans. Their names—significant of the state of things at present in the United States—are *The Freedom* and *The Glad Tidings*, and both are laden with free-labor cotton. *The Freedom* brings about 1700 bales and *The Glad Tidings* 2400 bales, being two of the largest cargoes of cotton which have reached Liverpool since the commencement of the war. The last named vessel was consigned to the well-known firm of Rathbone Brothers.[44]

Although this news reflected a positive moment for the American cotton trade, it did not mark a return to its prewar output. As a result of the war, Britain had

Peter John Brownlee

FIG. 23.
T. B. Bishop, "The Escaped Slave," and "The Escaped Slave in the Union Army," *Harper's Weekly,* July 2, 1864. Magazine illustrations, 16 × 10 1/2 in. Newberry folio A5.392 v. 8.

GENERAL SHERMAN'S CAMPAIGN.—GENERAL WILLIAMS'S DIVISION OF HOOKER'S CORPS LEAVING THE REBELS THROUGH THE WOODS.—SKETCHED BY THEODORE R. DAVIS.—[SEE FIRST PAGE.]

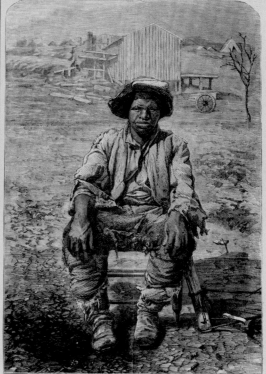

THE ESCAPED SLAVE.—PHOTOGRAPHED BY T. B. BISHOP.—[SEE PAGE 422.]

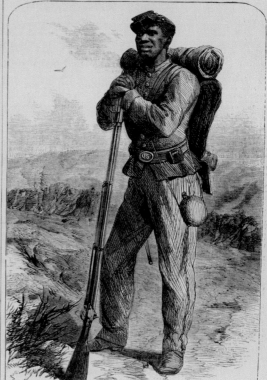

THE ESCAPED SLAVE IN THE UNION ARMY.—[SEE PAGE 422.]

increased imports from India and elsewhere, and the landscape of the cotton economy had been irrevocably altered.[45] The forces unleashed by Butler's classification of "contrabands" at Fortress Monroe, near Hampton, Virginia, were effectively, if not always efficiently, channeled by the free labor ideology and statistical calculations of figures such as Atkinson and Olmsted, among others. Utilizing the statistical maps they created to target areas with significant concentrations of cotton and slaves, the Union successfully co-opted these two pillars of the Southern economy to upend and destroy the Confederacy. Furthermore, containment of the South's maritime commerce reduced the flow of imports and exports to a trickle and decimated its economic strength as well as its ability to wage war or to sustain its population, either military or civilian. In the visual field, images such as those considered here offer some evidence of the transformative effects of this reversal. Perhaps most poignantly rendered in the illustration after Waud's drawing, the transitory status of newly freed peoples was conveyed through the artist's representation of their clothing and the threadbare nature of their material existence.

Though a far cry from the docks of New York, the ragged figures in Waud's "Contrabands Coming into Camp" are connected to the black figure who handles the cotton bale in Colman's *Ships Unloading, New York* through a shared syntax necessary for their representation in pictorial form. Painted three years after the war's conclusion, the man of color here represents a later stage in the evolution from fugitive to free laborer. As he labors over a cotton bale harvested by free labor, the dockworker suggests another version of the progress made by African Americans in the war's aftermath. He is now situated, however precariously, within the postwar wage labor system, purportedly as equal with his white counterparts. Here, in a moment of gradually increasing labor equality, the racial difference between figures is inscribed more subtly in the contrast between his dark brown skin and the thick impasto of white pigment Colman used to highlight the play of light on the fluffy bale over which he labors. Turned away from the viewer, the presence of the African American worker, particularly his darkness in contrast to the cotton he handles, also helps to mark a transition to a subsequent moment in the history of this once-powerful commodity and its extensive distribution networks.

From the open bale, Colman pulls the viewer's gaze back into space along the curving vector defined by the ship's starboard prow. Punctuating the stern of the hulking vessel, a horse-drawn carriage rumbles toward the viewer and supplies a visual axis to the dense bustle intersecting at the painting's lower center. Here, the kinetic energy of wharf activity is blurred into a morass of heat and steam that radiates outward from the semicircle of the steamer's wheelhouse at left. The upward path taken by the inky exhaust emitting from the steamer's smokestack is reversed in the snaking trace of the oily substance oozing out from under the cluster of barrels that occupy the left foreground. Seen only under considerable magnification are the words "New York Petroleum Co." painted across the head of the barrel facing the viewer.

Formed in 1865, this company represented what was then one of the new frontiers of American economic development. Significant quantities of petroleum had

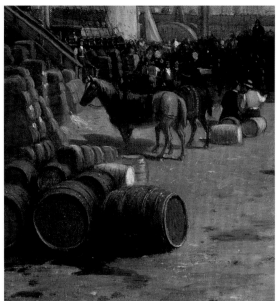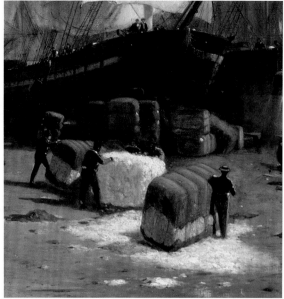

been discovered in Pennsylvania only a few years earlier in 1859. Just as the sail and steam vessels jostle against one another in Colman's picture, marking a moment of industrial transition between modes of travel, and just as the African American worker handles cotton harvested by free labor in the early stages of Reconstruction, the barrels at left and the cotton bales at right frame our view of the activities on the wharf. But the cotton bursting forth from the bale is not the only commodity spilling onto the ground. The barrels themselves are leaking oil onto the dirt. Here, in another pairing of light and dark, the white, puffy cotton spilling forth at right contrasts sharply with the dull, earthen color of petroleum puddles at left. Though the heaviness of the fossil fuel is sublimated in the distance, issuing upward as exhaust from the steamboat at left, its presence in the picture hints at the fuel's emerging importance in world markets.[46] Thus, questions regarding the geopolitical legacies of the rise and fall of King Cotton in the nineteenth century are raised in new ways with the emergence of petroleum. As it spills from wooden barrels, this commodity would fuel the engines of commerce, and warfare, for generations to come.

FIG. 24.
Samuel Colman, *Ships Unloading, New York*, 1868. Oil on canvas mounted on board, 41 5/16 × 29 15/16 in. (105.0 × 76.0 cm). Terra Foundation for American Art, Chicago, Daniel J. Terra Collection, 1984.4. Details.

SCOTT MANNING STEVENS

Other Homes, Other Fronts

Native America during the Civil War

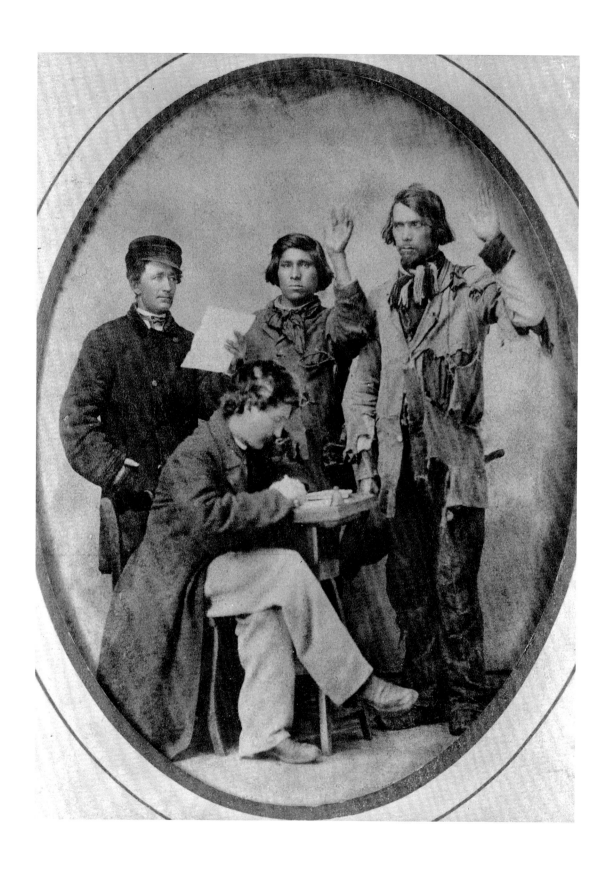

Most Americans are familiar with characterizations of the Civil War as one of the bloodiest conflicts in American history and as the first modern war, but rarely are we asked to consider the effects of that war on the indigenous peoples of North America. Where are American Indians in the historiography of the Civil War? We might sometimes hear of the Union's Seneca brevet brigadier general, Ely Parker, or the Confederacy's Cherokee brigadier general, Stand Watie, but very little attention is given to the Indian communities who experienced that conflict within their home communities. Most Northerners thought of the home front as a place removed from the direct destruction of battle. It was a place to which news of the battlefield was sent back, a place of laboring for the war effort, a place for the wounded to convalesce or the dead to be mourned. But for Native peoples from the Atlantic to the Pacific and from the Mexican border to the northern Plains, the war was something different; dozens of communities experienced firsthand the cataclysm of the American Civil War. Violence and displacement came to unforeseen regions and again and again drew Native lives into a war not of their making. The American Indian home front was not spared the horrors of war, but those accounts have not found their way into the national narrative of the conflict between the Union and the Confederacy.

Many Americans may also need reminding of the fact that the West was not the frontier to everyone; for the American Indians of the Plains and far West, these were their homelands and theirs was a home front and way of life perennially in danger. The coming of the Civil War would put new pressures on Indian Country; both the Union and the Confederacy laid claim to all, or portions of, the territory outside the established states. Indian nations closest to the border regions were in immediate danger of being drawn into the conflict but even those tribes further from the combatants found themselves in the sites of both armies as the gold fields of Colorado and California became strategic objectives.[1] Added to the pressures applied by the war was the opening of millions of acres of land that occurred when Lincoln signed the Homestead Act on May 20, 1862. Perhaps no single piece of legislation could draw into sharper relief the conflicting notions of the future of the trans-Mississippi west. The federal government in Washington granted its citizens the right to claim up to 160 acres of land, free of charge, if they would build a home on it and occupy it for a minimum of five years. This was in gross violation of dozens of preexisting treaties made with Indian nations who had long called these lands home.

The war also would directly affect those nations who had been removed from their ancestral lands in the East during the 1830s. Among those peoples most severely affected on the indigenous home front were the Creek and Seminole Union loyalists of Indian Territory. Whereas some slaveholding members of the Choctaw and Cherokee Nations had swayed large portions of their nations to side with

FIG. 25.
Swearing-In Native American Civil War Recruits, 1861. Photograph, Wisconsin Historical Society, WHS-1909.

the Confederacy, the Creek and Seminole Nations were deeply divided. Eventually some four thousand Union sympathizers would be driven from Indian Territory into Kansas, where they would spend the first two years of the war in miserable conditions in eastern Kansas near Fort Scott. Their leader, the Creek chief Opotheyehela, would plead with Union leaders repeatedly to organize a military campaign to help them return to their homelands, but without result.[2] In late 1862 an Indian Home Guard was finally organized in Kansas as an Indian brigade that participated in the Union actions throughout Indian Territory against both Confederates and enemy Native troops. For those Native nations along the thousand-mile frontier, the Civil War, far from deflecting American pressures on their communities, brought new threats and devastating military interventions between 1861 and 1865.[3]

We should not imagine that American Indians were prominent in the minds of most Euro-Americans during the Civil War either. For many who lived in the larger east coast cities Indians were either consigned to America's past or to its frontier, and little attention was paid to those Indian communities still living among them. This was even more true after the Indian Removal Policy of the 1830s and 1840s forced so many tribal nations to move west to Indian Territory in modern-day Oklahoma. So the newspaper reports of the violent attacks on the white settlers of Minnesota in late August 1862 must have shocked northeastern readers who were becoming accustomed to following the events of the Civil War raging on the Virginia frontlines and elsewhere in the South.

The state of Minnesota was about as far from the wartime violence as was possible in the North, and yet the news coming in was alarmingly dire. This was to be a separate war, an Indian war, one that would play on long-held fears throughout the Union. What historians have come to call the Dakota War of 1862 was an example of Indian outrage over government policies of dispossession, institutionalized graft, and neglect that had been going on since the colonial period and carried over to the early Republic. Beginning on August 17 with the murder of an American family on a remote Minnesota farmstead, the Dakota War would grow to take between 450 and 700 American settlers' lives, with an unknown number of Indian dead.[4] Viewed against this backdrop, Eugene Benson's *Indian Attack*, painted just four years earlier, takes on an uncanny quality. His melodramatic tableau, which looks back at the heroic struggles of the American settlers in the past, now might be seen as prescient, the benefits of hindsight notwithstanding.

Eugene Benson was born in New York's Hudson River Valley at Hyde Park in 1839. Little is known of his childhood there until his sixteenth year when he began his formal artistic training at the already prestigious National Academy of Design in New York City. The academy had been founded by the artists Samuel Morse, Thomas Cole, and Asher Durand, among others, and quickly became an artistic center in the early Republic. Benson studied there between 1855 and 1859, and again from 1863 to 1864. It was during the first period of study that he painted *Indian Attack*. The technically precocious Benson was only nineteen years

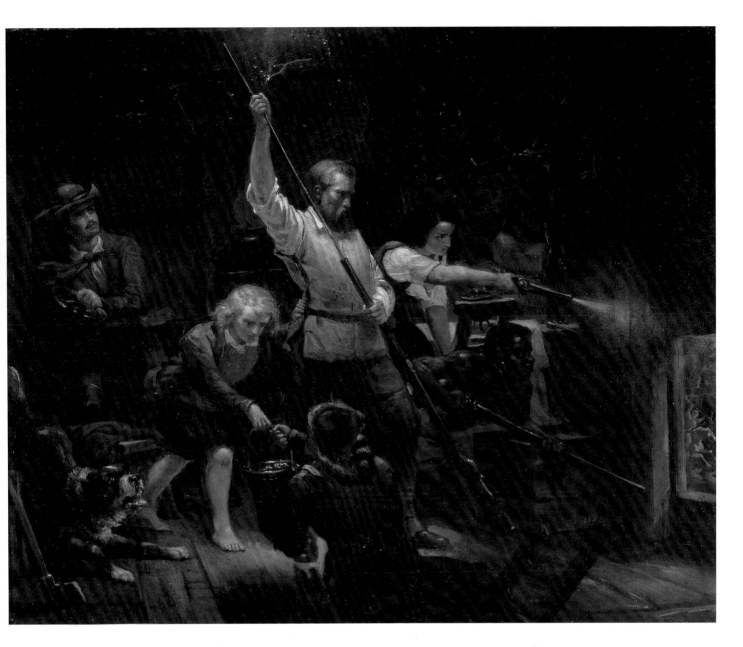

old when he completed this painting, but no contemporary exhibition record of it has been found.[5] Near the end of his student days at the National Academy Benson began sharing studio space with his friend Winslow Homer. It was with Homer that he traveled to England in 1866 and then on to Paris, where Homer's Civil War–themed *Prisoners from the Front* (see fig. 5.) had been selected for display at the Universal Exposition.

Benson had yet to settle into the genre painting with which he would eventually be associated, but clearly he embraced the realistic style of rendering his figures that one could see in works by contemporaries and fellow academicians such as Arthur Fitzwilliam Tait.[6] Benson, like many other artists of the young Republic, was keenly aware of the United States' artistic debt to Europe and its need to

FIG. 26.
Eugene Benson, *Indian Attack*, 1858. Oil on canvas, 10 1/2 × 12 1/2 in. (26.7 × 31.8 cm). Terra Foundation for American Art, Chicago, Daniel J. Terra Art Acquisition Endowment Fund, 1999.6.

establish a national cultural idiom if American culture was to become truly independent. His was not a rejection of the European figurative tradition or even the romanticism of the generation preceding him. But rather, like George Caleb Bingham or Jasper Cropsey, Benson sought out a specifically American subject. For both Bingham and Cropsey that subject would be frontier life and the immensity of the unsettled landscape.[7] Where Cropsey found sublimity in nature, like Cole and Durand before him, the youthful Benson focuses on the dangers of frontier life in his *Indian Attack.*

The image does not have an apparent specific historical or literary referent, but one does not have to look far to find numerous examples in mid-nineteenth-century America. Popular journals such as the *United States Magazine, Harper's Monthly,* and *Graham's Lady's and Gentleman's Magazine* routinely carried fictional and quasi-historical accounts of Indian attacks and settler heroics both past and present. The majority were set in the colonial past or on the old frontier of the trans-Appalachian west. They blended violence and providential deliverance in equal measure but for the most part took place, reassuringly, in the past. Popular writers drew on the familiar American genre of the captivity narrative for their stories but added a considerable amount of antebellum sentimentality. Those stories set on the United States' ever-expanding western frontier often portrayed the hardships and dangers of those emigrants making the arduous trip to Oregon or California.

Both American themes, the one emphasizing the hardships faced during the early settlement of the lands east of the Mississippi and the other concerned with the ongoing conquest of the West, served the larger notion that would come to be known as America's "manifest destiny," after the phrase identified with John L. O'Sullivan in the *Democratic Review* in 1845.[8] The themes of colonial-era frontier settler and Indian conflicts differed from the contemporary frontier tales because of the ultimate success of the colonial-era struggles. Such depictions of earlier struggles had the reassuring message that, in the end, the Euro-Americans won. The viewer of such paintings in a New York City exhibition at such venues as the National Academy or the American Art-Union could take comfort in how these distant historical struggles foreshadowed the outcome of contemporary violence on the western frontier. Benson had grown up in a period when the novels of Washington Irving and James Fennimore Cooper were at their height of popularity—as well as being upheld as true American artistic and cultural achievements. Whereas Irving began to look beyond the romanticized Dutch settler past of the Hudson Valley of his early fiction toward the West in such later works as *A Tour of the Prairies* (1835) and *The Adventures of Captain Bonneville* (1837), Cooper turned from *The Prairie* (1827) to explore the earlier colonial past in such works as *The Wept of Wish-ton-Wish* (1829), set in seventeenth-century Connecticut, and *Pathfinder* (1840) and *The Deerslayer* (1841), both set in eighteenth-century New York. Benson's *Indian Attack* appears to have more affinity with Cooper's world.

From a formal perspective Benson's 1858 painting follows many of the precepts prescribed by the art academies and popular drawing manuals of the period.

The action of *Indian Attack* is centered on the defense of a frontier home—here rendered rough-hewn and stocked with the signs of life in the wilderness: non-plastered walls, antlers, hunting gear, a defensive casement window.[9] The figures in the center are arranged in the typical pyramidal format with the Euro-American paternal figure in the act of muzzle-loading his rifle, while the female figure, presumably the wife and mother of this frontier nuclear family, discharges a pistol through the open window at one of the shadowy Indian figures without. The group is lit dramatically from above by fire that rains sparks on the group. All the figures on the left of the canvas are attempting to extinguish the fire, doubtless set by the attacking Indians without. We see a figure in backwoods-style coonskin cap handing a bucket of water to the fair-haired son of the family group, possibly from a cistern beneath. Another adult male behind the family looks up at the fire (somewhere just above the border of the canvas) and prepares to douse the flames. Crouching just beneath the mother is an African, quite likely a slave, bare-chested and wearing an earring to emphasize his exotic nature. A family dog raises the alarm in the left corner of the canvas as the frenzy of defensive activity goes on before him.

The scene could easily be one out of Cooper's world or that of the popular fiction of the day. The stern and bearded father figure holds the center of the action like an Old Testament patriarch while his dark-haired wife assumes the proactive stance of a character reminiscent of Cora in *The Last of the Mohicans*. The frontier would require such women and much prefer them to the overly refined ladies of Europe, who would be paralyzed by such events. Ever since the pragmatic and enduring figure of Mary Rowlandson entered the American imaginary such figures as the legendary Revolutionary War heroine Molly Pitcher or the Puritan Hannah Dustan were celebrated as America's original women warriors. Hannah Dustan, famous for the murder and scalping of her sleeping captors and their families—including two women and six children—is said to be the first nonallegorical American woman honored with a public statue.[10] Benson draws on that same tradition in depicting his resolute frontier mother.

We might also compare it to an earlier illustration that derived from a drawing by William Perring and appeared as an etching in *Graham's Lady's and Gentleman's Magazine* in 1843. The image depicts the actions described in Charles F. Hoffman's poem of the same name, "The Attack." Here we see a mother clutching her frightened child as her sister stands at the window with a rifle. An arrow is lodged in the floor before them. The poem notes the mother is overcome by maternal sympathies and unable to act, whereas her sister is described as drawing strength from the Bible that lies on the table beside them and leaping to action to defend their home. All the qualities of motherhood, faith, and bravery are celebrated in this vignette of the clash between savage and civilized. In 1856 the popular periodical the *United States Magazine* published an imaginative retelling of the 1704 Deerfield raid, titled "Mary Ellery the Indian Captive; or, The Sacking of Deerfield." As with the illustration in *Graham's*, we see the heroine kneeling in prayer, hiding behind a tree as Indians burn down her home. She is a model of female Christian

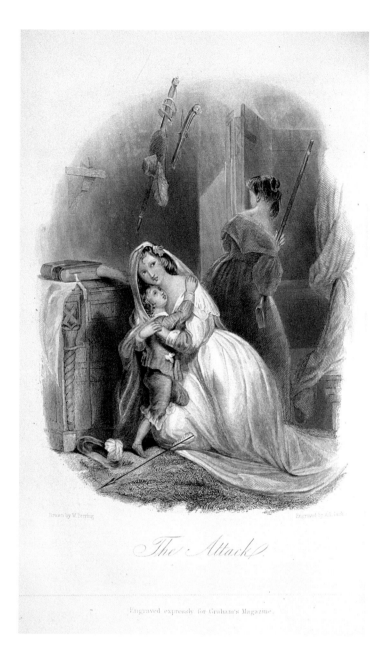

perseverance, even in the face of death. Her example helps others maintain their faith throughout their experience of captivity. It is a tale recounted to demonstrate the cruelty of the Indians and the fortitude of the settlers. For an audience in the New England of 1856 it must have seemed like ancient history.

Beyond the clash of civilized and savage a key aspect of the moral force of Benson's painting is the unifying effect this attack has on his microcosm of American society. All these individuals band together in defense of family and home. The quite literal pressures of this external foe have a galvanizing effect on members of this self-reliant household. Benson painted *Indian Attack* in 1858, when the country was reaching the breaking point over the divisions between slave and free

states. These were the days of violent confrontations between pro-slavery and abolitionist citizens over the fate of western territories on the verge of statehood, such as "Bleeding Kansas," and the increasingly shrill calls for disunion. Benson knits his community together by identifying a common goal and a common enemy—the wresting of the frontier from the Indians. His inclusion of an African within this context cannot be merely incidental. Nothing in the image reveals whether the figure is a slave or free but what is most significant is that he participates, armed, in defending the homestead. This rough frontier structure becomes an outpost of civilization in Benson's painting just as the singular cabins depicted picturesquely at the edge of the wilderness by Cropsey or Cole had done, more pacifically, in the paintings of the 1840s. But Benson's image submerges the viewer in the history of violence and conflict that was at the center of Euro-American expansion and settlement. In *Indian Attack* that violence attempts to invade what has been marked as domestic space and thus requires defense by the family and their associates. It is as though the cabins in Cole's *The Hunter's Return* or *Home in the Woods* were suddenly under attack.

FIG. 28.
Thomas Cole, *Home in the Woods*, 1847. Oil on canvas, 44 3/8 × 66 1/8 in. (112.7 × 168 cm). Gift of Barbara B. Millhouse, 1978.2.2, courtesy of Reynolda House Museum of American Art, Winston-Salem, North Carolina.

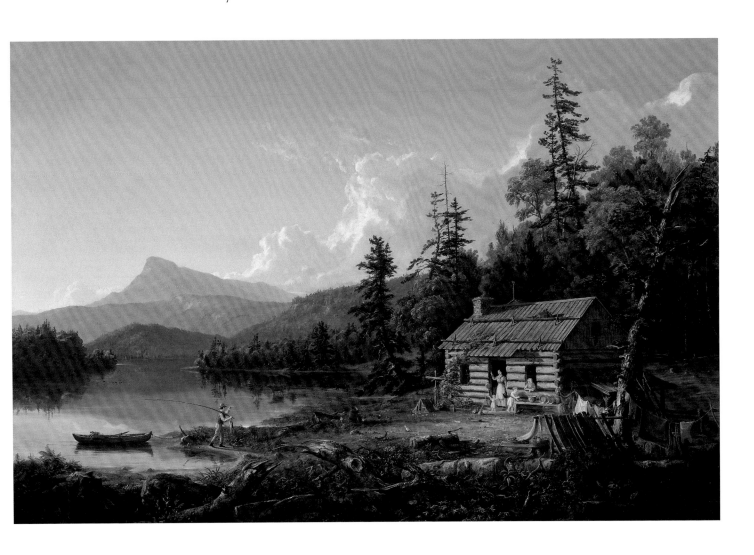

During the Antebellum period, dual impulses existed to relegate settler and Indian violence to the colonial past or to portray the drama of these conflicts as occurring on the distant frontier. Both currents were guided by an assumption of the inevitable extinction of the American Indian. Of course this assumption was not always the case in the early colonial period, but once the Europeans began to note the catastrophic population declines due to recently introduced pathogens, they began to theorize either a divine or biological causality that would seem to guarantee their eventual ascendancy.[11] To be sure the strength of various Indian nations such as the Iroquois and the Cherokee made settlers leery of becoming complacent in the face of Indian resistance. Only after the specter of a united intertribal alliance under Tecumseh passed could Euro-Americans return to their presumptions about the disappearance of the Indians. This was made policy when Andrew Jackson enacted his scheme of Indian Removal in the 1830s. The so-called Indian plays of the 1820s and 1830s were a popular means of dramatically representing on stage the much-anticipated demise of the American Indian. John Augustus Stone's *Metamora; or, The Last of the Wampanoags* (1829) was typical of such Indian plays and was widely performed and just as widely imitated.[12] We begin to see the examples of what Renato Resaldo has called "imperialist nostalgia" and the emergence of the figure Gordon Sayre has described as "the Indian chief as tragic hero"—this being especially true for frequently eulogized figures such as Tecumseh and Black Hawk.[13]

Americans were repeatedly being told that the Indians were fast disappearing, and this was born out in the visual arts just as it was in fiction, poetry, and drama. If we take, for example, Thomas Cole's depictions of scenes from Cooper's *Last of the Mohicans*, a series of four panels commissioned by the owner of a Hudson River steamship, we see the impact of Cooper's valedictory and elegiac novel. The scenes are set within an overwhelming landscape, where they appear diminutive and of secondary importance. Whatever human dramas are unfolding in these depictions, they are rendered insignificant by the truly epic matter of America, its natural beauty. Cole's Indians appear to rest in the figurative, if not literal, vanishing points of these four studies—as if the paintings themselves would survive the Indians' disappearance—the landscapes' aesthetic powers intact. But Cole was not likely a proponent of American expansionism given its potential drive toward empire and decay, a theme he had famously treated in his allegorical *Course of Empire* series. His reverence for America's wilderness seemed, as one critic put it, "a wishful continuum with the classical world, as if America could stop dead in its tracks and remain a never-changing Virgilian paradise."[14] For many viewers of the Hudson River school paintings, the absence of Indians in any but a decorative or romantic mode is not an issue meriting inquiry.

The same year Cole painted his *Home in the Woods* (1847), Tompkins Matteson painted his *The Last of the Race*; what Cole may have implied by omission, Matteson made explicit in his depiction of an Indian family standing on a rocky cliff overlooking an expanse of ocean. The melancholy scene predicts a day that many increasingly believed was coming as the nineteenth century progressed. The

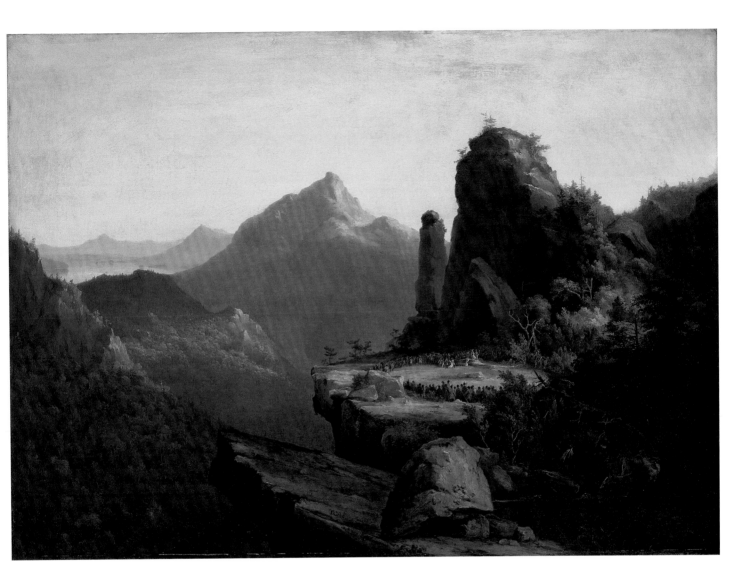

central male figure stands at the center with his back to the viewer, seemingly lost in contemplation of his fate and that of his race. Two of the other figures appear forlorn with heads bowed while the final figure of an Indian woman wrapped in her blanket, a perennial symbol of the Indian's primitive existence, stares sullenly back in the direction from which they have journeyed. Ten years later John Mix Stanley would produce a similarly titled painting, *The Last of Their Race* (1857), in which ten Indians, ranging in age from infancy to old age, cluster around another adult male figure at the ocean's edge. The details of their story are not necessary for the viewer to comprehend its import: the tide of US expansion westward will sweep the indigenous peoples of the continent before it, almost literally driving them into the sea. Long before Frederick Jackson Turner was announcing the closure of the American frontier in 1893, painters like Stanley were predicting its impact on the Natives of North America. Given the period in which these paintings were created and the continued vitality of many Indian nations at that point, this theme of imminent demise can only be characterized as aspirational.

FIG. 29.
Thomas Cole (1801–48), *Scene from the Last of the Mohicans: Cora Kneeling at the Feet of Tamenund*, 1827. Oil on canvas, 25 3/8 × 35 1/16 in. (64.5 × 89.1 cm). Bequest of Alfred Smith, 1868.3, Wadsworth Atheneum Museum of Art. Photo: Wadsworth Atheneum Museum of Art/ Art Resource, NY.

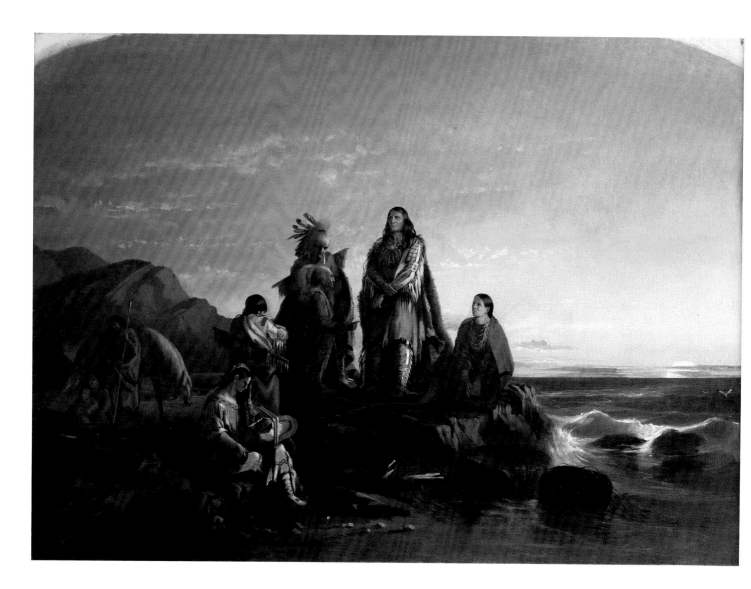

FIG. 30.
John Mix Stanley, *The Last of Their Race,* 1857. Oil on canvas, 43 × 60 in. (109.2 × 152.4 cm). Buffalo Bill Historical Center, Cody, Wyoming, U.S.A.; Museum Purchase, 5.75.

For a painter like Eugene Benson who, up to the point he painted *Indian Attack,* had lived his life entirely in New York State, the prospect of such violence must have seemed part of a distant history in the Northeast. Reports of Indian and settler violence still came in from the West, but these largely concerned so-called pioneers traversing Indian territories in search of land and prosperity in California or Oregon Territory. Historians have noted that actual violence against these wagon trains was much less frequent than popular fiction, and later Hollywood, would have us believe. The wagon trains were also, of course, a potent symbol of the progress of Euro-American civilization and hegemony over the continent. US citizens were secure in their belief that what had come to pass in the East would act as the template for the West. Violence and dispossession would occur, and the settler would triumph over the Native. Imperial nostalgia would be manifest in such heroic depictions as Ferdinand Pettrich's *The Dying Tecumseh* (1856). The public could see a once powerful enemy of the United States' designs on the trans-Appalachian west now rendered in white marble, with classical muscula-

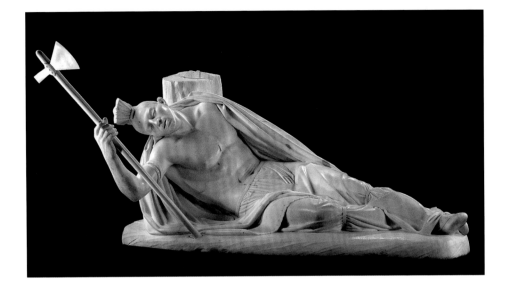

FIG. 31.
Ferdinand Pettrich, *The Dying Tecumseh*, modeled ca. 1837–46, carved 1856. Marble with painted copper alloy tomahawk, 36 5/8 × 77 5/8 × 53 3/4 in. (93.1 × 197.2 × 136.6 cm). Smithsonian American Art Museum, transfer from the US Capitol, 1916.8.1.

FIG. 32.
Thomas Crawford, *The Indian: The Dying Chief Contemplating the Progress of Civilization*, 1856. White marble and wood, 60 × 55 1/2 × 28 in. (152.4 × 141 × 71.1 cm). Collection of the New-York Historical Society, 1875.4.

ture, prone like the *Dying Gaul* of Roman statuary. Tecumseh is memorialized as a worthy, though defeated, enemy, even as he is transformed into a trophy of American expansionism. Ever since Jefferson had championed the native eloquence of Logan, the American public had been allowed to honor its adversaries so long as their eloquence and nobility were expressed in defeat.[15]

In Washington, DC, the politicians were keenly aware of the ever-shrinking American Indian homelands and the fact that lands open to settlement were lands open to the debates of the expansion of slavery into the West. The consequences of Indian dispossession were of central importance to the future of the Republic. Visitors also could look at the heroic sculpture of the Capitol Building and read the ethos of American expansionism. In the 1850s with the completion of the expanded legislative wings of the Capitol, competitions were held for the friezes that

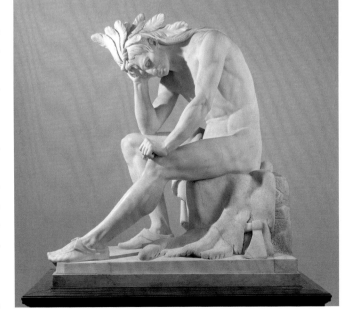

would fill the pediments of the Senate and House of Representatives' respective wings. Thomas Crawford was among those selected to provide allegorical and historical sculptures for the building.[16] Visitors to the Capitol Building today can still see Crawford's neoclassical *Progress of Civilization*, completed in 1856. These figures are arranged on the pediment of the Senate wing's east front and consist of a central allegorical figure, *The Genius of America*. To her right stand Euro-American figures representing agriculture, industry, education, and commerce, and to her left a backwoodsman felling a tree; an Indian youth hunting; a reclining male figure, titled *The Dying Chief Contemplating the Progress of Civilization*; a female figure; and a burial mound. In one admiring anonymous description written for the *United States Magazine*,

the group is described in the following words: "The Indian chief and his family typify the extinction of the red men before the onward march of their Caucasian exterminators, and the grave is ready to receive these last survivors of the millions who roamed in savage freedom over the continent less than three centuries since."[17] The unflinching tone of this passage, the use of the term "exterminators," as though it were a morally neutral term, is telling.

One might argue that artists led the way in what has come to be called salvage ethnology. Though their motivations were more romantic and nationalistic than the professional ethnologists that followed, their inclination to collect and preserve the fast-disappearing traces of an ancient way of life is evident in the writings of artists such as George Catlin: "I have flown to their rescue—not of their lives or their race (for they are 'doomed' and must perish), but to the rescue of their looks and their modes, at which the acquisitive world may hurl their poison and every besom of destruction, and trample them down and crush them to death; yet, phoenix-like, they rise from the 'stain on a painter's palette,' and live again upon canvass, and stand forth for centuries yet to come, the living monuments of a noble race."[18] The artist's praise for the almost necromantic power of his paintings implies that art will become an acceptable surrogate for living Indians. One could argue that America had too easy a time coming to terms with its part in the destruction of Indian lives and their traditional cultures. The gap between the accelerating industrial and technologically sophisticated lives of Euro-Americans and the more nomadic and subsistence life ways of many peoples of the Plains and far west meant that it was increasingly difficult to convince whites that such peoples constitute sovereign nations.

The question then was, what was to be the fate of Indian nations in the expanding Republic if it were not outright extermination? Many schemes were put forward in the name of humanitarian dealings with the Indians. The argument had been in place since the days of Thomas Jefferson that agriculture and not hunting was the future to which the Indians must assimilate. If they were to do so, then less acreage would be required to sustain their communities than in wide ranging hunts; this in turn would conform to a desire that Native people live in settled or fixed communities, thus freeing up their former territories for settlement by whites. For the most part such reallocations of land were accomplished by treaties. In such, vast quantities of land were exchanged for guaranteed annuities and specific rights pledged to those Indians living on what were to be called reservations. Once a region was organized into a territory by the federal government the apparatus was in place to create reservations in that territory, relegate the Indians to that area, and open the rest of the land up to settlement.[19] The two largest acquisitions of territory by the contiguous United States were the Louisiana Purchase (1803) and the Treaty of Guadalupe Hidalgo (1848). These treaties—by which the United States laid claim to the trans-Mississippi west and could claim a sea-to-sea nation—were claims in name only. At the time the United States acquired those huge territories they were very sparsely settled by Europeans and even more loosely administered in their furthest reaches.

The myth of the "vanishing red man" had lulled the majority population into a false sense of security. Violent conflicts with Indians were not unknown, but they were just as often dismissed as feeble attempts to preserve a way life not worthy of the keeping. Horace Greeley remarked on "their paltry but interminable wars" in the same 1859 piece in which he wrote, "These people must die out—there is no help for them. God has given this earth to those who will subdue and cultivate it, and it is vain to struggle against His righteous decree."[20] Such sentiments were as typical as those predicting the inevitable extinction of the Natives, and more often than not they served to minimize any efforts at resistance by Indian nations. In the treaties leading up to the Civil War, American officials had secured vast tracts of land from the Plains nations and northern Midwest, and immigrants continued to pour into the region from the east.

One of the main factors affecting the Indian homelands was the corrupt Indian system that developed in Washington during the antebellum period. After the administrative and bureaucratic machinery that controlled Indian affairs was transferred from the War Department to the Department of the Interior in 1849, presidential administrations found it even easier to fill positions within the Office of Indian Affairs as political rewards. This came to be effectually a spoils system by which political supporters were given control of funds allocated by Congress to be dispersed to various tribal nations in accord with treaty obligations.[21] In a short span of time an entirely corrupt patronage system developed in which officials who had no familiarity with Indian peoples or their needs were put in charge of the annuity funds on which they depended. These officials could reward their allies in turn. Many of those involved became tremendously wealthy speculating on Indian land, working with merchants to overcharge Indians for provisions, or making them loans at usurious rates. Essentially, no one was held accountable, and Indians had little or no course for redress in these matters. This system was firmly in place when Abraham Lincoln came into office, and he made no attempt to reform or end it.

In Minnesota this would prove to have catastrophic results. The 1851 Treaty of Traverse des Sioux guaranteed the surrender by the Dakota of almost twenty-four million acres of land in what was then the Minnesota Territory. This they did in exchange for a reservation along the Minnesota River and a guaranteed annuity with which they could buy necessary goods. The treaty paved the way for the settlement of Minnesota by whites, especially recent immigrants from northern Europe, and for the territory to become a state in 1858. The Dakota people immediately began to experience the injustices of the Indian system as corrupt officials and merchants siphoned off the money from their promised annuity and new settlements ensured the loss of hunting grounds and a traditional means of survival. The harvests of 1861 had been poor, and by summer 1862 tribal leaders found their people in a desperate condition. This was exacerbated by the fact that one of the prominent traders with a virtual monopoly at the Lower Sioux Agency, Andrew Myrick, charged inflated prices and extended credit at exorbitant rates. The situation was often such that when annuity funds finally did arrive they were

withheld in payment for the loans brokered by the local merchants such as Myrick.

With the outbreak of hostilities between the North and South the functioning of the Indian system was disrupted. The Dakota of Minnesota desperately needed their annuity to purchase food and other necessities in summer 1862, but the funds were late—with no assurance they would arrive at all. When tribal leaders took their complaints to the traders Myrick famously said, "So far as I am concerned, if they are hungry, let them eat grass."[22] When the war began in August of that same year, Myrick would be one of the first men killed—after his body was discovered it was noted that his mouth was stuffed with grass. The actual outbreak occurred on a settler farm near the Lower Agency Reservation when several Dakota youths, in a dispute over eggs, killed a farmer and his wife and two other adult males close to Acton Township. Leaders such as Little Crow believed that this act had thrown them inescapably into a state of war since whites would seek harsh justice and Indian grievances would continue to go unheard. To the Dakota, the United States had failed to live up to its treaty commitments, and now the Dakota would reclaim the land they had earlier surrendered. The ensuing violence was swift and severe. In the second half of August hundreds of settlers were killed or taken prisoner. The news shocked the nation.

Somehow after years of being told that the Indians were on the verge of extinction, the United States found itself at war with an Indian nation determined to drive the white settlers from the land that was once theirs. The news from Saint Paul was reported in the *New York Times* on the twenty-fourth of August under the headline "THE INDIAN MASSACRES: Terrible Scenes of Death and Misery in Minnesota. Five Hundred Whites Supposed to be Murdered. The Sioux Bands Unite against the Whites. Ft. Ridgeley in Danger." The author speculated on possible connections between this war and the Civil War, writing near the conclusion of the report, "A private letter received in this city, to-day, from St. Paul, dated the 20th instant, says, it seems to the general opinion among the best informed of our citizens that these Indian troubles originated with the cursed Secessionists of Missouri."[23] This was a typical reaction that both ignored the causes of the Dakota declaration of war and Dakota agency in organizing a campaign to reclaim their traditional homelands.

Governor Alexander Ramsey appointed Colonel Sibley to head the campaign against the Dakota, but a portion of his troops under the command of Major Joseph Brown were defeated by Little Crow and his army at the Battle of Birch Coulee on September 2, 1862. The popular press continued to assume the Confederacy was somehow involved, as is evident in a September 13, 1862, *Harper's Weekly* cartoon depicting the Indians massacring women and children while lying at their feet is a liquor jug labeled "Agent CSA"—implying that the Confederate States of America had been involved in instigating the violence. Below the image is a quotation, "'I am happy to inform you that, in spite of the blandishments and threats, used in profusion by the agents of the government of the United States, the Indian nations within the confederacy have remained firm in their loyalty and steadfast in the observance of their treaty engagements with this government.' (The above Ex-

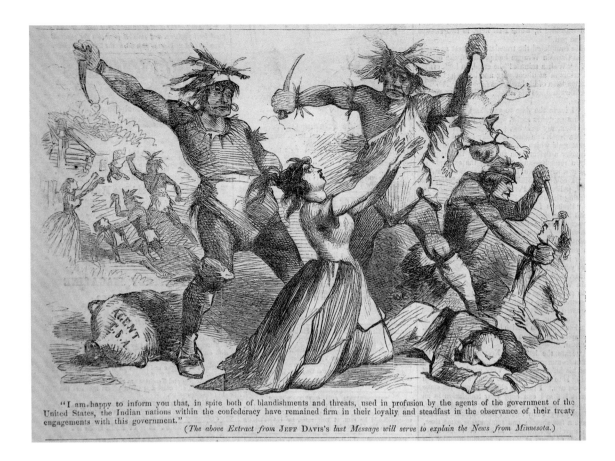

"I am happy to inform you that, in spite both of blandishments and threats, used in profusion by the agents of the government of the United States, the Indian nations within the confederacy have remained firm in their loyalty and steadfast in the observance of their treaty engagements with this government."

(The above Extract from JEFF DAVIS's last Message will serve to explain the News from Minnesota.)

tract from Jeff Davis's last Message will serve to explain news from Minnesota.)"[24] President Lincoln, realizing the gravity of the situation, appointed General John Pope, fresh from his bitter defeat at the Second Battle of Bull Run, to end what was being called the "Sioux Uprising." Pope arrived in Minnesota in September and decisively defeated the Dakota at the Battle of Wood Lake on September 23. Following the battle, the US Army took some 1,200 Dakota men, women, and children prisoner from the reservation, an act that prompted the surrender of eight hundred Dakota warriors.

The prisoners were held under extremely poor conditions at Fort Snelling while the state and military authorities planned for a mass trial of some 393 Dakota soldiers on charges of rape and murder. The trials were notoriously brief, each case getting less than ten minutes of hearing; the accused were not provided with council or, in many cases, interpreters. Another *Harper's* image, this time the cover illustration depicting a wounded settler's boy pointing out his Indian attackers, was clearly meant to inflame public sympathies. In the end, 303 of the accused were sentenced to death for their parts in the war. Contrary to the prisoner-of-war status afforded Confederate soldiers, the Dakota were treated simply as criminals guilty of capital crimes. The final decision on their fate fell to Lincoln. The Episcopal bishop Henry Whipple of Minnesota decried the trials and protested the sentences handed down, but state officials knew the citizens wanted blood. In the end, Lincoln signed the order of execution condemning thirty-eight men to

FIG. 33.
Untitled cartoon (Dakota War scene), *Harper's Weekly,* September 13, 1862. Magazine illustration, 5 × 7 3/4 in. Newberry folio A5.392 v. 6.

HARPER'S WEEKLY.

A JOURNAL OF CIVILIZATION.

Vol. VI.—No. 312.] NEW YORK, SATURDAY, DECEMBER 20, 1862. [SINGLE COPIES SIX CENTS.
[$2 50 PER YEAR IN ADVANCE.

Entered according to Act of Congress, in the Year 1862, by Harper & Brothers, in the Clerk's Office of the District Court for the Southern District of New York.

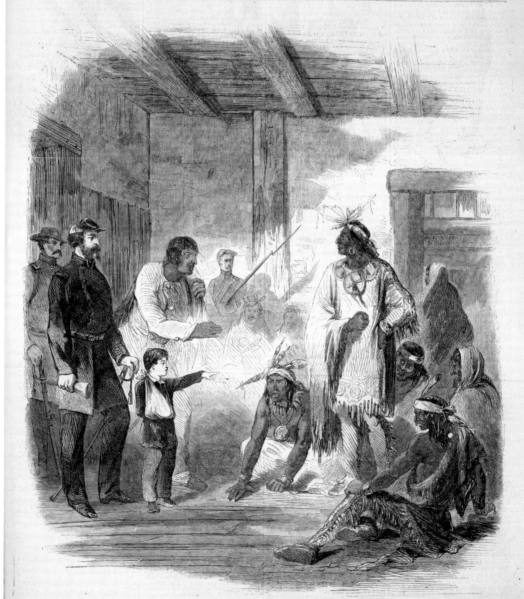

IDENTIFICATION OF INDIAN MURDERERS IN MINNESOTA BY A BOY SURVIVOR OF THE MASSACRE.—[SEE PAGE 807.]

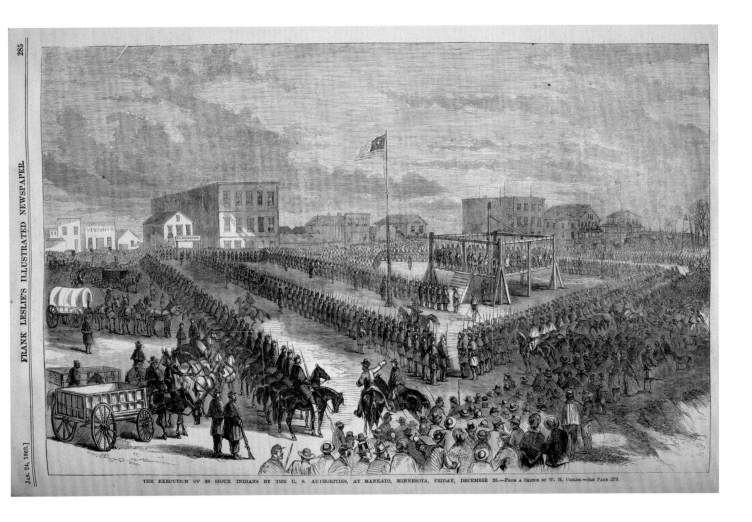

THE EXECUTION OF 38 SIOUX INDIANS BY THE U. S. AUTHORITIES, AT MANKATO, MINNESOTA, FRIDAY, DECEMBER 26.—FROM A SKETCH BY W. H. CHILDS.—SEE PAGE 279.

hang. Claiming that he had reduced the number dramatically because he "could not afford to hang men for votes," Lincoln still made possible the largest mass execution in US history. The thirty-eight men were hanged on a public scaffold especially designed for the occasion on December 26, 1862.[25]

The suffering of the Dakota was not at an end of course. After months of internment of almost two thousand prisoners through a brutal Minnesota winter, dozens of those held died at Fort Snelling before being deported. Their Minnesota reservation was abolished.[26] Most who had been held there were forced into exile in Kansas Territory and would eventually be placed on reservations in what is now South Dakota. The United States' conflicts with the Sioux (its name for the Dakota, Lakota, and Nakota peoples) were far from over.

But the Sioux were not alone in their struggles for their homeland during the American Civil War; the Navajo were similarly involved in a struggle for their traditional way of life on their home territories as a result of US intervention in the region. The complex relations that had developed over the centuries between Spanish colonists and the Indian nations of the Southwest were made even more difficult when the region was annexed in the wake of the Mexican War. The population of the territory was divided between Indians, Hispanic settlers, and a minor-

FIG. 34.
"Identification of Indian Murderers in Minnesota by a Boy Survivor of the Massacre," *Harper's Weekly,* December 20, 1862. Magazine illustration, 16 × 10 1/2 in. Newberry folio A5.392 v. 6.

FIG. 35.
"Execution of the 38 Sioux Indians," *Frank Leslie's Illustrated Newspaper,* January 24, 1863. Magazine illustration, 16 × 10 1/2 in. Newberry oversize A5.34 v. 15.

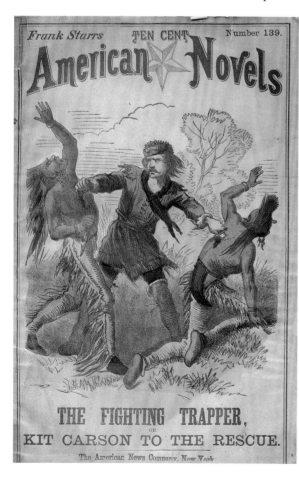

ity of recently arrived Euro-Americans. A long series of intertribal competitions for resources had created a cycle of raiding and guerilla attacks that went on intermittently for decades before the US authorities arrived.[27] The Civil War brought new demands that the Indians of the region be "pacified" and settled in permanent communities. Such further disruptions to traditional cultures were resisted by many groups—most famously the Navajo, the Comanche, and the Apache Nations.

The threat of a Confederate capture of territory in the Southwest became a reality when Texas militia established the Confederate Arizona Territory with its capital in Tucson shortly after the Battle of Masilla in late July 1861. Up until that point, the states we now know as New Mexico and Arizona constituted a single New Mexico Territory. The Confederates created their new territory out of the southern portion of the New Mexico Territory. The ultimate goal was of course the gold fields of Colorado and trails to California. The New Mexico Campaign was launched in January 1862 under the command of Brigadier General Henry Hopkins Sibley (no relation to Henry Hastings Sibley, the commander of the Minnesota militia), who was defeated at the Battle of Glorieta Pass on March 28 of that same year. The effect of this activity on the western frontier called attention in Washington to the dangers of instability in the territories. Indian Territory had supplied the Confederacy with thousands of soldiers and an extremely tenacious leader in the person of Brigadier General Stand Watie—the Cherokee military leader would be one of the last Confederate generals to surrender at the end of the war.

Following the Battle of Pea Ridge in March 1862, in which eight hundred Indian troops fought for the Confederacy, reports of scalping began to appear in eastern newspapers and demonstrated to Northern officials the possible effect on morale such deeply held fears could have.[28] By the end of the summer of 1862, following the Dakota War, the Union's "Indian problem" had resurfaced. Officials in Washington now approached the situation in the New Mexico Territory with renewed urgency. In August 1862, General James Carleton was put in command of the Department of New Mexico, where he set about realizing his plans to subdue the Navajo. It was Carleton who chose the veteran army scout Kit Carson to lead his field campaign against the Navajo. Carson's longtime familiarity with the region's terrain and its Native inhabitants made him ideal for the job. His reputation as a larger-than-life frontiersman had been established in John Fremont's accounts of his travels, and he would go on to become a hero of dime novels—primarily as an Indian fighter. But to the Diné, or Navajo, people he was one of their history's greatest villains. His tireless scorched-earth campaign against them led to tremendous suffering and hardships

during the so-called Second Navajo Campaign from 1863 to 1864, when several leaders of the Navajo Nation surrendered after the Battle of Canyon de Chelly on January 8, 1864. Within a week Carson ordered the removal of the Navajo from their homeland in the region of the Four Sacred Mountains of the northern New Mexico Territory to a government reservation some four hundred miles away at Bosque Redondo near Fort Sumner.[29]

This was to be accomplished by forcing some eight thousand Navajo civilians to walk through the arid land for eighteen days; along the way at least two hundred people died of exhaustion and malnutrition. When they arrived at Fort Sumner, the internment camp already held some five hundred Mescalero Apache, a people who had often skirmished with the Navajo. At its height the population at Bosque Redondo would rise to over nine thousand people. The camp was never meant to hold more than half that number. For the Diné, Bosque Redondo would come to be known as Hwéeldi or "the place of suffering." The Navajo and Apache confined at Bosque Redondo would remain there throughout the Civil War and not be allowed to return to their respective homelands until 1868, at which point they had to make the long walk home.[30]

The same anxiety around Indian raiding and desire for Indian land was at play in other western territories in 1864.[31] One of the heroes of the Battle of Glorieta Pass, John Chivington, a Colorado militia officer and Methodist minister, would perpetrate one of the most infamous massacres of the nineteenth century. The lead-up to this attack lies primarily in the fact that gold had been discovered in Colorado Territory in November 1858; as with California before it and the Black Hills subsequently, this discovery was disastrous for Native people. What whites once distained as remote wasteland was now almost universally coveted, and a gold rush became the inevitable prelude to Indian dispossession and extermination.

FIG. 37.
US Army Signal Corps, *Navajo Indian Captives under Guard Fort Sumner, New Mexico*, ca. 1864–68. Courtesy of Palace of the Governors Photo Archives (NMHM/DCA), negative number 028534.

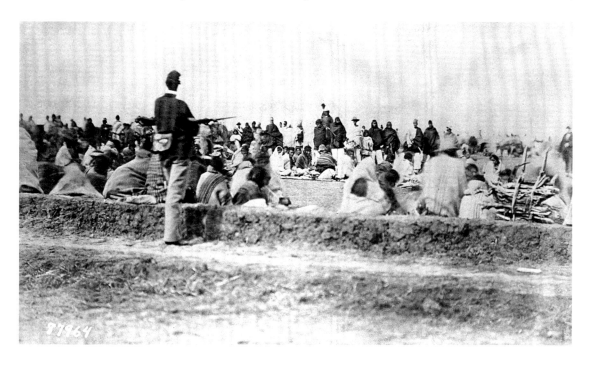

The vast tracts of land that had been guaranteed the Cheyenne and Arapahoe, among others, in the 1851 Treaty of Laramie were increasingly desirable to whites moving into the Plains or seeking gold and other mineral riches in the Rockies. By 1861, through the Treaty of Fort Wise, the Southern Cheyenne and Arapaho had ceded most of the land from the Fort Laramie Treaty under pressure from the commissioner of Indian affairs. Internal divisions arose over the terms of the treaty, and various militants refused to acknowledge the validity of the Treaty of Fort Wise.[32]

The Indian faction that refused to restrict its hunting to the new reservation boundaries was soon accused of destroying livestock and posing a threat to settlers moving into the region; the territorial governor, John Evans, took this as a pretext to launch a series of campaigns against the Cheyenne and Arapaho communities living in the region of the Arkansas River and Sand Creek. Raids on villages and hunts by territorial troops drew reprisals, and soon Colonel Chivington and others were calling for a war against the Indians.

Part of what made this such a tragedy was the attempt by Indian leaders from the Cheyenne, Arapaho, and Kiowa Nations to seek peace through official channels. In 1863 a delegation representing each of these nations went to Washington, DC, in hope of reaching an agreement that would secure their homelands for their respective peoples. The photograph taken by Mathew Brady of members of this delegation in the White House conservatory in March 1863, a group that includes the Indian agent Samuel Colley and Mary Todd Lincoln, retains today a ghostly presence in the catalog of Indian delegation portraits.[33] Among the Indian leaders identified in the photographs are War Bonnet, Standing in the Water, and Lean Bear of the Cheyenne, and Yellow Wolf of the Kiowa. Herman Viola has noted that within eighteen months from the date of this sitting, all four men in the front row would be dead. Both War Bonnet and Standing in Water were killed at Sand Creek, and Lean Bear was killed by troops from Colorado Territory who mistook him for a hostile.[34]

FIG. 38. "Attention! Indian Fighters," August 13, 1864. Courtesy of Colorado State Archives.

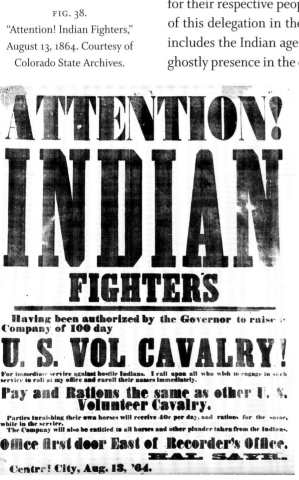

The tragedy is one well known, of seven hundred members of the Colorado Militia attacking a peaceful camp of Cheyenne and Arapaho at Sand Creek the morning of November 29, 1864. Black Kettle, who had long counseled peace, raised the American flag and a white flag in hope that promises of protection would be honored; they were not. The mutilated bodies of at least 175 men, women, and children lay on the ground after the soldiers left, many wearing Indian scalps and body parts on their hats as trophies. Initially, the massacre at Sand Creek was called anything but that; the *Daily Rocky Mountain News* heralded the attack as "the most effective expedition against the Indians ever planned

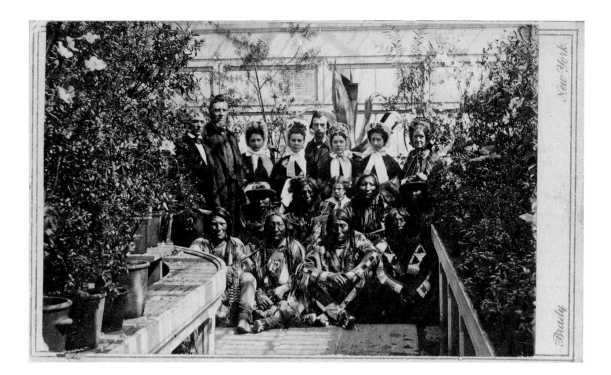

FIG. 39.
Mathew Brady, *Indian Delegation in the White House Conservatory during the Civil War, with J. G. Nicolay, President Abraham Lincoln's Secretary, Standing in Center Back Row,* March 27, 1863. Albumen photographic print on carte de visite mount. Courtesy of Prints and Photographs Division, Library of Congress, LC-DIG-ppmsca-19914.

and carried out."[35] But the persistent and credible reports of atrocities were serious enough to warrant a congressional inquiry that was reported on in the *New York Times* in July 1865.[36] Though Chivington was roundly condemned by the committee, he was not in any way officially punished. The incident served as yet one more tragic reminder of the vulnerability of Indian homelands during the Civil War. The exigencies of war were used as a cover for a multitude of crimes against Indian communities, and most of these acts would be lost in the larger tale of the triumph of the federal cause, the emancipation of the slaves, and the restitution of the Union.

For Cheyenne leaders such as Black Kettle, Sand Creek was not an aberration or isolated moment of violence. He had been one of the proponents of peace and diplomacy, and he had survived the massacre at Sand Creek, but that would not be the end of his story. Black Kettle joined with other survivors and regrouped with fellow Cheyenne who had not been at the massacre. But now the Cheyenne were restricted to Indian Territory by the 1867 Medicine Lodge Treaty. This treaty alienated the Southern Cheyenne from their traditional homelands and put them into conflict with competing Indian nations within the territory. When a loose intertribal alliance began attacking white settlements in western Kansas and southern Colorado, the same rhetoric that preceded the attack on Sand Creek would be heard again. More than three years after the Civil War ended, in November 1868 at the Battle of Washita River, Black Kettle was killed by the troops of General George Armstrong Custer. The violence of the Civil War period bled unimpeded into the era of the Indian Wars.

One survivor of Sand Creek and several subsequent battles was the remarkable Southern Cheyenne warrior and ledger book artist Ho-na-nist-to or Howling

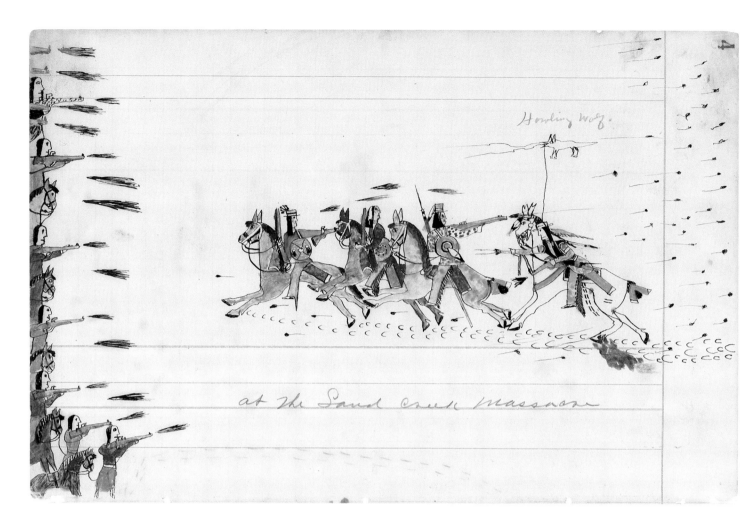

FIG. 40.
Howling Wolf, *At the Sand Creek Massacre*, ca. 1874.
8 × 12 1/2 in. (20.3 × 31.8 cm). Allen Memorial Art Museum, Oberlin College, Ohio, gift of Mrs. Jacob D. Cox, 1904.1180.5 p.4.

Wolf. Having gone into battle the first time at age fourteen, Howling Wolf was only about fifteen years old when his encampment was attacked by Colonel Chivington and his troops. Some ten years later, while a prisoner at Fort Marion in Saint Augustine, Florida, Howling Wolf began creating drawings in the traditional Plains style that we have come to know as ledger art.[37] This was an art that had deep roots in the pictographic traditions of the Plains Indians who originally used buffalo hides as their canvases and later adopted the paper found in the blank ledger books of traders and soldiers in the region. Such art traditionally depicted the noteworthy deeds of an individual or community—especially those acts of bravery that brought a young warrior honor. Most prominent among those acts were "counting coup"—or the touching of one's enemy at close quarter and escaping— as well as capturing enemy horses and beating an enemy in hand-to-hand combat. Over the years a specific visual vocabulary had developed as a shorthand for these events and their details. Howling Wolf's art falls into this tradition.

Among the many remarkable drawings Howling Wolf executed, many while imprisoned with his fellow Plains warriors at Fort Sills and later Fort Marion, is the depiction of the part he played in defense of his people at Sand Creek. This powerful visual testimony belies the presumption of an absence of an Indian per-

spective. Howling Wolf, looking back on the previous decade of his life, places his depiction of his actions at Sand Creek near the beginning of the ledger, sheets of which are now held in the art collection of Oberlin College. Experts date this drawing to 1874 or 1875, before Howling Wolf's imprisonment at Fort Marion in Saint Augustine, Florida. There, as Joyce Szabo has demonstrated, his style changed slightly, and the Sand Creek image is consistent with the work from the mid-1870s.[38] In this dramatic image we see a group of Cheyenne warriors charging their attackers in a hail of bullets. Howling Wolf, the last figure on the left, shoots into the ranks of the Colorado volunteers, while his comrades turn and fire at an unseen enemy at their rear. The attack took place at dawn, and this fact may help explain Howling Wolf's depiction of the warriors without their traditional war bonnets and other regalia. As Szabo has pointed out, Howling Wolf would not have depicted himself wearing the warriors' regalia anyway, since at his youthful age of fifteen he had not yet counted coup and thus had not earned the right to wear the war bonnet. In his depictions of later events in his life he does represent himself wearing the full military regalia accorded his position as a warrior.

The ledger carries the caption "At the Sand Creek Massacre." This would have been written by Ben Clark, a noted army scout fluent in the Cheyenne language who had served under Custer at the Battle of the Washita and later as the post interpreter at Fort Reno in Indian Territory. There, he collected ledger drawings and often gave them to commanding officers as gifts. The captive Howling Wolf knew Clark, who was married to a Cheyenne woman, and would likely have explained his drawings to Clark. In keeping with Plains artistic traditions the name of the subject, and thus usually the artist, was represented by a figure drawn overhead and connected with an identifying line. In this case we see Howling Wolf's usual symbol denoting his name, the wolf with vocalization marks coming from its mouth. Chivington's volunteer army would not have worn uniforms of regular enlisted men and so are drawn generically in everyday dress. Howling Wolf's depiction of this event places it at the beginning of his resistance fighting against the encroachment of settlers on his peoples' territory. He would survive both Sand Creek and Custer's attack on his people encamped on the Washita River in 1868 as well as numerous smaller encounters until he was taken prisoner in 1875 and sent to Fort Marion. Howling Wolf was held at Fort Marion for three years before being allowed to return to Indian Territory. The drawings he made chronicle not only his life but also the struggles of the Southern Cheyenne, who were finally forced onto a reservation near Fort Reno in 1869. With the passage of the Dawes Allotment Act and other aggressive anti-Indian legislation even the reservation was not safe from dissolution. While the massacre at Sand Creek was sensational in its day and led to a rare congressional inquest, its infamy was soon subsumed under the history of the Civil War. Like so many conflicts between Indians and settlers over the homelands cherished by one group and coveted by the other, the master narrative attends only to the victors.

The home front for the Native Nations of North America was a place of lawlessness and danger in the face of land-hungry settlers. More disturbing perhaps is the

fact that most of these events, defining historical events to the tribes involved, are all but forgotten by the majority culture. To be sure, the events of the Dakota War must have haunted the American imagination through the end of nineteenth century. The eruption of Indian violence into the settler home front was a traumatic event that surely colored Indian policy well beyond 1862. It is easy to imagine the young boy in Winslow Homer's *On Guard* (see fig. 72), in the wake of the Dakota War, as possibly standing guard against an Indian attack as well as a Confederate incursion. We cannot treat these events as micro-histories or they will continue to be obscured and forgotten in the macro-narrative of the US Civil War. Instead, we must strive to reconnect these events to the two decades of the "Indian Wars" that followed directly on the heels of the Civil War. Those conflicts of the 1870s and 1880s provided America with a common enemy—Indians—and a common prize— their lands. The Civil War takes our eyes off of Indian Country, but it remains an ever-present backdrop: it was the opening of the contested lands that acted as a catalyst to the crisis regarding the extension of slavery, and it was the prize of land and resources that made its conquest after the war so enticing.

DANIEL GREENE

Nothing Daunts Chicago

Wartime Relief on the Home Front

Chicago Tribune.

SATURDAY, APRIL 13, 1861.

WAR INAUGURATED!

By the act of a handful of ingrates and traitors, war is inaugurated in this heretofore happy and peaceful Republic! While we write, the bombardment of Sumter is going on; and the blood of the few gallant defenders of the glorious old flag which yet, we hope, floats over that fortress, is being poured out for their fidelity to the Constitution as it is, and the Union as our fathers made it!

The people know the cause of the fratricidal strife. The party, which, in the interests of a barbarous institution, has governed the country for the last forty years, was beaten in the November election. The verdict of the people which does not touch a single one of the rights of any man, guarantied by the fundamental law, forbids the extension of that barbarous institution into national territory as yet uncursed by its blighting presence. This is the cause of the rebellion which months of effort has ripened into the bloody strife this day commenced!

"Nothing daunts Chicago," announced the *Atlantic Monthly* in 1867, two years after the close of the Civil War.[1] Indeed, the British journalist sent to report on Chicago to readers of the *Atlantic Monthly* was particularly impressed that the Civil War seemed to energize the rapidly growing northwestern city. Chicago sat hundreds of miles from most battle sites, yet Chicagoans' lives were acutely linked to the war. Chicago's leading citizens turned the conflict into an opportunity for both civic growth and personal profit. Many Chicagoans fought for the Union. And significant numbers volunteered for wartime relief efforts. Three Chicagoans in particular—Eliphalet Wikes (E. W.) Blatchford, Mary Livermore, and Jane Hoge—provided local and national leadership for efforts by the US Sanitary Commission (USSC), the largest wartime relief effort the nation had ever known.[2] Their relief activities make evident the deep ties that existed between home and front during the Civil War. Their wartime efforts bridged the geographic and emotional distance between home and front, and brought the war home to Chicago.

Chicagoans reacted almost immediately to the firing on Fort Sumter that sparked the war. In a demonstration of the patriotic sentiment that gripped the North during the war's opening days, the *Chicago Tribune* included an image of a banner on its cover of Saturday, April 13, 1861, with the headline "War Inaugurated!"[3] Chicagoans' burst of patriotism was common in Northern cities. "Indeed," historian Adam Goodheart writes, "the response to Sumter seemed to manifest itself, among Northerners of every political and cultural hue, as a kind of flag mania."[4] One historian of Civil War–era Chicago explains how quickly public spaces became festooned with American flags: "The *Tribune* emphasized its editorial position by flinging a huge flag on a rope stretched from its building to the roof of the Tremont House across the street. As the flag opened to the breeze, people on the street bared their heads and cheered."[5]

Not all Chicagoans united in support of the war, as evidenced by the popularity of the *Chicago Times*, perhaps the most influential Democratic, anti-Lincoln newspaper in the North. Yet most Chicagoans backed the Union. Some felt a particular kinship with President Lincoln because he had been nominated as the Republican presidential candidate in 1860 at "the Wigwam," the two-story wooden structure built for the convention near Lake Street and the Chicago River. The city was less than thirty years old when it hosted this important convention—a remarkable achievement considering Chicago's short history to that point. Just three decades before the convention, it had been a military outpost and fur station at the confluence of Lake Michigan and the Chicago River. In the decades prior to the Civil War, the rush of settlers to Chicago was unmatched. Chicago's population hovered around four thousand during the 1830s. By 1860, the population neared 109,000, and it would nearly triple during the 1860s.[6]

Chicagoans would have been hard pressed to miss the changes that occurred in the city in the days after the war began. On Monday, April 15, 1861, President

FIG. 41.
"War Inaugurated!," *Chicago Tribune*, April 13, 1861. Newspaper, 29 × 21 5/16 in. Newberry A6.169

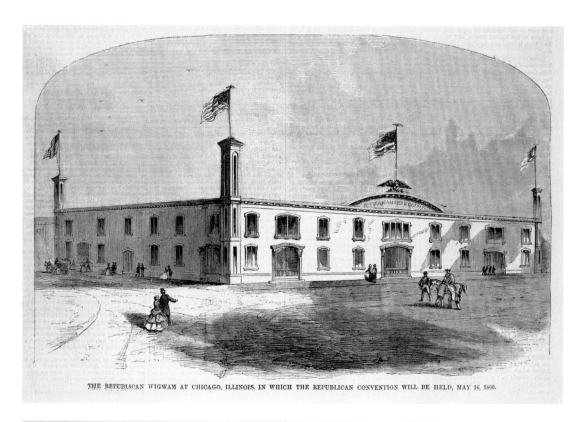

THE REPUBLICAN WIGWAM AT CHICAGO, ILLINOIS, IN WHICH THE REPUBLICAN CONVENTION WILL BE HELD, MAY 16, 1860.

FIG. 42.
"The Republican Wigwam
at Chicago, Illinois,"
Harper's Weekly, May
12, 1860. 16 × 10 1/2 in.
Newberry folio A5.392 v. 4.

FIG. 43.
"The Republicans in
Nominating Convention in
Their Wigwam at Chicago,
May 1860," *Harper's
Weekly,* May 19, 1860. 16 ×
10 1/2 in. Newberry folio
A5.392 v. 4.

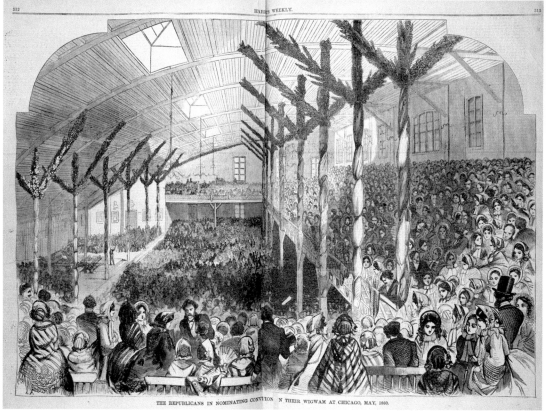

THE REPUBLICANS IN NOMINATING CONVITION N THEIR WIGWAM AT CHICAGO, MAY, 1860.

Lincoln called for seventy-five thousand troops to aid the Union war effort. The following day, two small companies of regular artillery arrived in Chicago via the North Western Railway. The growing railroad industry moved troops from the North and West through the emerging hub in Chicago over the next four years. Many units marched through the city on their way South; troops passing through Chicago provided a constant physical and visual reminder of the war to those in the city. By the end of the war, Chicago itself would send seventeen infantry regiments, five cavalry regiments, and ten artillery regiments to the front—approximately fourteen thousand troops—in addition to the numerous units that passed through from Minnesota, Wisconsin, and other points northwest.[7]

On April 18, two days after the first troops moved through Chicago for points South, Chicagoans gathered at a rally at Bryan Hall to formally pledge their support to saving the Union.[8] Chicago residents formed their first war aid society that same day.[9] At the rally, they sang, "Let the free-born sons of the North arise," lyrics to *The First Gun is Fired! "May God Protect the Right!"* the earliest of many wartime songs composed by George Frederick Root's Chicago firm, Root and Cady.[10] Rallies like this one demonstrated that the outpouring of patriotic sentiment could spur fund-raising. At this quickly assembled rally, $8,000 was raised for Chicago volunteers.[11] It was a portent of much greater efforts that followed.

Chicago's relief activities never ceased throughout the war. By the sixth month of combat, relief efforts had been coordinated and centralized through the USSC. The Chicago Branch of the Sanitary Commission, renamed the Northwestern Branch in 1863, was established at a meeting on October 17, 1861, at the Tremont House. Judge Mark Skinner was elected president. Chicago lead manufacturer E. W. Blatchford was appointed treasurer, and Ezra B. McCagg secretary.[12] Although men held the board offices and high titles, women coordinated much of the relief work on the ground. Mary Livermore and Jane Hoge would rise to national prominence for their work with the Northwestern Branch, and they received some recognition from the men who held higher offices in the USSC. But scores of women in Chicago and across the North toiled anonymously, often driven by a profound sense of service to the Union, and to the young men who fought on the front lines.[13]

Soon after its founding in 1861, the Chicago Branch of the USSC became the most important relief organization

FIG. 44.
George F. Root, *The First Gun Is Fired! "May God Protect the Right!"* Chicago: Root & Cady, 1861. Sheet music, 9 × 5 1/4 in. Newberry Case minus VM1639 R78f.

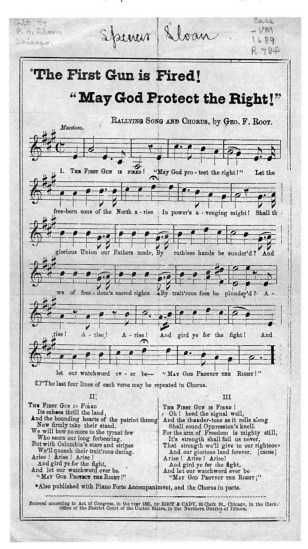

in the West. Early efforts included establishing soldiers' rests, where troops in transit were fed. By 1863, the Chicago Branch founded a soldiers' home for sick and wounded men to convalesce. The most innovative contribution of the Chicago Branch, however, was undoubtedly the city's two sanitary fairs—fund-raising expositions organized both to raise money and to collect supplies for the Union Army. Chicago hosted the first and the last of the nation's many Civil War sanitary fairs, in 1863 and 1865, respectively. The Chicago fairs, conceived and executed by the exceptionally dedicated Livermore and Hoge, were charity events and expositions in one. Together, the two Chicago fairs raised more than $400,000. (According to the consumer price index, this would have equaled $10.8 million in 2010.) The fairs, like the work of the Chicago Branch of the Sanitary Commission generally, bridged the distance between home and front and brought the urgency of war relief to Chicagoans' doorsteps.

Travel to the South and back home again by multiple Sanitary Commission representatives also brought the war nearer to Chicago. In late spring 1864, for example, Blatchford traveled to the South from Chicago to report on the USSC's war relief efforts. He followed the entire line of USSC operations from Louisville to Kingston, Georgia, moving from the depots where bandages and supplies were stored to the sites of their delivery to wounded troops. Blatchford explained the necessity of the journey by emphasizing the USSC's desire to operate efficiently. He and his travel companion, Ezra B. McCagg, returned from the South deeply impressed with the commission's work in the field. Without directly citing criticism of the USSC's inefficiency that circulated from time to time during the war, Blatchford did admit that wounded soldiers often waited many hours on the battlefield before being removed to field hospitals where agents could be of real assistance.[14] Nevertheless, Blatchford wrote, "any waste, or loss, or evils" paled in comparison to the "good accomplished" by the USSC.[15]

Blatchford traveled south in 1864 not as a member of the Union Army, but as a civilian officer of the USSC. He took great pride in the accomplishments of the USSC, lauding the organization for its ability to collect and send supplies, clothes, food, and nurses to army camps and hospitals. He praised the fact that the USSC provided meals and shelter for a night's rest to soldiers in transit to and from the front. These efforts had significant impact. In June 1864, the USSC shipped an average of ten tons of supplies each day to soldiers' homes and hospitals. These supplies included nourishment—tea, sugar, dried fruit, codfish, crackers, cornstarch, butter, wine, whiskey, lemons, beef, condensed milk, and more—as well as clothing, bedding, rags, and bandages.[16]

In Chicago, perhaps no man did more to aid the war effort than Blatchford. Like some of his fellow USSC officers and volunteers, he became a conduit that helped to move goods, people, and information about the war from home to front and back again. He was both deeply patriotic and driven by a profound sense of Christian morality. Although he never fought in battle, he believed that his work was critical to the Union's victory. Blatchford served the Union through both his lead manufacturing business—which made weapons used in battle—and his activities

FIG. 45.
Eliphalet Wickes Blatchford
Photograph. Photograph,
4 × 2 1/2 in. Newberry E.
W. Blatchford Papers, box
116, folder 2129, gift of the
heirs of Eliphalet Wickes
Blatchford.

with the USSC—which aided soldiers injured in battle. His experiences seeking both to profit from the war and to fulfill what he perceived as a Christian obligation to provide war relief are particularly instructive, for they demonstrate in a single individual's lived experience Chicago's deep connections to the Civil War front.

Fifty years later, in private writings about his important journey south, Blatchford grew reflective. When he wrote his memoir in the mid-1910s, he noted how frequently the "ghastly sights" of wounded troops still haunted him. Two generations after his wartime mission, Blatchford insisted that the "harrowing scenes" of this trip "will dwell with me through life."[17] Though he achieved great success in both business and civic life in the half century following the war, there is little doubt that Blatchford considered his war relief efforts to be his life's most important work. Although he profited significantly from lead manufacturing during the war, Blatchford seems to have had little trouble squaring his own wartime munitions profit with his Christian sensibility. He drew his sense of purpose from his deeply held Christian conviction, as well as from his beliefs about the evils of slavery. In 1864, Blatchford penned a resolution to President Lincoln on behalf of the

Christian Community of Chicago. In it, he explained that "the war is a Divine retribution upon our land for its manifold sins," and that "there can be no deliverance from Divine judgments *till slavery ceases in the land.*" Blatchford closed the resolution with a prayer to God that "the name of *Abraham Lincoln* may go down to posterity with that of *George Washington, as the second savior of our country.*"[18]

The history of the US Sanitary Commission is intimately bound with the efforts of those who, like Blatchford, did not join the Union Army but who nonetheless deeply wanted to serve the war effort. The USSC got off to a quick start after the firing on Fort Sumter in April 1861. The very next month, the commission's representatives organized a trip to Washington to seek federal support for civilian-led war relief activities. They encountered significant resistance, especially from the Army Medical Bureau, but succeeded at higher levels in the administration, appealing from Secretary of War Edwin M. Stanton all the way up to the White House. Lincoln was initially skeptical of the idea of a civilian war relief organization—he wondered whether the Sanitary Commission would become a fifth wheel to the coach of the war.[19] Lincoln's did not want to upset the surgeon general or the Medical Bureau, yet he approved an order creating the USSC on June 9, 1861, less than two months into the war. Many organizations were founded to promote relief during the Civil War, but the USSC was the only one that ever received government sanction.[20]

The Sanitary Commission soon became the largest voluntary association in the nation's history. The leadership and membership of the USSC tended to be mainline Protestants, like Blatchford. Evangelicals were drawn, in contrast, to the US Christian Commission, organized in November 1861 to offer religious support as well as social services for soldiers.[21] Henry Bellows, a Unitarian minister, was the first president of the USSC. Along with Treasurer George Templeton Strong and Executive Secretary Frederick Law Olmstead, Bellows sat at the head of a bureaucracy that oversaw seven thousand local chapters by 1863.[22] Twelve branches were established across the North, with the most active in New York City, Boston, and Chicago.[23]

As the number of war dead mounted, the USSC played an important role by collecting and circulating information to civilians about the location of the wounded and aiding in the burial of the dead. The USSC did all this with an eye toward efficient handling of information. "Dedicated to order and system, the Sanitarians created a bureaucracy to meet the growing demand," according to historian Drew Gilpin Faust. Americans looked to the USSC increasingly over time to inquire about the whereabouts of their loved ones, and to find out whether those who had fought were living or dead. After establishing a Hospital Directory in late 1862, the commission was flooded with requests for information about soldiers— more than one thousand came in each month in 1863. "By early 1865," Faust reports, "more than a million names had been recorded in office ledgers."[24]

Some critics of the USSC questioned whether its efforts were too paternalistic, too bureaucratized, or too obsessed with efficiency and order. Writing in Octo-

ber 1862, Olmstead rebutted these critics by citing the need for a united, coordinated relief effort. He defended the USSC's methods, insisting that "the necessity of sacrificing local, personal, and transitory interests to the policy of the Union" governed the military effort and should govern the relief effort as well. Olmstead warned: "In union is strength. In disunion is weakness and waste. Can we not, in this trial of our nation, learn to wholly lay aside that poor disguise of narrowness of purpose and self-conceit, which takes the name of local interest and public spirit, but whose fruit is manifest in secession?"[25] The suggestion that critics of the USSC were akin to those who would secede from the Union surely did not satisfy critics, who were also loyal to the Union. Yet, Olmstead claimed the USSC already had proven itself the best equipped to handle a coordinated relief effort. Just three days after the battle of Antietam, he reported, the USSC had more than forty agents distributing supplies to the wounded—everything from clothing and food to medicine and medical supplies.[26]

Olmstead's call for a centralized war relief effort orchestrated by a certain class of men epitomized the ethos shared by officers of the USSC. As historian George Fredrickson explained, the sanitary commissioners espoused a "social philosophy" that envisioned a highly conservative government and society. Bellows and his contemporaries were concerned that the outbreak of war might exacerbate tensions between classes, and they hoped to use their affiliation with the USSC to exert the dominant influence of the upper classes over the masses, including soldiers. According to Fredrickson, Sanitary Commission officials saw their work not only as a duty, "but as a heaven-sent opportunity for educating the nation."[27] Even the positive impulses of Good Samaritans needed to be tamped down in favor of organized, efficient relief coordinated through an elite body of men who envisioned an American society in which the upper class retained its ability to define the boundaries of acceptable behavior.

In addition to this important class dimension, the work of the USSC divided along gendered lines. Most of the USSC's five hundred paid workers were male; many of its thousands of citizen volunteers were women.[28] In his April 9, 1864, *Harper's Weekly* illustration Thomas Nast dubbed the Sanitary Commission's female volunteers "Our Heroines," and included celebratory imagery of women tending to wounded soldiers at home and on the front, as well as sewing uniforms and selling wares to raise funds for relief. Such depictions of women were a pervasive aspect of Civil War visual culture.[29] Women and men reaped different benefits from their war relief work, and they entered into association with the USSC with different intentions. As historian Judith Giesberg has shown, relief work helped to create "a new political culture for women," which included "access to political decision making."[30] Indeed, histories of the USSC have revealed deep tensions between some of the most active women in the commission and the men who held offices in the organization. Nevertheless, men and women alike who led USSC were motivated by patriotism, even as many of them hoped to solidify their social standing and to shape society in ways that they desired.

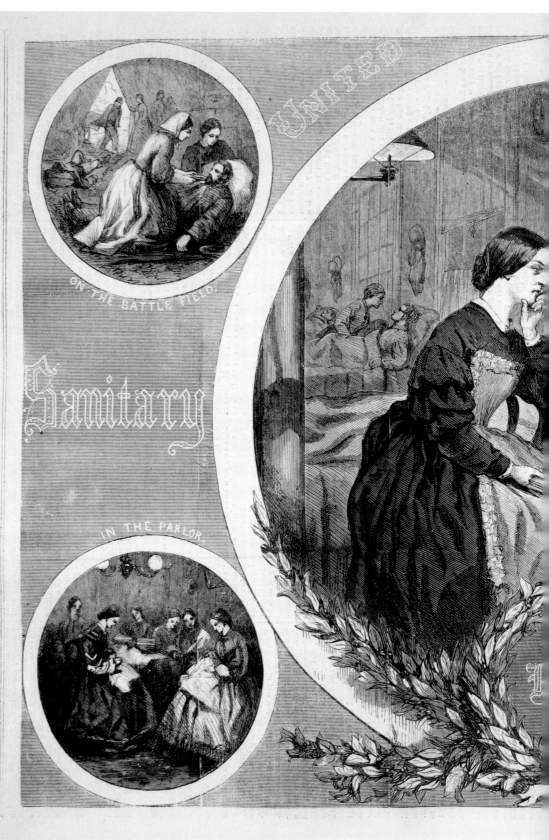

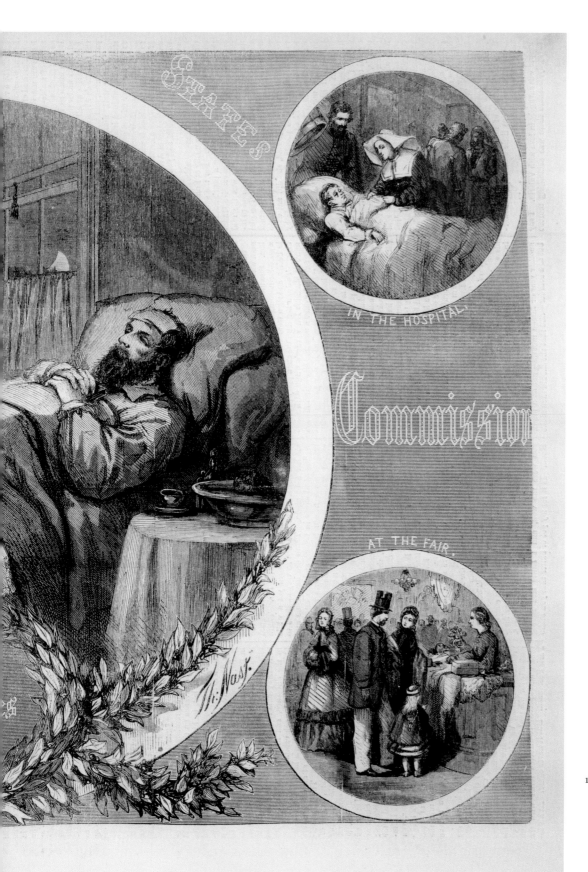

FIG. 46.
Thomas Nast, "Our
Heroines," *Harper's
Weekly,* April 9, 1864.
16 × 10 1/2 in. Newberry
folio A5.392 v. 8.

Some men and women who spearheaded relief work had similar responsibilities and experiences. Just like Blatchford, a number of women who were associated with the USSC visited training camps and hospitals close to sites of battle. They became firsthand witnesses to the devastation of war and the needs of the troops. And they traveled back home with this information, using it to raise awareness, supplies, and funds for the Union war effort. The physical distance between the home and the front was fluid, of course, because fronts moved throughout the course of the war. Yet, as the work of the Sanitary Commission reveals, this distance frequently was bridged by the flow of people, information, and goods of war relief.[31] The work of the Sanitary Commission reveals not only the gendered dimensions of war relief, then, but also the deep connections between the home and the front, both physically and emotionally.

◆ ◆ ◆

Although he held the office of treasurer, rather than president, Blatchford did more than any other man in Chicago to ensure the success of the Sanitary Commission locally. By 1860, Blatchford had become a well-known businessman and civic leader in Chicago, where his family had lived intermittently for over twenty years by the time the war began. Indeed, Blatchford's family had early, if not continuous, roots in Chicago. In 1837, the family set out from Stillwater, New York, to Chicago when John Blatchford, E. W.'s father, became pastor of Chicago's First Presbyterian Church. Chicago was incorporated the year the Blatchfords arrived. After completing his schooling at Illinois College in Jacksonville, E. W. Blatchford worked as a clerk for his uncle's law firm in New York City. He knew little of the lead business at this time, but earned the confidence of Samuel G. Cornell, who entrusted Blatchford to open a branch of Cornell's Lead Manufacturing in Saint Louis. Blatchford moved back to Chicago in 1850 to observe the Chicago offices of Cornell's firm and learn the trade. "Chicago was not to me, at this time, an attractive City, but it had 'great expectations,'" Blatchford recalled.[32]

Blatchford's own firm—Blatchford & Collins—succeeded quite well, a fact he attributed not to his own acumen but to "guiding Providence."[33] The company produced lead pipe and sheet lead, dealt in pig lead and bar lead, and employed about forty laborers by 1858. Shortly after settling in Saint Louis, Blatchford earned a reputation for honorable and fair business dealings.[34] Though he was raised the son of a Presbyterian clergyman, Blatchford in his adult life became a Congregationalist. As his comment about guiding Providence suggested, religious convictions structured his life, especially his charitable works. While in Saint Louis, Blatchford helped to organize that city's branch of the Young Men's Christian Association. He also turned his attention to "Americanizing" immigrant laborers who came to Saint Louis during the 1850s.

Despite developing a deep attachment to Saint Louis, Blatchford returned again to Chicago in 1854. The city would remain his home until his death in 1914.

Just as he explained his move to Saint Louis by citing the influence of God's plan for him, he acknowledged the "providence of God as a directing element which was leading me on" to Chicago. Yet Blatchford also attributed the move north to his antislavery sentiment. "An increasing appreciation of the burden which rested upon City and State deepened by daily scenes of inhumanity on land, and river, was a constant reminder of the underlying wrong, which gave a touch of instability to even the best elements in church and Christian life and effort," he recalled in the early 1910s. Finally, the concerns of profitability drove Blatchford north. "For lead pipe the demands [*sic*] in the South was quite a limited one," he admitted.[35] Citing both divine providence and the practical considerations of business brings into focus the constant presence of both God and profit in Blatchford's life. Yet, any tension between religion and business seems to have motivated Blatchford to work in a deeply committed manner on both fronts, as he found success both producing lead used in fighting and organizing the charitable work that aided the wounded.

Blatchford would claim that his experiences in Saint Louis in the early 1850s provided him with better perspective than other Northerners had about the coming conflict. "The ominous relations between North and South foreboded more to me than to many," Blatchford wrote.[36] He left the South with lingering concern about the ways in which slavery was impeding the region's progress. When explaining this move, he cited the inhumanity of slavery just as often as the economic problems that slavery created for the region.

Even though the rising tensions between North and South were palpable to Blatchford in Chicago in early 1861, he was not fully prepared for what he found when he traveled to Washington, DC, that winter. He went to the capital to inquire about business opportunities in February 1861, a period of great anxiety about the nation's future that came between Lincoln's election in November 1860 and his inauguration the following March. While he was in Washington, Blatchford met with John Dahlgren, who commanded the Washington Navy Yard.[37] During their visit, Blatchford came up with the idea of manufacturing lead wire to fit federal weaponry. Blatchford's samples were soon approved by the Department of War, and he went on to supply the Washington Navy Yard as well as many arsenals with lead wire carefully wound on reels.

Blatchford's travel to Washington, in addition to being lucrative, was revealing of the coming storm. As he remembered, "We there found ourselves in a city of intense political and personal excitement, for which we had hardly been prepared. Resignations of Southern members of the Senate and House were frequent, their impressive farewells being uttered in language most threatening and exasperating." Working his way further south to Richmond, Virginia, on the same trip, Blatchford observed that the Tredegar Iron Works operated at full capacity to manufacture guns, cannon, and artillery. When he inquired about the purpose of the breakneck pace of manufacturing these supplies, he was told that they were being made on orders from the Carolinas and other Southern states. Blatchford returned to

Washington deeply distraught, and reported being "burdened with a new estimate of the gravity of the real conditions of our country, a heavy burden in which very many did not then sympathize."[38]

This travel to the political front also deepened Blatchford's love of country, as would his travel to battle fronts during the war years. Upon returning to Washington from a side trip to Annapolis, Blatchford recalled the moment he saw the Capitol Building, then in the midst of a massive expansion, as his train entered the city. He described a "brilliant sunset" that "shone upon the flag waving from its lofty dome." Then, Blatchford recalled, the moment overcame him. "I was alone in the car and did not control the tears that fell as I realized as never before the meaning at this hour of this emblem of liberty, of the safety of our capital." Although he would travel abroad frequently following the war, and always would be moved by seeing the American flag fly in foreign lands, it would never strike him with the same "mingled emotions with which I gratefully greeted it on that sunset evening."[39]

By traveling to the nation's political center, a new borderland where he crossed lines between North and South, Blatchford became privy to experiences and information that many of his fellow Chicagoans did not share. Much of his concern focused on the severing of railroad connections that made travel in early 1861 perilous, even before the war began. The idea that the nation's rail connections could be interrupted caused Blatchford great anxiety. He had imagined the nation to that point as increasingly unified and connected. The relative ease with which he had once traversed the nation was no longer possible in 1861, as regional tensions began to hinder movement in noticeable ways. He returned to Chicago carrying these concerns about the nation's future with him, and he would pass this information to some of his fellow Chicagoans prior to the onset of war.

Blatchford was six weeks shy of thirty-five years old when the fighting commenced. He expressed a sense of "duty and privilege" in serving the Union as well as a "desire to bear personally some active part in the struggle."[40] This activity would not come as a soldier or officer, however. Blatchford cited family circumstances, including an ailing mother, for his desire to remain at home during the war. He coupled this with the knowledge gained from meeting with Dahlgren and other government representatives that his business of lead production could serve the war effort. Though there is no way to be certain, it is plausible that the potential for wartime profit from the sale of lead also might have motivated Blatchford's choices. There is little doubt that Blatchford's association with the USSC satisfied a passion for service that emanated from his convictions as a Christian and eased whatever doubts about not serving in battle might have lingered for him during the war.

Blatchford was involved with the USSC's Chicago Branch from its founding, serving as an officer of the board, raising funds, and traveling on behalf of the board to inspect the conditions of soldiers' care. One of Blatchford's first important contacts with soldiers came during the summer of 1861, when he visited

Springfield, Illinois, to witness encampment grounds where Ulysses S. Grant was training troops. In late April 1861, Illinois governor Richard Yates had asked Grant to oversee the creation of four new Illinois regiments.[41] While in Springfield, Blatchford learned firsthand about the needs of newly enlisted troops. Even during this first month of the war, Blatchford claimed to have known that relief efforts at home would be critical. Thoughts of the soldiers pervaded many homes, Blatchford reported. "Mothers, sisters, and wives, were aroused," he wrote, "and with tender solicitude, asked the question, 'What can *we* do for them?'"[42]

In these early days of the USSC, Blatchford also interacted with women who coordinated the fund-raising and relief activities of the Chicago Branch. The two most influential were Mary Livermore and Jane Hoge. Livermore, born Mary Ashton Rice, moved to Chicago in 1857 with her husband Daniel Parker Livermore, a Universalist minister. She dedicated much of her life's work to philanthropy, especially focusing on women and children's health prior to the war. Livermore also was a writer, publishing short stories that supported temperance as early as the mid-1840s. As the associate editor of the Universalist newspaper *New Covenant*, Livermore was the only woman to cover the Republican convention in Chicago in 1860, during which Lincoln was nominated. In addition to her work as an author and editor, she would become one of Chicago's most important voices for the causes of antislavery, women's suffrage, women's rights, and temperance.[43]

Despite tensions between the male and female members of the Sanitary Commission, Livermore thought highly of Blatchford. "I shall always congratulate myself that the work of the Sanitary Commission brought me into association with Mr. Blatchford," Livermore wrote in 1887.[44] She praised him as prompt, courteous, patient, and kind, while noting that his devotion to the commission never wavered even when he had his own pressing business interests.

Jane Currie Blaikie Hoge came to Chicago from Pennsylvania in 1848 and became involved in charitable causes in 1857. A mother of thirteen children (eight of whom survived infancy), Hoge focused her charitable work on serving orphans and finding refuge for women and children. Two of her own sons enlisted in the Union Army; one became a colonel in the 113th Illinois Volunteer Infantry. After the war, she worked closely with Frances Willard in Evanston to found the Evanston College for Ladies (which later merged with Northwestern University) and, from 1872 to 1885, served as president of the Woman's Presbyterian Board of Foreign Missions.[45] Her 1867 book, *The Boys in Blue*, chronicled her work with the US Sanitary Commission, as did Livermore's 1887 book, *My Story of the War*.

FIG. 47.
A. N. Hardy, "Mary Ashton Rice Livermore, ca. 1876." Albumen silver print, 3 5/16 × 2 5/16 in. (10 × 5.9 cm). National Portrait Gallery, Smithsonian Institution, NPG.81.71.

Livermore and Hoge were acquainted by the time the war began. Almost as soon as it commenced, the two took responsibility for aid efforts of local relief agencies in Chicago. While working together to nurse soldiers at Camp Douglas in Chicago in 1861, they helped to organize a branch of the USSC. In December 1862, they became the associated directors of the branch. Like Blatchford, Livermore and Hoge would travel to Washington, DC, to speak with government officials about war relief. They met with President Lincoln in November 1862 to brief him on their work. Livermore and Hoge also would travel to the front at least three times during the war to inspect the conditions of hospitals and others arenas where wounded soldiers received care. Based on their experiences at these sites, they made recommendations to the USSC and helped to chart the course of war relief.

In the days immediately following the Battle of Fort Donelson in mid-February 1862, for example, Livermore and Hoge were consumed with collecting supplies and packing them to be shipped to troops. "It became evident," Livermore later explained, "that the tide of war was setting towards other large battles," and "Mrs. Hoge and myself were sent to the hospitals and to medical headquarters at the front, with instructions to obtain any possible information, that would lead to better preparation for the wounded of another great battle."[46]

Many of the Union troops wounded at Fort Donelson had been taken to military hospitals in Saint Louis, so Livermore and Hoge went there first. Livermore remembers that she and Hoge traveled south in the company of "recently formed regiments," further blurring the lines between those involved in relief efforts and those who fought at the front. Livermore boasted, in fact, that she immediately recognized the most inexperienced. "We could easily distinguish soldiers who had 'been under fire' from the new recruits," she wrote. Livermore clearly placed herself in the camp of the war tested. The war weary traveled "in a grim silence," while new recruits acted in what Livermore considered to be an overly boisterous manner. Livermore knew that this "first rollicking enthusiasm of ignorance" would soon give way to the "desperate purpose" shared by experienced soldiers and relief workers alike.[47]

Even though she considered herself much more seasoned than a new recruit, Livermore's first visit to a military hospital took her aback. "The sickening odor of blood and healing wounds almost overpowered me," she remembered. One of her first tasks was to assist a soldier who had lost his jaw and his tongue. While helping this wounded man, Livermore became so distraught that she had to leave his bedside three separate times while the surgeon examined him. "The horrors of that ward," Livermore would write, "were worse than anything I had imagined."[48] In this comment, Livermore reminds her readers, perhaps inadvertently, about

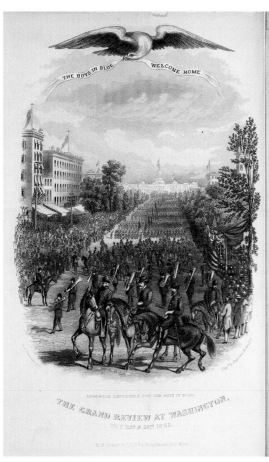

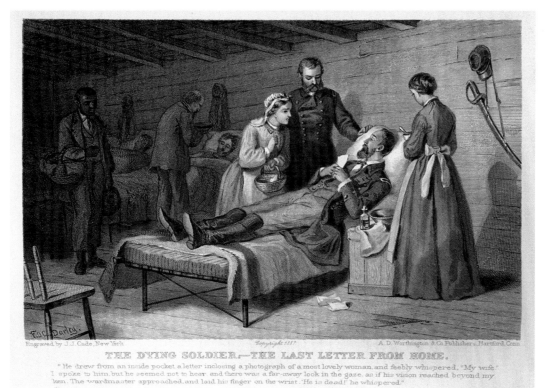

FIG. 49.
Jane Currie Blaikie Hoge,
*The Boys in Blue; or, Heroes
of the "Rank and File,"* New
York: E. B. Treat & Co.;
Chicago: C. W. Lilley, 1867.
Book, 9 × 5 7/8 in.
Newberry F8344.4.

FIG. 50.
"The Dying Soldier: The Last
Letter from Home," Mary
Livermore, *My Story of the
War*, Hartford, CT: A. D.
Worthington, 1889. Book
illustration, 8 5/8 × 5 1/2 in.
Newberry F8344.51.

the distance between the home and the front. Reading about military hospitals in newspaper coverage of the war paled in comparison to a visit. She was overcome by firsthand witnessing and, especially, by the smell of the hospital, which she referred to often in her memoirs. The sensation of smell could not be easily conveyed in print, but it did return with Livermore to the home front in her experiences, which she shared widely.

In addition to opening a conduit for the flow of information between home and front, these visits led to specific initiatives on the part of the Sanitary Commission. Livermore and Hoge traveled to Mississippi in February 1863, where they visited General Grant's army. There, they met multiple times with Grant himself and discussed the struggle to provide nutritious food and clean water for troops. Livermore returned home to Chicago motivated to collect fresh fruit and vegetables for troops so that they could ward off scurvy.[49] By July, the Chicago Branch sent more than eighteen thousand bushels of fresh fruit and vegetables as well as sixty-one thousand pounds of dried fruit to the soldiers.[50]

The two women also learned that some tragedies of the war could not be solved, only witnessed. Livermore and Hoge departed Mississippi with twenty-one soldiers who had been discharged because of the severity of their wounds. One soldier died in transit, and a second died as soon as they reached Chicago. A third missed his train connection out of Chicago, and Livermore helped settle him in a hotel. She left for no more than a few hours, primarily to telegraph the boy's mother the information that her son was on his way home. When she returned to his bedside in the hotel, Livermore found that the young solider had died. The

Daniel Greene

FIG. 51.
"The Patriot Mother at Her Boy's Grave," *The Soldier's Casket*, Philadelphia: Ch. W. Alexander, 1865. Magazine illustration, 9 1/8 × 6 in. Newberry F834.0075 v. 1.

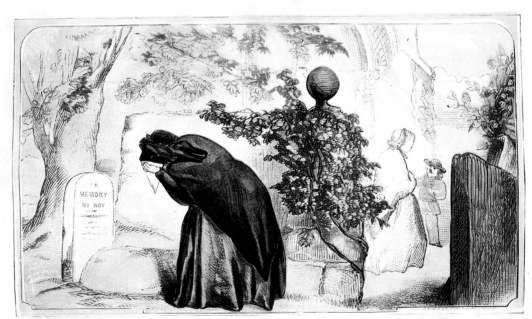

THE PATRIOT MOTHER AT HER BOY'S GRAVE.

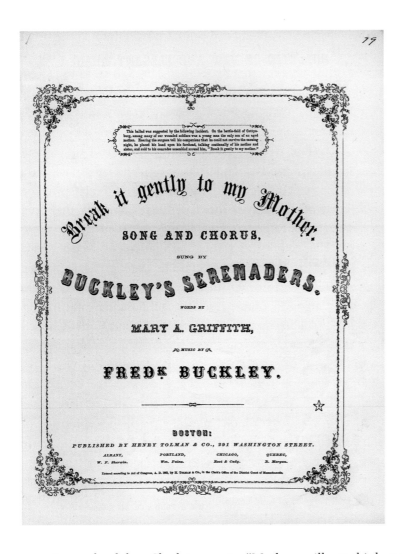

FIG. 52.
Mary A. Griffith and F. R.
Buckley, *Break It Gently to
My Mother*, Boston: Henry
Tolman & Co., 1863.
13 × 9 3/4 in. Newberry
Case 8A 309, James Francis
Driscoll Collection of
American Sheet Music, gift
of the Driscoll Family.

experience shook her. She later wrote, "Mothers will not think me weak when I confess that I closed the door and locked it, and then wept long and bitterly over the dead boy—not for him, but for the mother whose youngest child he was. He has so longed for his mother, this boyish twenty-year-old soldier!" A day later, the boy's mother came to Chicago to retrieve his body. She bent over him, Livermore reported, and "wrestled with the mighty grief," trying to find comfort in the fact that he had given his life for his country.[51] Livermore had experienced what would become one of the most important tropes of Civil War culture, that of a mother weeping over her fallen son. Popular images of mother's standing over their son's graves as well as song titles expressing the grief of lost children and their mothers became pervasive during the war.

Visiting the front and traveling with gravely wounded soldiers convinced Livermore and Hoge that home-front relief efforts needed to be redoubled. In December 1861 the two women had organized a bazaar that netted $675 for war relief.[52] By 1863, they devised the creative idea of holding a much more ambitious fair in Chicago to raise money. These sanitary fairs would be copied in many cities across

the North—Boston, Rochester, Cincinnati, Brooklyn, Cleveland, Pittsburgh, and elsewhere—between 1863 and 1865.

Chicago would remain notable for staging the first fair, known as the Great Northwest Fair, in October 1863 and the last, the Northwest Soldiers' Home Fair, in May 1865. According to historian Beverly Gordon, Chicago's 1863 fair "created a stir throughout the Union and functioned as a turning point—a kind of sea change—in the way women's fairs were perceived and operated in the nineteenth century."[53] Chicago's post offices, courts, schools, factories, and shops closed on the fair's opening day in October 1863. The *Tribune* noted that the fair was the "principal topic of conversation" throughout the city.[54] On opening day, the paper reported, "Yesterday will never be forgotten either in the city of Chicago, or in the West."[55] Visitors to Bryan Hall could walk through exhibitions of livestock, produce, and machinery. Military drills for show occurred throughout the day. Music was played almost continuously throughout the fair. The art gallery drew thousands of visitors. The fair's large restaurant served three thousand people in a sitting. The fair cost about $11,000 to mount. Livermore and Hoge initially hoped to raise $25,000 for war relief; by the conclusion of the fair, the proceeds totaled more than $78,000.[56]

Just as with the USSC itself, men held the officers' seats on the fair boards, but the day-to-day operations fell to women. Livermore reminded readers of her 1887 memoir that the fair was an "experiment" almost entirely the "enterprise of women." Men doubted that the fair would succeed and only "atoned for their early lack of interest" once it became clear just how successful the fair would be.[57] The male leaders of the commission praised women's efforts in staging these fairs, but not without some reservation and condescension. Henry W. Bellows, the USSC president, wrote to Livermore and Hoge on October 29, 1863, to decline their invitation to attend the fair: "I cannot sacrifice the claim of dying parishioners who bind me to their bed-sides at this moment with the sacred cords of duty and affection." Bellows's metaphors reveal a gendered bias, as he expressed full confidence that the women who organized the fair, "will bake it into the biggest batch of Union bread the world ever saw, and invite all honest hearts from all oppressed nations to come and eat at her hospitable board, beneath the glorious Stars and Stripes of a vast American nationality." Women across the nation had "given their husbands, their sons, their lovers and brothers, with a generous abnegation of all their own interests, to the army and the cause, with a heroism that cannot be surpassed even by those they have sent," Bellows wrote. He likened this to a "great quilting party," in which women sacrificed their own quilts and blankets from their own homes for the Union effort.[58] Like so many of his male colleagues, Bellows sought to box female volunteers into the role of glorified homemakers and nurturers, even as he recognized how they had crossed boundaries that separated the home from the war.

One of Livermore and Hoge's greatest feats at the first fair was convincing President Lincoln to donate for auction his handwritten final draft of the Emancipa-

tion Proclamation—issued only ten months prior to the fair. On October 11, weeks before the fair opened, Livermore requested that Lincoln send the Emancipation Proclamation to the fair organizers. She assured the president that the document would be preserved by a worthy trustee: "We should take pains to have such an arrangement made as would place the document permanently in either the State or the Chicago Historical Society. There would seem great appropriateness in this gift to Chicago, or Illinois, for the benefit of Western soldiers, coming as it would from a Western president."[59] Lincoln responded on October 26, including with his letter the draft of the proclamation. The decision does not appear to have been a simple one for him. "I had some desire to retain the paper," Lincoln wrote to Livermore, "but if it shall contribute to the relief or comfort of the soldiers that will be better."[60] Chicago newspapers celebrated Livermore's coup.[61] There is no doubt that securing Lincoln's handwritten copy of the Emancipation Proclamation was a boon to fund-raising. The document, exhibited at Bryan Hall during the fair, fetched $3,000, the highest price of any single item. It was placed on deposit at the Chicago Historical Society, where it remained for only eight years, lost when the society's building burned in the October 1871 Chicago fire.

The Great Northwest Fair closed on November 7 with appropriate ceremony. On the final day, the fair organizers hosted a dinner for soldiers who were convalescing at the Soldiers' Home in Chicago as well as those who stationed at Camp Douglas, three and half miles south of the city center.[62] Livermore reported emotionally on this event, noting that young men who had lost arms or legs filed in on crutches, or leaning on others who were more able, as onlookers waved flags and cheered their service. Following remarks by clergy, "All stood in solemn silence," Livermore wrote, "with uncovered heads, while the band wailed a dirge for those to whom God had granted discharge from the conflict, and promoted the ranks of crowned immortals." After the moving tribute to soldiers, a second dinner was held to fete the women who organized the fair. Livermore more lightheartedly recounted the men's attempt to serve those women who had been doing all the serving throughout the fair. Most women, according to Livermore, received "a baptism of oyster soup or coffee" as "gentleman waiters ran hither and thither like demented men, colliding with each other."[63] The effort, however comic, to acknowledge what the women had accomplished was deeply appreciated by Livermore and her colleagues after their many months of hard work. A special resolution acknowledged the "untiring zeal, industry and effort" of Livermore, Hoge, and their colleagues.[64] According to Blatchford, Livermore's and Hoge's names became "household words throughout the country" as a result of the fair.[65]

The fair had deep and lasting effects. It became a model for more than a dozen other sanitary fairs staged around the North during the war to raise funds for soldiers and relief efforts. At least one fair to benefit freed slaves—the North-western Freedmen's Aid Commission's North-western Epicurean Fair of December 1864—modeled itself on the Great Northwestern Fair and raised $10,000 to support black soldiers.[66] Politics entered the mix at what the *Tribune* and other Chicagoans

commonly referred to as the "Freedmen's Fair." Every visitor was asked to sign a petition to repeal the Black Laws, which prohibited immigration into Illinois by blacks and marriages between blacks and whites.[67]

Even as she organized the sanitary fairs in Chicago, Jane Hoge continued to visit wounded soldiers as a representative of the USSC. Where Blatchford reported on the efficiency of operations, Hoge tended to tell personal stories to motivate individuals to support the USSC. She always emphasized that the work of the USSC at home was intimately connected to the soldiers' efforts and fully dependent on its desire to support the troops at the front. At an address at Packer Institute in Brooklyn in March 1865, Hoge told her listeners: "The women at home don't think of much else but the soldiers. If they meet to sew, 'tis for you; if they have a good time, 'tis to gather money for the Sanitary Commission; if they meet to pray, 'tis for the soldiers; and even the little children, as they kneel at their mother's knees to lisp their good-night prayers, say, 'God bless the soldiers.'"[68] Thoughts of soldiers, indeed, had entered every realm of the home, from sewing tables to children's bedsides, and were ever present.

By 1865, Livermore and Hoge were planning a second sanitary fair in Chicago. They hoped that the fair would open in February 1865, but the challenges of planning led to a decision in January to postpone the opening until May. Hoge emphasized the fact that the war might end, but the need for relief efforts would not. Amputees and other veterans would still need the support of relief agencies, even after the fighting was over, Hoge stressed. As she later wrote, "The effect of the sudden collapse of the rebellion was damaging to the Fair. It was difficult to convince people that hospitals were necessary, after the war had ceased."[69] In rousing people to support the second fair in Chicago, she spoke of wounded soldiers, of mothers who had lost their sons, and of how impressed she and her colleagues were with the willingness of individuals to sacrifice themselves to the Union's cause. "The shadow of death has passed over almost every household, and left desolate hearthstones and vacant chairs," Hoge said. She likened volunteers to soldiers when she encouraged women to "put on your armor anew" in order to ensure that each "wounded soldier shall be restored to home and friends if he has them; and if not, have a 'Home' provided for him."[70] The necessity of continuing relief efforts after the close of battle would be trumpeted continually at the Northwest Soldiers' Home Fair in Chicago.

When the Northwestern Branch of the Sanitary Commission opened Chicago's second fair on May 30, 1865, the war was over but approximately fifty thousand soldiers remained in hospitals and some regiments still had not returned home.[71] The 1865 fair required the construction of a new building, Union Hall, which covered the entirety of Dearborn Park, at Washington and Randolph Streets. The central exhibition space in the hall stretched 386 feet long and was 60 feet wide, with wings of 44 feet on both sides. The building sported an arched Gothic roof 55 feet high. The Washington Street entrance had circular stained glass windows.[72] A reporter for *Frank Leslie's Illustrated Newspaper* called Union Hall "more extensive and in point of design, more beautiful than any structure ever raised for the same

FIG. 53.
"Exterior View of the Great North-Western Sanitary Fair Building, Chicago, Ill.," *Frank Leslie's Illustrated Newspaper,* July 8, 1865. Magazine illustration, 6 × 21 1/4 in. Newberry oversize A5.34 v. 20.

FIG. 54.
"Interior View of the Union Hall, North-Western Sanitary Fair Building, Chicago, Ill.," *Frank Leslie's Illustrated Newspaper*, July 8, 1865. Magazine illustration, 10 × 13 in. Newberry oversize A5.34 v. 20.

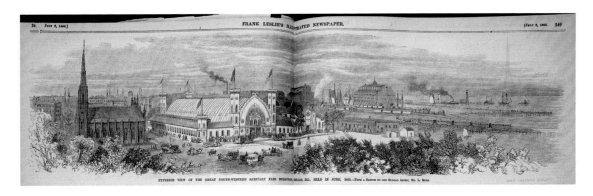

EXTERIOR VIEW OF THE GREAT NORTH-WESTERN SANITARY FAIR BUILDING, CHICAGO, ILL., HELD IN JUNE, 1865.—From a Sketch by our Special Artist, Mr. L. Hume.

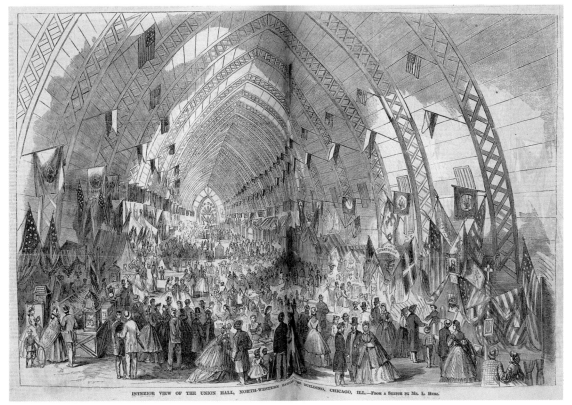

INTERIOR VIEW OF THE UNION HALL, NORTH-WESTERN SANITARY FAIR BUILDING, CHICAGO, ILL.—From a Sketch by Mr. L. Hume.

purpose in this country."[73] In the end, the fair's receipts would total $325,000, a significant sum that was intended to fund relief for wounded veterans as well as relieve the debts of the Sanitary Commission.

Like the 1863 fair, the 1865 fair had significant connections to President Lincoln. The organizers of the fair claimed to have secured for display the log cabin built by Lincoln during his childhood in Hodgenville, Kentucky. The *Voice of the Fair*, a newspaper issued on the fairgrounds, reported on June 3: "The veritable Lincoln log cabin, built by Lincoln and Hanks, and identified by Governor Oglesby, will be exhibited on the corner of Lake street and Wabash avenue, during the Fair; for the benefit of the general fund."[74] Lincoln's log cabin surely did not exist by the time of the sanitary fair, nor could it have been identified definitively if it had, but it made a nice story for the papers.[75]

CHICAGO, SATURDAY, APRIL 15, 1865.

TTAWA.

upreme Court.

e Chicago Tribune.]
TTAWA, April 14, 1865.
ons as follows: No. 66,
error granted; No. 155,
overruled.
ere then entered: No
ppelee's cost allowed
or non-joinder allowed;
: to strike plea, and affi-
om the files; motion by
lea; No. 115, motion to
o. 166, motion to set
73, motion to have the
kenson struck from the
Northern Illinois Coal
to place cause on hear-

re submitted on briefs
4 by plaintiff in error
efendant in error; No-
ellant; No. 126 by both
ce.
led. No. 196 was taken
y Puterbaugh for plain-
No. 203 submitted by

ket is now concluded.
sit to hear cases taken
Monday the second call
e proceeded with at the

NGFIELD.

**, Robb's Move-
ion of Regiments
ion—Refugees—An**

e Chicago Tribune.]
GFIELD, April 14, 1865.
ave died at Camp But-
l 8th, viz: George W.
Aaron Foster, Hugh
inois volunteers; Wm.
d William White, 24th
n, 7th Illinois cavalry;
is infantry; Henry Wal-
y, and D. M. Topping.
mortality at that camp,
e result is mainly due to
Director, Surgeon H. B.
urgeon Wm Sturgis.
y State Agent for Illi-
y days furlough to at-
ness, has, after a press-
State Sanitary Commis-
en. Sherman's army to
unded Illinois soldiers.
m $1,000, and is empow-
required.
of troops at Camp Fry
65th regiment of Illinois
dered to join the regi-
e.
ved by Gen James Oakes

POSTSCRIPT.

4 O'CLOCK A. M.

TERRIBLE NEWS

President Lincoln Assassinated at Ford's Theater.

A REBEL DESPERADO SHOOTS HIM THROUGH THE HEAD AND ESCAPES.

Secretary Seward and Major Fred Seward Stabbed by Another Desperado.

THEIR WOUNDS ARE PRONOUNCED NOT FATAL.

Full Details of the Terrible Affair.

UNDOUBTED PLAN TO MURDER SECRETARY STANTON.

Very Latest---The President is Dying.

of secession procl
would be unjust t
evidence of his gui
that the person allu
The la est advice
veals more desperat
posed. Seward's w
fatal, but in connect
and the great loss o
sidered doubtful.
It was Clarence A.
Seward, Jr., who
was also badly cut,
who were in attenda
ing that a desperat
but not fatally. T
were dressed.

WASH
I have just visited
Lincoln. He is no
his physicians say
hour.
He is surrounded
net, all of whom a
Sumner is seated or
which he is lying, t
cheeks, and so
around him are his
Barnes is directing
conscious, and the
by the movement
raises feebly.
Mrs. Lincoln and
joining room, into
just gone to infor
physicians have pr
As I pass throug
I hear shrieks and
in which the grief-
seated.
We obtain from
following account
half past ten o'clock
and hat, entered
Lincoln and his pa
Miss Harris, da
and Captain
were seated.
ing the door
Lincoln, with a si
hand and a bowie-
The President,
did not notice his
who was seated be
reason of his entr
the assassin what
from his revolver,
of the President's
and came out at
bone, who was in
tempted to arrest
received a shot i

Though we should not trust the legends surrounding Lincoln's log cabin, Livermore and Hoge did succeed in convincing Lincoln himself to visit. A February 26, 1865, issue of the *Tribune* announced: "President Lincoln Coming to Fair: He Will Probably Inaugurate Sanitary Fair."[76] As the Northwest Soldiers' Home Fair neared, anticipation of Lincoln's first trip to Chicago during his presidency was reported with increasing excitement. By April, USSC officials had been informed through a reliable source that President Lincoln and Mary Todd Lincoln had every intention of being in Chicago to inaugurate the fair. On April 14, 1865, a *Tribune* headline read simply: "President Lincoln Coming." That very evening, Lincoln was shot at Ford's Theater; he died the following morning. Rather than welcoming Lincoln back to the city where he had been nominated for the presidency, the fair became a tribute to him as a fallen martyr. The inaugural issue of the *Voice of the Fair*, printed two weeks after Lincoln died, placed his portrait front and center. It described the entire nation as "draped in mourning" over Lincoln, the "Savior of his country." Lincoln "lives, immortal, in the hearts of his countrymen, and the good in all countries and all climes," the paper eulogized.[77]

Livermore and Hoge and their USSC colleagues, including Blatchford, mourned. Even fifty years after the fair, Blatchford remembered sadly the lost opportunity to welcome Lincoln to Chicago. The final line of Blatchford's unpublished memoir, which he completed during the early 1910s, reads, "The crowning event of the Fair was to have been the presence of Mr. Lincoln, his first visit to his own State since he left for Washington."[78] The memoir ends there abruptly. One can only speculate on why. Blatchford died in 1914; perhaps he did not have enough time to write all that he wanted. Or, perhaps the memoir ends with Lincoln's death in 1865, and says nothing about the following fifty years of Blatchford's life as one of Chicago's important citizens and philanthropists, because the loss of Lincoln remained so devastating even at such a temporal distance.[79]

FIG. 56.
US Sanitary Commission Lapel Badge and Pin, ca. 1861–65. Artifacts, 5 3/4 × 4 in. (badge), 2 1/4 × 1 1/4 in. (pin). Newberry E. W. Blatchford Papers, box 8, folder 219, gift of the heirs of Eliphalet Wickes Blatchford.

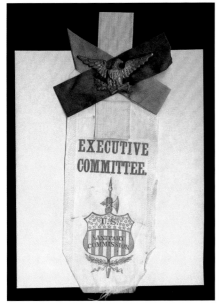
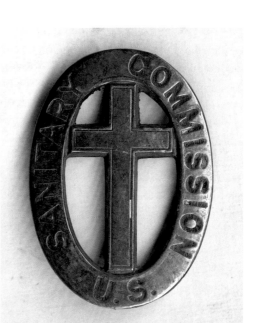

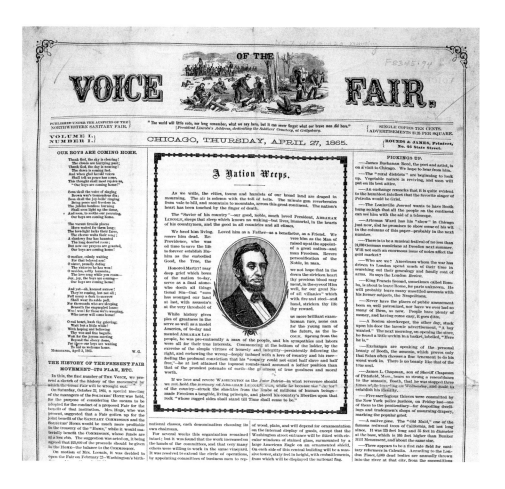

Joy and loss mingled at the fair. Both Generals Grant and Sherman attended the fair, and celebrated the Union victory while emphasizing the need for on-going, postwar relief. Yet Lincoln remained on the minds of the fair goers and the organizers. Next to the portrait of Lincoln on the first issue of the *Voice of the Fair* newspaper sat a poem, "Our Boys Are Coming Home," which celebrated the return of the soldiers from the front. The poem's fourth verse harkened back to a critical trope of home-front culture throughout the war—the connection between mothers and sons:

> O mother, calmly waiting,
> For that beloved son!
> O sister, proudly dating
> The victories he has won!
> O maiden, softly humming,
> The love song while you roam—
> Joy, Joy the boys are coming—
> Our boys are coming home!

The fair organizers emphasized that the effects of war would continue to be felt at home and would require continuing relief efforts. One champion of the

fair's fund-raising efforts explained that cessation of war "leaves a people with their bodies covered with unhealed wounds." The fair's organizers called on both those made "fatherless" by the war as well as "sonless mothers" to assist those in need. They emphasized that those who never saw the front still had their lives inextricably altered by the war, writing: "There is no spot in the North that has not those whom the war has made objects of relief."[80] Although phrased awkwardly, this sentiment motivated the USSC's four-year effort to raise funds and spur relief throughout the war and past its closing days. All soldiers passed through home fronts on the way to battle, and many convalesced in homes of their own or of strangers as well as in hospitals and soldiers' rests during the war and following its conclusion. The USSC aided much of this travel and healing. Its efforts depended on understanding how deeply intertwined home and front were throughout the war, and on recognizing the permeability of the boundaries between the two realms.

SARAH BURNS

Rending and Mending

The Needle, the Flag, and the Wounds of War in Lilly Martin Spencer's Home of the Red, White, and Blue

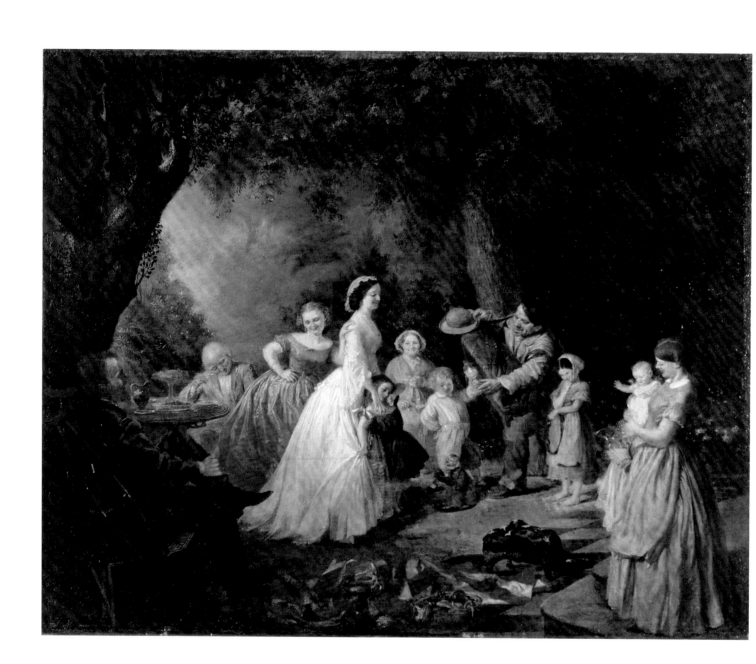

In the spring of 1862, the painter Lilly Martin Spencer penned a long, and long overdue, letter to her parents in Ohio. Far too preoccupied by her shaky career and her ever-growing family to write even as often as once a year, Spencer made up for it by offering a detailed account of her life in Newark early in the Civil War. Lilly and Benjamin Spencer had moved from Cincinnati to New York in 1848 so that she could seek artistic fame and modest fortune. But her career had never taken off, and to save money, the Spencers had moved to Newark in 1858. Now, in wartime, business had dried up almost completely. Only the "utmost economy and industry" had enabled them to make it through the winter. There was so little money that they had "not bought a yard of anything new in the shape of clothing or anything else for nearly three years" but had been "obliged to piece and patch and patch and piece, in order to send the children to school." Even so, Spencer was not discouraged: "When I see the good and just cause of the Union suceeding [*sic*] so well, I feel then hopefull [*sic*] that all good causes will do the same sooner or later." This preamble paved the way for the biggest news of all: "We have just got another baby. . . . I would have told you before but I thought it would only worry you Mother" (the Spencers having already so many mouths to feed). They named the baby Victor McClellan in honor of General George McClellan, since he had been born among "a series of noble victories, that of Yorktown, and of Norfolk, and the blowing up of that ugly nightmare, the Merimac [*sic*]."[1]

Chronicling Spencer's worries, hopes, and fears, this letter offers an intimate glimpse of the war's multifaceted impact on the domestic home front. It reflects a shifting landscape in which life no longer went on as before. Under threat, the Union had become the focus of new and powerful patriotic sentiment that in turn demanded willing sacrifice for a higher cause. Within and outside the home, traditionally feminine domestic chores, sewing above all, were conscripted to the cause as middle-class women stitched shirts and flags, while working-class women in factories and sweatshops produced drawers, uniforms, and cartridge bags by the millions. Women nursed the wounded, spearheaded fund-raising initiatives, ran the family farm, and became increasingly visible in the public sphere. Indeed, their vociferous participation led British diarist George Augustus Sala to ponder the question "whether either ancient or modern history can furnish an example of a conflict which was so much of a 'Woman's war' as this."[2]

But what of the aftermath; what were women's roles to be in the enormous project of reconstituting a shattered society? Pondering the answer to such vital questions, Harriet Beecher Stowe exhorted women young and old to press on with the vital work they had done throughout the war to save "our country." "We have just come through a great struggle," she wrote, "in which our women have borne an heroic part . . . and now we are in that reconstructive state which makes it of the greatest consequence to ourselves and the world that we understand our own institutions and position, and learn that, instead of following the corrupt and worn-

FIG. 58.
Lilly Martin Spencer, *The Home of the Red, White, and Blue*, ca. 1867–68. Oil on canvas, 24 × 30 in. (61 × 76.2 cm). Terra Foundation for American Art, Chicago, Daniel J. Terra Art Acquisition Endowment Fund, 2007.1.

out ways of the Old World, we are called on to set the example of a new state of society,—noble, simple, pure, and religious; and women can do more towards this even than men, for women are the real architects of society." Now more than ever, women must turn aside from fashion and frivolity to put "noble meaning" into the humblest of domestic chores. Even sewing—"the attention to buttons, trimmings, threads, and sewing-silk" that women might once have lavished on their toilettes— could be an expression of patriotism and religion, a labor symbolizing women's power to rebuild the nation.[3]

With its dominating central group of a mother (a self-portrait) flanked by two daughters in a leafy suburban setting, Lilly Martin Spencer's ambitiously allegorical *Home of the Red, White, and Blue* might be the visual equivalent to Stowe's rousing postwar call to action. Mother in lacy white, elder daughter in rose red, and younger in blue with perky red, white, and blue bows on her shoulders, they stand as symbols of female patriotism. Behind them is a grandmotherly woman at work on two pieces of red-and-white striped bunting. The three adults sport gold thimbles on their middle fingers, the mother's pointing directly down to a sewing basket, dead center and closer to the picture plane than any other object. This basket overflows with trimmings, spools of thread, scissors, a pincushion, and loops of tasseled, golden braid. The task at hand, however, is far weightier than sewing buttons on kid gloves or fringe on a stylish bonnet. Lying in disarray on the ground beneath the basket is a large US flag, its stripes severed from the starry blue-and-white canton draped upon a gold-and-purple footstool. It is not clear whether the women are mending a damaged flag or fabricating a new one, but the banner's status as symbol of a nation wounded and still divided is unambiguous. These elements—thimbles, sewing materials, and partitioned flag—add up to what seems at first a transparent message. It asserts that women—tailors rather than architects of society in this instance—have the skill, and the will, to mend a fractured union.

But there are many other elements to reckon with. Behind the women on the left, a grandfather enjoys a dish of raspberries at a table under the trees. Farthest to the left and in shadow sits a bearded man—husband and father—in the uniform of a Union soldier, the crutches propped by his side revealing that he is a wounded veteran. In aggregate, this group represents the long-settled, Anglo-European family unit. On the right side, we see an assortment of strikingly different char-

· 102 ·

Sarah Burns

FIG. 59.
Lilly Martin Spencer, *The Home of the Red, White, and Blue*, ca. 1867–68. Oil on canvas, 24 × 30 in. (61 × 76.2 cm). Terra Foundation for American Art, Chicago, Daniel J. Terra Art Acquisition Endowment Fund, 2007.1. Detail.

acters. A swarthy organ-grinder encumbered by his boxy instrument reaches for a glass of milk carelessly held up to him by a small boy with a mop of yellow curls. A squatting monkey in red offers up his tiny plumed cap to the little girl in blue, who—clutching a coin—nervously shrinks back against her mother's lacy skirt. Standing by the organ-grinder is a barefoot girl with a tambourine. Finally, on the far right is a nursemaid, red hair suggesting her Irish origin. Sturdy and strong, she easily balances a milk pitcher and the youngest child, a postwar baby beribboned in red, white, and blue. Do all these disparate elements reinforce, complicate, or muddle the painting's meanings?

Deploying a roster of types that would be instantly legible to her cultivated, middle-class audience, Spencer's painting presents a postwar landscape of change in which the "American" family stands counterpoised against more recent, conspicuously alien arrivals. With the long-settled "Americans" on the left and immigrants on the right, the composition might amount to a standoff were it not for the proffered milk and, at right, the conjunction of Irish nursemaid and "American" baby, the latter extending a little hand toward the central group as if to assert the possibility of some eventual happy connection among all. That, at least, is the most obvious narrative thread—the war is over; the established Northern family has survived and triumphed; women will repair the nation and stitch together a society rent by war and social upheaval.

But Spencer's allegory is both retrospective and prospective, end product as much as new beginning, the sum of many different parts. It refers to the rich visual culture of the war, which supplied the raw materials of the painter's symbolic vocabulary. It reflects on the experience, moods, tensions, and uncertainties of women's lives during the war years, which so deeply eroded the boundaries between the domestic realm and the wider world, reshaping gender roles in the process.[4] At the same time, it weighs the war's costs and assesses its consequences for women, the family, and American society. Overarching all is the one vital question: it may have been (as diarist Sala put it) a woman's war, but would it be a woman's peace?

At the core of the painting and its multivalent meanings are the women's thimbles, the sewing basket, and the partitioned flag. They transport us back to 1861, when immediately after the attack on Fort Sumter, a tidal wave of flag mania swept the Northern home front. As soon as Lincoln issued the call for volunteers, flags, as war relief volunteer Mary Livermore recalled, "floated from the roofs of houses, were flung to the breeze from chambers of commerce and boards of trade, spanned the surging streets, decorated the private parlor, glorified the schoolroom, festooned the church walls and pulpit, and blossomed everywhere." So great was the clamor for flags that, in flag historian George Henry Preble's words, "The manufacturers could not furnish them fast enough. Bunting [a type of worsted wool most commonly used in flag fabrication] was exhausted." In New York the demand for flags "raised the price of bunting from four dollars seventy-five cents a piece to twenty-eight dollars, and book-muslin, used for the stars, usually worth six to ten cents, was sold for three dollars a yard."[5]

Many of those flags on housetops and steeples, in streets and schools, were the

product of women's industry and their desire for active and public agency in the fight for the Union. Middle-class and elite women in particular laid claim to the flag—and flag making—as the badge of their patriotic fervor. Mere days after Fort Sumter, four generations of Newcombe women together manufactured a thirty-foot flag to hang above a store on Maiden Lane in Manhattan. Even bigger was the "mammoth flag" set up over the central station of the Erie Railroad in New Jersey. Made by women, it was forty-five feet long—the same as the original Star-Spangled Banner. On the other end of the scale, women made tapestry flag needle cases and taught their daughters to make their own tiny "flaglets."[6]

In particular, women both Northern and Southern devoted themselves to the production of regimental flags, which they ceremoniously gave to local companies to take into the field. One such ritual, in Roxbury, Massachusetts, involved a "beautiful silk flag" made by ladies and presented to a Captain Chamberlain's company. During the ceremony, a Unitarian clergyman delivered an address, after which "the flag was placed in Captain Chamberlain's hands by a little girl tastefully dressed in white, trimmed in red and blue."[7] In Richmond, Pennsylvania, ladies formed a society to gather supplies for the Pennsylvania volunteers but interrupted their work to make a "suitable flag" at the request of Captain J. S. Hoard of the Tioga Mountaineers. As Reid Mitchell notes, flag and ritual alike symbolized the "community that sent companies and regiments into the field." The battle flag was the physical tie between home and war, linking the two together across vast distances. Made and remade by so many women's hands for so many regiments, it brought a surrogate female presence into the very theater of war itself.[8]

Flags and femininity more generally shared intimate symbolic as well as material bonds, connections that mass culture reified and circulated widely in various media. In Thomas Nast's "Our Flag," for example, a large central roundel shows the stately figure of Columbia brandishing a voluminous flag, on either side of which black and white Americans kneel and gaze in worship, one woman bringing a fold of its drapery to her lips for a reverent kiss. Directly above this allegorical scene is a smaller roundel, showing a group of women around a worktable assembling a large Union flag. One stitches on the last few stars while, opposite, two others attach red stripe to white. No allegory, this image bears witness to the central role Northern women played in fabricating the flag, that most revered and compelling symbol of the Union. The peacetime quilting bee has become the "flag bee" of war.[9]

The Currier and Ives certificate of the Ladies' Loyal Union League embroiders on the same set of associations. Such certificates were official proof of membership in one of the many loyalty societies organized by women in the North. Like Nast's illustration, this hand-tinted lithographic print emphatically pairs women with the Stars and Stripes. Dramatically unfurling banners flank cameos of Martha Washington and a modern American wife at the top. At left, a woman points to the flag as she sends her soldier off to war, while on the opposite side, a mother uses the flag to inspire patriotic ardor in her children. At the bottom right, women line city streets as a regiment marches by, the flags streaming from windows above

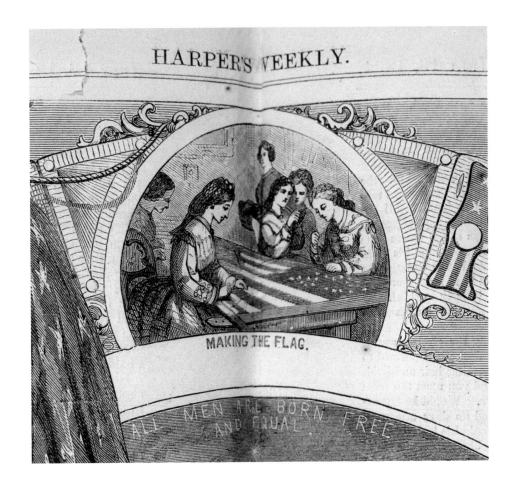

FIG. 60.
Thomas Nast, "Our Flag,"
Harper's Weekly, July 16,
1864. 16 × 21 in. Newberry
folio A5.392 v. 6. Detail.

stitched up, no doubt, by needles, threads, and thimbles from the ordinary domes-
tic sewing basket now pressed into wartime service. Clearly, Lilly Martin Spencer
was no mother of invention when it came to the centerpiece of her *Home of the
Red, White, and Blue.* Rather, she based it on a set of well-established connotations
rooted deeply in the gendered cultural and social practices of the war so recently
ended.

 During the war, however, the tools in that sewing basket would find other uses:
stitching women turned out a great deal more than flags as they labored with
needles or machines to help clothe the Union soldier. Along with flag mania, an
epidemic of "havelock mania" swept through Northern parlors and sewing rooms
early in the war. These linen cap coverings and neck protectors were supposed
to shield the troops from sunstroke in the sultry South. Although the havelocks
soon proved suffocatingly hot and useless for the intended purpose, middle-class
Northern women churned them out in huge numbers. In her diary, New York
blueblood Maria Lydig Daly wrote that she had been busily engaged making have-
locks out of white linen for the Sixty-Ninth New York Regiment, otherwise known
as the Irish Brigade. Abby Howland Woolsey, another New Yorker, wrote in a letter
that she and a friend had between them made six havelocks, adding that there was
a demand for six thousand more. Soon, however, the havelock industry reached
the saturation point: "The poor fellows in the army were so inundated with them

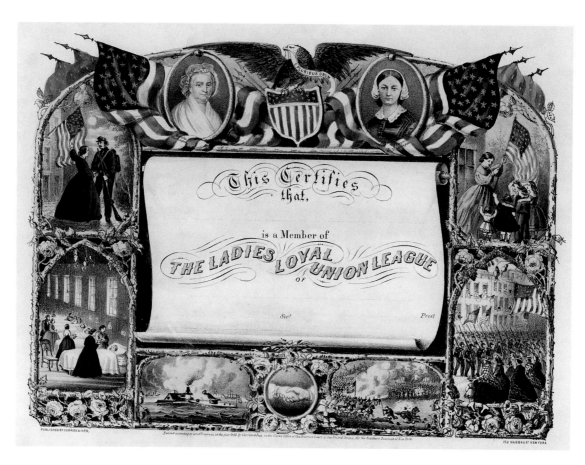

FIG. 61.
Currier and Ives, *Certificate
of the Ladies' Loyal Union
League*. 17 1/2 × 12 3/4 in.
Gift of Lenore B. and Sidney
A. Alpert, supplemented
with Museum Acquisition
Funds, Michele and
Donald D'Amour Museum
of Fine Arts, Springfield,
Massachusetts. Photography
by David Stansbury.

FIG. 62.
Winslow Homer, "Making
Havelocks for the
Volunteers," *Harper's Weekly*,
June 29, 1861. Magazine
illustration, 16 × 10 1/2 in.
Newberry folio A5.392 v. 5.

that those who had the fewest relatives and sweethearts were much the best off," in the words of general's wife Septima Collis.[10]

Winslow Homer documented the havelock fever two weeks after the Confederate attack on Fort Sumter, when "Making Havelocks for the Volunteers" appeared on the front page of *Harper's Weekly*. As emblematic as Spencer's *Home of the Red, White, and Blue*, Homer's image represents a middle-class interior, where several young women in fashionable, bouffant dresses concentrate intently on their task. Two have sewing baskets on their laps, and a larger basket heaped with finished havelocks offers evidence of their collective industry. Looking down on them from the wall at left is the portrait of a mustachioed soldier. His kepi conspicuously lacks a havelock, suggesting the sore need the young seamstresses are striving to fill. Before the war, these young, middle-class women would have been busy sewing and trimming articles of dress for themselves or other members of the family. Their sitting room is sunny and peaceful, as it must have been before. But their new occupation—ostensibly so domestic—tells us that the boundaries between the home and the wider world have already begun to crumble, at the very outset of what would prove to be a long and bloody conflict.

Homer's illustration suggests how the war breached domestic boundaries in other ways as well. The young seamstress on the left has casually donned a kepi identical to that worn by the soldier in the portrait (albeit with havelock added). She wears what would, in color, most certainly be a red, white, and blue cockade

HARPER'S WEEKLY.

A JOURNAL OF CIVILIZATION.

VOL. V.—No. 235.] NEW YORK, SATURDAY, JUNE 29, 1861. [SINGLE COPIES SIX CENTS.
$2 50 PER YEAR IN ADVANCE.

Entered according to Act of Congress, in the Year 1861, by Harper & Brothers, in the Clerk's Office of the District Court for the Southern District of New York.

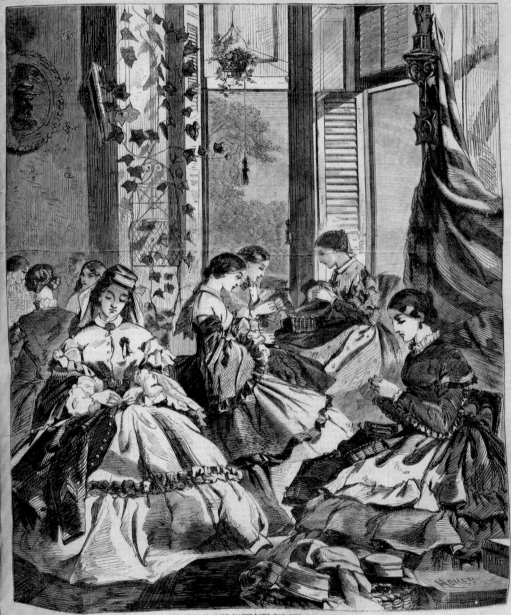

THE WAR—MAKING HAVELOCKS FOR THE VOLUNTEERS.

pinned to her bodice and looks down pensively at the soldier's jacket in her lap; she seems to be sewing on the buttons. Her neighbor to the right stitches on a similar jacket, this one inscribed with the letters "ZOUA"—a reference to the Zouave regiments that conspicuously sported exotic uniforms of tasseled fez, baggy red or blue trousers, and short, tight jackets embellished with curlicues of braid.[11]

The Zouave jacket in Homer's illustration alludes to the militarization of fashion in the early war years. Almost immediately after Fort Sumter, the martial spirit came into vogue, prompting women to indulge in murderous fantasy or to recast their wardrobes along more military lines. "Would to God the war were finished," complained Maria Daly. "I hate to hear the women, gentle-hearted ladies, admiring swords, pistols etc., and seeming to wish to hear of the death of Southerners." In that spirit, women—and fashion magazines—freely adapted the Zouave jacket. Although there was no single authoritative model, a *Godey's* fashion plate illustrating a dress "trimmed en Zouave," exemplifies the type with its bolero cut and ornate braided trim.[12] Arrayed in such martial finery, women became fashion warriors at home.

Kepis, on the other hand—with or without havelocks—never became fashionable; only soldiers wore them. Sporting that explicitly and exclusively masculine headgear, Homer's young seamstress stands out as an anomaly among her more decorously disposed companions. In conjunction with the army jacket on her lap, the kepi bridges the gap between masculine battlefield and feminine home.

Another such figure appears in Spencer's *The Artist and Her Family at a Fourth of July Picnic*. Here, the artist's hefty husband, who has fallen from a broken swing, is the object of derision and concern. At the edge of the commotion stands a young woman, hands rakishly on hips and a sly grin on her face beneath the kepi she has snatched from the head of the Union soldier beside her. Under the guise of humor, the picnic scene alludes to the war's liberating potential in enabling women to bend the rules for proper feminine deportment and to embrace active roles that moved them into erstwhile masculine, public space, just as the war had infiltrated the domestic realm.[13]

For the most part, though, artists figured women performing war work in appropriately feminine fashion. In "Our Women and the War," Winslow Homer portrays a wartime sewing circle, a group of women young and old, hard at work knitting socks and hand-seaming (or perhaps basting) shirts while another operates a sewing machine. In front lies a box labeled "Soldiers' Shirts." A large vignette, this scene anchors a constellation of others representing a nun and a matron nursing the wounded and a laundress in camp, washing shirts under the gaze of an officer and several soldiers leering from the shadows. Acting out conventionally domestic roles, these women have brought the home to the front. The

Sarah Burns

FIG. 63.
"Gored Dress, Trimmed en Zouave," *Godey's Lady's Book,* February 1862. Magazine illustration, 9 3/4 × 6 7/16 in. Newberry A5.375 v. 64.

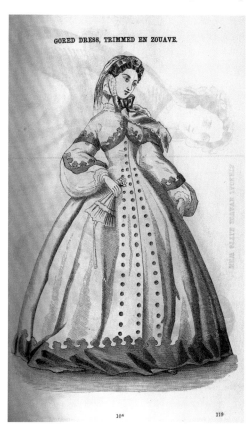

GORED DRESS, TRIMMED EN ZOUAVE.

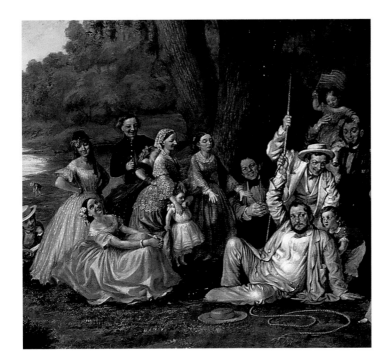

FIG. 64.
Lilly Martin Spencer, *The Artist and Her Family at a Fourth of July Picnic*, ca. 1864. Oil on canvas, 49 1/2 × 63 in. (125.7 × 160 cm). National Museum of Women in the Arts, Washington, DC, given in memory of Muriel Gucker Hahn by her loving husband, William Frederick Hahn Jr., conservation funds generously provided by the Florida State Committee of the National Museum of Women in the Arts. Detail.

women in Homer's sewing circle, for their part, have absorbed the front into the home. They personify the spirit celebrated in an anonymous poem describing how women come together and sit side by side "To fight for their native land, / With womanly weapons girt, / For dagger a needle, scissors for brand, / While they sing the song of the shirt."[14] Likewise armed, Homer's women too are soldiers on the domestic front. At the same time, they are safely within bounds. One cools herself with a decidedly feminine folding fan; there are no kepis to be seen.

Yet the erosion of boundaries greatly facilitated women's movement outside the home, just as the war had moved into it. In vast numbers, women bore their domestic weapons into public and industrial space, where the war exerted its most radical (and radicalizing) impact. Class barriers sometimes fell as together women fought to meet the escalating need for wartime clothing, equipment, and supplies. Mary Livermore recalled the war's early days in Boston, where social and religious elites mobilized hundreds of women to supply five thousand urgently needed shirts to Massachusetts troops in the South. On that occasion, all fetters of "caste and conventionalism" purportedly dropped away, and women of every class toiled in harmony. "The plebeian Irish Catholic of South Boston ran the sewing-machine, while the patrician Protestant of Beacon Street basted—and the shirts were made at the rate of a thousand a day." Abby Howland Woolsey praised Mrs. Lowell of Boston, who, "being a lady of means and leisure, took the Government contract for woolen shirts in Massachusetts and is having them cut and made under her own eyes by poor women at good prices, and the sum that would have gone into some wretched contractor's pocket has already blessed hundreds of needy women."[15]

Such amity was rare. Far more often than not, working-class seamstresses and

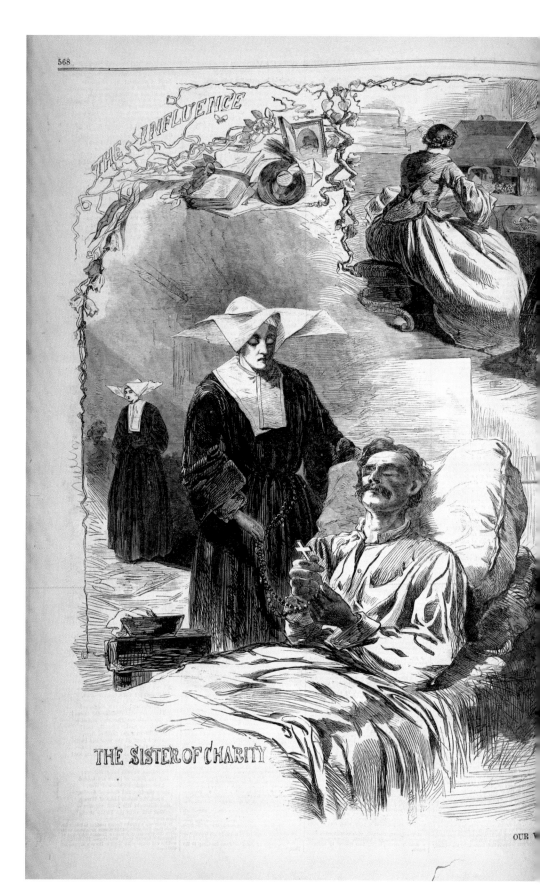

THE INFLUENCE

THE SISTER OF CHARITY

OUR

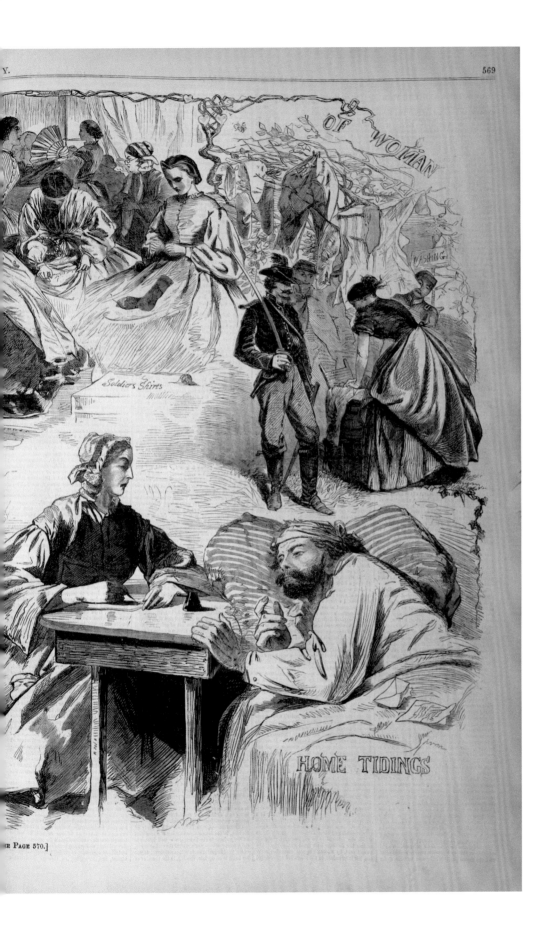

FIG. 65.
"Our Women and the War,"
Harper's Weekly, September
6, 1862. Magazine
illustration, 16 × 10 1/2 in.
Newberry folio A5.392 v. 6.

factory laborers—the rank and file of the army at home—were left to their own devices as they struggled to support themselves and their families while husbands and sons went off to war. The war opened up some one hundred thousand new manufacturing jobs to women in factories, sweatshops, and arsenals. The demand for seamstresses in particular skyrocketed as the military sought to meet the incessant demand for uniforms, shirts, undergarments, tents, bedding, and cartridge bags. The government outsourced much of the work to profit-hungry and unscrupulous contractors, who took advantage of the labor surplus to keep wages low and profits high.[16]

The same conditions affected many other branches of industry as well and led in the fall of 1863 to widespread strikes in New York and other Northern communities. Under the aegis of New York judge Charles Patrick Daley and his wife, the Workingwomen's Protective Union organized to fight for fair wages and improved working conditions. Widely publicized meetings trained a spotlight on the challenges posed by pay so meager and hours so long that it was all but impossible for sewing women to make ends meet. Such activism, which also included petition-signing campaigns, failed to bring about sweeping reforms, but it represented a decisive step in women's organized movement from domestic into public and political space.[17] The war had politicized the homely skills they brought to the marketplace.

Beyond needle and thimble, other domestic weapons also entered the fray. Women rallied to protest the conscription act that Lincoln had signed into law on March 3, 1863, sparking the deadly draft riots that consumed New York on July 12 and 13 of that year.[18] Only days later, a large crowd of women armed with kitchen knives and other cooking implements marched on the courthouse in Lancaster, Pennsylvania, to disrupt the selection process; similar demonstrations occurred elsewhere.[19] Although it predates those riotous protests, the cover of the Henry C. Work song *We'll Go Down Ourselves* suggests the sheer transgressiveness of such actions. The lively illustration represents a crowd of women brandishing brooms, fire tongs, and boiling teakettles as they rush after a rag-tag crowd of retreating Confederate soldiers, poorly armed. Bold and angry, the women are determined to join in and finish the fight. Even in the context of such an ephemeral illustration, the militant feminine mob seems powerfully threatening.

Many women, North and South, fought not with brooms but with real weapons, side by side with their masculine comrades, exposing themselves to the same deadly dangers.[20] But the home front itself offered no guarantee of safety to the female rank and file. However far from the battlefield, they could still be in harm's way; indeed, many more fell victim to horrific violence on the home front than ever fell in battle. All during the conflict, thousands of women and girls, both North and South, worked in arsenals, sewing cartridge bags, forming cartridges, assembling small arms, and stitching uniforms. The women earned more than did subcontractors who took work home from the factories, but the jobs themselves were hazardous in the extreme.

FIG. 66.
Henry C. Work, *We'll Go Down Ourselves*, Chicago: Root and Cady, 1862. Sheet music, 13 1/2 × 10 1/4 in. Newberry Case sheet music M1.A13 no. 2814, James Francis Driscoll Collection of American Sheet Music, gift of the Driscoll Family.

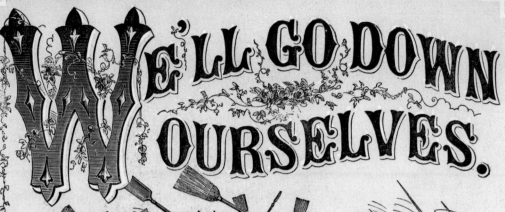

WE'LL GO DOWN OURSELVES.

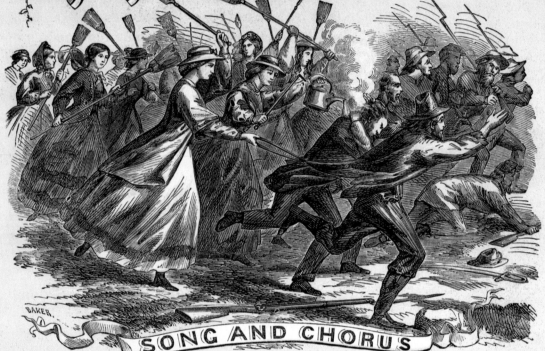

SONG AND CHORUS

BY

HENRY C. WORK.

3

CHICAGO:

Published by ROOT & CADY, 95 Clark Street.

WM. HALL & SON, FIRTH, POND & CO., New York. HENRY TOLMAN & CO., Boston. S. BRAINARD & CO., Cleveland.

H. N. HEMPSTED, Milwaukee. J. H. WHITTEMORE, Detroit.

Winslow Homer's "Filling Cartridges at the United States Arsenal, at Watertown, Massachusetts" glosses over the potential danger of the work by representing the young women in the top register as if they were engaged in quasi-domestic tasks. In the bottom register, men fill paper cartridges with gunpowder; the women's job in turn is to insert the bullets. As Judith Giesberg notes, they could just as easily be stitching clothing rather than forming cartridges.[21] It is not too much of a stretch to imagine them at a sewing or quilting bee, cloaks and bonnets neatly hung on the wall just as the women themselves (albeit under surveillance) sit quietly in rows on both sides of the table. Dating from the early months of the war, Homer's illustration seems to suggest that such labor is peaceful, ordered, and even pleasant. Yet there is a nagging subtext: each of those cartridges (and the arsenals produced them by the millions) is a tiny death package slated to injure, maim, destroy, and kill. In contrast to Homer's portrayal of young women making havelocks—published just weeks earlier—his arsenal interior represents the opposite extreme on the continuum of women's "domestic" labors in the war effort. Both bring the war home, but the arsenal scene does so with a vengeance.

That vengeance played itself out in real life, far from the safety of the sewing circle. In spaces full of live ammunition, the least spark could trigger a catastrophic explosion, as happened on several occasions. By far the worst occurred at the Allegheny Arsenal in Lawrenceville, Pennsylvania, on September 17, 1862—the same day as the Battle of Antietam.[22] More than seventy died in the disaster, the majority women and girls, some as young as ten. Most of the victims were working-class Irish struggling to help support their families. Although Antietam overshadowed the local tragedy, newspapers published grisly descriptions of the scene: "Two hundred feet from the laboratory was picked up the body of one young girl, terribly mangled; another body was seen to fly in the air and separate into two parts; an arm was thrown over the wall; a foot was picked up near the gate; a piece of skull was found a hundred yards away, and pieces of the intestines were scattered about the grounds." One victim had been riddled with seven Minié balls; of others, little remained but the singed steel bands of their hoop skirts.[23] This was a home-front battlefield as gruesome and terrible as any strewn with soldiers' bullet-ridden corpses. Photographers documented the grim aftermath of Antietam, but no artist ever recorded the carnage at Allegheny. To describe such horrific wartime violence to the female body was beyond the scope of visual representation at that time.

Yet the flag rent apart in Spencer's *Home of the Red, White, and Blue* does constitute a surrogate female presence. Flag historian Scot M. Guenter writes that soldiers dedicated and even sacrificed their lives to protecting the national and regimental flags, carried into battle by color-sergeants whose duty it was at all costs to prevent the colors from falling to the ground or into enemy hands, even when the fabric had been ripped to shreds.[24] The colors of the Eleventh Ohio were so badly damaged at Chickamauga that "it was with difficulty they could be kept fastened on the staff, but at Mission Ridge they were literally torn to ribbons by shot and shell, and hung in strips about the scarred and splintered staff." Of the three men

451

HARPER'S WEEKLY.
A JOURNAL OF CIVILIZATION.

VOL. V.—No. 238.] NEW YORK, SATURDAY, JULY 20, 1861. [SINGLE COPIES SIX CENTS.
$2 50 PER YEAR IN ADVANCE.

Entered according to Act of Congress, in the Year 1861, by Harper & Brothers, in the Clerk's Office of the District Court for the Southern District of New York.

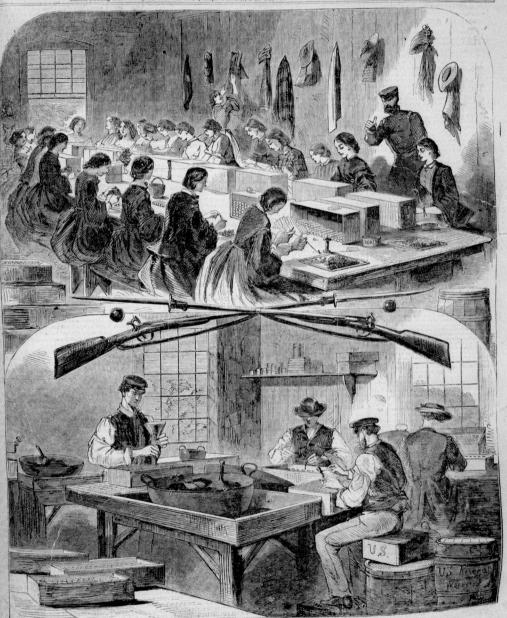

FILLING CARTRIDGES AT THE UNITED STATES ARSENAL, AT WATERTOWN, MASSACHUSETTS.—[SEE NEXT PAGE.]

that bore those colors, one was instantly killed and two seriously wounded. Likely made by women of the community, the flag was something to be protected, just as wives and mothers were. The Star-Spangled Banner stood for and, in a sense, *became* the maternal body. That was the message of Edward Everett Hale's popular wartime story "The Man without a Country," in which the exiled and dying protagonist conflates flag, mother, and nation in a tearful homily: "Never look at another flag, never let a night pass but you pray God to bless that flag. Remember, boy, that behind [all else] . . . there is the Country Herself, your Country. . . . Stand by Her, boy, as you would stand by your mother."[25]

War-torn flags that survived the carnage were accorded reverential treatment. In December 1862, Mary Lydig Daly went to see new flags presented to the Irish Brigade and the battle-worn, bullet-riddled banners consigned to the care of Mr. John Devlin. "It was very touching," she wrote, "to see the old, faded, tattered standards which I had seen in all their first freshness, and the officers of the brigade, with their honorable scars, who received the second ones." Thomas Waterman Wood's *Return of the Flags, 1865* depicts several regiments of that same Irish Brigade entering New York with their battle-torn colors, now little more than limp and shredded rags but still hanging proudly from their staffs. Carried by brave veterans, the flags are on their way to Albany, to be ceremoniously handed over to the governor and kept as sacred relics in the state capitol.[26]

The Irish Brigade's flags—like its honorably scarred officers—are heroic and triumphant. But the flag in Spencer's painting lies heaped and jumbled upon the ground, not torn to ribbons in battle but cut in two, the Union surgically sliced from the field of stripes as if it were an amputated limb. A surrogate body, it evokes that of the soldier sprawled dead on the battlefield, or of the young female arsenal worker, limbs severed and strewn amid smoldering rubble. Like them, the fallen and implicitly feminized flag seems a casualty of war, suggestive of some obscure defeat despite the Union's glorious victory. Coupled with the sidelined veteran under the tree, it lies in shadow; the edge of the cloth and the tip of the man's boot just touching, as if to suggest some vital connection between them. The war has disabled them both.[27]

In postwar society, wounded and traumatized survivors struggled to adjust and adapt to changed circumstances. Eloquently speaking to those challenges is Winslow Homer's "Our Watering Places—The Empty Sleeve at Newport." Here, a young and stylish woman drives a wicker phaeton along the shore, while beside her sits a one-armed veteran (still wearing his kepi), titular sleeve pinned to the body of his jacket, remaining hand limp in his lap, his face in

FIG. 68.
Thomas Waterman Wood, *Return of the Flags, 1865*. Oil on canvas, 30 × 37 in. (76.2 × 94 cm). Image courtesy of the West Point Museum, US Military Academy, 1s 7361.

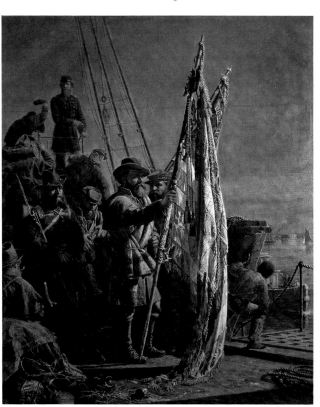

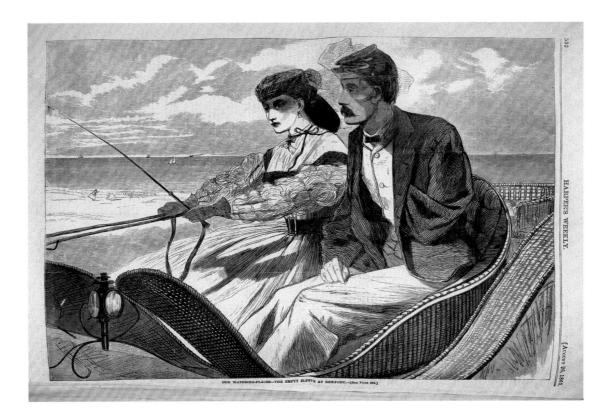

OUR WATERING-PLACES—THE EMPTY SLEEVE AT NEWPORT.—[SEE PAGE 534.]

[AUGUST 26, 1865.

shadow. Once his own whole man, the veteran is now dependent; once dependent, the woman now assumes a commanding and conspicuously public role.

Yet there lingers a note of ambiguity. As Frances Clarke has discovered, the majority of Civil War amputees refused prosthetic replacements, even though the government offered them at no charge. Many deliberately drew attention to their loss by pinning sleeves or trouser legs to other parts of their clothing. No shameful and emasculating handicap, the missing limb was an honorable scar, emblem of sacrifice, assertion of undiminished manhood. The rhetoric of the empty sleeve had broad cultural and political resonance as well. New York and Washington hosted exhibitions of the Left-Armed Corps, a group of veteran amputees who had learned to write all over again and now displayed the results of their labors to the public. In the exhibition hall hung banners praising the "conquering heroes" or boasting, "The Arm and Body you may Sever, But Our Glorious Union Never."[28] In that light, the man's empty sleeve in Homer's illustration is as much badge of honor as symbol of his weakness. That, indeed, was the message of the popular song celebrating the empty sleeve as a sign that "whispers of the dear old flag / And tells who sav'd our banner."[29] The scope of wartime change, however, is inescapably evident in the woman driver's new agency. Is her passenger a helpless and handicapped victim, or a proud and still conquering hero? At this moment, power seems to hang in the balance.

In Spencer's painting, the status of the shadowed veteran is equally ambiguous. Reposing in the shade, safe with his family, he is quite cheerful and comfortable. But neither does he play an active role. The two crutches tell of an injured leg; he

FIG. 69.
Winslow Homer, "Our Watering Places—The Empty Sleeve at Newport," *Harper's Weekly*, August 26, 1865. Magazine illustration, 16 × 10 1/2 in. Newberry folio A5.392 v. 9.

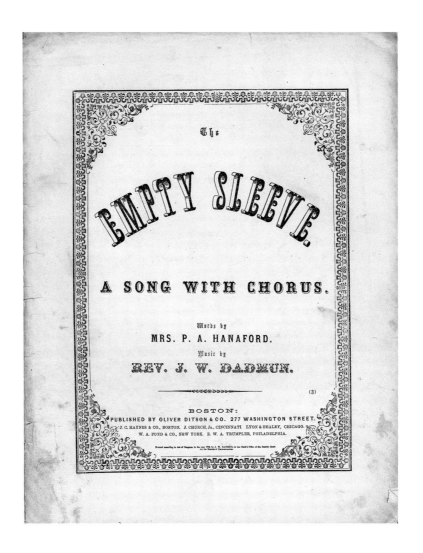

FIG. 70.
Mrs. P. A. Hanaford (words)
and J. W. Dadmun (music),
The Empty Sleeve, Boston:
Oliver Ditson & Co., 1866.
Sheet music, 13 5/8 ×
10 9/16 in. Newberry Case
8A 322, James Francis
Driscoll Collection of
American Sheet Music, gift
of the Driscoll Family.

may be impaired in other, less obvious ways as well. As in Homer's "Our Watering Places," role reversal has pushed the war hero to the margin (which he shares with the old patriarch, likewise sidelined with his berries) and positioned the women prominently at center.

There too, however, we sense a lack. The young woman in red is clearly of marriageable age. Dressed for display as if ready for a ball, she flaunts a gold bracelet, a jeweled brooch, and flashy dangling earrings. But there are no eligible prospects in sight, no one to fill the gap between the older men—father and grandfather—and the son, who can be no older than four or five, the age when boys commonly began to wear breeches. The little boy's very presence, there in the spotlight he shares with females old and young, hints obliquely at the generation gap that at this time was all too real. Where have the young men gone?

The large empty space left by absent men was the subject of a cartoon in *Yankee Notions* involving a large traveling gentleman and a very small country boy at a railroad depot. Asked to find a porter, the boy retorts that *he* is the "only man that's left in the village! All the others have gone to the war!" In real life, boys by the thousands found themselves thrust into premature adulthood when their fathers

and older brothers left to take up arms. Like their mothers and sisters, they assumed new roles and took on heavy new responsibilities. Many, like fifteen-year-old Sam Goodnow in Jefferson County, Indiana, acted on paternal instructions from afar. His father, Lieutenant James Goodwin, fought in the Union army from 1862 to 1864. While away, he wrote home often, exhorting Sam and his siblings to do everything possible to help their mother. In one letter, James instructed them to carry all the wood, make all the fires, milk the cow, work in the garden, and in general "take all the work off her hands that you can do."[30]

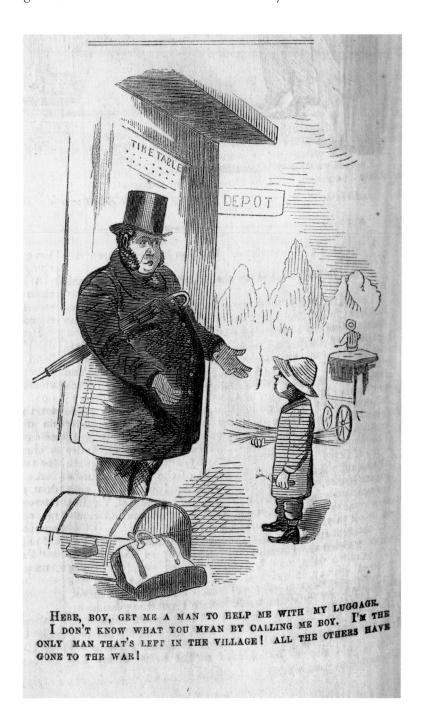

HERE, BOY, GET ME A MAN TO HELP ME WITH MY LUGGAGE. I'M THE I DON'T KNOW WHAT YOU MEAN BY CALLING ME BOY. ONLY MAN THAT'S LEFT IN THE VILLAGE! ALL THE OTHERS HAVE GONE TO THE WAR!

FIG. 71.
Untitled cartoon ("Here, Boy"), *Yankee Notions*, November 1862. Magazine illustration, 10 3/4 × 7 15/16 in. Newberry folio A 5.9914 v. 11.

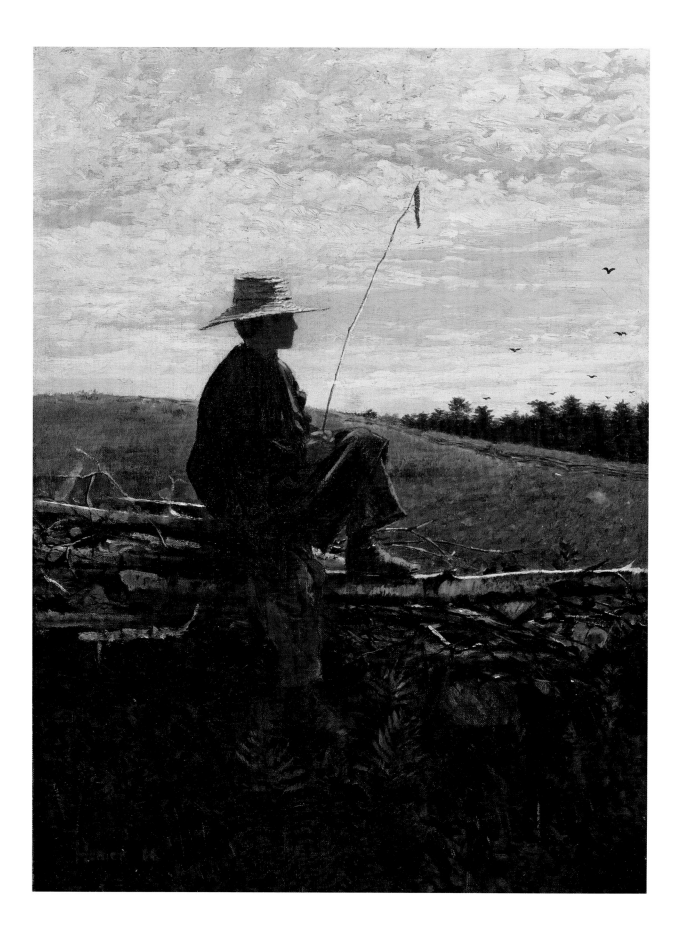

Like Sam, the young boy in Winslow Homer's *On Guard* watches over the home front in his father's stead. Clad in ragged garments and a yellow straw hat, he perches on a rough wall of rocks and logs bordering a partially harvested field. Beyond that is a copse of trees from which birds fly up, as if suddenly startled. The boy clutches a slender switch with a scrap of red cloth at the tip as if to warn of danger. He is apprehensive, on the watch. Nothing has happened yet, but the sense of a possible threat hovers in the air. What unseen menace has frightened the birds? What attackers might be creeping through the trees? Likely the boy is safe from actual harm. At the same time, he mirrors the far-off soldier standing guard against a threat infinitely more real. The wall beneath him subtly reinforces the connection. Unlike the neat zigzag rail fence on the far side of the field, this one looks as if it had been piled up in haste, the birch saplings so fresh that green leaves still cling to the twigs. The breastworks on Culp's Hill at Gettysburg a year previous were of the same crude construction, using just-hewn logs heaped atop a jumble of boulders. Whether Homer intended the reference is impossible to say, but the resemblance subtly reinforces the notion of the home front as battlefield in its own right.[31]

In the same year Homer produced *On Guard*, Horatio Alger Jr. published the story of Frank Frost. His father at the front, young Frank takes over the management of the family farm. In so doing, he acts out his convictions. "Now that so large a number of our citizens have been withdrawn from their families ... to engage in putting down this wicked Rebellion," he proclaims, "it becomes the duty of the boys to take their places.... A boy cannot wholly supply the place of a man, but he can do so in part.... If he does this voluntarily and in the right spirit, he is just as patriotic as if he were a soldier in the field." In precisely that way, Homer's tense young sentry is a patriot and a soldier in his own battlefield, poised on a homemade breastwork as he acts out the part of the absent father or brother playing out his perilous role in the theater of war.[32]

Three years after the war's end, Homer used *On Guard* as template for an illustration in the children's magazine *Our Young Folks*. If *On Guard* portrays the boy soldier on the home front, "Watching the Crows" restores him to innocence. Clad now in a rustic smock, he still clutches a switch, but the warning flag has disappeared. Above sail some marauding birds, but they imply no greater danger. Homer's boy inhabits a kingdom so peaceable that it is as if no war had ever taken place there or anywhere. Demobilized, the surrogate man has become a child once more.

By contrast, the boy with his lace collar in *Home of the Red, White, and Blue* has never been anything else. Does he represent the new generation born to replace the lost? That need was uppermost in Spencer's mind when she gave birth to Victor

FIG. 72.
Winslow Homer, *On Guard*, 1864. Oil on canvas, 12 1/4 × 9 1/4 in. (31.1 × 23.5 cm). Terra Foundation for American Art, Chicago, Daniel J. Terra Collection, 1994.11.

FIG. 73.
Winslow Homer, "Watching the Crows," *Our Young Folks*, June 1868. Magazine illustration, 8 3/8 × 5 3/4 in. Newberry A5.701 v. 4.

WATCHING THE CROWS.
DRAWN BY WINSLOW HOMER.] [See *Watching the Crows*, page 355.

McClellan in 1862. Acutely aware of the staggering death toll in recent battles, she rationalized Victor's arrival by pointing out that "there have been so many men distroyed [*sic*] that I think it is quite a good thing for the country and the girls in future, that all the boys that can come should come."[33] The boy in Spencer's painting is not Victor McClellan, who died in infancy, but he too represents that new cohort. The generation gap, however, still yawns. Between the golden boy and the crippled patriarch, there are only girls.

There is one other man, of course, decidedly ineligible: the organ-grinder. The street musician and the barefoot young girl by his side are anomalies, intruders into this sheltered enclave of privilege and peace. Difference marks these figures indelibly: homeless wanderers, they are dark and ragged, living on the margins far from the ideal of the settled, stable Anglo-American family unit. What is the significance of their appearance in this postwar landscape? And why would Spencer include them in the first place?

Laura Napolitano has convincingly argued that their disruptive presence serves as a vivid reminder of the deep and intractable social divisions separating American middle-class society from the immigrant poor.[34] But in the figure of that rootless mendicant, Spencer may have perceived subtler meanings as well. In the winter of 1867–68, the artist rented a Broadway studio, where she hoped to reenergize her career. While there, she certainly would have seen and heard the roving musicians in the tumultuous streets outside, where men cranked their barrel organs while the boys and girls who often accompanied them displayed white mice or pounded on tambourines. Both adult and child street performers (the majority hailing from around Parma) were recruited by *padroni*, labor brokers who provided lodging and equipment in return for a percentage of the take from the day's work. Thus, the children who so often traveled with the older musicians were not necessarily offspring but rather business partners of sorts, though often from the same extended immigrant community.[35] Squalid living conditions and systematic child exploitation made the *padrone* system the target of reformers, who made well-intentioned efforts to provide educational and employment opportunities, especially for the young. Far less public-spirited were the very many who actively despised organ-grinders as lazy foreigners responsible for generating intolerable noise that exacerbated the stresses of urban life to the point of madness. As itinerants who purportedly lived outside the normative familial context and worked outside conventional economic channels, organ-grinders and their accessories were alien and threatening.[36]

That alone might account for the strangeness and awkwardness of the encounter between Anglo-American family and Italian outsiders in Spencer's painting. The pictorial narrative hints as well at unseen but vital connections that in turn expose what may be deeper fears. By the time Spencer started work on *Home of the Red, White, and Blue*, organ-grinders had begun to vanish from city streets as they put down roots in "Little Italies" in New York and elsewhere. As a contemporary observer put it, "The old Italian organ grinder, with his moving figures and red-capped monkey, has become almost a thing of the past." And yet, organ-grinders

were still very much a part of the urban landscape: disabled veterans had taken their place. "A crippled soldiery now receive for their support the coppers which once kept alive a disgraceful vagabondage."[37]

That humiliating fate was the subject of a story claiming to reflect what all could see on the streets of any postwar city. In this tale, John Williams, a valiant Union soldier, loses his right leg at the battle of Cold Harbor. Honorably discharged, he returns to the town where he had enlisted, confident that potential employers will honor his service and sacrifice by finding work for him. All turn him away as his small stock of money dwindles. Finally, he disappears. But one day, his friends catch sight of a crowd collected around a "cracked and rickety hand-organ." The organ-grinder turns out to be Sergeant Williams, "clad in his suit of faded blue, with his sergeant's chevrons and all," and "grinding away at his old hand-organ as the last means left him for support . . . every day he may be seen along the principal streets of the city, patiently and sadly earning his pittance in this way—a mode so very repugnant to one's manhood."[38] The crippled veteran has sunk to the level of the detested foreigner. Both wander the streets begging for pennies; both are less than men.

Missing limbs and hobbling on crutches, disabled veterans were visible everywhere, haunting the postwar landscape. "Suffering Heroes," an illustration in *The Mother's Journal*, shows two ex-soldiers, both amputees, one lacking an arm and an eye, the other missing a leg. The latter has only one crutch; for support, he must lean on his armless comrade. Apart, each is half a man; together, they make a whole. Maimed veterans on crutches also appeared in *Harper's Weekly*, including a one-legged cripple selling shoelaces on a street corner under a "wounded at Gettysburg" sign, and, in another illustration, a one-armed amputee holding out his kepi and begging for a handout from a woman and child in a fancy carriage.[39]

Overtly and covertly, such is the case with the men in Spencer's painting. The grandfather, of course, is an ancient and faded presence. But the veteran and the organ-grinder seem to be roughly the same age. Spencer hinted at their connection compositionally by anchoring each figure to a large and sturdy tree. Of course, as noted, the veteran is at home and safely sheltered while the shabby organ-grinder and his companion are wanderers dependent on the generosity of strangers. Yet there remains their shared identity as men unmanned: one by his "disgraceful vagabondage," the other by whatever wartime wounds have relegated him to the shadowed sidelines with his crutches. Neither has a central place in Spencer's postwar landscape, now explicitly the realm of women armed with thimbles and standing guard over the next generation. Men pushed to the sidelines, women lead the way.

Women's rights advocates had hoped that the momentum of change would propel and sustain the new agency women had won during the war. In the words of feminist Elizabeth Cady Stanton, women had arrived at a transition period "from slavery to freedom." They were now poised to cast off the shackles of wifely subordination and work toward the goal of self-supporting autonomy and full citizenship. But activists met bitter disappointment when the Fifteenth Amendment

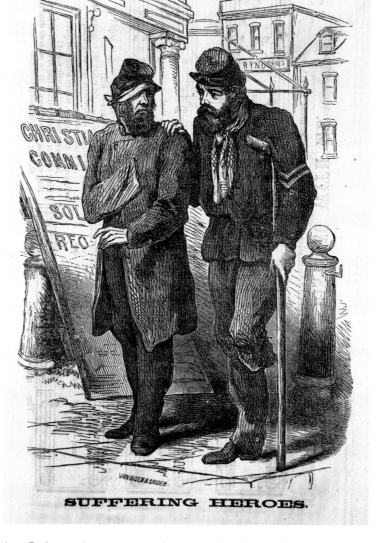

SUFFERING HEROES.

FIG. 74.
Vaningen and Snider,
"Suffering Heroes,"
The Mothers' Journal,
January 1865. Magazine
illustration, 9 1/16 × 5 13/16
in. Newberry A5.6079.

(ratified on February 3, 1870) extended voting rights only to males, regardless of race. Women, disenfranchised, were left behind. Divided on the amendment's passage, the women's rights movement broke in two and foundered. Although some stalwart activists like Stanton continued to campaign for women's rights, the movement began to regain its momentum only in 1887, when the two factions finally merged.[40]

The barriers the war had eroded rose again as pressures mounted on women to retreat from public life and action. No crusading feminist, Harriet Beecher Stowe was among those who believed that women should wield their moral influence in the home, where they would safeguard America's future by nurturing and shaping the next generation. "We have saved our government and institutions, but we have paid a fearful price for their salvation; and we ought to prove now that they are worth the price," she wrote. Women could best serve that cause in the place where they belonged: "*To make and keep a home* is, and ever must be, a woman's first glory, her highest aim."[41] For all the power and centrality Spencer conferred

on the women in *Home of the Red, White, and Blue,* it seems clear that their kingdom, too, is there, and only there.

The women and girls in Spencer's tableau are once again sovereigns of the home alone, the "home front" now confined to their own kitchen, fireside, and nursery. And yet questions hang in the air: Can feminine needle, thread, and thimble repair the damage wrought by war? Everything is still in pieces. In this new, postwar world, on the brink of an uncertain future, is the flag—key symbol of the nation—beyond repair? Even should it be possible to mend, can it ever be restored to its original state? It seems unlikely. The stripes and the starry field may again become one, but the trace of their violent separation will endure, as the turbulent years of Reconstruction would amply demonstrate.[42] Women may stitch up the flag, but the deep wounds of the war and its aftermath may be beyond their ability to heal.

Tracking and piecing together the many disparate parts of Spencer's painting enables us to make new sense of Spencer's work not as a simple scene of everyday life but as a modern, moral history painting infused with a forthrightly feminine point of view. Paintings by Spencer's male contemporaries invariably privileged the veteran negotiating his place in postwar society. Their images of Northern life after the Civil War assigned women the same conventional domestic roles they had played before, as if nothing had ever changed.[43] *Home of the Red, White, and Blue,* by contrast, is unique, not only in its relegation of the veteran to the shade but also, as we have seen, in giving the women pride of patriotic place in the light. Nor does it altogether sidestep history: the women may still have thimbles on their fingers, but for one fleeting pictorial moment at least, they stand empowered, between the detritus of war and the threshold of an uncertain future.

DIANE DILLON

Nature, Nurture, Nation

*Appetites for Apples and
Autumn during the Civil War*

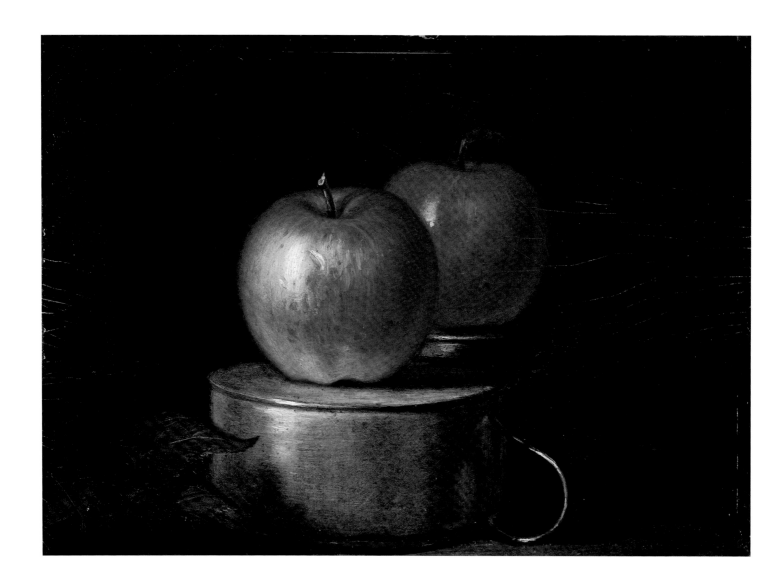

In his diary entry dated "about the first of December '63," William Sidney Mount noted that he had "painted two small fruit pieces—apples natural size—the first I ever painted as pictures by themselves."[1] This excursion into still life was a departure for Mount, who had built his reputation painting genre scenes of rural life on Long Island, near his family home at Setauket.[2] The Civil War seems to have occasioned this shift in subject matter, for Mount set his two freshly picked apples atop a pair of tin cups of the type used by soldiers.

This essay explores the complex meanings of Mount's *Fruit Piece: Apples on Tin Cups*, considering the picture within the context of autumnal themes and exhibition practices on the Northern home front during the final years of the conflict and its immediate aftermath. If Frederic Church commemorated the war's opening battle in the South with his apocalyptic sunrise in *Our Banner in the Sky* (see the essay "The Home at War, the War at Home," in this volume, especially fig. 6) his fellow landscape painters Thomas Moran, Alfred Thompson Bricher, and Sanford Robinson Gifford looked more quietly to the war's end in their autumnal, late-in-day, Northern landscapes. Other artists and writers turned to magazine illustrations, photographs, short stories, poems, and recipes. The variety of autumnal motifs and metaphors was as wide as the spectrum of media, ranging from red apples and red leaves to red blood and red Indians. In diverse ways, painters and writers manipulated natural imagery and visual conventions to make political hay. In casting distinctively *Northern* landscapes and fruit as *national* scenery, they supported the Union cause. And by weaving symbolic red threads through their diverse canvases, the artists and authors created moving memorials to lives lost in the war.

Although audiences in the 1860s probably recognized at least some of the references to the war in these representations, the subtlety of the message was important. Despite the critical and popular success of *Our Banner in the Sky*, Church's picture did not inspire similarly exuberant works of American art. Winslow Homer was one of the few painters to engage the war directly as a sustained theme.[3] Most artists opted to express wartime sentiments metaphorically. For example, Albert Bierstadt gestured toward a united nation by including a kingfisher—a bird whose migration spanned North and South—at the center of his 1863 *Mountain Brook*.[4] Church also took this approach, representing the nation's turmoil as a volatile volcanic landscape in *Cotopaxi* and exhibiting his *Icebergs* with the title *The North* in 1861 and again in 1865. Church fortified the association between the *Icebergs* and the war by donating the revenue from the 1861 exhibition of the painting to the Union Patriotic Fund, a new charity created to support the families of Union soldiers.[5]

Oblique references to the war and its toll must have appeared all the more appropriate just before and after the end of the conflict, when the nation had grown weary of scarred battlefields and slain soldiers. Like the cruelties of slavery, the gore of war itself may have seemed too awful for representation in fine art. By

FIG. 75.
William Sidney Mount, *Fruit Piece: Apples on Tin Cups*, 1864. Oil on academy board, 6 1/2 × 9 1/16 in. (16.5 × 23.0 cm). Terra Foundation for American Art, Chicago, Daniel J. Terra Collection, 1999.100.

picturing other subjects artists could offer their audiences a superficial escape from the stress and tragedies of the conflict. More pointedly, the conflict may have struck artists as a subject unlikely to hold wide or lasting appeal to critics and patrons. Military painting had traditionally occupied a small niche in the history of art, rarely finding sustained prestige or prominent collectors. Monuments honoring soldiers and battles gained ground in later years, after the Civil War receded from the stuff of breaking news to that of dimming memories. But artists working in the 1860s could not foresee this trend, and the task of public commemoration would fall increasingly to sculptors and architects rather than painters anyway. Moreover, artists could contribute to the war effort more quickly through display strategies. By exhibiting art in war-related venues such as sanitary fairs, artists could mobilize for the cause works on a variety of subjects, including those produced before the war.

Fine artists also may have been nudged toward indirect imagery by the proliferation of more obvious references to the war in popular culture. For example, after the Confederate attack at Fort Sumter, flag mania quickly penetrated every dimension of American visual culture, including stationery, sheet music, broadsides, magazines, books, jewelry, and many other media.[6] These representations found instant favor because their message was so obvious and timely, so easy to produce and appreciate. Ambitious artists like Mount understood the value of maintaining a distance from such ubiquitous and uncomplicated expressions. To ensure the status, price, and profundity of self-consciously high art, painters took a different path from the makers of mass culture. They synthesized craftsmanship and invention, seeking emotional and intellectual texture that was subtler and deeper than what was typically offered by commercial or journalistic imagery. Allegorical expression lent itself to manifold, many-layered interpretations, enabling artists to entwine meanings that were at once public and private, optimistic and elegiacal. And because the subject matter was not solely or obviously about the war, it would not soon seem like yesterday's news.

An oblique approach to the war was consistent with Mount's style of political picture making. In earlier genre paintings, he often represented political ideas through vernacular symbolism. For example, in *Farmer's Nooning* (1836), the tam-o'-shanter sported by the boy leaning on the haycock identifies him with abolitionism (referring to the activities of Scottish aboli-

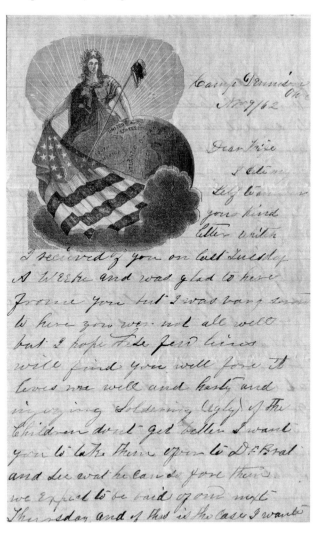

FIG. 76.
George Deal, letter to his wife, Camp Denison, November 9, 1862. Manuscript, 9 11/16 × 8 1/2 in. Newberry George Deal Papers, box 1, folder 2, gift of Carolyn Young.

tion societies), while his youth and playfulness brand the movement as naive and irresponsible. Although Mount's patrons and thoughtful viewers appreciated his veiled political commentary, reviewers did not discuss this layer of meaning.[7] In skirting the political symbolism, critics avoided offending readers who held opposing views and preserved the position of the fine arts as above the fray.

By the time he painted *Fruit Piece: Apples on Tin Cups*, Mount's political beliefs had shifted. An active member of the Democratic Party, Mount opposed abolition and dubbed the Republicans "Lincoln-poops" during the 1860 presidential campaign. By the time the war erupted the following year, however, Mount had crossed over to Lincoln's side.[8] The weight of the war was on Mount's mind when he conceptualized and exhibited his *Fruit Piece*. In his diaries and letters from this period, he interspersed war news and his thoughts about current events with comments about daily routines, the weather, health, and art. Shortly before the war began, Mount expressed his faith in the power of another art form to save the Union. On December 14, 1860, he wrote to the editor of the *New York Herald*:

> Please suggest in the Herald, the importance of having in each house of Congress, a *band of music*, that when a Union speech is delivered, the band shall strike up some stirring National air—to harmonize the debates.
>
> If music, prayers, and union speeches, offered up with a firm resolve for each state (in the future) to mind its own business—If this I repeat, will not tend to keep the glorious Union together—what in the name of heaven will?[9]

Mount had expressed this idea visually in his 1847 genre painting *The Power of Music*. In the picture, three white men—a fiddler playing to an audience of two—sit inside a barn, while a black man listens from just outside the door. Although the four figures occupy separate spheres, they are united in their appreciation of the music. The painting drew voluminous praise from critics and prompted the French firm of Goupil and Vibert to reproduce it as a lithograph. The portrayal of the black man as a sensitive music lover challenged the racial stereotypes of the era, yet the spatial separation of the races ensured that the work could be palatable to white viewers.[10] Mount retained this ideal of racial harmony through segregation during the war years. In an 1864 letter he described local ice skaters creating "a gay scene, Negroes on one pond and whites on the other—that was right and proper."[11]

When the war broke out, Mount, like Church, responded by producing battle-themed art. In June 1861, he noted that the first picture he painted in his new portable studio was titled *The Confederate in Tow*. That August, he began another military composition, *Peace and Humor or Tranquility (The Cannon)*.[12] These small paintings did not have the public impact of Church's *Our Banner in the Sky*. Mount decided not to exhibit *The Confederate in Tow* in spring 1862, but sold it that year to Samuel P. Caldwell of Brooklyn. The disposition of *Peace and Humor or Tranquility (The Cannon)* remains a mystery. What seems clearer is that Mount

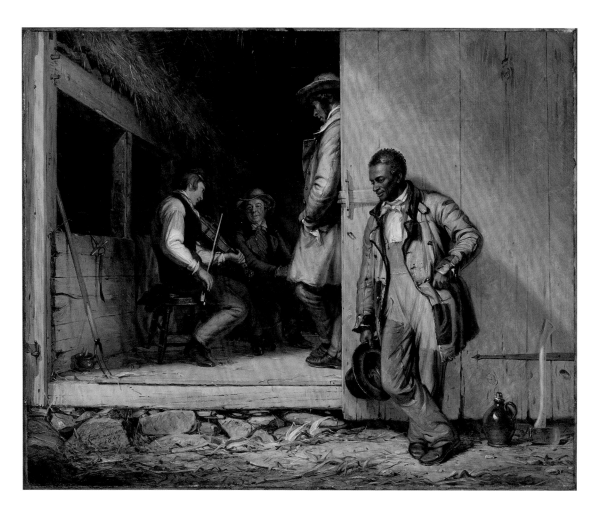

FIG. 77.
William Sidney Mount
(American, 1807–68),
The Power of Music, 1847.
Oil on canvas, 17 1/16 ×
21 1/16 in. (43.4 × 53.5 cm).
The Cleveland Museum of
Art, Leonard C. Hanna Jr.
Fund 1991.110.

quickly moved away from these apparently straightforward representations of military subjects in favor of more metaphorical meditations on the war.

In April 1862, Mount developed a new fascination with the power of still life imagery to narrate war themes and memorialize fallen soldiers. In his journal he describes a work by his friend William M. Davis featuring a gravestone, "arranged about it the various accompaniments of a rebel soldier. Every thing (the incidents of the war) that he could think of to tell his story—was placed about the grave stone on the table and imitated as close as was desirable. A very ingenious way to tell a story by still life arrangement."[13]

At the same time that he rejected the literal representation of war, Mount came increasingly to regard visual displays—including painting and other genres—as patriotic acts. He practiced his own flag mania. In summer 1862, he mentioned trimming the outside of his portable studio with red, white, and blue paint. In February 1864 he sent a letter to President Lincoln asking him to "recommend to Congress the 'Good old Flag'—'the Star Spangled Banner' to be forever kept *before the people* by hanging it placed upon every Post Office in the City and Country." In the fall of that year he wrote to his fellow artist Francis Carpenter to say that he was "pleased to see so favorable notice" of Carpenter's painting *President Lincoln Singing the Proclamation of Emancipation*.[14]

Mount's contributions to the sanitary fairs—the grand exhibitions staged by the US Sanitary Commission to raise funds for their war relief efforts—likewise reflected his faith in the cultural power of display and spectacle. In February 1864 he painted a small oil sketch, *Child's First Ramble*, specifically for the Brooklyn and Long Island Fair, recommending that it be priced at fifty dollars.[15] To the larger Metropolitan Fair staged in Manhattan that April, he sent *Fruit Piece: Apples on Tin Cups* and "a sketch in oil of cherry blossoms." He directed *Apples on Tin Cups* to the art section and sent the other sketch to one of his patrons, Mrs. William H. Wickham of New York City, who had indicated to him that she would have a table of donations for sale at the fair.[16]

Like the world's fairs of the nineteenth and early twentieth centuries, the sanitary fairs were conceived as comprehensive displays of human achievement. As the organizers of the Metropolitan Fair put it: "We call on every workshop, factory, and mill for a specimen of the best thing that it can turn out; on every artist, great and small, for one of his creations; on all loyal women, for the exercise of their taste and industry; on farmers, for the products of their fields and dairies." The Sanitary Commission sold the donated goods to raise funds for their work: "The miner, the naturalist, the man of science, the traveler, can each send something that can, at the very least, be converted into a blanket that will warm, and may save from death one soldier whom Government supplies have failed to reach. Everyone who can produce anything that has money-value, is invited to give a sample of his best work as an offering to the cause of National unity."[17] Few of the items displayed—including the works of art—represented or related to the war directly. Rather, the exhibits acquired connection to the war specifically through their display at the fairs. The exhibitors generally eschewed violent or somber images of war in favor of upbeat evidence of national productivity and honor. For example, instead of showing his critically acclaimed battle photographs at the Metropolitan Fair, art committee member Mathew Brady exhibited portraits of the war's military leaders, political officials, and the organizing committees of the fair, as well as installation views of the art gallery and other departments of the fair. Brady also collaborated with USSC president Henry W. Bellows to produce a congressional album featuring new portraits of senators and representatives.[18]

In this context, Mount's *Fruit Piece* resonated on several levels. Like most of the exhibits, it avoided the war's gruesome aspect. In the apples and tin cups, the picture depicted the sorts of products that the fair organizers sought for display, while the painting itself was yet another commodity that could be sold for the

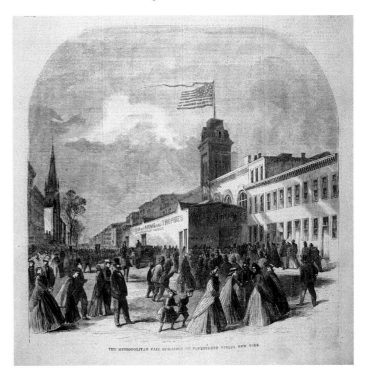

FIG. 78.
"The Metropolitan Fair Buildings, on Fourteenth Street, New York," *Harper's Weekly,* April 9, 1864. 16 × 10 1/2 in. Newberry folio A5.392 v. 8.

cause. Moreover, apples and cups were precisely the kinds of supplies that the soldiers needed on the battlefront.

The promotional and educational rewards of the fairs were at least as important as their financial achievements. The fairs rallied enthusiasm for the war effort between 1863 and 1865, when public spirits were low. Through the battlefront aid they promoted and funded, the fairs informed audiences about the medical needs of soldiers and raised awareness more generally about public health. The fairs were also sites of conviviality and entertainment. The events were animated by speeches and sermons, theatrical and musical performances, parades, and feasting.

The art galleries raised some funds through sales, but probably made a greater impact by enhancing the high cultural dimension of the fairs, drawing audiences and boosting admission revenues. At the Metropolitan Fair, the art gallery was divided into two sections. At the head of the hall hung the grandest and most famous works of art—136 American and European paintings, including Frederic Church's *Heart of the Andes,* Albert Bierstadt's *The Rocky Mountains, Lander's Peak,* and Emanuel Leutze's *Washington Crossing the Delaware.* These canvases were on loan to the fair, enhancing its prestige and cultural meaning but only indirectly enriching its coffers. Mount made a similar contribution through the display of *The Power of Music,* lent by Mrs. Gideon Lee. These loans brought patriotic kudos to the artists and patrons alike.

At the lower end of the hall hung 196 works of art labeled *"Pro Patria."* Artists and collectors donated these works, so they could be sold to benefit the fair. The art auction raised funds through admissions as well as sales; tickets to the three-day event cost double the normal admittance fee to the fair. There were a few major items on the block. One prominent New York collector donated an *Ecce Homo* by Van Dyck, which sold for $500, while John F. Kensett's *A Coast Scene* brought in $660.[19] Most of the art sold at the auction, however, was more modest, akin to the small oil sketches Mount donated. The listed price for the *Fruit Piece* was fifty dollars, but it sold for thirty-five dollars at the auction.[20] Like Mount, most artists produced works especially for the auction, although some contributed earlier objects they had on hand.[21]

The *New York Times* described the exhibition as "the most extensive, the most choice and the most elegantly arranged that has ever been seen in New York City.... The private galleries of the wealthiest collectors of New-York and vicinity have been liberally drawn upon to enrich the collection; and it now stands a superb monument to the art wealth of our metropolis, and a school in which the student at a glance can trace the progress of art in his own country, and compare it with the finest examples of the Old World."[22] A critic for *The Round Table* offered a more jaundiced view. The reviewer acknowledged that the "art-exhibition at the Metropolitan Fair proved its greatest attraction," but went on to note the predominance of works from members of the selection committee and their friends. The critic opined that because the exhibition "was gotten up for the benefit of the soldier," every artist had a right to be included.[23]

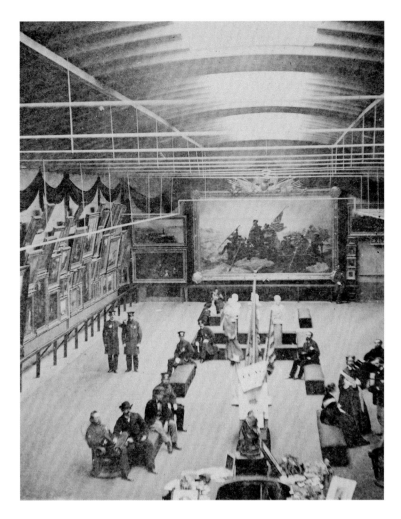

FIG. 79.
J. Gurney and Son, "View
in the Art Gallery," *A Record
of the Metropolitan Fair in
the Aid of the United States
Sanitary Commission*, 1867.
3 5/8 × 2 7/8 in. Newberry
F8345.73.

The Round Table writer did not mention Mount's *Fruit Piece*, but this tiny sketch exemplified the democratic ethos that the critic championed. The tin cups propping up the apples were not military regalia of the sort displayed in the fair's arms and trophies exhibition, but utilitarian objects issued to every soldier. Mount singled out this same group when he recounted his purpose in sending the picture to the fair, hoping "the sick and wounded soldiers will be benefited thereby." Mount lauded ordinary people throughout his life by putting them at the center of his artwork. He regarded the war from a similar perspective, noting in 1865 that it was brought on "not by industrious mechanics and farmers, but by educated scoundrills [*sic*], Politicians, and even preachers, both north and south." Mount seems to have been proud of his contribution to the relief effort, but recognized that it distracted him from his main purpose as an artist. As he put in his diary in March 1864: "If I had strictly attended to my own business, instead of working up Sketches for Fairs, my larger works would have been more advanced. I hope the time spent is all right."[24]

More broadly, *Fruit Piece* expressed sentiments about the war and the nation that resonated profoundly in 1864. The complex connotations of the tin dippers

and especially the apples encourage a more intricate cultural interpretation than the deceptively simple composition it first begs. Plus, the juxtaposition of food from the home front and equipment from the battlefield adumbrates the close connection between the two spheres.

Apples, of course, have a long history as potent symbols in Western culture, from tempting Eve in the biblical Garden of Eden to serving as an attribute of Venus, the classical goddess of love. Closer to home, the legend of Johnny Appleseed and the new seeds and fruit grafts introduced by scientific farming stressed the connection of the apple to the productive American landscape.[25] These home-grown connotations were probably the most meaningful for Mount and his nineteenth-century audiences. Apple trees grew near the painter's Long Island home, and he exploited the local bounty in compositions such as *Apple Blossoms* (1859) and *Cider Making* (1841), as well as two pictures from the Civil War years, *Returning from the Orchard* (1862) and *Apples in a Champagne Glass* (1864).

Like the colorful fall foliage favored by landscape painters, apples were abundant in the North in the fall and were associated with that region. Because they were sturdy, apples could be shipped to other parts of the country and enjoyed year round. They became so ubiquitous that Ralph Waldo Emerson called the apple "our national fruit."[26] During the mid-nineteenth century, most American diets included little fruit except apples. They were used in many dishes year round and served as the focus of most fruit desserts, because they were plentiful and kept well.[27]

During the war, however, apples were increasingly hard to come by on the Southern home front and on the battlefront. As Southern homemaker Ella Gertrude Clanton Thomas noted in her diary at Christmastime in 1862, "To form some idea of the extravagant prices of things. . . . I will mention that the apples for the dessert were 10 cts. a piece."[28]

The letters sent to friends and family by Union and Confederate soldiers frequently focused on the food they consumed in camp or on the march, what they missed most, and how they made do with what was available. Edward W. Curtis, a Massachusetts native who served as a private in the Eighty-Eighth Illinois Infantry, recounted his rations in letters to his aunt, Rachel W. Kingsley. On July 18, 1863, he wrote from Cowan's Station, Tennessee, "As to my health, it is slim, I do no duty. I do not gain strength very fast for my appetite is not very great for the Army rations."[29] Here and elsewhere the soldiers supplemented their official food allotment with whatever they could forage in the surrounding countryside. For example, Curtis mentioned that he planned to venture out beyond the pickets to collect blackberries. The next month he had a more encouraging report: "We have just got a ration of five large fall apples, the second one; and we have had one or two of green corn, peaches and apples are getting ripe, too. I am going out tomorrow, if I can, two or three miles, after what I can get. I baked a pie yesterday, and some biscuit today, with pretty good success."[30] Curtis was fortunate that his regiment was stationed in a rich agricultural area enabling the men to add fresh produce to their diet. But his ration of ripe apples was quite rare.

The storied abundance of the American landscape failed to reach many regiments, especially in the later part of the war. The rations typically issued to soldiers sometimes included dried apples, but rarely fresh fruit. In camp, soldiers usually stewed the dried apples to make a sauce for hard tack, the plain flour and water biscuits that, along with coffee, were the staples of soldiers' diets.[31] When dried apples were not available, soldiers made mock apple pies by crumbling hard tack with sugar—probably in tin cups like the ones Mount painted. This simple technique adapted a common practice of thrifty nineteenth-century home cooks, who combined soda crackers with cream of tartar, lemon juice, sugar, and cinnamon to simulate apple pie filling.[32] Although the resemblance of the taste of cracker pie to apple pie was uncanny, the mock pies probably stimulated longing for the real thing even as they tempered the soldiers' immediate hunger pangs.

Reports of meager provisions in the army were common. As William T. Foster, a Union soldier with Company F of the Illinois Eighty-Fourth Volunteer Infantry, noted while serving in Kentucky and Tennessee in October 1863, "we are on ½ rations of bread and ¼ rations of sugar and coffee."[33] Robert Leslie Wiles, a corporal in Company D of the Eleventh Missouri Cavalry Regiment, described in his journal the state of supplies on the march to Fort Smith, Arkansas, in autumn 1864. They arrived in Little Rock on October 30 with "no feed for our horses nor nothing to eat for us." On November 6, the soldiers captured sixty head of beef cattle and some sheep from the rebels. When they arrived at Fort Smith on November 7, Wiles observed, "We found the Soldiers were almost in starvation and all the Calvary Regiments are dismounted on account of the horses had been starve [sic] to death." Three days later he noted that conditions "are worse at Ft. Gibson, they only draw 4th ration for 10 days."[34]

Soldiers occasionally found preserved fruit in the packages they received from home. In January 1864, Sarah McLean wrote from Jersey County, Illinois, to her son Edgar, a First Lieutenant in the 122nd Illinois Regiment: "I will send you some butter canned fruit and some other things."[35] But these well-meaning gestures could easily backfire. As a Sanitary Commission report published in the *New-York Daily Tribune* advised in 1862: "Let the homes of the land abandon the preparation of comforts and packages for individual soldiers. They only load down and embarrass him. If they contain eatables, they commonly spoil; if they do not spoil, they enervate the soldier. If made up of extra clothing, they crush him on the march. All this kindness helps fill the hospitals."[36] If they had the funds, soldiers also could buy food from sutlers, private provisioners who followed the troops in wagons stocked with everything from writing paper and pens to newspapers and baked goods, often proffered at exorbitant prices.[37] Writing to his wife Sarah in Columbus, Ohio, from Vicksburg, Union soldier George Deal noted, "any kinds of can fruit is worth one dollar for a quart can."[38] If the letters and packages exchanged between soldiers and loved ones chart the personal, quotidian connections between battle front and home front, in this context apples became powerful objects of nostalgia, synthesizing a longing for home and the comforts of family meals before the war unsettled domestic life.

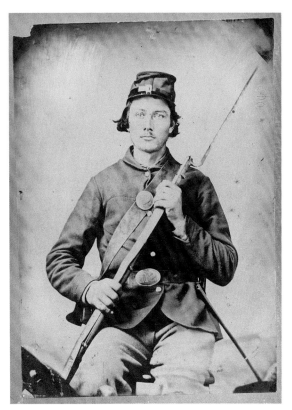

FIG. 80.
George Deal Photograph.
Photograph, 7 1/2 ×
5 1/2 in. Newberry George
Deal Papers, box 1, folder 55,
gift of Carolyn Young.

The powerful connections between apples and the idea of home also were demonstrated in the restaurants and kitchens at the sanitary fairs. The formal dining rooms in the restaurants offered fresh apples or apple pie for ten cents per serving.[39] The kitchens served food to fair visitors in more casual surroundings decorated to create "a feeling of home," reminding fairgoers what the soldiers at the front craved most.[40] The Chicago and Brooklyn fairs included New England Kitchens, installations that would become standard features at later regional and world's fairs. The Metropolitan Fair in Manhattan boasted a Knickerbocker Kitchen, which evoked the atmosphere of Old Dutch New York, undoubtedly filtered through the lens of Washington Irving's phenomenally popular *Knickerbocker History of New York*. The room incorporated the hallmarks of seventeenth-century Dutch interiors, characterized by low ceilings with ponderous beams, deep window seats backed by windows with tiny panes, and an abundance of brass and pewter. The beams were festooned with dried apples.[41]

The Great Central Fair for the Benefit of the Sanitary Commission staged in Philadelphia in June 1864 featured a Pennsylvania Kitchen as a subdepartment of the main restaurant. Like the Knickerbocker Kitchen, the Pennsylvania Kitchen offered "a picture of the domestic life of the early German settlers of the interior of this State." The kitchen served lot-werk (apple butter), omelette ewtwas (scrambled eggs), trichter-kuchen (flannel cakes), and other traditional German fare. As the comprehensive report on the fair noted, "The cooking is going on very constantly, and a glance into the back kitchen reveals cakes and loaves and pies, and all the delicacies we have named, in exhaustless profusion." The Pennsylvania Kitchen also incorporated a variety of historical exhibits, ranging from a German Bible printed in 1748 to Benjamin Franklin's desk. At the time of the fair, the interior of Pennsylvania was more prominently associated with the location of the 1863 Battle of Gettysburg than with its earlier settlement by German immigrants who established farms and made apple butter. In calling up visions of this more distant past, the Pennsylvania Kitchen sidestepped some of the most painful recent memories of the war in favor of incentives "to eat, drink, and be merry." Like the Knickerbocker Kitchen in New York, the Pennsylvania Kitchen celebrated the area's early settlers and, by implication, affirmed the elevated status of their descendants over more recent immigrants. If the sanitary fairs broadly envisioned a harmonious urban order maintained by the local elites who comprised the Sanitary Commission, the colonial-era kitchens suggested that the status of these civic leaders was rooted in their northern European ancestry.[42]

Although the historical kitchens echoed Mount's strategy of avoiding straightforward representation of the conflict, the war was not completely absent. Upon

entering the Pennsylvania Kitchen, visitors' eyes were riveted by a mammoth chimneypiece at the far end of the room, over which was arranged a semicircle of the words "Grant's up to schnitz." The words literally translate as "Grant's up to dried apples," but the final report suggested that they could be interpreted just as well as "Grant's up to snuff." All of the letters were formed from dried apples.[43]

Much as Mount drafted still life painting for the war effort in his *Fruit Piece: Apples on Tin Cups*, others pressed landscape imagery into service for the Union. Most landscape painters also opted to express wartime sentiments metaphorically rather than directly. Both patrons and artists achieved patriotic goals through exhibition strategies as well as through thematic imagery. For example, Mr. Oliphant, the owner of "the largest and most important landscape we have as yet seen" from the easel of John Frederick Kensett, offered the public its first glimpse of *October Afternoon on Lake George* (1864) in a single-picture exhibition at Goupil's New York gallery. Mr. Oliphant permitted the canvas to remain on view for the duration of the sanitary fair, and then donated the proceeds of the ticket sales to the Sanitary Commission.[44] Critics praised the picture's singular contribution to the American tradition of fall scenery. As the review for *The Round Table* observed, "Mr Kensett has given us an autumn effect in which a subdued richness and quiet and tender beauty of color is most noticeable and which differs from the autumn pictures of all other painters." The writer did not miss the picture's relevance to the Civil War, regarding it as salve for the nation's wounds: "It is certainly pleasant to contemplate in these lulls of the dreadful tumult of war, soothing to the sense of a people

FIG. 81.
"The Knickerbocker Kitchen, Union Square," *Harper's Weekly*, April 23, 1864. 16 × 10 1/2 in. Newberry folio A5.392 v. 8.

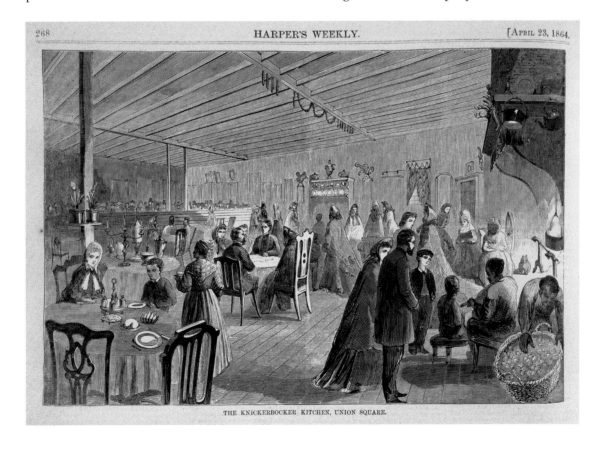

268 HARPER'S WEEKLY. [APRIL 23, 1864.

THE KNICKERBOCKER KITCHEN, UNION SQUARE.

racked by the shattering agitations of battles won and lost; of sons and brothers and husbands, wounded and killed."[45]

The consummate master of yoking landscape imagery and spectacle to advance patriotic and personal goals at the sanitary fairs was surely Albert Bierstadt. His position on the art committee of the Metropolitan Fair enabled him to use three different tactics to promote his new venture in western American scenery. The first centered on the installation of the most significant picture from his 1859 trip to the West, *The Rocky Mountains, Lander's Peak,* within the loan section of the art gallery. Painting during the grimmest days of the Civil War in 1863, Bierstadt constructed an image of an American Eden, a stunning landscape populated by a camp of peaceful Blackfeet Indians.[46] The six-by-ten-foot showpiece cast the American West as a land of promise, untouched by conflict—a perfect escape from the war. The artist ensured that audiences would connect the painting to the Civil War by naming the central mountain Lander's Peak. Frederick W. Lander had led the government survey expedition through the Rocky Mountains that Bierstadt joined in 1859 and subsequently served as a general in the Army of the Potomac during the Civil War.[47] When Lander died of complications from pneumonia after suffering a severe leg wound during the defense of Hancock, Maryland, against forces led by "Stonewall" Jackson, the *New York Times* eulogized him as "the very beau idea of an American soldier."[48] Bierstadt's glorious western scenery thus served simultaneously as visual balm for the war weary and a memorial to a fallen general.

In the context of the sanitary fair, the canvas took on an added meaning: *The Rocky Mountains* hung directly across the gallery from Church's equally monumental *Heart of the Andes,* encouraging viewers to interpret the pair in terms of the opposition between North and South. This reading was encouraged by a toponymic coincidence: Chimborazo, the South American volcano pictured by Church, also denoted one of the "seven hills" of Richmond that was the site of a Civil War military hospital.[49] Plus, Leutze's *Washington Crossing the Delaware* hung at the end of the hall, within ready sight of both the Bierstadt and the Church, serving as a linchpin between them and reminding viewers of the glorious tradition of fighting for the nation. The link of Bierstadt's *Rocky Mountains* to the Civil War was reinforced after the Metropolitan Fair closed, when the owner shipped it to Philadelphia for exhibition in the Great Central Sanitary Fair.[50] There the canvas again drew attention as "the master-work of the artist" was accorded a central spot in the gallery and crowned with swags of bunting.[51]

In the *Pro Patria* section at the other end of the gallery, Bierstadt used a second strategy, exhibiting *Valley of the Yo Semite, California,* a painting that proved more valuable than any of the other works put up for sale. The picture fetched $1,600, making it the top seller in the auction. The *New York Evening Post* described this painting as "an elaborately finished study for one of the large pictures on which the artist is now engaged."[52] The artist's decision to donate a painting that was more self-consciously important than most in the *Pro Patria* group was a shrewd publicity move.[53] Although Bierstadt could not have predicted the hammer price, his donation of such a notable work burnished his reputation as a patriot willing

to sacrifice personal gain for the national cause. Bierstadt's auction winner also secured more press coverage than any other artwork in the sale, effectively advertising the major Yosemite painting currently underway in his studio and his larger series of California pictures.

Bierstadt's third promotional tactic, and by far the most spectacular, was to organize the fair's Indian Department, featuring a series of performances by Native Americans staged in an elaborate setting filled with Indian artifacts. As the *New York Herald* reported, Bierstadt, "during his extended sojourn at the Rocky Mountains and vicinity, has had unusual facilities for becoming acquainted with the customs and mode of life of the Indian tribes, and he has contributed a variety of articles procured in that region for the decoration and fitting up of the monster wigwam."[54] The space devoted to the Indian Department was at the Fourteenth Street end of the fair building, toward Sixth Avenue. The *Herald* and other accounts

FIG. 82.
"The Metropolitan Fair," *New York Herald*, April 4, 1864. 12 1/8 × 9 1/2 in. Newberry A6.632.

referred to the department as the "Wigwam," but the exhibit actually filled a sixty-by-thirty-foot room. At one end, a stage with a painted landscape backdrop was framed by a pair of Native-style dwellings, constructed of birch bark and animal skins.[55] The entire space was "lined with the skins of buffaloes, bears and other wild animals, from which are suspended every article of wearing apparel and every weapon of warfare which the Indians use, such as buckskin skirts, ornamented pantaloons and coats, pipes, bows and arrows of all sizes, shields of various devices, ornaments for horses, bone saddles, canoes, stone axes and tomahawks and other curious ornamental and useful articles."[56]

Bierstadt essentially recreated on a grander scale the installations he had set up in his studio following his western trips, adorning his work space with buffalo hides, Indian artifacts, and sketches and photographs of western scenery, to serve as a backdrop for the landscape paintings on his easel.[57] At the fair, the live Indians and full-size wigwams replaced Bierstadt's easel at center stage, but they created a scene resembling the Blackfeet camp in the foreground of *The Rocky Mountains, Lander's Peak.* In casting Native performers in a live version of his painting, Bierstadt followed in the footsteps of his fellow western painter George Catlin, who brought a troupe of Indians and their artifacts to London and Paris to enliven the exhibition of his Indian Gallery in the 1840s. In both instances, the spectacle of the Indians attracted more attention than the paintings they were intended to promote, but kept the artists in the public eye.[58] During the sanitary fair, the press ensured that the artist was given credit for the display, referring to the Indian Department as "Bierstadt's Indian wigwam."[59]

From the moment it opened, the "Wigwam" was thronged with visitors who packed the room to watch the Indians perform "a series of dances that were more than corybantic in execution—muscular savagery fairly distancing muscular Christianity in their common field."[60] The dances included staged rituals that would become staples at Wild West shows later in the century, such as the "Buffalo dance" and the "Scalp dance." A "Thanksgiving dance" and "Thanksgiving song" added a hint of Civil War relevance to the program. The term "Wigwam" also called to mind (in addition to the Native style of architecture) the popular name of the convention hall in Chicago where Lincoln had been nominated for president in 1860.

The *Herald* lauded the illusion of the exhibit, claiming that even "the most unimaginative individual, when beholding these men and women of the forest enacting their peculiar customs in full costume, cannot help feeling that he is really in the wilderness." In this way, the exhibit echoed the vision of a pristine American continent, untouched by the Civil War, that Bierstadt offered in his western landscape paintings. The *Herald* article also noted, however, that the Indian artifacts came from disparate locations. In addition to the objects Bierstadt had obtained in the Rocky Mountains, the display featured Sioux articles "captured by General Soule last September at Dakota," and others taken by "US officers in different skirmishes with Indian tribes, while many of the curiosities were brought from the Pacific coast, which belonged to the Six Nations. Most of the costumes have gone

from the Shosone or Shake Indians."[61] Although the reporter's understanding of tribal geographies is clearly limited—Indians from the Six Nations resided in the eastern rather than the western section of North America—the hodgepodge of artifacts encouraged audiences to regard them all as a theatrical display of Indianness rather than a scientific exhibit of specific cultures.

Much as Bierstadt's *The Rocky Mountains* avoided direct references to the Civil War, the Indian Department sidestepped the contemporary military conflicts in Indian Country, discussed in detail in Scott Stevens's essay in this volume. Although the decorations included objects reportedly "captured by General Soule last September at Dakota," this oblique reference to the 1862 Dakota War did not attract further comment. Similarly, the department made no mention of the contemporaneous military campaign to defeat the Navajo in the New Mexico Territory.

The Indian Department kept its distance from contemporary conflicts temporally as well as spatially. Whereas many of the objects and decorations represented the American West, the "company of Indians selected to illustrate life among the red men" was not from the West; all hailed from upstate New York. The group comprised one Cayuga man and thirteen men and four women from the Onondanga settlement near Syracuse.[62] Like the colonial kitchens and exhibits celebrating the American Revolution, the Iroquois were popularly associated with

FIG. 83.
"The Metropolitan Sanitary Fair—The Indian Department," *Frank Leslie's Illustrated Newspaper*, April 16, 1864. 16 × 10 1/2 in. Newberry oversize A5.34 v. 18.

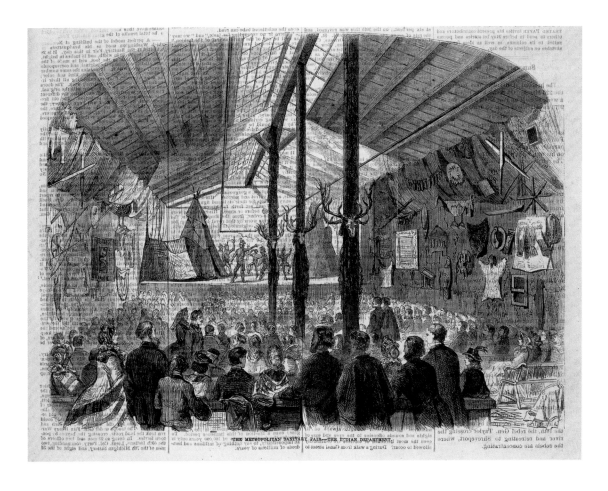

an earlier era, when their population and territorial dominance were greater. By the 1860s, the Iroquois had been subdued for the better part of a century and posed no current threat to the United States. By harking back to a time when Euro-American settlers in the North first prevailed over the Natives, the Iroquois reminded contemporary audiences of the military might of the Euro-American residents of the Northern United States, implying that Northern citizens would also prevail in the current conflict.

These oblique references to the US government's subjugation of Native Americans lent the Indian Department a memorial quality of its own. Instead of honoring fallen Civil War soldiers, the display practiced a kind of salvage ethnology, presenting and preserving—at least temporarily, in the form of spectacle—the rituals and material culture of people that whites generally believed were doomed.

Although the Iroquois were popularly associated with the American past rather than the present, they remained quintessentially American symbols—and thus perfectly suited to the nationalist mission of the fair. With local pride, the *Herald* noted that the previous fairs "held in other parts of the country failed to call upon the Indians to furnish their 'quota' to the national cause. Thus it was left to New York, which some say is the center of the extremes of barbarism and civilization, to 'conscript' the savage in helping forward this natural benevolent undertaking."[63]

By casting racial others as entertainment, the sanitary fairs attempted to neutralize racial controversies and turn attention away from tough political issues. While the Iroquois performers distracted audiences from the contemporary bloodshed in Indian Country, blacks filled roles that diverted attention from the harsh realities of slavery. At the Philadelphia fair, the restaurant was staffed by "Colored waiters, in spotless white aprons and jackets, and black pants, with rosettes of red, white, and blue." The fair report went on to observe that these waiters "bustle round with a very important air, as if the success of the Fair depended upon the individual exertions of each."[64] In the Knickerbocker Kitchen at the Metropolitan Fair, the "regular ornaments" of the chimney corner were "Chloe and Caesar, respectable people of color, the one busy with knitting, the other 'on hospitable cares intent' scraped his fiddle for the beguilement of visitors." Rounding out the tableau were "one or two pickaninnies who played upon the hearth." On special occasions, "for more boisterous amusement, there came in a real Virginia darky, all ebony and ivory, who could dance a 'breakdown' with all the vigor and splendor of embellishment of an age that is passing away."[65] The writer seemed to believe that that the African American dance traditions would die out when slavery ended, implying that this art form, like the Indians' dances, would soon warrant its own eulogy.

FIG. 84.
J. Gurney and Son, "View in the Wigwam," *A Record of the Metropolitan Fair in the Aid of the United States Sanitary Commission*, 1867. 3 5/8 × 2 7/8 in. Newberry F8345.73.

The performances by blacks and Indians at the fair echoed the contrasting approaches that Bierstadt and Mount took to representation in general. The black performers at the fair were akin to the African Americans painted by Mount in works such as *The Power of Music;* they seemed like people that the Northern fair visitors could live along side. The Indians seemed much wilder and more exotic, and their performances were more attention grabbing, like Bierstadt's art. By contributing major canvases to the art gallery and organizing the Indian Department for the fair, Bierstadt boldly proclaimed his support for the Union cause. But because these displays emanated from his current and already well-received personal project of celebrating the American West, they neatly promoted his own cause as well. Mount took a much subtler approach in sending his *Fruit Piece,* yet it was more risky: the canvas was small, but the genre of still life was brand new to him.

FIG. 85.
Unidentified Soldier in Union Uniform with Fork, Knife, Plate, and Cup Sitting on the Floor and Preparing to Eat a Slice of the Apple on His Lap, ca. 1861–65. Hand-colored tintype, 3 11/16 × 3 3/16 in. (9.4 × 8.1 cm). Courtesy of Prints and Photographs Division, Library of Congress, LC-DIG-ppmsca-32132.

Although both painters engaged the war indirectly, Mount's picture was more intimately related to the conflict, offering a profound meditation on the experience of Civil War soldiers. An anonymous camera operator focused on the same essential symbols, picturing an unidentified soldier sitting cross-legged on a wooden floor, balancing a plate holding a single apple in his lap, framed by the fork and knife he holds in either hand. His tin cup is poised carefully atop the small suitcase at his side. The soldier's ceremonial pose and the prominent placement of the apple and the dipper assure us that both items are highly prized.

The juxtaposition of Mount's *Fruit Piece* and this photograph draws attention to additional dimensions of the painting's meaning. By depicting the apples and cups in their "natural size" (as Mount put it) and concealing his brush strokes, Mount achieved a trompe l'oeil effect, encouraging viewers to mistake his painted objects for real ones. Verisimilitude had been a staple of still life paintings of fruit since ancient times, but during the Civil War, simulated apples may have called to mind the mock apple pie that soldiers made on the battle front.[66] More broadly, in the mid-nineteenth century, painting's hold on visual simulation was challenged by the new media of photography

During the war years, Mount was preoccupied by this issue. He often painted over photographs with watercolor for friends and family members on Long Island, enhancing the images' simulation of both reality and of paintings. In his journal he complained about these side projects, writing in May 1862: "It is about time I stop painting so many Photographs for nothing—It takes too much time." The following May he again mentioned "coloring some *card visites* and large Photographs—in watercolor." Mount went on to note that his "ambition is satisfied in that line of painting at present," concluding that "it is a kind of work *partly following but not leading. It is slavery.*"[67] Mount's anecdote points to the artist's "coloring" as ex-

ploited labor akin to that of black slaves in the South, but also to the escalating challenges to the fine arts during the war, as military-themed photographs, magazine illustrations, sheet music, and other vernacular forms of expression proliferated. His comment also calls attention to the superficiality of the color he applied to the photographs. The color made the pictures more eye catching and lifelike, but did not shape or create the image in the way that he did when he painted in oil on canvas. With his *Fruit Piece*, Mount rose to the challenge posed by vernacular imagery, producing a picture that not only fooled the eye more completely, but portrayed soldiers in a more meaningful, multifaceted way than the literal representation of the soldier with the apple and cup in the photograph.

Mount's illusionism also rivaled Bierstadt's showmanship. In his Indian Department, Bierstadt filled a sixty-by-thirty-foot room with live Natives, Indian artifacts, wigwams, and painted scenery to create a spectacular realization of the scene at the center of his painting of *The Rocky Mountains, Lander's Peak*. Mount achieved his verisimilitude with paint alone, on a board that measured only 6 1/2 by 9 1/16 inches.

In Mount's still life, the apples and tin cups are brilliantly present, but the soldiers who owned them are conspicuously absent. The still life elements serve as figurative surrogates for the missing men. The human imprints in the picture—the foreground apple shows a fingernail impression, one of the cups is tarnished and worn—underscore this anthropomorphism. The painting calls to mind the young soldiers who, like the apples, were plucked in their prime and shipped out. Some returned in fine condition, like the shiny cup, but others came home with scars.

A related metaphor appeared in a short story published in *Godey's Lady's Book* in November 1863, featuring a family mistakenly notified of a son's death on the battlefield. When the mother insists, despite the family's mourning, that they cook a traditional Thanksgiving dinner, the "apple-parings, skillfully left in one unbroken coil" reminded her of "the strong young arm" of the son who loved watching her bake pies. The *Godey's* story had a happy ending, as the son returns in time to enjoy the pies, his reunited family serving as a ready stand-in for a reunited nation. The son's homecoming gestures toward the end of the war, making plain a theme to which the *Fruit Piece* hints. Bereaved families became common subjects in popular writing, music, and art as the war wore on. For example, countless pieces of sheet music featured titles such as *Dear Mother I've Come Home to Die*.

The connections between the autumnal imagery and the war intimated in still life and landscape paintings were made manifest in William Cullen Bryant's poem "My Autumn Walk," penned in October 1864.[68] The "woodlands ruddy with autumn" where the poet walks are rustled by winds from southwest, "Where our gallant men are fighting." Bryant equated the season's falling leaves with fallen soldiers:

> Full fast the leaves are dropping
> Before that wandering breath
> As fast, on the field of battle,
> Our brethren fall in death.

· 146 ·

Diane Dillon

FIG. 86.
E. Bowers (words) and Henry Tucker (music), *Dear Mother I've Come Home to Die,* New York: Firth, Son, & Co., 1863. Sheet music, 12 3/16 × 9 1/2 in. Newberry Case 8A 319, James Francis Driscoll Collection of American Sheet Music, gift of the Driscoll Family.

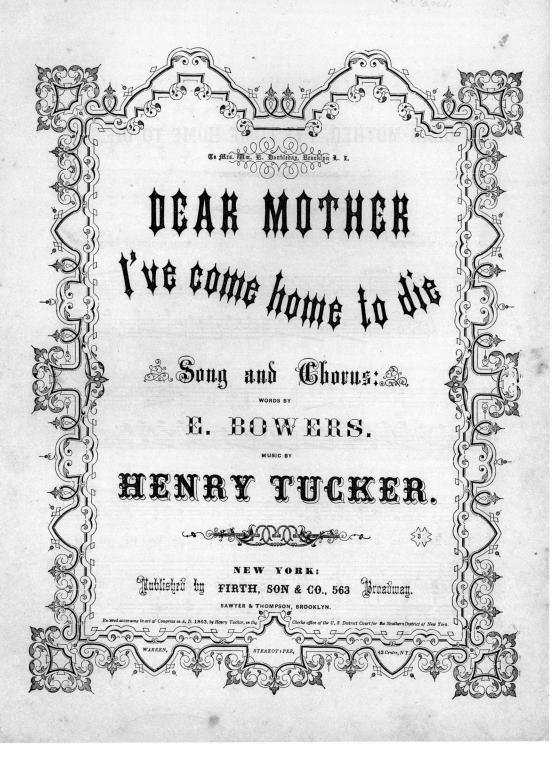

Inspired perhaps by *Our Banner in the Sky,* the poet sees in the woods:

> The mock-grape's blood-red banner
> Hung out on the cedar-tree.

Nature's gory flag returns his attention to the war's carnage:

> And I think of days of slaughter,
> And the night-sky red with flames,
> On the Chattahoochee's meadows,
> And the wasted banks of the James.

Bryant's "Autumn Walk" tacks back and forth between battle and home fronts as the poet wonders: "But who will comfort the living" in their "peaceful dwellings. . . . With croft and garden and orchard." Over the course of its sixteen stanzas, the poem adumbrates the multiple associations of the color red in the autumn of 1864: ruddy leaves, orchard apples, cannon fire, spilled blood, the cycle of life and death.

The same year, Alfred Thompson Bricher and Thomas Moran created *Hudson River at West Point* and *Autumn Afternoon, the Wissahickon,* respectively. Like Mount's *Fruit Piece,* at first glance these two canvases appear unrelated to the war; rather, they seem to be celebrations of the autumn glories of the American landscape celebrated by Bryant, following in the antebellum tradition of the Hudson River school.[69] But closer analysis reveals that these paintings, like Mount's *Fruit Piece,* incorporate layers of meaning, public and private, that yoke them to the war.

A native New Englander, Bricher probably made a pilgrimage to the Hudson River early in his career to glimpse the celebrated scenery that inspired Thomas Cole and the first generation of American landscape painters.[70] The stunning vistas of the Hudson River Valley encouraged tourists and settlers as well as artists to come to the area, which Bricher acknowledges through the inclusion of steamboats on the river, figures on the grassy foreground point, and the village of Cold Spring on the distant shore. The composition offers an object lesson in the eighteenth-century English aesthetic formulas that guided so many American painters: the perfectly smooth water of the Hudson River and golden sky above meet Edmund Burke's definition of the beautiful; Mount Taurus rising in the distance hints at the sublime; and the foreground landscape, complete with rustic cottage, uneven fence, and rocky shore, exemplifies the picturesque.[71] The idea that the painting serves as a lesson is reinforced by the two tiny female figures on the bank, who seem to study the landscape. The seated figure holds a book or sketch pad on her lap while the other looks over her shoulder. If the artistic lessons Bricher presents derive from European models, the red, amber, and fading green foliage marks the landscape as unquestionably American. From the early nineteenth century onward, painters, poets, and essayists had identified spectacular autumn scenery as a distinctive feature of the American landscape.

FIG. 87.
Alfred Thompson Bricher, *The Hudson River at West Point,* 1864. Oil on canvas, 20 1/8 × 42 1/4 in. (51.1 × 107.3 cm). Terra Foundation for American Art, Chicago, Daniel J. Terra Collection, 1993.17.

FIG. 88.
Thomas Moran, *Autumn Afternoon, the Wissahickon,* 1864. Oil on canvas, 30 1/4 × 45 1/4 in. (76.8 × 114.9 cm). Terra Foundation for American Art, Chicago, Daniel J. Terra Collection, 1999.99.

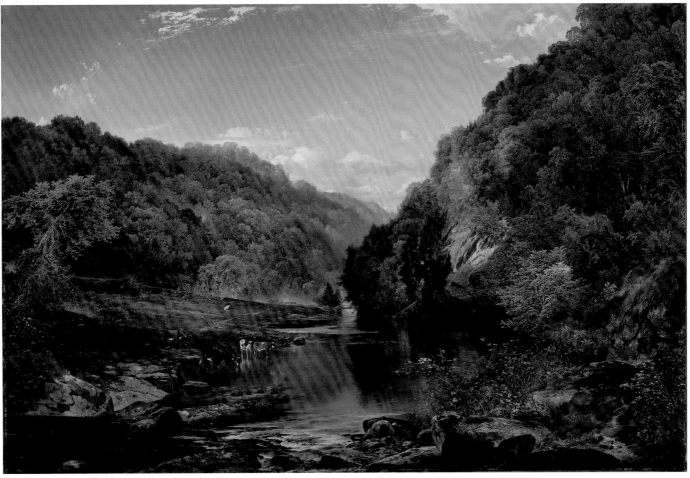

Thomas Moran presents even more flamboyant fall scenery in *Autumn Afternoon, the Wissahickon*. The artist knew this landscape intimately. He grew up on the outskirts of Philadelphia, and he and his brothers spent many hours sketching the scenery of the streams and woods surrounding the city.[72] In 1863 and 1864, Moran painted at least four fall landscapes with the Wissahickon creek at the center. According to his personal "Opus List," he painted the first version, *Autumn on the Wissahickon,* in October and November 1863, "incited by a most glorious Autumn." Upon finishing it, Moran "decided that my forte lay in color & would prove my strongest point."[73]

The natural beauty of the Wissahickon creek was never as storied as the Hudson River Valley, but in the mid-nineteenth century it was celebrated by painters, poets, and tourists. The area was a favorite destination of Philadelphians for picnics and day trips into the countryside. A letter published in the *Lady's Home Magazine* in 1857 reported on an excursion on the Wissahickon road on a balmy October day, "feasting our eyes on the most brilliant colors and beauties." In this context, the writer felt that *the Ideal of the earth seems realized.*"[74] As a writer for *Gleason's Pictorial Drawing-Room Companion* described the area in 1851, "From the falls down some six or eight miles, it is a perfect fairy land. Within fifty feet of the creek, on each side, is a fine road, with a canopy of trees; while the winding creek is lined on either side with the richest foliage, and ever and anon, peeping through the trees are little inns and hotels, where are all the amusements requisite for a residence of bricks and mortar.... The scenery in the vicinity is beyond description."[75]

In his canvas, Moran balanced his rendering of "the richest foliage" of a "wild landscape" with hints of the "material industries" nearby. The cows drinking lazily in the stream imply that a dairy farm is not far away, while the tiny wooden bridge over the water and the large covered wagon pulled by oxen on the road in the distance remind us that commercial transportation through the landscape was well established. The bridge may be the new wooden railroad bridge that was erected by the Philadelphia, Germantown and Norristown Railway after fire destroyed the existing bridge in 1862. That same year, the local citizens authorized the railway to extend their line through the area; the new route promised "considerable revenue," as the region offered "good land at low rates" as well as "beautiful country and scenery."[76]

The glorious scenery painted by Bricher and Moran would have offered visual escape to eyes weary of war, much as Bierstadt's western landscapes did. Yet the locations they pictured are not nearly so removed from the conflict as they might at first seem. *Hudson River at West Point* features a site near the US Military Academy, where many officers in the Union Army trained. In 1864, the academy at West Point was a topic of heated debate in Congress and in the press, as critics called for competitive admissions and more rigorous academic standards.[77] Bricher's site was also not far from the West Point Iron and Cannon Foundry in Cold Spring, New York. A local landmark frequented by tourists and artists as well as military engineers, the foundry produced most of the Union Army's large

guns through the end of the war. The facility gained attention after the Parrot gun, invented by foundry superintendent Robert Parker Parrot, made its debut at the Battle of Bull Run.[78] For Bricher, the military associations of the landscape carried personal meaning, as his younger brother William, a Union soldier, lost his life in combat at Spotsylvania in 1864.[79] *Hudson River at West Point* serves as a memorial to William Bricher.

Autumn Afternoon, the Wissahickon depicts an area known for its woolen mills, which contributed to the war effort by producing fabric for soldiers' uniforms and blankets. As the *Scientific American* reported in February 1862, "All the woolen mills in our country have been stimulated to prodigious efforts in order to supply the demands made upon them. Most of the factories have been engaged on army contract work, and it is stated that all of the corporations have made handsome profits." The journal went on to note that despite the army's specification of "long staple wool" for blankets and clothing, "great quantities of shoddy goods" were foisted on the government for the early volunteers. "Shoddy" consisted of old woolen rags ground up and mixed with new wool. The short fibers so diminished the strength of the cloth that with a little wear, "the shoddy rubs off and comes out in fine fuzz."[80] The prevalence of shoddy early in the war helps explain the rapid tattering of army uniforms, which in turn stimulated women on the home front to sew for the troops. The area painted by Moran gained another connection to the conflict when the US Navy ordered the construction of twenty-three new gunboats for the war, one of which was christened *Wissahickon*.[81] During the September 1863 attack on Fort Sumter, Lieutenant Commander Williams of the *Wissahickon* commanded the first division of boats.[82]

Moran likely had the war in mind when he painted *Autumn Afternoon, the Wissahickon*. The first and second pictures in the Wissahickon series were among the eight pictures Moran exhibited at the Great Central Fair in Philadelphia in June 1864. Moran also served on the fine arts committee for the event. The first painting in the series, *Autumn on the Wissahickon*, had garnered high praise when it was shown at the Pennsylvania Academy that spring. The critic for *The Round Table* noted that "the splendid brilliancy of our October landscape is portrayed with truthfulness and grace" and found the scene "among the most attractive landscapes of the exhibition."[83] The critical and financial success of the first Wissahickon picture prompted the series. After Philadelphia banker A. Drexel purchased this canvas for $300, J. S. Earle & Sons commissioned four landscapes, including *Autumn Afternoon, the Wissahickon*. Moran wrote that he made the charcoal cartoon for this picture in June 1864, while the sanitary fair was in progress. Shortly thereafter, on July 16, his brother William Moran began his service in the Union Army.[84] When he finished the painting, Moran observed that it was "decidedly my best picture up to this time," and that Earle sold it for $600, the "highest price yet obtained for any of my pictures."[85]

The autumnal scenes rendered by Bricher and Moran in 1864 stood as middle grounds in the Civil War landscape—removed from the battlefields but not so distant as Church's *Cotopaxi* or Bierstadt's *The Rocky Mountains*. In addition to their

proximity to war-related industries, the towns and farm communities in the areas pictured provided soldiers to the Union Army and donations to the sanitary fairs held in Philadelphia, Brooklyn, and New York. Moreover, the 1863 draft riots in New York had demonstrated that the war could provoke bloodshed away from the battlefront.[86]

The patriotic atmosphere of the pictured locales along the Hudson and Wissahickon was heightened by their links to important episodes during the American Revolutionary War, a connection that was proudly celebrated in local histories and tourist accounts. West Point was a strategic junction during the Revolution, centrally located between the ports in New York and Canada and the Patriots in New England. The Academy at West Point was the repository for the famed Putnam guns that had been made in France and sent to Quebec, captured by the British on the Plains of Abraham, and then finally surrendered to the Americans by Burgoyne at Saratoga. And West Point became the scene of the "real, romance of the Revolution" when Benedict Arnold "sold his country, in devilish purpose at least, and his soul, for ten thousand pounds and a British epaulette."[87] Moran's site was not far from the activities of the Continental Congress at Philadelphia and even closer to George Washington's exploits at Valley Forge (remembered in the grand canvas by Leutze shown at the Metropolitan Fair, *Washington Crossing the Delaware*). While Virginia troopers commanded by Washington were stationed on a farm on the Wissahickon, they were surprised by company of British dragoons; the Tory soldiers killed seven of the Virginians, who were then buried on the farm. On February 22, 1860, the Pennsylvania dragoons laid the cornerstone to a monument on the Virginia troopers' gravesite.[88] These connections to the American Revolution gained traction when Lincoln conjoined the two eras in the opening words of the Gettysburg Address: "Four score and seven years ago, our fathers brought forth on this continent, a new nation."[89]

The symbolic value of autumn landscapes, food, domestic rituals, Indians, and memorials came together at Thanksgiving, declared a national holiday by Lincoln in 1863. Long before Lincoln's official action, the holiday had served a range of purposes in a variety of cultural settings. The New England Pilgrims famously celebrated by feasting and praying in the company of Indians, and religious leaders in the centuries that followed used the holiday as an occasion to encourage acts of charity and gratitude. George Washington and subsequent presidents and governors issued Thanksgiving declarations focused on more local civic goals.[90] Lincoln's four proclamations about the holiday cast it as civil religion, emphasizing Americans' shared purpose and destiny as a nation.[91]

Sarah Josepha Hale, editor of the Philadelphia-based *Godey's Lady's Book*, had initiated the campaign to establish the national holiday in 1847. She published yearly editorials on the topic and sought the support of elected officials, missionaries, and military leaders. Hale hoped that the holiday would help prevent the Civil War by fostering national unity.[92] The end of the war did not diminish the Thanksgiving mission for Hale and other supporters. As she put it to readers in an 1865 editorial, "Can there be a doubt that to make this anniversary truly national will

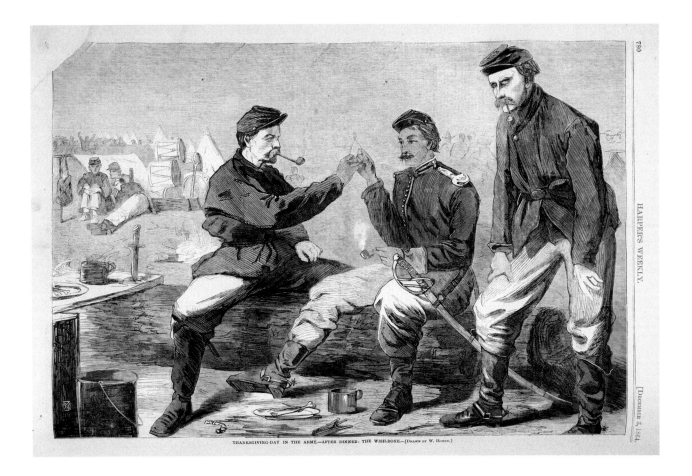

THANKSGIVING-DAY IN THE ARMY.—AFTER DINNER: THE WISH-BONE.—[DRAWN BY W. HOMER.]

be to create a powerful means of national unity?" Articles in the pages of *Godey's* taught readers—mostly middle-class women—how to mark the holiday in the domestic sphere, offering advice about family gatherings (ideally in rural home- steads, where colorful autumn foliage was plentiful), maintaining wholesome tra- ditions, and, of course, recipes for apple pie and other Thanksgiving dishes.[93]

Artists seconded Hale's enthusiasm, particularly Winslow Homer, who de- picted the power of Thanksgiving rituals in a series of wartime engravings pub- lished in *Frank Leslie's Illustrated Newspaper* and *Harper's Weekly*. "Thanksgiving Day in the Army" showed soldiers observing the holiday with meager fare on the battlefront, while "Thanksgiving Day—Hanging Up the Musket" celebrated the return to civilian life. In "Thanksgiving Day—The Church Porch," Homer de- picted a uniformed soldier leaving a Thanksgiving service on crutches, one of his pant legs clearly empty. Published in December 1865, the picture at once marks the war's end and portrays its costs.

The autumn landscape continued to compel painters and audiences after the war, but for most of them, the focus shifted. Visually flamboyant fall scenery, largely undisturbed by man, lost currency.[94] In the immediate aftermath of the conflict, many artists turned to the agricultural landscape, drawn to its conno- tations of nurtured productivity and natural renewal. George Inness celebrated the end of the war with *Peace and Plenty* (1865), a lush harvest scene animated

FIG. 89.
Winslow Homer, "Thanksgiving Day in the Army—After Dinner: The Wish-Bone," *Harper's Weekly*, December 3, 1864. Magazine illustration, 16 × 10 1/2 in. Newberry folio A5.392 v. 9.

by abundant sunshine, crops, and hope for the future. Homer also explored the transition from war to peace in a major oil painting, *The Veteran in a New Field*. Painted in the months following Lee's surrender at Appomattox on April 9, 1865, the picture centers on a soldier who has literally cast his army jacket aside as he takes up his new (or renewed) vocation as a farmer. Homer expressed considerably more doubt about the possibility of neatly putting the war behind us than Inness. His veteran cuts his tall wheat with a scythe, a then-outmoded tool that called to mind the grim reaper as well as the fall harvest, reminding viewers of the recent carnage.[95]

Sanford Robinson Gifford's *Hunter Mountain, Twilight* (1866) likewise presents an ambivalent image of the American landscape, implying a sober outlook for the future. Gifford was one of the few major American painters to serve in the Civil War. In 1861 he enlisted with the Seventh Regiment of the National Guard in New York and spent part of each year through 1863 on duty in Baltimore and Washington, DC. He memorialized his military service in paintings such as *Camp of the Seventh Regiment, near Frederick, Maryland, in July, 1863*. Gifford's military commitments shaped his choice of subjects during these years in more subtle ways as well. As his guard duties limited his spring and summer sketching trips, he stayed close to his home in Hudson, New York, and to his familiar artistic territory in the Catskills.[96] Gifford registered the impact of the war's dramatic beginnings in his 1861 *A Twilight in the Catskills*. In this picture and in *Baltimore, 1862—Twilight*, Gifford nodded to Church's *Our Banner in the Sky* by painting uncharacteristically gaudy effects of light. Before resigning from the regiment in late summer 1863, Gifford observed the maneuvers following the Battle of Gettysburg. From his post at Frederick, Maryland, he saw both the Confederate and Union soldiers marching south.[97]

Although he experienced no battlefield duty, Gifford must have been keenly aware of the war's destruction of lives and landscapes. In addition to whatever military information he may have received, his proximity to Washington, DC, and New York would have accorded him access to Mathew Brady's studios and the battlefield photographs produced by Timothy O'Sullivan and other camera operators. He probably also saw engraved reproductions of the photographs in *Harper's Weekly*.

Like the wartime pictures by Mount, Bricher, and Moran, Gifford's *Hunter Mountain, Twilight* entwines private and public meanings. Around the time that he left the National Guard in 1863, his brother Edward died while serving with the 128th New York Regiment in Louisiana. Two years later he mourned the death of his brother Frederick and his friend and fellow artist James Suydam.[98] These personal losses, combined with the nation's collective wartime losses, contributed to the somber mood of *Hunter Mountain, Twilight*. The painting's stump-strewn foreground resembles other landscapes devastated by clear-cutting, such as Inness's *The Lackawanna Valley* (1855). Art historians have pointed to stump-filled landscapes as signs of the price of settling the wilderness.[99] For Gifford in particular, they have noted the toll taken on this specific locale by the tanning industry

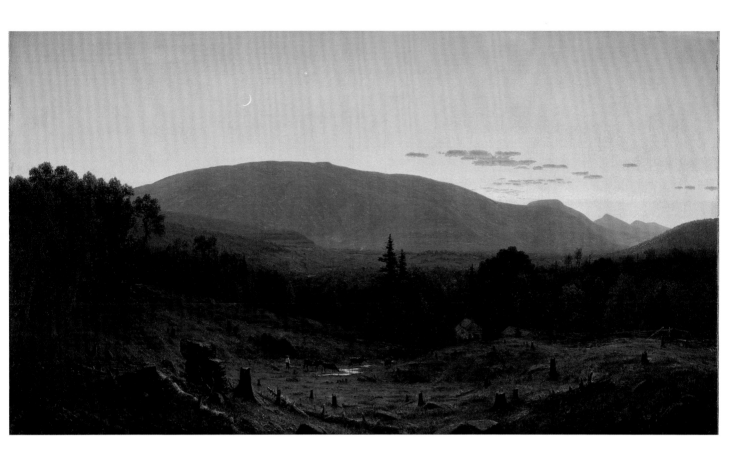

and its devastating harvest of the hemlock trees in the area for the tannin in its bark.[100] But the more immediate inspiration for the scene may well have been Timothy O'Sullivan's *A Harvest of Death, Gettysburg* (see fig. 4.), the now-famous photograph of dead bodies strewn across the Gettysburg landscape. Gifford may have seen this photograph in Brady's studio, or when it was published in *Gardner's Sketch Book of the Civil War* in 1866.

Despite their subtle reminders of Civil War losses, the larger message of the memorializing imagery discussed here may be more hopeful. *Hunter Mountain, Twilight* includes cows and a farmhouse—perhaps a reference to Gifford's own home in the Catskills—indicating that the land is still productive. If dead trees and fading light recalled the war's ravages, they also promised eventual rebirth, recovery, and reunion. And if Mount's *Fruit Piece: Apples on Tin Cups* honors the countless fallen soldiers buried in anonymous mass graves, the survival of the dippers also remind us that many veterans made it back to the home front, where their tin cups could be put to new uses, in art as in life.

FIG. 90.
Sanford Robinson Gifford, *Hunter Mountain, Twilight*, 1866. Oil on canvas, 30 5/8 × 54 1/8 in. (77.8 × 137.5 cm). Terra Foundation for American Art, Chicago, Daniel J. Terra Collection, 1999.57.

Acknowledgments

This book, as well as the exhibition and programs that accompany it, are the result of a successful collaboration between the Newberry Library and the Terra Foundation for American Art in Chicago. The Newberry especially appreciates the Terra Foundation's financial support for the book, exhibition, and programs to commemorate the sesquicentennial of the Civil War.

Newberry staff across the library made significant contributions to the project. Particular thanks are due to David Spadafora, president and librarian, for his support of this project since its inception. Contributions to research, exhibition planning, programming, and administration were made by John S. Aubrey, Ayer librarian; Joy Austria, special collections senior library assistant; Rachel Bohlmann, director of public programs; John Brady, director of reader services and bibliographer of Americana; Christopher Cantwell, assistant director, Dr. William M. Scholl Center for American History and Culture; Lesa Dowd, director of conservation services; Catherine Gass, photographer; James Grossman, former vice president for research and education; Hjordis Halvorson, vice president for library services; Barbara Korbel, collections and exhibitions conservator; Kelly Kress, project archivist; Kelly McGrath, director of communications and marketing; Michael Mitchell, facilities manager; Liesl Olson, director, Dr. William M. Scholl Center for American History and Culture; John Powell, digital imaging services manager; Ann Repp, conservator; Rachel Rooney, director, professional development programs for teachers; Gwendolyn Rugg, program assistant and spotlight exhibitions coordinator; and Giselle Simon, former director of conservation services. Scholl Center interns Maggie Grossman and Maxwell Johnson provided valuable research support. Carmen Jaramillo, program assistant in the Scholl Center, helped with research and coordinated many aspects of the project ably.

At the Terra Foundation for American Art, several staff members contributed to the project. Particular thanks are due to Elizabeth Kennedy, former curator of collection, for initiating conversations with the Newberry and to Elizabeth Glassman, president and chief executive officer, for her enthusiastic support. Thanks also to Elizabeth Turner, vice president for collection and curatorial affairs; Amy Zinck, vice president and director, Terra Foundation for American Art, Europe; Katherine Bourguignon, associate curator and associate program officer; Cathy

Ricciardelli, registrar of collection; Bonnie Rimer, consulting conservator; Jennifer Siegenthaler, program officer, education programs; Eleanore Neumann, former programs and communications associate; Carrie Haslett, program officer, exhibition and academic programs; Amy Gunderson, grants manager; Charles Mutscheller, communications and web manager; and Lynne Summers and Caroline Kearns, executive assistants. Collection interns Naomi Hood Slipp, Annelise K. Madsen, and especially Sara Jatcko provided valuable research and logistical support. Terra Foundation board members Charles E. Eldredge, Michael Shapiro, Gerhard Casper, and David Weinberg made useful suggestions for conceptualizing the exhibition in its initial stages. Collegial conversations with Eleanor Harvey at the Smithsonian American Art Museum also yielded a number of valuable insights.

At the University of Chicago Press, Senior Editor Robert Devens acquired this book, and Timothy Mennell shepherded it through publication. Editorial Assistant Russell Damian oversaw the book's production. Mark Reschke, senior manuscript editor, saved us from many errors. Susan Hernandez compiled the Index.

The contributors to the book would like to thank Adam Goodheart for his thoughtful foreword, as well as his representatives at The Wylie Agency, Jin Auh and Jacqueline Ko. We benefited from critical and helpful readings of earlier essay drafts by many colleagues, including the anonymous readers on behalf of the University of Chicago Press, Christopher Cantwell, Richard Allen Greene, Jennifer A. Greenhill, Thavolia Glymph, John W. Hall, Sara Jatcko, Lisa Meyerowitz, and Liesl Olson.

It has been a pleasure to collaborate with Alan Teller and Frank Madsen, of Teller Madsen Inc., on the exhibition design and production. We thank Arthur Holzheimer for graciously lending from his collection for the exhibition. We extend thanks to the Chicago History Museum, the Chicago Public Library, Rare Books and Special Collections at Northern Illinois University Libraries, and the Allen Memorial Art Museum at Oberlin College, Ohio, for their assistance in lending materials to the exhibition.

All projects of the Dr. William M. Scholl Center for American History and Culture at the Newberry are supported in part by the Dr. Scholl Foundation.

Exhibition Checklist

Louisa M. Alcott
Little Women; or, Meg, Jo, Beth and Amy
Boston: Roberts Brothers, 1869
Book
6 7/8 × 4 11/16 in.
Newberry Case Y255.A3323 v. 1

The American Boy, ca. 1861–65
Broadside
8 1/2 × 5 1/2 in.
Newberry Case Y274.17.
No. 41

The American Volunteer, ca. 1861–65
Broadside
8 7/8 × 5 1/2 in.
Newberry Case Y274.17.
No. 21

Edward Atkinson
The Cotton Kingdom
Boston, March 1863
Map
21 1/4 × 17 1/2 in.
Newberry H42.052

Jane Goodwin Austin
Dora Darling: The Daughter of the Regiment
Boston: J. E. Tilton & Co., 1865
Book illustration
7 5/16 × 4 7/8 in.
Newberry Y255.A881

I. Winslow Ayer
The Great Northwestern Conspiracy
Chicago: Rounds and James, 1865
Book
9 × 6 in.
Newberry Case F83411.054

Banner of Stars, ca. 1861–65
Broadside
8 7/16 × 5 1/2 in.
Newberry Case Y274.17 no. 44

Eugene Benson
Indian Attack, 1858
Oil on canvas
10 1/2 × 12 1/2 in. (26.7 × 31.8 cm)
Terra Foundation for American Art, Chicago, Daniel J. Terra Art Acquisition Endowment Fund, 1999.6

T. B. Bishop
"The Escaped Slave" and "The Escaped Slave in the Union Army"
Harper's Weekly, July 2, 1864
Magazine illustrations
16 × 10 1/2 in.
Newberry folio A5.392 v. 8

Eliphalet Wickes Blatchford
Letter to Mary Williams Blatchford, June 29, 1862
Manuscript
8 × 5 1/16 in.
Newberry E. W. Blatchford Papers, box 1, folder 6
Gift of the heirs of Eliphalet Wickes Blatchford

Eliphalet Wickes Blatchford
"Memorial of the Public Meeting of the Christian Men of Chicago. To His Excellency, Abraham Lincoln, President of the United States," ca. 1864
Manuscript
12 1/2 × 8 in.
Newberry E. W. Blatchford Papers, box 7, folder 193
Gift of the heirs of Eliphalet Wickes Blatchford

Eliphalet Wickes Blatchford
Photograph
Photograph
4 × 2 1/2 in.
Newberry E. W. Blatchford Papers, box 116, folder 2129
Gift of the heirs of Eliphalet Wickes Blatchford

Eliphalet Wickes Blatchford Family Photographs
Photographs
4 × 2 1/2 in.
Newberry E. W. Blatchford Papers, box 118, folder 2197
Gift of the heirs of Eliphalet Wickes Blatchford

Albert Bobbett and Edward
Hooper
"The New Place"
Vanity Fair, December 27, 1862
Magazine illustration
11 1/2 × 8 7/8 in.
Newberry folio A5.93 v. 6

Albert Bobbett, Edward Hooper,
and Louis H. Stephens
"The Highly Intelligent
Contraband"
Vanity Fair, April 26, 1862
Magazine illustration
11 1/2 × 8 7/8 in.
Newberry folio A5.93 v. 5

Albert Bobbett, Edward Hooper,
and Louis H. Stephens
"Principle vs. Interest"
Vanity Fair, April 13, 1861
Magazine illustration
11 1/2 × 8 7/8 in.
Newberry folio A5.93 v. 3

"The Bombardment of Fort
Sumter, Charleston Harbor,
the 12th and 13th of April,
1861"
*Frank Leslie's Pictorial History of
the American Civil War*
New York: Frank Leslie, 1862
Magazine illustration
22 1/4 × 30 1/2 in.
Newberry Dawes F834.496
From the collection of Ephraim
C. Dawes, gift of the
Honorable Charles G. Dawes

E. Bowers (words) and Henry
Tucker (music)
*Dear Mother I've Come Home
to Die*
New York: Firth, Son, & Co.,
1863
Sheet music
12 3/16 × 9 1/2 in.
Newberry Case 8A 319
James Francis Driscoll Collec-
tion of American Sheet Music
Gift of the Driscoll Family

Charles Brandon Boynton and
T. B. Mason
*A Journey through Kansas;
With Sketches of Nebraska:
Describing the Country,
Climate, Soil, Mineral,
Manufacturing, and Other
Resources*
Cincinnati: Moore, Wilstach,
Keys & Co., 1855
Map
7 7/8 by 4 5/8 in. (book)
7 7/8 × 7 7/8 in. (map)
Newberry Graff 376
Everett D. Graff Collection of
Western Americana
Bequest of Everett D. Graff

Alfred Thompson Bricher
The Hudson River at West Point,
1864
Oil on canvas
20 1/8 × 42 1/4 in. (51.1 ×
107.3 cm)
Terra Foundation for American
Art, Chicago, Daniel J. Terra
Collection, 1993.17

John M. Chivington
*To the People of Colorado:
Synopsis of the Sand Creek
Investigation; Denver, Colorado,
June 1865*
Pamphlet
8 × 5 1/2 in.
Newberry Vault Graff 698
Everett D. Graff Collection of
Western Americana
Bequest of Everett D. Graff

Frederic Edwin Church
Our Banner In the Sky, 1861
Oil paint, over photomechani-
cally produced lithograph,
on paper, laid down on card-
board
7 1/2 × 11 3/8 in. (19.0 × 28.9
cm)
Terra Foundation for American
Art, Chicago, Daniel J. Terra
Collection, 1992.27

A Collection of Patriotic War
Envelopes in Common Use
During the War of the
Rebellion, ca. 1861–65
Scrapbook
9 × 7 1/4 in.
Newberry Case Wing ZC 25.185
Bequest of John M. Wing

Miss M. A. Collier and
E. J. Loder
*Eliza's Flight: A Scene from Uncle
Tom's Cabin*
Boston: Oliver Ditson & Co.,
1852
Sheet music
14 × 10 1/2 in.
Newberry sheet music
VM1621.L82e

Samuel Colman
Ships Unloading, New York, 1868
Oil on canvas mounted on
board
41 5/16 × 29 15/16 in. (105.0 ×
76.0 cm)
Terra Foundation for American
Art, Chicago, Daniel J. Terra
Collection, 1984.4

George Deal
Letter to Wife, Camp Denison,
November 9, 1862
Manuscript
9 11/16 × 8 1/2 in.
Newberry George Deal Papers,
box 1, folder 2
Gift of Carolyn Young

George Deal Photograph
Photograph
7 1/2 × 5 1/2 in.
Newberry George Deal Papers,
box 1, folder 55
Gift of Carolyn Young

"The Dying Patriot"
Charles Carleton Coffin
*My Days and Nights on the
Battle-field: A Book for Boys*
Boston: Ticknor and Fields,
1864
Book illustration
7 × 4 3/4 in.
Newberry F8342.185

"The Dying Soldier: The Last
Letter from Home"
Mary Livermore
My Story of the War
Hartford, CT: A. D. Worthing-
ton, 1889
Book illustration
8 5/8 × 5 1/2 in.
Newberry F8344.51

"Eliza Crosses the Ohio on the
Floating Ice"
Harriet Beecher Stowe
Uncle Tom's Cabin
London: John Cassell, Ludgate
Hill, 1852
Book illustration
8 3/16 × 5 7/16 in.
Newberry Case Y255.S8848

Edward Sylvester Ellis
*The Fighting Trapper; or, Kit
Carson to the Rescue; A Tale of
Wild Life on the Plains* (cover
illustration)
Frank Starr's American Novels,
No. 139, 1874
Johannsen Collection, Rare
Books and Special Collec-
tions, Northern Illinois
University Libraries, PS648.
A36 F737 1869a no.139

Edward Sylvester Ellis
*Indian Jim: A Tale of the Minne-
sota Massacre*
London: Beadle and Company,
1864
Book
6 7/16 × 4 3/16 in.
Newberry Ayer 438.E39 1864
Edward E. Ayer Collection
Gift of Edward E. Ayer

Edward Sylvester Ellis
*The Life and Times of Christopher
Carson: The Rocky Mountain
Scout and Guide*
Book
6 5/8 × 4/18 in.
Newberry Ayer 247.C15 E4
1861
Edward E. Ayer Collection
Gift of Edward E. Ayer

Edward Sylvester Ellis
*Nathan Todd; or, The Fate of the
Sioux Captive*
London: G. Routledge, ca. 1861
Book
6 1/2 × 4 1/8 in.
Newberry Ayer 439.B36 1861
v. 4
Edward E. Ayer Collection
Gift of Edward E. Ayer

Elmer E. Ellsworth
*Zouave Drill: Manual of Arms for
Light Infantry*
Chicago: P. T. Sherlock, 1861
Book
5 3/4 × 4 in.
Newberry Graff 1240
Everett D. Graff Collection of
Western Americana
Bequest of Everett D. Graff

The Ever Welcome Sanitary
Commission, 1890
Stereograph card
4 × 7 in.
Newberry Oliver Barrett-Carl
Sandburg Papers, box 8, no.
1199
Gift of Roger Barrett

"Execution of the 38 Sioux
Indians"
*Frank Leslie's Illustrated News-
paper*, January 24, 1863
Magazine illustration
16 × 10 1/2 in.
Newberry oversize A5.34 v. 15

"Exterior View of the Great
North-Western Sanitary Fair
Building, Chicago, Ill."
*Frank Leslie's Illustrated
Newspaper*, July 8, 1865
Magazine illustration
6 × 21 1/4 in.
Newberry oversize A5.34 v. 20

The Flag of the Free, ca. 1861–65
Broadside
8 15/16 × 5 5/8 in.
Newberry Case Y274.17 no. 20

The Flag of Our Union, ca.
1861–65
Broadside
8 1/2 × 5 1/2 in.
Newberry Case Y274.17. No. 55

"The Fugitives Are Safe in a
Free Land"
Harriet Beecher Stowe
Uncle Tom's Cabin
Boston: John P. Jewett & Co.,
1852
Book illustration
7 3/4 × 5 in.
Newberry Case 4A 924 v. 2

James Lorraine Geddes
*The Bonnie Flag with the Stripes
and Stars*
Saint Louis: Balmer and Weber,
1863
Sheet music
14 × 11 in.
Newberry sheet music VM1640.
G29b

M. A. Geuville (poetry) and
Ferdinand Mayer (music)
*When This War Is Over I Will
Come Back to Thee*
Boston: Henry Tolman & Co.,
1863
Sheet music
13 3/16 × 9 3/16 in.
Newberry Case 8A 376
James Francis Driscoll Collec-
tion of American Sheet Music
Gift of the Driscoll Family

Sanford Robinson Gifford
Hunter Mountain, Twilight, 1866
Oil on canvas
30 5/8 × 54 1/8 in. (77.8 ×
 137.5 cm)
Terra Foundation for American
 Art, Chicago, Daniel J. Terra
 Collection, 1999.57

The Glorious Stripes & Stars, ca.
 1861–65
Broadside
8 1/2 × 5 1/2 in.
Newberry Case Y274.17. No. 57

"Gored Dress, Trimmed en
 Zouave"
Godey's Lady's Book, February
 1862
Magazine illustration
9 3/4 × 6 7/16 in.
Newberry A5.375 v. 64

"Group of Chicago Zouave
 Cadets"
*Frank Leslie's Illustrated
 Newspaper*, July 28, 1860
Magazine illustration
15 3/4 × 22 in.
Newberry oversize A5.34 v. 10

A Group of "Contrabands,"
 1890
Stereograph card
4 × 7 in.
Newberry Oliver Barrett-Carl
 Sandburg Papers, box 8,
 no. 383
Gift of Roger Barrett

A Group of "Contrabands,"
 1890
Stereograph card
4 × 7 in.
Newberry Oliver Barrett-Carl
 Sandburg Papers, box 8,
 no. 2594
Gift of Roger Barrett

Mrs. P. A. Hanaford (words)
 and J. W. Dadmun (music)
The Empty Sleeve
Boston: Oliver Ditson & Co.,
 1866
Sheet music
13 5/8 × 10 9/16 in.
Newberry Case 8A 322
James Francis Driscoll
 Collection of American Sheet
 Music
Gift of the Driscoll Family

Jane Currie Blaikie Hoge
*The Boys in Blue; or, Heroes of
 the "Rank and File"*
New York: E. B. Treat & Co.;
 Chicago: C. W. Lilley, 1867
Book
9 × 5 7/8 in.
Newberry F8344.4

"Home from the Wars: Grand
 Review of the Returned
 Armies of the United States"
*Frank Leslie's Illustrated
 Newspaper*, June 10, 1865
Magazine illustration
16 × 21 in.
Newberry oversize A5.34 v. 20

Winslow Homer
"Filling Cartridges at the United
 States Arsenal, at Watertown,
 Massachusetts"
Harper's Weekly, July 20, 1861
Magazine illustration
16 × 10 1/2 in.
Newberry folio A5.392 v. 5

Winslow Homer
"Home from the War"
Harper's Weekly, June 13, 1863
Magazine illustration
16 × 10 1/2 in.
Newberry folio A5.392 v. 7

Winslow Homer
"Making Havelocks for the
 Volunteers"
Harper's Weekly, June 29, 1861
Magazine illustration
16 × 10 1/2 in.
Newberry folio A5.392 v. 5

Winslow Homer
On Guard, 1864
Oil on canvas
12 1/4 × 9 1/4 in. (31.1 ×
 23.5 cm)
Terra Foundation for American
 Art, Chicago, Daniel J. Terra
 Collection, 1994.11

Winslow Homer
"Our Watering Places—The
 Empty Sleeve at Newport"
Harper's Weekly, August 26,
 1865
Magazine illustration
16 × 10 1/2 in.
Newberry folio A5.392 v. 9

Winslow Homer
"Thanksgiving Day in the
 Army—After Dinner: The
 Wish-Bone"
Harper's Weekly, December 3,
 1864
Magazine illustration
16 × 10 1/2 in.
Newberry folio A5.392 v. 8

Winslow Homer
"Watching the Crows"
Our Young Folks, June 1868
Magazine illustration
8 3/8 × 5 3/4 in.
Newberry A5.701 v. 4

Howling Wolf
At the Sand Creek Massacre,
 ca. 1874 (graphic)
Allen Memorial Art Museum,
 Oberlin College, Ohio
Gift of Mrs. Jacob D. Cox,
 1904.1180.5 p.4

"I have no one to send—I'll go
 myself, and nurse the sick."
Collection of United States
 Civil War Envelopes, ca.
 1861–65
Envelope
3 × 5 in.
Newberry Case Wing E468. 9.
 C65
Gift of William B. McIlvaine

"Identification of Indian Murderers in Minnesota by a Boy Survivor of the Massacre"
Harper's Weekly, December 20, 1862
Magazine illustration
16 × 10 1/2 in.
Newberry folio A5.392 v. 6

"If I cannot fight, I can feed those who do."
Collection of United States Civil War Envelopes, ca. 1861–65
Envelope
3 1/4 × 5 1/2 in.
Newberry Case Wing E468. 9. C65
Gift of William B. McIlvaine

"The Indian Massacres and War of 1862"
Harper's New Monthly, June 1863
Magazine illustration
10 3/16 × 6 11/16 in.
Newberry A5.391

"Indian Outrages in the Northwest"
Frank Leslie's Illustrated Newspaper, October 25, 1862
Magazine illustration
6 3/4 × 10 1/2 in.
Newberry oversize A5.34 v. 15

"The 'Infant Confederacy' in the Cotton States"
Yankee Notions, March 1862
Magazine illustration
10 3/4 × 7 15/16 in.
Newberry folio A5.9914 v. 11

"Interior View of the Union Hall, North-Western Sanitary Fair Building, Chicago, Ill."
Frank Leslie's Illustrated Newspaper, July 8, 1865
Magazine illustration
10 × 13 in.
Newberry oversize A5.34 v. 20

John Bull's Blockade Played Out, ca. 1861–65
Broadside
9 × 5 1/4 in.
Newberry Case Y274.17. No. 40

"Map Showing the Line of the Blockade, and the Strategic Routes in the Interior"
Harper's Weekly, May 25, 1861
Map
16 × 10 1/2 in.
Newberry folio A5.392 v. 5

Thomas Moran
Autumn Afternoon, the Wissahickon, 1864
Oil on canvas
30 1/4 × 45 1/4 in. (76.8 × 114.9 cm)
Terra Foundation for American Art, Chicago, Daniel J. Terra Collection, 1999.99

"Morning Mustering of the Contraband"
Frank Leslie's Illustrated Newspaper, November 2, 1861
Magazine illustration
16 × 10 1/2 in.
Newberry oversize A5.34 v. 12

William Sidney Mount
Fruit Piece: Apples on Tin Cups, 1864
Oil on academy board
6 1/2 × 9 1/16 in. (16.5 × 23.0 cm)
Terra Foundation for American Art, Chicago, Daniel J. Terra Collection, 1999.100

The Myriopticon: A Historical Panorama; The Rebellion
Springfield, MA: Milton Bradley & Co., ca. 1866–70
Artifact
5 5/8 × 8 7/16 × 2 7/16 in.
Newberry Vault Case oversize E468.7.M96 1890

"New Style Zouave Jackets"
Godey's Lady's Book, February 1862
Magazine illustration
9 3/4 × 6 7/16 in.
Newberry A5.375 v. 64

"The Old Flag Again on Sumter"
Frank Leslie's Illustrated Newspaper, March 11, 1865
Magazine illustration
16 × 10 1/2 in.
Newberry oversize A5.34 v.19

"Our Cotton Campaign in South Carolina"
Frank Leslie's Illustrated Newspaper, February 15, 1862
16 × 22 in.
Newberry oversize A5.34 v. 13

Our Country, ca. 1861–65
Broadside
8 1/2 × 5 1/2 in.
Newberry Case Y274.17. No. 50

"Our Women and the War"
Harper's Weekly, September 6, 1862
Magazine illustration
16 × 10 1/2 in.
Newberry folio A5.392 v. 6

J. A. Palmer
Cotton Field, 1890
stereograph card
4 × 7 in.
Newberry Oliver Barrett-Carl Sandburg Papers, box 8, no. 175
Gift of Roger Barrett

The Patriot Flag, ca. 1861–65
Broadside
7 3/4 × 4 3/4 in.
Newberry Case Y274.17. No. 60

"The Patriot Mother at Her Boy's Grave"
The Soldier's Casket, Philadelphia: Ch. W. Alexander, 1865
Magazine illustration
9 1/8 × 6 in.
Newberry F834.0075 v. 1

William Perring
"The Attack"
Graham's Lady's and Gentleman's Magazine, August 1843
Magazine illustration
9 3/4 × 6 in.
Newberry A5.38

Marie Adrien Persac
Norman's Chart of the Lower Mississippi River, 1858
Map
64 13/16 × 26 7/16 in.
The Arthur Holzheimer Collection

Raising the Old Flag over Fort Sumter, 1890
Stereograph card
4 × 7 in.
Newberry Oliver Barrett-Carl Sandburg Papers, box 8, no. 6140
Gift of Roger Barrett

William C. Reynolds
Reynolds's Political Map of the United States
New York: William C. Reynolds and J. C. Jones, 1856
Map
29 1/2 × 34 in.
Newberry map 6F G3700 1856.R4

Ring, Merry Bells! or, The Union Victory, ca. 1861–65
Broadside
8 3/4 × 5 7/8 in.
Newberry Case Y274.17. No. 42

B. E. Roefs
Mother Is the Battle Over?
Boston: Oliver Ditson & Co., ca. 1861–65
Sheet music
13 1/4 × 10 3/16 in.
Newberry Case 8A 338
James Francis Driscoll Collection of American Sheet Music
Gift of the Driscoll Family

George F. Root
Battle Cry of Freedom
Chicago: Root and Cady, 1862
Sheet music
13 1/4 × 10 in.
Newberry Case sheet music M1.A13 no. 2785
James Francis Driscoll Collection of American Sheet Music
Gift of the Driscoll Family

George F. Root
The First Gun Is Fired! "May God Protect the Right!"
Chicago: Root & Cady, 1861
Sheet Music
9 × 5 1/4 in.
Newberry Case minus VM1639 R78f

George F. Root
Lay Me Down and Save the Flag
Chicago: Root and Cady, 1864
Sheet music
13 5/16 × 10 in.
Newberry Case sheet music M1.A13 no. 2880
James Francis Driscoll Collection of American Sheet Music
Gift of the Driscoll Family

Charles Carroll Sawyer
Coming Home; or, "The Cruel War Is Over"
Boston: Oliver Ditson & Co., 1865
Sheet music
12 7/8 × 9 3/4 in.
Newberry Case 8A 316
James Francis Driscoll Collection of American Sheet Music
Gift of the Driscoll Family

B. M. Smith and A. J. Hill
Map of the Ceded Part of Dakota Territory: Showing Also Portions of Minnesota, Iowa and Nebraska, 1861
Map
17 3/4 × 23 1/2 in.
Newberry Vault Graff 3835
Everett D. Graff Collection of Western Americana
Bequest of Everett D. Graff

"The Soldiers' Thanksgiving Dinner in Camp"
Frank Leslie's Illustrated Newspaper, December 3, 1864
Magazine illustration
16 × 10 1/2 in.
Newberry oversize A5.34 v. 19

A Song, Dedicated to the Colored Volunteer, ca. 1861–65
Broadside
7 1/2 × 4 in.
Newberry Case Y274.17. No. 12

Lilly Martin Spencer
The Home of the Red, White, and Blue, ca. 1867–68
Oil on canvas
24 × 30 in. (61.0 × 76.2 cm)
Terra Foundation for American Art, Chicago, Daniel J. Terra Art Acquisition Endowment Fund, 2007.1

Stand by the Flag, ca. 1861–65
Broadside
8 1/2 × 5 1/2 in.
Newberry Case Y274.17 no. 58

"Terrible News"
Chicago Tribune, April 15, 1865
Newspaper
29 × 21 5/16 in.
Newberry A6.169

"Thanksgiving Day—The
 Church Porch"
*Frank Leslie's Illustrated News-
 paper*, December 23, 1865
Magazine illustration
16 × 10 1/2 in.
Newberry oversize A 5.34 v. 21

"Thanksgiving Day—Hanging
 Up the Musket"
*Frank Leslie's Illustrated News-
 paper*, December 23, 1865
Magazine illustration
16 × 10 1/2 in.
Newberry oversize A5.34 v. 21

Mabel Loomis Todd, editor
*Poems by Emily Dickinson: Third
 Series*
Boston: Roberts Brothers, 1896
Book
7 × 4 3/4 in.
Newberry Vault Ruggles 94
 no. 3
Rudy Lamont Ruggles
 Collection
Gift of Rudy Lamont Ruggles Sr.

Mabel Loomis Todd and T. W.
 Higginson, editors
Poems by Emily Dickinson
Boston: Roberts Brothers, 1890
Book
7 1/4 × 5 1/8 in.
Newberry Vault Ruggles 94
 no. 1
Rudy Lamont Ruggles
 Collection
Gift of Rudy Lamont Ruggles Sr.

Tim Tramp
*War Life: Illustrated by Stories
 of the Camp and Field*
New York: Callender, Perce &
 Welling, 1862
Book
7 1/2 × 5 in.
Newberry F8305.95

J. T. Trowbridge
"The Color Bearer"
Our Young Folks, January 1865
Magazine illustration
8 3/8 × 5 3/4 in.
Newberry A5.701 v. 1

Rev. E. B. Tuttle
The History of Camp Douglas
Chicago: J. R. Walsh, 1865
Book
8 5/8 × 5 3/4 in.
Newberry Case E616.D7 T8

Unfurl the Glorious Banner,
 ca. 1861–65
Broadside
8 1/2 × 5 1/2 in.
Newberry Case Y274.17. no. 54

US Sanitary Commission Lapel
 Badge and Pin, ca. 1861–65
Artifacts
5 3/4 × 4 in. (badge)
2 1/4 × 1 1/4 in. (pin)
Newberry E. W. Blatchford
 Papers, box 8, folder 219
Gift of the heirs of Eliphalet
 Wickes Blatchford

Untitled cartoon (Dakota War
 scene)
Harper's Weekly, September 13,
 1862
Magazine illustration
5 × 7 3/4 in.
Newberry folio A5.392 v. 6

A. J. Vaas
Zouave Cadets Quickstep
Chicago: Root and Cady, 1860
Sheet music
13 3/4 × 11 in.
Newberry Case sheet music
 M1.A13 no. 2728
James Francis Driscoll Collec-
 tion of American Sheet Music
Gift of the Driscoll Family

Vaningen and Snider
"Suffering Heroes"
The Mothers' Journal, January
 1865
Magazine illustration
9 1/16 × 5 13/16 in.
Newberry A5.6079

Voice of the Fair
Chicago: Northwestern Sani-
 tary Fair, 1865
Newspaper
17 1/2 × 11 3/4 in.
Newberry Case oversize
 F8345.94 v.1

*Volunteers Wanted! From
 Winnebago County*
Broadside
5 1/4 x 11 1/8 in.
Chicago Public Library 86.12.2

J. C. Wallace
*We Are Coming from the Cotton
 Fields*
Chicago: Root & Cady, 1864
Sheet music
13 13/16 × 10 3/4 in.
Newberry Case M1.A13 no.
 2886
James Francis Driscoll Collec-
 tion of American Sheet Music
Gift of the Driscoll Family

"War Inaugurated!"
Chicago Tribune, April 13, 1861
Newspaper
29 × 21 5/16 in.
Newberry A6.169

Gouverneur Kemble Warren
*Map of the Territory of the United
 States from the Mississippi
 to the Pacific Ocean*, 1857,
 printed 1868
Map
44 1/2 × 48 in.
Newberry map 6F G4051.
 P3 1853. U5 v. 11, pt 2, no. 14

A. R. Waud
"Contrabands Coming into
 Camp in Consequence of the
 Proclamation"
Harper's Weekly, January 31,
 1863
Magazine illustration
16 × 10 1/2 in.
Newberry folio A5.392 v. 7

Walt Whitman
Drum Taps
New York: 1865
Book
7 1/4 × 4 3/4 in.
Newberry Case Y285.W5941

Walt Whitman
Leaves of Grass
Brooklyn, New York: 1855
Book
11 1/2 × 8 1/8 in.
Newberry Vault Ruggles 369
Rudy Lamont Ruggles
 Collection
Gift of Rudy Lamont
 Ruggles Sr.

Walt Whitman
Leaves of Grass
Boston: Thayer and Eldridge,
 1860
Book
7 9/16 × 5 1/8 in.
Newberry Case 3A 1315

"The Widow's Mite"
Godey's Lady's Book, September
 1861
Magazine illustration
9 3/4 × 6 7/16 in.
Newberry A5.375 v. 63

F. Wilmarth
*Home the Boys are Marching;
 or, Ring the Merry Bells*
Boston: Oliver Ditson & Co.,
 1865
Sheet music
13 9/16 × 10 in.
Newberry Case 8A 328
James Francis Driscoll Collec-
 tion of American Sheet Music
Gift of the Driscoll Family

*Within Fort Sumter: By One of
 the Company*
New York: N. Tibbals, 1861
Book
7 5/16 × 4 7/8 in.
Newberry F8347.494

Henry C. Work
Song of a Thousand Years
Chicago: Root & Cady, 1863
Sheet music
13 × 9 9/16 in.
Newberry VM1497 M.67 v. 1

Henry C. Work
We'll Go Down Ourselves
Chicago: Root and Cady, 1862
Sheet music
13 1/2 × 10 1/4 in.
Newberry Case sheet music
 M1.A13 no. 2814
James Francis Driscoll Collec-
 tion of American Sheet Music
Gift of the Driscoll Family

Yankees Are Coming, ca.
 1861–65
Broadside
8 3/8 × 5 1/8 in.
Newberry Case Y274.17. No. 22

Zouave-style silk dress worn by
 Sarah Cadwallader Logan
 Knowland, 1865–66
Dress
Chicago History Museum 1976.
 212. 3
Courtesy of Chicago History
 Museum, Gift of Mrs. Louis E.
 Laflin Jr.

Notes

Foreword: Picturing War

1 "The Bombardment of Fort Sumpter [*sic*], Charleston Harbor, the 12th and 13th of April, 1861," *Frank Leslie's Illustrated Newspaper,* April 27, 1861. Copies of *Leslie's* customarily went on sale one week before the date on the cover. William E. Huntzicker, "Picturing the News: Frank Leslie and the Origins of American Pictorial Journalism," in *The Civil War and the Press,* ed. David B. Sachsman et al. (New Brunswick, NJ: Transaction Publishers, 2000), 318.

2 For these and other details of the battle, see Adam Goodheart, *1861: The Civil War Awakening* (New York: Knopf, 2011), 136–84.

3 In the nineteenth century, the term "taking a picture" meant creating a documentary image in any visual medium, not just photography.

4 See, for example, James M. McPherson, *Abraham Lincoln and the Second American Revolution* (New York: Oxford University Press, 1992).

5 Ian M. G. Quimby, "The Doolittle Engravings of the Battle of Lexington and Concord," *Winterthur Portfolio* 4 (1968): 83–108.

6 David Tatham, *Winslow Homer and the Pictorial Press* (Syracuse, NY: Syracuse University Press, 2003), 30.

7 Precise circulation figures are hard to pin down, but by one scholar's estimate, *Leslie's* printed more than one hundred thousand copies of each regular issue before the war, with "special issues" having press runs of up to three hundred thousand. The circulation of *Harper's* was likely somewhat larger, and that of the *New York Illustrated News* smaller. All of these periodicals' circulations increased during the war; exactly how much is uncertain. It should also be taken into account that in an era of scarcer reading matter and larger households, each copy probably had more readers per copy on average than modern magazines. See Harry L. Katz, *Civil War Sketchbook: Drawings from the Battlefront* (New York: W. W. Norton, 2012).

8 In one notable scoop in 1861, *Leslie's* literally brought its readers into Abraham Lincoln's front parlor with a series of detailed engravings of the interior of the president-elect's Springfield, Illinois, house. *Frank Leslie's Illustrated Newspaper,* March 9, 1861.

9 Joshua Brown, *Beyond the Lines: Pictorial Reporting, Everyday Life, and the Crisis of Gilded Age America* (Berkeley: University of California Press, 2006). Even on the west coast, which was not yet connected to the rest of the country by railroad or telegraph, the illustrated weeklies played a role. Barely a month into the war, one San Francisco editor wrote that the woodcuts in *Leslie's* would eventually constitute "the History of the War," and predicted that "everybody will want Leslie's Pictorial." "Frank Leslie," *California Farmer and Journal of Useful Sciences,* May 24, 1861.

10 Walter Benjamin, "The Work of Art in the Age of Mechanical Reproduction," *Illuminations* (New York: Schocken Books, 2007), 233. See also Gillen D'Arcy Wood, *The Shock of the Real: Romanticism and Visual Culture, 1760–1860* (New York: Palgrave, 2001).

11 See, for example, *The Daily Constitutionalist* (Augusta, GA), February 2, 1861: "These northern illustrated newspapers are all unworthy of southern support.... They are incendiary and pernicious."

12 J. Henry Harper, *The House of Harper: A Century of Publishing in Union Square* (New York: Harper and Brothers, 1912), 182. Stanton's favorable disposition, however, did not prevent a Union topographical

officer in Virginia from being arrested—and copies of *Harper's* from being impounded—when he was accused of supplying the magazine with detailed sketches of the Union lines that compromised military security. Merl M. Moore Jr., "More about the Events Surrounding the Suppression of *Harper's Weekly*, April 26, 1862," *American Art Journal* 12, no. 1 (Winter 1980): 82–85.

13 "Brady's Photographs: Pictures of the Dead at Antietam," *New York Times*, October 20, 1862.

14 "Important Notice!," *Frank Leslie's Illustrated Newspaper*, April 27, 1861.

15 Kent Ahrens, *The Drawings and Watercolors of Truman Seymour* (Scranton, PA: Everhart Museum, 1986); Richard Wagner, *For Honor, Flag, and Family: Civil War Major General Samuel W. Crawford, 1827–1892* (Shippensburg, PA: White Mane Books, 2005); Samuel Wylie Crawford to A. J. Crawford, March 4, 1861, Samuel Wylie Crawford Papers, Library of Congress. Drawing—considered essential for military engineering and reconnaissance work—was an important part of the West Point curriculum in the nineteenth century.

16 "What Our Artists Are Doing in Behalf of the War Movement," *New York Commercial Advertiser*, May 6, 1861; "Artists' Patriotic Fund," *New York Commercial Advertiser*, May 28, 1861. The sale in late May of some seventy paintings raised the considerable total of $4,781—although a later newspaper report complained that as of mid-July, the artists had still not handed over these proceeds to the war effort (*New York Commercial Advertiser*, May 30, 1861; *New York Herald*, July 19, 1861).

17 See the essay "The Home at War, the War at Home" in this volume.

18 See especially Peter H. Wood, *Near Andersonville: Winslow Homer's Civil War* (Cambridge, MA: Harvard University Press, 2010).

19 "A Visit to a Battlefield," *New York Times*, August 31, 1861. In one case, *Harper's* boasted that sketches of a Tennessee skirmish had been made by the magazine's artist "on the spot"—who had actually been twenty miles away at the time. See Phillip Knightley, *The First Casualty: The War Correspondent as Hero and Myth-Maker from the Crimea to Iraq* (Baltimore: Johns Hopkins University Press, 2004).

20 Alice Fahs, *The Imagined Civil War: Popular Literature of the North and South, 1861–1865* (Chapel Hill: University of North Carolina Press, 2001), 31–39. Fahs suggests, however, that Southerners' interest in Northern illustrated weeklies may actually have increased during the war, as the Confederate public was hungry for any visual representation of the conflict whatsoever.

21 In many parts of the antebellum South, Northern books and periodicals were routinely confiscated and possession of material deemed "abolitionist" could be punished with a long prison sentence. See W. Sherman Savage, *The Controversy over the Distribution of Abolitionist Literature, 1830–1860* (New York, 1968). Overall newspaper circulation per capita in the free states was about three times as large as in the slave states.

22 Mark E. Neely Jr., Harold Holzer, and Gabor S. Borritt, *The Confederate Image: Prints of the Lost Cause* (Chapel Hill: University of North Carolina Press, 1987), 23–30.

23 See, for instance, the work of the German-born, pro-Confederate Baltimore engraver Adalbert Volck.

24 "Stampede among the Negroes in Virginia," *Frank Leslie's Illustrated Newspaper*, June 9, 1861.

25 Compare, for instance, Homer's lithograph *Our Jolly Cook* (1863) with his painting *Near Andersonville* (1865–66).

26 John I. H. Baur, ed., *The Autobiography of Worthington Whittredge, 1820–1910* (New York: Arno Press, 1969), 43.

27 See Eleanor Jones Harvey, *The Civil War and American Art* (New Haven, CT: Yale University Press, 2012) for an imaginative and persuasive decoding of many such paintings.

28 "Art and Artists—The Recent Sales of Pictures," *New York Herald*, March 2, 1863.

29 Randall C. Griffin, *Winslow Homer: An American Vision* (New York: Phaidon, 2006), 32–33.

30 "Annus Mirabilis," *New York Herald*, July 4, 1861.

The Home at War, the War at Home

1 J. J. Shea, *It's All in the Game* (New York: Putnam's, 1960), 81–82. Later editions of the game included up to twenty-nine scenes. See James Marten, "History in a Box: Milton Bradley's *Myriopticon*," *Journal of the History of Childhood and Youth* 2, no. 1 (2009): 5–7.

2 The scholarly and popular literature on the Civil War is vast, and it is proliferating quickly during the war's sesquicentennial. To cite the works here that have influenced the authors of each essay would take pages. The notes for each of the essays demonstrate our indebtedness to this literature.

3 [Clarence Cook], "Painting and the War," *Round Table* 2 (July 23, 1864). On the crisis in representation, see Steven Conn and Andrew Walker, "The History in the Art: Painting the Civil War," in *Terrain of Freedom: American Art and the Civil War, Art Institute of Chicago Museum Studies* 27, no. 1 (2001): 66–67. Studies on the representation of the Civil War in contemporary painting include Harold Holzer and Mark E. Neely Jr., *Mine Eyes Have Seen the Glory: The Civil War in Art* (New York: Orion Books, 1993), and Lucretia Hoover Giese, "'Harvesting' the Civil War: Art in Wartime New York," in *Redefining American History Painting,* ed. Patricia M. Burnham and Lucretia Hoover Giese (New York: Cambridge University Press, 1995), 64–81.

4 For a full account of *Our Banner in the Sky,* see Doreen Bolger Burke, "Frederic Edwin Church and 'The Banner of Dawn,'" *American Art Journal* 14, no. 2 (Spring 1982): 39–46. Burke's thorough article seeks mainly to document the immediate circumstances of its production and to link it with Henry Ward Beecher's sermon, "The National Flag," delivered at the Plymouth Church in Brooklyn, April 28, 1861.

5 Burke, "Frederic Edwin Church and 'The Banner of Dawn,'" 39–40n1, provides details on the publication of the lithograph after Church's painting. On flag mania and the fetishizing of the Union flag more generally, see Scot M. Guenter, *The American Flag, 1777–1924: Cultural Shifts from Creation to Codification* (Cranbury, NJ: Associated University Presses, 1990), 66–87; Adam Goodheart, *1861: The Civil War Awakening* (New York: Knopf, 2011), 180; and Robert E. Bonner, "Star-spangled Sentiment," *Common-Place* 3, no. 2 (January, 2003), at http://www.common-place.org/vol-03/no-02/bonner/index.shtml. Accessed February 2, 2012. In *The Union Image: Popular Prints of the Civil War* (Chapel Hill: University of North Carolina Press, 2000), 9, Harold Holzer and Mark E. Neely Jr. briefly allude to Church's painting but otherwise focus exclusively on mass-produced prints.

6 Drake wrote his patriotic poem soon after the War of 1812; in 1861, New York publisher James G. Gregory published a special edition of it, with illustrations by the prolific and popular Felix Octavius Darley.

The Fabric of War

1 The *Glad Tidings* was captained by H. Nelson through 1863, then by Merrill in 1864, Thomas from 1865 to 1867, and Thom[p]son from 1868 to 1874. The Wm. Nelson–owned *Glad Tidings* operated as a "New Orleans Packet" between 1856 and 1874, when it may have been wrecked. See *Lloyd's Register of British and Foreign Shipping* (London: Wyman and Sons, 1873; London: Gregg Press Limited, 1964).

2 Edward Atkinson, *Cheap Cotton by Free Labor: By a Cotton Manufacturer* (Boston: A. Williams, 1861), 3–4; 26. See also Harold Francis Williamson, *Edward Atkinson: The Biography of an American Liberal, 1827–1905* (Cambridge, MA: Riverside Press, 1934).

3 On the evolution of the terminology surrounding contrabands, see Kate Masur, "'A Rare Phenomenon of Philological Vegetation': The Word 'Contraband' and the Meanings of Emancipation in the United States," *Journal of American History* 93, no. 4 (March 2007): 1050–84.

4 Atkinson, *Cheap Cotton by Free Labor,* 3.

5 On popular publications such as *Vanity Fair,* see Cameron C. Nickels, *Civil War Humor* (Jackson: University Press of Mississippi, 2010), 13.

6 On the plight of Tom Wilson, see "English and American Slavery," in *Essays & Sketches on Men and Things by Thomas Thompson* (Cockermouth, England: D. Fidler, 1858), 48–49.

7 On *Frank Leslie's Illustrated Weekly* and the practices of pictorial journalism in the nineteenth century, see Joshua Brown, *Beyond the Lines: Pictorial Reporting, Everyday Life, and the Crisis of Gilded Age America* (Berkeley: University of California Press, 2002), 7–57; and Eric Foner, *Forever Free: The Story of Emancipation & Reconstruction,* illustrations edited and with commentary by Joshua Brown (New York: Vintage, 2006).

8 John Jackson, *A Treatise on Wood Engraving, Historical and Practical* (London: Charles Knight, 1839), 663.

9 My attempt to wrest meaning from the engraver's line in Civil War imagery is inspired by Michael Gaudio, *Engraving the Savage: The New World and Techniques of Civilization* (Minneapolis: University of

Minnesota Press, 2008). An engaging application of this mode of analysis can also be found in Jennifer A. Greenhill, "Troubled Abstraction: Whiteness in Charles Dana Gibson and George du Marier," *Art History* 34, no. 4 (September 2011): 732–53. On notions of "whiteness," see Richard Dyer, *White* (New York: Routledge, 1997). I thank Professor Greenhill for helping me to articulate this aspect of my argument.

10 On the development of thematic maps and "statistical cartography," see Susan Schulten, *Mapping the Nation: History and Cartography in Nineteenth-Century America* (Chicago: University of Chicago Press, 2012), 119–55.

11 On the invisibility of labor, see Raymond Williams, *The Country and the City* (New York: Oxford University Press, 1973).

12 See US Bureau of the Census, *The Seventh Census of the United States: 1850* (Washington, DC: Harold Armstrong, 1853). Parishes along waterways like Orleans, Concordia, Tensas, Landry, and West Feliciana had proportionally larger slave populations than others in 1850.

13 H. C. Carey, "The Harmony of Interests: Agricultural, Manufacturing, and Commercial," *Plough, the Loom and the Anvil* 2, no. 11 (May 1850): 667.

14 On the growth of the textile industry, see Barbara M. Tucker and Kenneth H. Tucker Jr., *Industrializing Antebellum America: The Rise of Manufacturing Entrepreneurs in the Early Republic* (New York: Palgrave Macmillan, 2008).

15 "Cotton and the War," *The Independent . . . Devoted to the Consideration of Politics, Social and Economic Tendencies, History, Literature, and the Arts* 13, no. 663 (August 15, 1861): 4. On relations between the United States and Great Britain before and during the war, see Amanda Foreman, *A World on Fire: Britain's Crucial Role in the American Civil War* (New York: Random House, 2010).

16 For the advertisement, see *The Independent . . . Devoted to the Consideration of Politics, Social and Economic Tendencies, History, Literature, and the Arts* 12, no. 580 (January 12, 1860): 5.

17 "Cotton-Clad," *Maine Farmer* 31, no. 36 (August 20, 1863): 2.

18 On Olmsted's journey and the map he produced from its findings, see Schulten, *Mapping the Nation*, 145–55. See also, Elizabeth Stevenson, *Park Maker: A Life of Frederick Law Olmsted* (New York: Macmillan, 1977).

19 Frederick Law Olmsted, *Journeys and Explorations in the Cotton Kingdom: A Traveler's Observations of Cotton and Slavery in the American Slave States; Based upon Three Former Volumes of Journeys and Investigations by the Same Author,* vol. 1 (London: Sampson Low, 1861), 8.

20 Quoted in Edward Atkinson's statistical map, *The Cotton Kingdom* (Boston, 1863).

21 Olmsted, *Journeys and Explorations in the Cotton Kingdom,* 8–9.

22 Edward Atkinson, "Is Cotton Our King?," *Continental Monthly* 1, no. 3 (March 1862): 251.

23 Accounts of blockade-running activities were regular features in newspapers and periodicals throughout the war. See, for example, see "Is the Blockade Effectual?," *Scientific American* 5, no. 23 (December 7, 1861): 355; "Capture of the Rebel Steamer 'Calypso,'" *Maine Farmer* 31, no. 29 (July 2, 1863): 4; and "Military and Naval," *Zion's Herald and Wesleyan Journal* 35, no. 45 (November 9, 1864): 179. For more on "inter-belligerent trade," see David G. Surdam, "Traders or Traitors: Northern Cotton Trading During the Civil War," *Business and Economic History* 28, no. 2 (Winter 1999): 301–12.

24 For a recent account of the plight of contrabands at Fortress Monroe, see Adam Goodheart, *1861: The Civil War Awakening* (New York: Knopf, 2011), 293–347.

25 See Benjamin Butler, "Report on the Contrabands of War," in *The Rebellion Record: A Diary of American Events, with Documents, Narratives, Illustrative Incidents, Poetry, etc., etc.,* ed. Frank Moore (New York: Putnam, 1861–68).

26 Calls for African "recolonization" become stronger during this period as well. See, for instance, "What to Do with the Darkies?," *Continental Monthly* 1, no. 1 (January 1862): 84.

27 "Lincoln's Negro Scale," *Old Guard* 1, no. 5 (June 1, 1863): 143.

28 "The Contrabands—Letter from Fortress Monroe," *The Independent . . . Devoted to the Considerations of Politics, Social and Economic Tendencies, History, and the Arts* 13, no. 661 (August 1, 1861): 2.

29 On contraband activities, see Masur, "'A Rare Phenomenon of Philological Vegetation,'" as well as Thavolia Glymph, "Noncombatant Military Laborers in the Civil War," *OAH Magazine of History* 26, no. 2 (April 2012): 25–29.

30 See also Sarah Burns's reading of the shadow in this image in her book, *Painting the Dark Side: Art and the Gothic Imagination in Nineteenth-Century America* (Berkeley: University of California Press, 2004), 144.

31 See, for instance, "The Landing of U.S. Troops at Fort Walker, Port Royal Harbor," and "View of the Interior of Fort Walker, Port Royal Harbor," *Frank Leslie's Illustrated Newspaper,* November 30, 1861, 24, 25.

32 For more on this and other battles during the Civil War, see James McPherson, *Battle Cry of Freedom: The Civil War Years* (New York: Oxford University Press, 1988). See "The Naval Expedition," *Circular* 10, no. 42 (November 21, 1861): 167.

33 "Freedmen at Port Royal," *The Independent . . . Devoted to the Considerations of Politics, Social and Economic Tendencies, History, and the Arts* 14, no. 692 (March 6, 1862): 4.

34 "More Dirty Work," *Liberator* 32, no. 14 (April 4, 1862): 56.

35 Thomas Wentworth Higginson, *Army Life in a Black Regiment* (1869; New York: Barnes and Noble, 2009), 5.

36 "Facts and Phases of the War," *Circular* 10, no. 44 (December 5, 1861): 174. Italics added.

37 "Our Cotton Campaign in South Carolina," *Frank Leslie's Illustrated Newspaper,* February 15, 1862, 206.

38 The technique necessary for rendering smoke and clouds is similar to that employed in the delineation of cotton in its raw or ginned state. See Gaudio, *Engraving the Savage.*

39 See "Appeal for Clothing for the Refugees," *Independent* 13, no. 682 (December 26, 1861): 3.

40 "The Song of the Contraband," *Vanity Fair* 5, no. 214 (May 10, 1862): 229.

41 Alfred Waud, "Contrabands Coming into Camp," *Harper's Weekly,* January 31, 1863, 78.

42 Higginson, *Army Life in a Black Regiment,* 212.

43 "The Escaped Slave and the Union Soldier," *Harper's Weekly,* July 2, 1864, 422.

44 "Free-Labor Cotton," *Friends' Review: A Religious, Literary, and Miscellaneous Journal* 19, no. 14 (December 2, 1865): 216.

45 For an interesting art historical account of the visuality of cotton in the postbellum period, see Marilyn R. Brown, *Degas and the Business of Art: A Cotton Office in New Orleans* (University Park: Pennsylvania State University Press, 1994).

46 See, for instance, "A Sketch in Oils," *Putnam's Magazine* 2, no. 8 (August 1868): 212. For general discussion of the burgeoning oil industry, see "The Petroleum Fever," *Maine Farmer* 33, no. 11 (February 23, 1865): 2.

Other Homes, Other Fronts

1 Howard Lamar, *The Far Southwest, 1846–1912: A Territorial History* (New Haven, CT: Yale University Press, 1981), 109–35.

2 See David Nichols, *Lincoln and the Indians: Civil War Policy and Politics* (Columbia: University of Missouri Press, 1978), 54–64.

3 See Laurence Hauptman, *Between Two Fires: American Indians in the Civil War* (New York: Free Press, 1995), 1–17.

4 There remains no reliable final figure for the dead on the Minnesota frontier. No census was available at the time, and the area saw a large influx of immigrants following the land cessions of the Treaty of Traverse des Sioux in 1851. See Kenneth Carley, *The Dakota War of 1862: Minnesota's Other Civil War,* 2nd ed. (Minneapolis: Minnesota Historical Society, 2001), 1.

5 See Helen Wright, "Eugene Benson," in *Dictionary of American Biography* (New York: Scribner's, 1929), 2:204–5. Given that the themes of *Indian Attack* are reminiscent of the work of fellow National Academy of Design artists, such as William Ranney, we can surmise their influence on Benson. We know that Benson contributed a painting to the academy's fund-raising efforts to support Ranney's widow in 1858. Special thanks to Ms. Miriam Touba, reference librarian at the Klingenstein Library of the New-York Historical Society, for helping to locate the sales records for that auction. After 1871, because of a marital scandal, Benson became a permanent expatriate in Venice where he continued to paint, though his work was largely allegorical or of the genre painting variety. He did not return to historical tableaux.

6 As in most of Tait's depictions of conflicts between frontiersmen and Indians, the Native combatants either are not depicted or are shown as shadowy figures on the horizon or the dark recesses of a wood.

The focus and drama center on the trappers or settlers. See Warder Cadbury, "Arthur F. Tait," in *American Frontier Life: Early Western Painting and Prints* (New York: Cross River Press, 1987), 109–29.

7 See Ron Tyler, "George Caleb Bingham: The Native Talent," in *American Frontier Life: Early Western Painting and Prints* (New York: Cross River Press, 1987), 25–50. Also, Robert Rosenblum on Bingham in *19th-Century Art* (Englewood Cliffs, NJ: Prentice Hall, 1984; New York: Harry Abrams, 1984), 183–84.

8 See Howard Lamar, "An Overview of Westward Expansion," in *The West as America: Reinterpreting Images of the Frontier, 1820–1920*, ed. William Truettner (Washington, DC: Smithsonian Institution Press, 1991), 2.

9 I wish to acknowledge the expertise of Carol Kregloh at the Smithsonian Institute's Division of Home and Community Life. After consultation concerning the period details of costume and setting, we agree that Benson's depiction is likely meant to signify the colonial past. Given that the artist was only nineteen, and by no means an expert on such matters, his depiction is as likely drawn from his own imagination as it is from any authoritative source.

10 See *Women's Indian Captivity Narratives*, ed. Kathryn Zabelle Derounian-Stodola (New York: Penguin Books, 1998), 57.

11 See Joyce Chaplin, *Subject Matter: Technology, the Body, and Science on the Anglo-American Frontier, 1500–1676* (Cambridge, MA: Harvard University Press, 2001), 120–24.

12 See Scott Martin, "Interpreting *Metamora*: Nationalism, Theater, and Jacksonian Indian Policy," *Journal of the Early Republic* 19, no. 1 (Spring 1999): 73–100, and Werner Sollors, *Beyond Ethnicity: Consent and Descent in American Culture* (New York: Oxford University Press, 1986), 102–30.

13 Rosaldo succinctly summarizes imperialist nostalgia as "mourning for what one has destroyed." See Renato Rosaldo, "Imperialist Nostalgia," *Representations*, Special Issue: Memory and Counter-Memory, no. 26 (Spring 1989): 107–22, and Gordon Sayre, *The Indian as Tragic Hero: Native Resistance and the Literatures of America, from Moctezuma to Tecumseh* (Chapel Hill: University of North Carolina Press, 2005).

14 William Truettner, "Ideology and Image: Justifying Westward Expansion," in *The West as America*, 29. Truettner also suggests that Asher Durand's *The Indian's Vespers* (1847) functions in a similar manner (43).

15 The Mingo (as the Iroquois living in the Ohio Country were called) chief Logan's speech or "lament" was made famous by Thomas Jefferson who printed it as an example of Native eloquence in his *Notes on the State of Virginia* in 1785.

16 Crawford was appointed by Montgomery Meigs, the engineer of the Capitol extension, who worked closely with his supervisor, Secretary of War Jefferson Davis. Vivien Fryd has noted that Davis made clear that no reference to slavery was to be made in the art of the Capitol, even to the extent that allegorical figure of Liberty could not be shown wearing a Roman liberty cap, since Davis saw this as "the liberty of a freed slave." See Vivien Green Fryd, *Art and Empire: The Politics of Ethnicity in the United States Capitol, 1815–1860* (Athens: Ohio State University Press, 2001), 188.

17 Anonymous, "The Capitol at Washington," *United States Magazine* 3 (July 1856): 11.

18 George Catlin, *Letters and Notes on the Manners, Customs and Conditions of the North American Indians Written during Eight Years of Travel amongst the Wildest Tribes of North America*, vol. 1 (London: H. Bond, 1866), 17.

19 See Clyde Milner II, "National Initiatives," in *The Oxford History of the American West*, ed. Clyde Milner II and Carol A. O'Connor (New York: Oxford University Press, 1996), 155–95.

20 Horace Greeley, Letter 13, in *An Overland Journey, from New York to San Francisco, in the Summer of 1859* (New York: C. M. Saxton, Barker, 1860).

21 See Nichols, *Lincoln and the Indians*, 3–28.

22 See C. M. Oehler, *The Great Sioux Uprising* (New York: Oxford University Press, 1959), 27; Kenneth Carley, *The Dakota War of 1862*, 1–7; Gary Anderson, *Through Dakota Eyes: Narrative Accounts of the Minnesota Indian War of 1862* (Minneapolis: Minnesota Historical Society, 1988), 19–33.

23 *New York Times*, August 24, 1862, 1.

24 *Harper's Weekly*, September 13, 1862, 592.

25 Nichols, *Lincoln and the Indians*, 94–118.

26 See Oehler, *Great Sioux Uprising*, 211–13.

27 Lamar, *The Far Southwest*, 100–135.

28 See "Another Chapter Regarding Indian Barbarities at Pea Ridge," *New York Times*, April 13, 1862. For an account of antebellum depictions of Indian savagery, see John Coward, *The Newspaper Indian: Native American Identity in the Press, 1820–1890* (Urbana: University of Illinois Press, 1999), 43–64.

29 See Clifford Trafzer, *The Kit Carson Campaign: The Last Great Navajo War* (Norman: University of Oklahoma Press, 1990), 169–97.

30 Lynn Bailey, *Bosque Redondo: The Navajo Internment at Fort Sumner, New Mexico, 1863–1868* (Tucson, AZ: Westernlore Press, 1998), 191–95.

31 For a typical story of fears of Indian raiding, see "From New Mexico: The Difficulties of a Trip to Santa Fe Dangers from the Indians," *New York Times*, August 9, 1864.

32 See Stan Hoig, *The Sand Creek Massacre* (Norman: University of Oklahoma Press, 1974), 3–17.

33 Janet Buerger has noted that Brady was among those who celebrated America's supposed "manifest destiny" in his 1850 Gallery of Illustrious Americans. Of the twelve portrayed, ten had connections to the United States' expansionist policies. See Janet Buerger, "Ultima Thule: American Myth, Frontier, and Artist-Priest in Early American Photography," *American Art* 6, no. 1 (Winter 1992): 90.

34 Herman Viola, *Diplomats in Buckskins: A History of Indian Delegations in Washington City* (Washington, DC: Smithsonian Institution Press, 1981), 101.

35 *Daily Rocky Mountain News*, December 13, 1864, 2, cited by Coward, *The Newspaper Indian*, 98.

36 See "Our Indian Troubles: Report of the Committee on the Conduct of the War on the Massacre of Cheyenne Indians," *New York Times*, July 23, 1865.

37 See Joyce M. Szabo, *Howling Wolf and the History of Ledger Art* (Albuquerque: University of New Mexico Press, 1994).

38 Szabo, *Howling Wolf and the History of Ledger Art*, 178.

Nothing Daunts Chicago

1 "Chicago," *Atlantic Monthly* 19 (March 1867): 327.

2 "Sanitary reform" was commonly used in the mid-nineteenth century to refer to conditions pertaining to health or the promotion of good health. The general populace at the time would not have thought it odd that a commission founded to tend to the needs of wounded soldiers be called a "sanitary commission."

3 "War Inaugurated!," *Chicago Tribune*, April 13, 1861.

4 Adam Goodheart, *1861: The Civil War Awakening* (New York: Knopf, 2011), 180.

5 "1861: Chicago Goes to War," *Chicago History* 6, no. 3 (Spring 1961): 66.

6 Walter Nugent, "Demography," *Encyclopedia of Chicago.* http://encyclopedia.chicagohistory.org/pages /962.html. Accessed November 3, 2011.

7 "1861: Chicago Goes to War," 76; Theodore J. Karamanski, "Civil War," *Encyclopedia of Chicago.* http://www .encyclopedia.chicagohistory.org/pages/2379.html. Accessed August 9, 2012.

8 *Halpin's Chicago City Directory: Eighth Annual Edition* (Chicago: T. M. Halpin, 1865), 927; "Dedication of Bryan Hall," *Chicago Press and Tribune*, September 18, 1860. Bryan Hall, a multipurpose assembly hall, was erected in 1860 at 89 South Clark Street (present-day 119 North Clark).

9 Beverly Gordon, *Bazaars and Fair Ladies: The History of the American Fundraising Fair* (Knoxville: University of Tennessee Press, 1998), 59.

10 *The First Gun is Fired! "May God Protect the Right!"* (Chicago: Root and Cady, 1861).

11 "1861: Chicago Goes to War," 69

12 Theodore J. Karamanski, *Rally 'Round the Flag: Chicago and the Civil War* (Lanham, MD: Rowman and Littlefield, 2006), 100.

13 One study suggests that nearly a quarter of a million women worked for Northern aid societies during the Civil War era. See Patricia L. Richard, *Busy Hands: Images of the Family in the Northern Civil War Effort* (New York: Fordham University Press, 2003), 8.

14 In 1861, the *New York Times* criticized the Sanitary Commission for "stabbing the reputation of so able, energetic, and experienced an officer as our Surgeon-General" and called the commission's conduct "ill-advised and eccentric." Accusations about waste and inefficiency on the part of the USSC would

continue throughout the war. "Camp Inspection and the Sanitary Commission," *New York Times*, December 4, 1861, 5.

15 *Report of the Northwestern Sanitary Commission, Branch of the U.S. Sanitary Commission, for the Months of May and June, 1864* (Chicago: Dunlop, Sewell and Spalding, 1864), 34.

16 *Report of the Northwestern Sanitary Commission*, 3.

17 E. W. Blatchford, Writings, "Reminiscences," Transcript ca. 1910, E. W. Blatchford Papers, Box 9, Folder 229, p. 286, Newberry Library, Chicago (hereafter "Reminiscences").

18 "Memorial of a Public Meeting of the Christian Men of Chicago. To His Excellency, Abraham Lincoln, President of the United States." ca. 1864, E. W. Blatchford Papers, Box 7, Folder 193, Newberry Library, Chicago. Emphasis in original.

19 See Livermore, *My Story of the War* (Hartford, CT: A. D. Worthington, 1889), 129; William Quentin Maxwell, *Lincoln's Fifth Wheel: The Political History of the United States Sanitary Commission* (New York: Longmans, Green, 1956).

20 Judith Ann Giesberg, *Civil War Sisterhood: The U.S. Sanitary Commission and Women's Politics in Transition* (Boston: Northeastern University Press, 2000), vii.

21 The relationship between the Sanitary Commission and the Christian Commission was fraught. By 1864, Sanitary Commission reports regularly praised the Christian Commission but also claimed that the Sanitary Commission should be entrusted fully with warehousing, transporting, and distributing supplies to the army. Sanitary Commission officials suggested that the Christian Commission should limit activities to the spiritual needs of soldiers. See *Report of the Northwestern Sanitary Commission*, 22–24.

22 James M. McPherson, *Battle Cry of Freedom: The Civil War Era* (New York: Oxford University Press, 1988), 481.

23 Giesberg, *Civil War Sisterhood*, 5.

24 Drew Gilpin Faust, *This Republic of Suffering: Death and the American Civil War* (New York: Knopf, 2008), 87, 110–17; quotations on 112.

25 Olmstead, "What They Have to Do Who Stay at Home," Sanitary Commission Document No. 50 (October 21, 1862), 2, 10.

26 Both Mary Livermore and Jane Hoge would echo Olmstead's response to criticism of the USSC's inefficiency in their autobiographies, written after the conclusion of the Civil War. See Livermore, *My Story of the War*, especially 121–22; Hoge, *The Boys in Blue; or, Heroes of the "Rank and File"* (New York: E. B. Treat; Chicago: C. W. Lilley, 1867), 66.

27 George M. Fredrickson, *Inner Civil War: Northern Intellectuals and the Crisis of the Union* (New York: Harper and Row, 1965), 102.

28 McPherson, *Battle Cry of Freedom*, 481. On gender and war relief see, among others, Jeanie Attie, *Patriotic Toil: Northern Women and the American Civil War* (Ithaca, NY: Cornell University Press, 1998); Frances M. Clarke, *War Stories: Suffering and Sacrifice in the Civil War North* (Chicago: University of Chicago Press, 2011); Giesberg, *Army at Home: Women and the Civil War on the Northern Home Front* (Chapel Hill: University of North Carolina Press, 2009); Gordon, *Bazaars and Fair Ladies*; Mary Elizabeth Massey, *Bonnet Brigades* (New York: Knopf, 1966); Nina Silber, *Daughters of the Union: Northern Women Fight the Civil War* (Cambridge, MA: Harvard University Press, 2005).

29 See, for example, Sarah Burns's discussion of Winslow Homer's "Our Women and the War" (fig. 65) in her essay in this volume.

30 Giesberg, *Civil War Sisterhood*, 8.

31 William Cronon's *Nature's Metropolis: Chicago and the Great West* (New York: Norton, 1991) convincingly demonstrates that "City and country might be separate spaces, but they were hardly isolated" (7). Cronon explores the connection between city and country through the flow of commodities. Home and front were distinct spaces during the war, and the boundaries between them had meaning, but they were porous boundaries through which people, information, and commodities flowed.

32 Blatchford, "Reminiscences," 180.

33 Blatchford, "Reminiscences," 181.

34 Jacob N. Taylor and M. O. Crooks, *Sketch Book of Saint Louis* (Saint Louis: G. Knapp, 1858), 350.

35 Blatchford, "Reminiscences," 204, 205, 206.

36 Blatchford, "Reminiscences," 245.

37 Madeleine Vinton Dahlgren, *Memoir of John A. Dahlgren, Rear-Admiral United States Navy* (Boston: J. R. Osgood, 1882), 166, 127.

38 Blatchford, "Reminiscences," 246, 248.

39 Blatchford, "Reminiscences," 250.

40 Blatchford, "Reminiscences," 257.

41 U. S. Grant, *Personal Memoirs of U. S. Grant in Two Volumes* (New York: Charles L. Webster, 1885): 1:240–43; Brigadier General J. W. Vance, *Report of the Adjutant General of the State of Illinois: Containing Reports for the Years 1861–1863* (Springfield, IL: H. W. Rokner, 1886), 186.

42 Blatchford, "Reminiscences," 251. Emphasis in original.

43 "Death of Mary A. Livermore," *Chicago Tribune,* May 24, 1905, 6.

44 Livermore, *My Story of the War,* 158.

45 Henry J. Forsyth, *In Memoriam: Jane C. Hoge* (Chicago: Illinois Printing and Binding Company, 1890).

46 Livermore, *My Story of the War,* 184.

47 Livermore, *My Story of the War,* 185.

48 Livermore, *My Story of the War,* 187, 188.

49 Livermore, *My Story of the War,* 308–18.

50 Dominic A. Pacyga, *Chicago: A Biography* (Chicago: University of Chicago Press, 2009), 53.

51 Livermore, *My Story of the War,* 318.

52 Pacyga, *Chicago: A Biography,* 53.

53 Gordon, *Bazaars and Fair Ladies,* 60.

54 "The Northwestern Sanitary Fair," *Chicago Tribune,* October 24, 1863.

55 "The Great Northwestern Sanitary Fair," *Chicago Tribune,* October 28, 1863.

56 "War-Time Chicago, 1863," *Chicago History* 7, no. 1 (Fall 1963): 18.

57 Livermore, *My Story of the War,* 412, 416.

58 Bellows, "A Letter to the Women of the Northwest, Assembled at the Fair at Chicago, for the Benefit of the U.S. Sanitary Commission," Sanitary Commission Document No. 63 (October 29, 1863).

59 Livermore to Lincoln, October 11, 1863, *Collected Works of Abraham Lincoln,* ed. Roy P. Basler (New Brunswick, NJ: Rutgers University Press, 1955), 6:540. Accessed online July 6, 2011.

60 Lincoln to Ladies in Charge of the Northwestern Fair, October 26, 1863, *Collected Works of Abraham Lincoln* 6:539. Accessed online July 6, 2011.

61 "The Original Emancipation Proclamation," *Chicago Tribune,* October 30, 1863.

62 Camp Douglas opened in 1861 as a location for drilling enlisted troops. After the fall of Fort Donelson, it became a military prison for Confederate soldiers. Reverend E. B. Tuttle, *The History of Camp Douglas* (Chicago: J. R. Walsh, 1865).

63 Livermore, *My Story of the War,* 453, 454.

64 "Close of the Northwestern Sanitary Fair," *Chicago Tribune,* November 8, 1863.

65 Blatchford, "Reminiscences," 279.

66 North-Western Freedmen's Aid Commission, *Great North-Western Fair for Benefit of the North-Western Freedmen's Aid Commission,* 1864, 1–2; Ronald E. Butchart, "Northwestern Freedmen's Aid Commission," in *Organizing Black America: An Encyclopedia of African American Associations,* ed. Nina Mjagkij (New York: Garland Publishing, 2001), 463; Frank B. Goodrich, *The Tribute Book: A Record of the Munificence, Self-Sacrifice and Patriotism of the American People during the War for the Union* (New York: Derby and Miller, 1865), 372.

67 "Northwestern Freedmen's Fair," *Chicago Tribune,* December 22, 1864; "Freedmen's Fair," *Chicago Tribune,* December 14, 1864.

68 Hoge, "Address Delivered by Mrs. Hoge, of the North Western Sanitary Commission, at a Meeting of Ladies, Held at Packer Institute, Brooklyn, L.I. March 1865, In Aid of the Great North Western Fair, to be held at Chicago, Illinois," US Sanitary Commission Document No 88. (May 30, 1865), 18.

69 Hoge, *The Boys in Blue,* 401.

70 Hoge, "Address Delivered by Mrs. Hoge," 4, 21.

71 Goodrich, *Tribute Book*, 286.

72 "The History of the Present Fair Movement—Its Plan, Etc.," *Voice of the Fair*, April 27, 1865, 1.

73 "Chicago Sanitary Fair," *Frank Leslie's Illustrated Newspaper*, July 8, 1865, 248.

74 *Voice of the Fair*, June 3, 1865, 3.

75 On the legends surrounding Lincoln's log cabin, see Barry Schwartz, *Abraham Lincoln and the Forge of National Memory* (Chicago: University of Chicago Press, 2000), 276–81.

76 In June 1864, Lincoln had attended the Great Central Sanitary Fair in Philadelphia, although he did not make a significant speech there. David Herbert Donald, *Lincoln* (New York: Simon and Schuster, 1995), 538.

77 "A Nation Weeps," *Voice of the Fair*, April 27, 1865, 1.

78 Blatchford, "Reminiscences," 289.

79 Following the Civil War, E. W. Blatchford served on the boards of the Chicago Theological Seminary and the Chicago Academy of Sciences. Blatchford also chaired the board of trustees of the Newberry Library from 1892 until 1914. See "Eliphalet Wickes Blatchford," typescript, unpublished document at the Newberry Library; Charles Hammond Blatchford Jr., *Eliphalet W. Blatchford and Mary E. W. Blatchford: The Story of Two Chicagoans* (privately printed, 1962); "'The Second Father of the Newberry,'" *Newberry Library Bulletin*, no. 7 (June 1947): 3–18.

80 "Our Mission," *Voice of the Fair*, April 27, 1865, 2.

Rending and Mending

1 Lilly Martin Spencer to Angélique and Gilles Martin, May 12, 1862. Lilly Martin Spencer Papers, microfilm roll no. 131, Archives of American Art, Smithsonian Institution. See Robin Bolton-Smith and William Truettner, *Lilly Martin Spencer, 1822–1902: The Joys of Sentiment,* exhibition catalog (Washington, DC: Smithsonian Institution Press, 1973); this remains the most comprehensive survey of Spencer's career. Lilly and Benjamin Spencer had thirteen children, seven surviving to adulthood.

2 George Augustus Sala, *My Diary in America in the Midst of War*, vol. 2 (London: Tinsley Brothers, 1865), 358.

3 Harriet Beecher Stowe, "The Chimney-Corner for 1866, IV: Dress, or Who Makes the Fashions," *Atlantic Monthly* 17, no. 102 (April 1866): 494.

4 Judith Giesberg, *Army at Home: Women and the Civil War on the Northern Home Front* (Chapel Hill: University of North Carolina Press, 2009), 12. I am indebted to Giesberg for the model of boundary erosion that I use here.

5 Mary A. Livermore, *My Story of the War: A Woman's Narrative of Personal Experience* (Hartford, CT: A. D. Worthington, 1892), 90; George Henry Preble, *Origin and History of the American Flag,* 2nd ed., vol. 2 (1872; Philadelphia: Nicholas Brown, 1917), 453. Preble's history is one of the most detailed, voluble, and comprehensive; subsequent flag historians quote him at length. More recent studies include Scot M. Guenter, *The American Flag, 1777–1924: Cultural Shifts from Creation to Codification* (Cranbury, NJ: Associated University Presses, 1990).

6 Preble, *Origin and History of the American Flag,* 457; Boleslaw Mastai and Marie-Louise d'Otrange Mastai, *The Stripes and the Stars: The Evolution of the American Flag,* exhibition catalog (Fort Worth, TX: Amon Carter Museum, 1973), 11; and Boleslaw Mastai and Marie-Louise d'Otrange Mastai, *The Stars and the Stripes: The American Flag as Art and as History from the Birth of the Republic to the Present* (New York: Knopf, 1973), 130, 200.

7 Preble, *Origin and History of the American Flag,* 460.

8 Giesberg, *Army at Home,* 192; Reid Mitchell, *Civil War Soldiers* (New York: Viking Penguin, 1988), 19–20.

9 Mastai and Mastai, *The Stars and the Stripes: The American Flag as Art,* 130.

10 Maria Lydig Daly, diary entry, May 30, 1861, in *Diary of a Union Lady, 1861–1865,* ed. Harold Earl Hammond (New York: Funk and Wagnalls 1962), 18; Abby Howland Woolsey to Eliza Newton Woolsey Howland, June 1, 1861, in *Letters of a Family during the War for the Union 1861–1865,* ed. Georgeanna Woolsey

Bacon and Eliza Woolsey Howland, vol. 1 (privately published, 1899), 96; Septima M. Collis, *A Woman's War Record, 1861–1865* (New York: G. P. Putnam's Sons, 1889), 13; it was Collis (13) who dubbed havelock manufacture the "mania of the hour."

11 Zouave uniforms were derived from the garb of Arab tribesmen who served in the French Colonial Army in North Africa; in the 1850s, the French government formed all-French regiments that wore the same distinctive outfit. See Michael J. McAfee, *Zouaves: The First and the Bravest* (Gettysburg, PA: Thomas Publications, 1991). See also Julia Grossman, *Echo of a Distant Drum: Winslow Homer and the Civil War* (New York: Abrams, 1974), and Marc Simpson, *Winslow Homer: Paintings of the Civil War,* exhibition catalog (San Francisco: Fine Arts Museums of San Francisco and Beford Arts, 1988), for in-depth analysis of Homer's career as an artist-reporter and painter of the war.

12 Daly, diary entry, November 7, 1861, *Diary of a Union Lady,* 73. Zouave jackets could also be highly functional: a Woolsey correspondent reported on her new hospital nurse's outfit, which included "a Zouave jacket giving free motion to the arms." See Georgianna Muirson Woolsey Bacon to Eliza Woolsey Howland, July, 1861, *Letters of a Family,* 106.

13 Saddled with the dual role of mother and breadwinner, Spencer herself had neither the time nor the energy to engage in war work. But the two paintings discussed here eloquently testify to the interest she took in women's wartime experience and its transformative potential. A third, *The War Spirit at Home; or, Celebrating the Victory at Vicksburg* (1866; Newark Museum), also probes the confluence or the clash of home front and battle front in the figure of the distracted mother whose infant is about to tumble from her lap as she reads the headlines on the front page of the *New York Times.*

14 Anonymous, "Soldiers' Aid Societies," in Frank Moore, *The Civil War in Song and Story 1860–1865* (New York: P. F. Collier, 1889), 29.

15 Livermore, *My Story of the War,* 111; letter from Abby Howland Woolsey to Georgeanna Muirson Woolsey Bacon and Eliza Newton Woolsey Howland, July 22, 1861, in *Letters of a Family,* 127.

16 Nina Silber, *Daughters of the Union: Northern Women Fight the Civil War* (Cambridge, MA: Harvard University Press, 2005), 61.

17 Mary Elizabeth Massey, *Bonnet Brigades: American Women and the Civil War* (New York: Knopf, 1966), 142–46. For women workers' resistance and efforts at organization, see Giesberg, *Army at Home,* 119–20, 139–41.

18 Iver Bernstein, *The New York City Draft Riots: Their Significance for American Society and Politics in the Age of Civil War* (New York: Oxford University Press, 1991).

19 Giesberg, *Army at Home,* 130.

20 Studies of women who became soldiers include Elizabeth D. Leonard, *All the Daring of the Soldier: Women of the Civil War Armies* (New York: W. W. Norton, 1999), and Richard H. Hall, *Women on the Civil War Battlefront* (Lawrence: University Press of Kansas, 2006).

21 Giesberg notes that the women at Watertown were subject to unwelcome sexual advances on the part of supervisors and male coworkers; they defended themselves by making collective complaints to officials in charge. Giesberg, *Army at Home,* 75, 84.

22 Other explosions included those at the Brown's Island Confederate Laboratory in Richmond, where some fifty died on March 13, 1863, and the Washington Arsenal, with a death toll exceeding twenty on June 18, 1864. On the latter and its memorialization, see Melissa Sheets, "A Memory Forgotten: Representation of Women and the Washington, D.C. Arsenal Monument," MA thesis (University of Nebraska, Lincoln, 2011). On Brown's Island, see http://rgkellerman.blogspot.com/2011/02/explosion-at-browns-island-confederate.html, accessed October 20, 2011.

23 *Pittsburgh Daily Post,* September 18, 1862; *Pittsburgh Gazette,* September 18, 1862. On the arsenals and other venues for female war workers, see Giesberg, *Army at Home,* 68–91. An informative overview, including primary-source documents, is the web exhibit designed by the National Archives at Philadelphia: http://www.archives.gov/midatlantic/exhibits/allegheny-arsenal/. Accessed October 20, 2011. On the emotional and spiritual wounding of home-front women, see Alice Fahs, "The Feminized Civil War: Gender, Northern Popular Literature, and the Memory of the War, 1861–1900," *Journal of American History* 85, no. 4 (March 1999): 1474–76.

24 Guenter, *The American Flag,* 75. It was not until the 1920s that flag etiquette was officially formulated, but many of the protocols were implicit in the ways soldiers handled and defended the Union flag during the course of the Civil War.

25 J. H. Horton and Sol. Teverbaugh, *A History of the Eleventh [Ohio] Regiment* (Dayton, OH: W. J. Shuey, 1866) 242; Mitchell, *Civil War Soldiers,* 19; Edward Everett Hale, "The Man without a Country," *Atlantic Monthly* 12, no. 73 (December, 1863): 675. Jochen Wierich, *Grand Themes: Emanuel Leutze, Washington Crossing the Delaware, and American History Painting* (University Park: Pennsylvania State University Press, 2012), 119–27, also analyzes the idea of the maternal body as national body in his discussion of Spencer's *War Spirit at Home.*

26 Daly, *Diary of a Union Lady,* 201–2. On the history of these flags, see Peter J. Lysy, *Blue for the Union and Green for Ireland: The Civil War Flags of the 63rd New York Volunteers, Irish Brigade* (South Bend, IN: Archives of the University of Notre Dame, 2001).

27 On the feminized flag, see Albert Boime, *The Unveiling of the National Icons: A Plea for Patriotic Iconoclasm in a Nationalist Era* (New York: Cambridge University Press, 1998), 20.

28 Frances Clarke, "'Honorable Scars': Northern Amputees and the Meaning of Civil War Injuries," in *Union Soldiers and the Northern Home Front* ed. Paul A. Cimbala and Randall M. Miller (New York: Fordham University Press, 2002), 364–66, 389. On the ostentatious pinning up of sleeves or trouser legs, see Laurann Figg and Jane Farrell-Beck, "Amputation in the Civil War: Physical and Social Dimensions," *Journal of the History of Medicine and Allied Sciences* 48 (October 1993): 467–68. Also see James Marten, *Sing Not War: The Lives of Union and Confederate Veterans in Gilded Age America* (Chapel Hill: University of North Carolina Press, 2011) for a detailed look the social and institutional experiences of needy, disabled, and traumatized veterans.

29 Mrs. P. A. Hanaford (lyrics) and Rev. J. W. Dadmun (music), *The Empty Sleeve: A Song with Chorus* (Boston: Oliver Ditson, 1866).

30 James Goodnow to Samuel Goodnow, January 11, 1863, quoted in James Marten, *Civil War America: Voices from the Home Front* (Santa Barbara, CA: ABC-CLIO, 2005), 130.

31 The Matthew Brady photograph of the Union Breastworks, Culp's Hill, Gettysburg (Library of Congress), shows an improvised wall similar to that in Homer's *On Guard.* Given that Homer freelanced as an artist-reporter for *Harper's Weekly* during the war, he very likely could have seen the wood engraving after the Brady photograph, published by the magazine in the August 22, 1863 issue.

32 Horatio Alger Jr., *Frank's Campaign: The Farm and the Camp* (Boston: Loring, 1864), 39. I am indebted to James Marten, *Children for the Union: The War Spirit on the Northern Home Front* (Chicago: Ivan R. Dee, 2004), for leading me to Alger's novel. *Children for the Union* more generally is a valuable source of information on the lives and struggles of Northern children and their families during the war. Homer's older colleague Eastman Johnson in 1864 produced *The Little Soldier* (art market, 2004), a much less subtle image, representing a young boy wearing a kepi and fully outfitted with outsize rifle, pistol, sword, bedroll, canteen, and other military gear.

33 Spencer to Angélique and Gilles Martin, May 12, 1862, Spencer Papers, Archives of American Art. The dearth of marriageable men was considerably greater in the Southern states, but young women in the North were affected as well; see Judith Harper, *Women during the Civil War: An Encyclopedia* (New York: Routledge, 2003), 98. The postwar baby might also be one of the "replacements," but it is not clear if it is a boy or a girl.

34 Laura Groves Napolitano, "Nurturing Change: Lilly Martin Spencer's Images of Children," PhD diss. (University of Maryland, 2008), 190. Napolitano (187) proposes that the message of *Home of the Red, White, and Blue* is about Reconstruction as a time not only to reunite North and South but also to mend antagonisms between the returned veteran and his family, and between the immigrant and the native-born. The conspicuous absence of African Americans in *Home of the Red, White, and Blue* remains a puzzle, especially since Spencer did include two black figures, albeit on the margins, in her wartime painting, *The Artist and Her Family at a Fourth of July Picnic.*

35 "Italians in New York—Who and What They Are," *Phrenological Journal and Science of Health* 52 (April 1871): 246.

36 John Zucchi, *Little Slaves of the Harp: Italian Street Musicians in Nineteenth-Century Paris, London, and New York* (Montreal: McGill-Queen's University Press, 1992), 7. For a typical attack on "lazy" Italian organ-grinders and their ilk, see "Phases of City Life," *New York Times*, November 4, 1871.

37 W. A. Linn, "Les Petits Italiens," *The Galaxy* 7, no. 5 (May 1869): 749. Zucchi, *Little Slaves of the Harp*, 41, notes that in the late 1860s, a new culture of child harpists and violinists emerged and soon dominated the scene, to the further consternation of reformers.

38 James Dabney, "The Story of a Patriot," *Flag of Our Union*, July 4, 1866, 439. Winslow Homer's "Thanksgiving Day—The Church Porch" in *Frank Leslie's Illustrated Newspaper*, December 23, 1865, takes a more optimistic view: his one-legged veteran is among the crowd of middle-class worshippers just emerging from Thanksgiving services.

39 These illustrations appeared in the issues of March 7 and September 9, 1868.

40 "Speech by Elizabeth Cady Stanton to Mass Meeting of Women in New York," May 17, 1870, *The Selected Papers of Elizabeth Cady Stanton and Susan B. Anthony*, ed. Ann D. Gordon (New Brunswick: Rutgers University Press, 2000), 342. Eric Foner gives a concise overview of women's rights and Reconstruction issues in Eric Foner and Joshua Brown, *Forever Free: The Story of Emancipation and Reconstruction* (New York: Knopf, 2005), 123–25. To what extent the war reshaped women's roles is still subject to debate; see Catherine Clinton and Nina Silber, eds., *Battle Scars: Gender and Sexuality in the American Civil War* (New York: Oxford University Press, 2006), 7, 12.

41 Harriet Beecher Stowe, "The Chimney-Corner for 1866: Being a Family-Talk on Reconstruction," *Atlantic Monthly* 17, no. 99 (January 1866): 681; Stowe, "The Chimney-Corner. XI. The Woman Question; or, What Will You Do with Her?," *Atlantic Monthly* 16, no. 98 (December 1865): 681.

42 Joining the edges would entail the construction of flat-fell seams (i.e., stitched with no raw edges on either side) customarily used in the fabrication of flags. See Grace Rogers Cooper, *Thirteen-Star Flags: Keys to Identification*, Smithsonian Studies in History and Technology 21 (Washington, DC: Smithsonian Institution Press, 1973), 24.

43 The exception was Winslow Homer, who in a handful of works done from the late 1860s into the 1870s featured independent young women bathing at the seashore or riding and hiking in the mountains.

Nature, Nurture, Nation

1 As quoted in Alfred V. Frankenstein, *William Sidney Mount* (New York: Abrams, 1975), 367.

2 "*Fruit Piece: Apples on Tin Cups*, William Sidney Mount," Collection Cameo sheet, Terra Museum of American Art, Chicago, December 1996.

3 See Marc Simpson, *Winslow Homer: Paintings of the Civil War* (San Francisco: Fine Arts Museums of San Francisco and Bedford Arts, 1988) and the many illustrations by Homer discussed throughout this volume.

4 Steven Conn and Andrew Walker, "The History in the Art: Painting the Civil War," in *Terrain of Freedom: American Art and the Civil War*, Art Institute of Chicago Museum Studies 27, no. 1 (2001): 77.

5 See Angela Miller, *The Empire of the Eye: Landscape Representation and American Cultural Politics, 1825–1875* (Ithaca, NY: Cornell University Press, 1993), 129–35, and Eleanor Jones Harvey, *The Voyage of the Icebergs: Frederic Church's Arctic Masterpiece* (Dallas: Dallas Museum of Art; New Haven, CT: Yale University Press, 2002), 61.

6 Doreen Bolger Burke, "Frederic Edwin Church and 'The Banner of Dawn,'" *American Art Journal* 14 (Spring 1982): 42–43; Gerald L. Carr, *Frederic Edwin Church—The Icebergs* (Dallas: Dallas Museum of Art, 1980), 80; Gerald L. Carr, *Frederic Edwin Church: Catalogue Raisonné of Works of Art of Olana State Historic Site* (Cambridge: Cambridge University Press 1994), 275–79.

7 Elizabeth Johns, *American Genre Painting: The Politics of Everyday Life* (New Haven, CT: Yale University Press, 1991), 34–36.

8 Frankenstein, *William Sidney Mount*, 10.

9 Frankenstein, *William Sidney Mount*, 358.

10 Johns, *American Genre Painting*, 119–21.

11 Frankenstein, *William Sidney Mount*, 394.

12 Frankenstein, *William Sidney Mount*, 264, 475.

13 Frankenstein, *William Sidney Mount*, 361, 475. The exhibition he refers to is most likely the spring exhi-bition of the National Academy of Design, which opened within a few weeks of this diary entry. In the same entry, Mount notes, "Brother Henry painted (beef) still life—first rate."

14 Frankenstein, *William Sidney Mount*, 362–63, 373, 395. Italics in original.

15 Frankenstein, *William Sidney Mount*, 378, 393, 394.

16 Mount painted a portrait of Mrs. Wickham and her daughter in September 1862. See Frankenstein, *William Sidney Mount*, 363.

17 "Metropolitan Fair," *New York Observer and Chronicle*, January 14, 1864, 42, 2.

18 "The Photographs," *New York Herald*, April 6, 1864; "Photographic Chef d'Oeuvre—Brady's 'Sanitary Commission,'" *New York Herald*, April 18, 1864; "Fine Arts, Brady's New Photographs," *New York Herald*, May 31, 1864.

19 *A Record of the Metropolitan Fair in Aid of the United States Sanitary Commission, Held at New York, in April 1864* (New York: Hurd and Houghton, 1867), 190.

20 *Spirit of the Fair*, April 20, 1864, 166.

21 Charlotte Emans Moore, "Art as Text, War as Context: The Art Gallery of the Metropolitan Fair, New York's Artistic Community, and the Civil War," PhD diss. (Boston University, 2009), 352.

22 "Art Notes/The Art Gallery of the Sanitary Fair," *New York Times*, April 11, 1864, 2.

23 "Art/Pictures at the Metropolitan Fair," *The Round Table: A Saturday Review of Politics, Finance, Literature, Society*, April 16, 1864, 1, 18.

24 Frankenstein, *William Sidney Mount*, 379, 382, 379.

25 "*Fruit Piece: Apples on Tin Cups*, William Sidney Mount," Collection Cameo sheet, Terra Museum of American Art, Chicago, December 1996.

26 Ralph Waldo Emerson, "Country Life," in *The Later Lectures of Ralph Waldo Emerson, 1843–1871*, vol. 2, ed. Ronald A. Bosco and Joel Myerson (Athens: University of Georgia Press, 2010), 55.

27 Lily May Spaulding and John Spaulding, eds., *Civil War Recipes: Receipts from the Pages of Godey's Lady's Book* (Lexington: University Press of Kentucky, 1999), 3, 9, 20.

28 Virginia Ingraham Burr, *The Secret Eye: The Journal of Ella Gertrude Clanton Thomas, 1848–1889* (Chapel Hill: University of North Carolina Press, 1990).

29 Edward W. Curtis to Rachel W. Kingsley, Folder 19, July 18, 1863, Edward W. Curtis Letters, Newberry Library, Chicago.

30 Edward W. Curtis to Rachel W. Kingsley, Folder 20, August 10, 1863, Edward W. Curtis Letters, Newberry Library, Chicago.

31 John D. Billings, *Hardtack and Coffee; or, The Unwritten Story of Army Life* (Lincoln: University of Nebraska Press, 1993), 111–12, 138, 114.

32 "Putting on the Ritz," *Saveur*, February 28, 2008.

33 Stephen C. Foster Family Letters, Folder 4, October 6, 1863, Newberry Library, Chicago.

34 Robert Leslie Wiles Journal, Newberry Library, Chicago.

35 Edgar McLean Papers, Folder 42, January 5, 1864, Newberry Library, Chicago.

36 "The Sanitary Commission, Report of its Operations," *New-York Daily Tribune*, September 27, 1862.

37 Simpson, *Winslow Homer*.

38 George Deal Papers, Folder 31, August 17, 1863, Newberry Library, Chicago.

39 *A Record of the Metropolitan Fair*, 66–67; Charles J. Stille, *Memorial of the Great Central Fair for the U.S. Sanitary Commission, Held at Philadelphia. June 1864* (Philadelphia: US Sanitary Commission, 1864), 99–100.

40 Stille, *Memorial of the Great Central Fair for the U.S. Sanitary Commission*, 103.

41 *A Record of the Metropolitan Fair*, 183.

42 Karal Ann Marling, *George Washington Slept Here: Colonial Revivals and American Culture, 1876–1986* (Cambridge: Harvard University Press, 1988), 38–39.

43 Stille, *Memorial of the Great Central Fair for the U.S. Sanitary Commission*, 103, 102, 101.

44 "J. F. Kensett," *The Round Table*, March 12, 1864, 201; "Fine Arts, Mr. Kensett on Lake George," *Albion* 42, no. 12 (March 19, 1864): 141

45 "Art, Kensett's *Lake George*," *The Round Table*, March 19, 1864, 216.

46 Nancy K. Anderson, Linda S. Ferber, and Helena Wright, *Albert Bierstadt: Art and Enterprise* (New York: Brooklyn Museum in association with Hudson Hills, 1990), 80.

47 Anderson, Ferber, and Wright, *Albert Bierstadt*, 71, 76.

48 *New York Times*, March 3, 1862.

49 John Peters-Campbell, "The Big Picture and the Epic American Landscape," PhD diss. (Cornell University, 1989), 240–50.

50 Elizabeth Milroy, "Avenue of Dreams: Patriotism and the Spectator at Philadelphia's Great Central Sanitary Fair," in *Making and Remaking Pennsylvania's Civil War*, ed. William Blair and William Pencak (University Park: Pennsylvania State University Press, 2001), 46.

51 "The Art Gallery," *Philadelphia Forney's War Press*, June 11, 1864, 5.

52 "Sale of Pictures at the Fair," *New York Evening Post*, April 21, 1864.

53 Moore, "Art as Text, War as Context," 363.

54 "A Monster Wigwam, War Dances," *New York Herald*, April 4, 1864.

55 "A Monster Wigwam, War Dances"; *A Record of the Metropolitan Fair*, 50.

56 "A Monster Wigwam, War Dances."

57 On Bierstadt's studio, see Anderson and Ferber, *Albert Bierstadt*, 73, 83.

58 William H. Truettner, *The Natural Man Observed: A Study of Catlin's Indian Gallery* (Washington, DC: Smithsonian Institution Press, 1978), 41–51.

59 "The Great Metropolitan Fair/A Brilliant Spectacle," *The Independent*, April 14, 1864.

60 *A Record of the Metropolitan Fair*, 50.

61 "A Monster Wigwam, War Dances."

62 "A Monster Wigwam, War Dances."

63 "A Monster Wigwam, War Dances."

64 Stille, *Memorial of the Great Central Fair for the U.S. Sanitary Commission*, 97.

65 *A Record of the Metropolitan Fair*, 183.

66 Pliny the Elder's anecdote about the trompe l'oeil paintings of Zeuxis and Parrhasius is the most famous example of this ancient tradition. See *The Natural History of Pliny*, book 35, chapter 36, "Artists Who Painted with the Pencil" (London: Henry G. Bonn, 1855–57), 6:251.

67 Frankenstein, *William Sidney Mount*, 362, 365. Italics in original.

68 William Cullen Bryant, "My Autumn Walk," in Edmund Clarence Stedman, *An American Anthology, 1787–1900*, vol. 1 (Cambridge: Riverside Press, 1900), 65–66.

69 The literature on autumnal imagery in the Hudson River school landscape art is vast. For example, see *American Paradise: The World of the Hudson River School* (New York: Metropolitan Museum of Art, 1987); Hudson River Museum, *Paintbox Leaves: Autumnal Inspirations from Cole to Wyeth* (Yonkers, NY: Hudson River Museum, 2010).

70 Jeffrey R. Brown and Ellen W. Lee, *Alfred Thompson Bricher, 1837–1908* (Indianapolis: Indianapolis Museum of Art, 1973), 14.

71 Edmund Burke, *A Philosophical Enquiry into the Origin of Our Ideas of the Sublime and Beautiful* (London: R. and J. Dodsley, 1757).

72 Nancy K. Anderson, *Thomas Moran* (Washington, DC: National Gallery of Art and New Haven, CT: Yale University Press, 1997), 25.

73 Thomas Moran, "Opus List," as reproduced in Anderson, *Thomas Moran*, 352.

74 "Extracts from Letters," *Lady's Home Magazine*, January 1857, 9. Italics in original.

75 "Falls of the Wissahickon," *Gleason's Pictorial Drawing-Room Companion* 1 (November 1, 1851): 432.

76 "Philadelphia, Germantown, and Norristown Railway," *Railway Times* 14 (December 27, 1862): 414.

77 "Art. IX.—History of West Point," *North American Review* 98 (April 1864): 530; B.G.N., "Health of the Cadets at West Point," *Massachusetts Teacher and Journal of Home and School Education* 17 (April 1864): 150; Henry Barnard, "Conditions of Admission," *American Journal of Education* 14 (March 1864): 103;

"Popular Military Education," *The Round Table*, February 20, 1864, 148; "U.S. Military Academy at West Point," *Massachusetts Teacher and Journal of Home and School Education* 17 (February 1864): 76.

78 Betsy Fahlman, "John Ferguson Weir: Painter of Romantic and Industrial Icons," *Archives of American Art Journal* 20, no. 2 (1980); 4.

79 Brown and Lee, *Alfred Thompson Bricher,* 14.

80 "Our Woolen Manufactures," *Scientific American* 6 (February 8, 1862): 89.

81 "The Naval Forces of the United States," *Merchants' Magazine and Commercial Review* 52 (January 1, 1865): 81.

82 "The Record of the War," *Maine Farmer* 31 (February 19, 1863): 3; *Maine Farmer* 31 (April 9, 1863): 2; *Maine Farmer* 31 (September 24, 1863): 2.

83 "Philadelphia Art Notes," *The Round Table*, May 14, 1864, 344.

84 Anderson, *Thomas Moran,* 189.

85 "Opus List," as reproduced in Anderson, *Thomas Moran,* 352.

86 Iver Bernstein, *The New York City Draft Riots: Their Significance for American Society and Politics in the Age of Civil War* (New York: Oxford University Press, 1991).

87 Miss Leslie, "Recollections of West Point," *Graham's Lady's and Gentleman's Magazine* 20 (April 1842): 206–7; "Art. IX.—History of West Point," 530.

88 "Historical and Literary Intelligence," *Historical Magazine, and Notes and Queries Concerning the Antiquities* 4 (February 1860): 64.

89 Abraham Lincoln, "The Gettysburg Address," November 19, 1863, in *The Collected Works of Abraham Lincoln*, ed. Roy P. Basler (New Brunswick, NJ: Rutgers University Press, 1955).

90 James W. Baker, *Thanksgiving: The Biography of an American Holiday* (Lebanon: University of New Hampshire Press, University Press of New England, 2009); Rose S. Klein, "Washington's Thanksgiving Proclamations," *American Jewish Archives* 20, no. 2 (July 1968): 156–62; William J. Petersen, "Thanksgiving in America," *Palimpsest* 49, no. 12 (December 1968): 545–55; William J. Petersen, "Thanksgiving in Iowa," *Palimpsest* 49, no. 12 (December 1968): 556–76; William J. Petersen, "Thanksgiving in Iowa Schools," *Palimpsest* 49, no. 12 (December 1968): 577–608.

91 Elizabeth Pleck, "The Making of the Domestic Occasion: The History of Thanksgiving in the United States," *Journal of Social History* 32 (Summer 1999): 776.

92 Pleck, "The Making of the Domestic Occasion," 775.

93 Pleck, "The Making of the Domestic Occasion," 776; Lily May Spaulding and John Spaulding, eds., *Civil War Recipes,* 3, 9, 20.

94 Bartholomew F. Bland, "The Landscape," in Hudson River Museum, *Paintbox Leaves,* 27.

95 Nicolai Cikovsky Jr., "Λ Harvest of Death: *The Veteran in a New Field*," in Simpson, *Winslow Homer,* 83–101.

96 Kevin J. Avery, "Gifford and the Catskills," in *Hudson River School Visions: The Landscapes of Sanford R. Gifford,* ed. Kevin J. Avery and Franklin Kelly (New York: Metropolitan Museum of Art, 2003), 32–33.

97 Avery, "Gifford and the Catskills," 37, 40–41.

98 Avery, "Gifford and the Catskills," 42.

99 Nicolai Cikovsky Jr., "'The Ravages of the Axe': The Meaning of the Tree Stump in Nineteenth-Century American Art," *Art Bulletin* 61 (December 1979): 611–26.

100 Avery, "Gifford and the Catskills," 42.

Contributors

Peter John Brownlee is associate curator at the Terra Foundation for American Art, where he recently organized the exhibitions *Manifest Destiny/Manifest Responsibility: Environmentalism and the Art of the American Landscape* and *A New Look: Samuel F. B. Morse's* Gallery of the Louvre. Brownlee is cocurator (with Daniel Greene) of *Home Front: Daily Life in the Civil War North*, the exhibition upon which this book is based. He has contributed essays to a number of exhibition catalogs, and his articles on nineteenth-century painting and visual culture have appeared in *American Art* and the *Journal of the Early Republic*. Brownlee earned his PhD in American Studies at The George Washington University.

Sarah Burns is professor of art history emeritus, Indiana University, Bloomington. She is the author of *Pastoral Inventions: Rural Life in Nineteenth-Century American Art and Culture* (1989), *Inventing the Modern Artist: Art and Culture in Gilded Age America* (1996), *Painting the Dark Side: Art and the Gothic Imagination in Nineteenth-Century America* (2004), and *American Art to 1900: A Documentary History*, coauthored with John Davis (2009). In addition, she has authored numerous articles and exhibition catalog essays on a wide range of topics in American nineteenth-century art. In 2008–9, she was the Terra Foundation for American Art Fellow at the Newberry Library.

Diane Dillon is director of scholarly and undergraduate programs at the Newberry Library. Her recent publications include "Indians and 'Indianicity' at the 1893 World's Fair," in *George De Forest Brush: The Indian Paintings*, ed. Nancy K. Anderson (2008); *Mapping Manifest Destiny: Chicago and the American West*, with Michael Conzen (2007); and "Consuming Maps," in *Maps: Finding Our Place in the World*, ed. James R. Akerman and Robert W. Karrow Jr. (2007). She has cocurated exhibitions on the 1909 *Plan of Chicago*, the history of cartography, and the 1933–34 Century of Progress International Exposition. Dillon holds a PhD in the history of art from Yale University.

Adam Goodheart is the author of *1861: The Civil War Awakening*, which was a finalist for the Los Angeles Times Book Prize in history and was named Book of the Year for 2011 by the History Book Club. A frequent contributor to the *New York Times*, *National Geographic*, and other publications, he is director of Washington College's C. V. Starr Center for the Study of the American Experience, an institute for fostering innovative approaches to American history and culture. He is currently at work on a book about the Civil War's final year, scheduled for publication by Alfred A. Knopf in 2015.

Daniel Greene is vice president for research and academic programs at the Newberry Library. He is the cocurator (with Peter John Brownlee) of *Home Front: Daily Life in the Civil War North*, the exhibition upon which this book is based. Greene is the author of *The Jewish Origins of Cultural Pluralism: The Menorah Association and American Diversity* (2011). Before joining the Newberry staff, he was a historian and curator at the US Holocaust Memorial Museum in Washington, DC. Greene is also an affiliated faculty member of the history department at the University of Illinois at Chicago. He earned his PhD in history at the University of Chicago.

Scott Manning Stevens is director of the D'Arcy McNickle Center for American Indian and Indigenous Studies at the Newberry Library. Stevens was raised in upstate New York and is a member of the Akwesasne/Saint Regis Mohawk Tribe. He received his PhD from Harvard University. In 2000–2001 Dr. Stevens was a Ford Foundation Postdoctoral Fellow at the John Carter Brown Library at Brown University. He is the author of several articles and chapters in collections and has lectured at universities the United States, Canada, Europe, and Asia. Before becoming the director of the McNickle Center, Stevens taught at Arizona State University and SUNY Buffalo. He is in the process of completing a book on American Indians and museum culture.

Index